WINSLOW HOMER
AND THE CRITICS

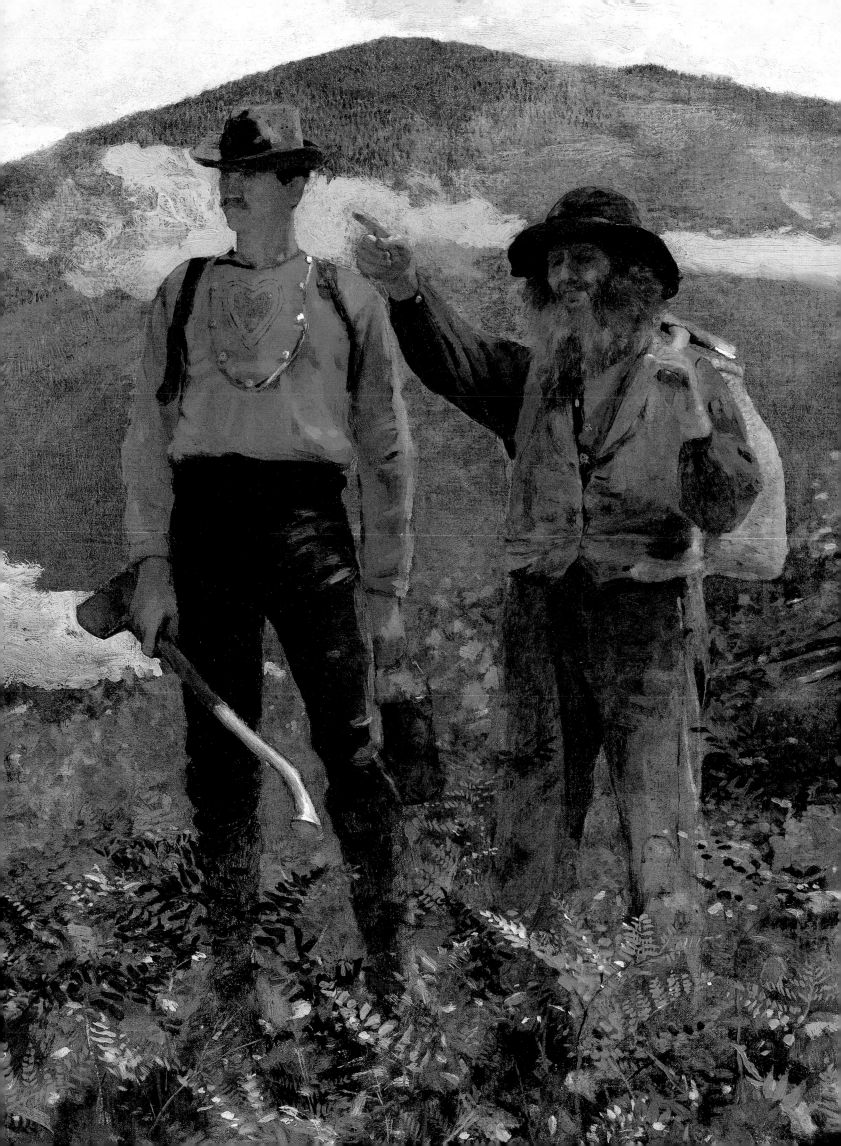

WINSLOW HOMER
AND THE CRITICS

———◆———

Forging a National Art in the 1870s

MARGARET C. CONRADS

PRINCETON UNIVERSITY PRESS

IN ASSOCIATION WITH THE NELSON-ATKINS MUSEUM OF ART

Published on the occasion of the exhibition *Winslow Homer and the Critics: Forging a National Art in the 1870s*

EXHIBITION ITINERARY:

THE NELSON-ATKINS MUSEUM OF ART, KANSAS CITY, MISSOURI
18 February–6 May 2001

LOS ANGELES COUNTY MUSEUM OF ART
10 June–9 September 2001

HIGH MUSEUM OF ART, ATLANTA
6 October 2001–6 January 2002

Winslow Homer and the Critics: Forging a National Art in the 1870s has been organized by The Nelson-Atkins Museum of Art. Primary funding has been provided by the Marguerite Munger Peet Museum Trust, Marguerite Peet Foster and UMB Bank, n.a., co-trustees. Financial assistance for this exhibition and its programs has been provided by the Campbell-Calvin Fund. Additional funding has come from H&R Block, Inc. and the Missouri Arts Council, a state agency MAC . Midwest Express Airlines is the official airline sponsor of the exhibition.

Publication of the catalogue has been supported by a grant from Furthermore, the publication program of the J. M. Kaplan Fund.

Published by Princeton University Press in association with The Nelson-Atkins Museum of Art

Princeton University Press, 41 William Street, Princeton, New Jersey 08540
In the United Kingdom: Princeton University Press, 3 Market Place, Woodstock, Oxfordshire OX20 1SY

The Nelson-Atkins Museum of Art, 4525 Oak Street, Kansas City, Missouri 64111

Jacket/cover illustrations: (front) *Breezing Up (A Fair Wind)*, 1873–76 (detail of fig. 76); (back) *Woman Sewing*, 1878–79 (detail of fig. 88)
Frontispiece: *Two Guides*, 1877 (detail of fig. 103)
Details used on divider pages: Chapter 1, *Prisoners from the Front*, 1866 (fig. 1); Chapter 2, *Snap the Whip*, 1872 (fig. 31); Chapter 3, *Looking Out to Sea (Female Figure in Black near a Window)*, 1872 (fig. 32); Chapter 4, *Milking Time*, 1875 (fig. 66); Chapter 5, *Unruly Calf (Cattle Piece)*, 1875 (fig. 77); Chapter 6, *Answering the Horn (The Home Signal)*, 1876 (fig. 93); Chapter 7, *Apple Picking (In the Orchard)*, 1878 (fig. 108); Chapter 8, *Sunset Fires*, 1880 (fig. 127); Chapter 9, *Man in Punt, Fishing*, 1874 (fig. 55)

Designed by Patrick Dooley
Typesetting by Sam Potts
Color separations and printing by South China Printing

Printed in Hong Kong
(Cloth) 10 9 8 7 6 5 4 3 2 1 (Paper) 10 9 8 7 6 5 4 3 2 1

Library of Congress Cataloging-in-Publication Data
Conrads, Margaret C., 1955–
 Winslow Homer and the critics : forging a national art in the 1870s / Margaret C. Conrads.
 p. cm.
 Published in conjunction with an exhibition held at The Nelson-Atkins Museum of Art, Kansas City, Mo., Feb. 18–May 6, 2001, the Los Angeles County Museum of Art, Los Angeles, Calif., June 10–Sept. 9, 2001, and the High Museum of Art, Atlanta, Ga., Oct. 6, 2001–Jan. 6, 2002.
 Includes bibliographical references and index.
 ISBN 0-691-07099-7–ISBN 0-691-07430-5 (pbk.)
 1. Homer, Winslow, 1836–1910–Exhibitions. 2. Homer, Winslow, 1836–1910–Criticism and interpretation. 3. Art criticism–United States–History–19th century. I. Homer, Winslow, 1836–1910. II. Nelson-Atkins Museum of Art. III. Los Angeles County Museum of Art. IV. High Museum of Art. V. Title.

ND 237.H7 A4 2001
759.13–dc21 00-064257

Contents

Lenders to the Exhibition

Addison Gallery of American Art, Phillips Academy, Andover, Massachusetts

Albright-Knox Art Gallery, Buffalo

Amon Carter Museum, Fort Worth, Texas

The Art Institute of Chicago

The Art Museum, Princeton University, New Jersey

Brooklyn Museum of Art

The Butler Institute of American Art, Youngstown, Ohio

Canajoharie Library and Art Gallery, New York

Chrysler Museum of Art, Norfolk, Virginia

Cincinnati Art Museum

The Cleveland Museum of Art

Cooper-Hewitt, National Design Museum, Smithsonian Institution, New York

The Corcoran Gallery of Art, Washington, D.C.

Delaware Art Museum, Wilmington

The Fine Arts Museums of San Francisco

Fogg Art Museum, Harvard University Art Museums, Cambridge, Massachusetts

Jo Ann and Julian Ganz, Jr.

Georgia Museum of Art, University of Georgia, Athens

Henry Art Gallery, University of Washington, Seattle

Hirshhorn Museum and Sculpture Garden, Smithsonian Institution, Washington, D.C.

Huntington Museum of Art, West Virginia

Mr. and Mrs. George M. Kaufman

Mr. and Mrs. R. Crosby Kemper

Krannert Art Museum, University of Illinois, Urbana-Champaign

Los Angeles County Museum of Art

Lyman Allyn Museum of Art at Connecticut College, New London

McNay Art Museum, San Antonio, Texas

The Metropolitan Museum of Art, New York

Mills College Art Museum, Oakland, California

Museum of Fine Arts, Boston

Muskegon Museum of Art, Michigan

National Gallery of Art, Washington, D.C.

The Nelson-Atkins Museum of Art, Kansas City, Missouri

Peabody Collection, Maryland Commission on Artistic Property of the Maryland State Archives

Philadelphia Museum of Art

Private collections

The Saint Louis Art Museum

Fayez Sarofim Collection

Smithsonian American Art Museum, Washington, D.C.

Sterling and Francine Clark Art Institute, Williamstown, Massachusetts

Mr. A. Alfred Taubman

Terra Foundation for the Arts, Chicago

Westmoreland Museum of American Art, Greensburg, Pennsylvania

Williams College Museum of Art, Williamstown, Massachusetts

Foreword

WINSLOW HOMER IS AN ARTIST WHO HAS BEEN EXAMINED THROUGH A VARIETY OF LENSES, ALL OF WHICH HAVE contributed to our understanding of his complex personality and art. His high position in our national artistic heritage makes it worthwhile to examine him again, this time concentrating on his relationship with the art press at a crucial moment in the development of both his own and America's art. In doing so, we are challenged to think about Homer in the broader context of nineteenth-century American art and its changing aesthetics. The exhibition and this catalogue primarily focus on the paintings that Homer chose to represent himself in New York in the 1870s and make it clear that he was not the solitary figure, either artistically or socially, that has been mythologized. This earlier work played a critically important role in constructing the rich fabric of American art in the years after the Civil War as well as providing Homer with the foundation for the following stages of his career. This exhibition and catalogue present some of the artist's best known and least familiar works. Considered here according to their first appearance and first notices, we get a better sense of his situation as the best-loved and most fiercely criticized artist of the 1870s as he alternately fulfilled a role as America's national art hero and her most perplexing disappointment.

Winslow Homer and the Critics: Forging a National Art in the 1870s has been organized by the Nelson-Atkins Museum of Art under the curatorial direction of Margaret Conrads, Samuel Sosland Curator of American Art. Her dedicated efforts have been especially aided by Randall Griffey, assistant curator of American art; Carrie Morgan, project assistant; Cindy Cart, curator of exhibitions management; and Carol Inge Hockett, coordinator of adult programs, as well as the many other staff members at the Nelson-Atkins upon whom we rely for all exhibitions. Early interest in the exhibition from our colleagues at the Los Angeles County Museum of Art and the High Museum in Atlanta confirmed the importance of the project, and we appreciate their continued commitment. We are extremely grateful to the Marguerite Munger Peet Museum Trust, Marguerite Peet Foster and UMB Bank, co-trustees, for providing generous financial assistance to the Nelson-Atkins. We are also thankful for additional funding from the Missouri Arts Council and H&R Block, Inc.

Our sincere thanks go to the many lenders, both public and private, who have graciously shared their collections with us. We are pleased that visitors in Kansas City, Los Angeles, and Atlanta will have the opportunity to see Homer's beautiful and compelling paintings in a broadened context that is both intellectually stimulating and aesthetically rewarding.

Marc F. Wilson
Director/C.E.O.
The Nelson-Atkins Museum of Art

Acknowledgments

ALL EXHIBITIONS AND THEIR ACCOMPANYING PUBLICATIONS ARE COLLABORATIVE EFFORTS, AND *Winslow Homer and the Critics: Forging a National Art in the 1870s* has depended on the great kindness and assistance of many people. We are first and foremost grateful to the more than forty lenders to the exhibition, listed at the front of this volume, without whose generosity this exhibition simply would not have been possible. In Kansas City, we are also deeply thankful to the supporters of the exhibition: the Marguerite Munger Peet Museum Trust, Marguerite Peet Foster and UMB Bank, co-trustees; H&R Block, Inc.; the Missouri Arts Council; and Midwest Express, the official airline of the exhibition. It is always a pleasure to work with our colleagues at the Los Angeles County Museum of Art and the High Museum, the two institutions where the exhibition will also be seen. In particular, Ilene Fort and Christine Lazzaretto in Los Angeles and Michael Shapiro, Linda Merrill, and Linda Boyte in Atlanta have been wonderful partners in the project.

Anyone working on Winslow Homer is dependent on the large body of existing scholarship, and the writings of many scholars have provided me with a sturdy foundation on which to build my work. The bibliography at the back of this volume enumerates the breadth and depth of Homer publications, but I have especially benefited from the writings, and often the collegial support, of Henry Adams, Scott Atkinson, Linda Ayres, Sarah Burns, Nicolai Cikovsky, Jr., Helen Cooper, Karen C. C. Dalton, the late Albert Ten Eyck Gardner, Lucretia Giese, the late Lloyd Goodrich, Franklin Kelly, Michael Quick, Marc Simpson, David Tatham, John Wilmerding, and Peter Wood. I owe special thanks to Abigail Booth Gerdts, director of the Lloyd Goodrich and Edith Havens Goodrich Whitney Museum of American Art Record of Works by Winslow Homer, for her constant willingness to share both the facts and her understanding of Homer's art of the 1870s.

Many museum and academic colleagues, collectors, librarians, and art dealers have provided generous assistance, including: Gerald Bolas, Ackland Art Museum; Julie Dunn, Susan Faxon, and Denise Johnson, Addison Gallery of American Art; Warren Adelson and Susan Mason, Adelson Galleries; Laura Fleischmann, Holly Hughes, Daisy Stroud, and Kenneth Wayne, Albright-Knox Art Gallery; Arthur G. Altschul; Courtney DeAngelis, Patricia Junker, Jane Myers, and Melissa Thompson, Amon Carter Museum; Judy Throm, Archives of American Art; Judith Barter, Hsui-ling Huang, Suzanne McCormick, Andrew Walker, Tamra Yost, and Frank Zucarro, The Art Institute of Chicago; Kathleen Gillikin, Sona Johnston, and Shelley Svaboda, Baltimore Museum of Art; Frederick Hill, Berry-Hill Galleries; Barbara O'Neil, Biltmore Estate; Laura J. Latman, Bowdoin College Museum of Art; Alex Boyle; Lisa Cain, Terry Carbone, Linda Ferber, Barbara Gallati, and Ruth Janson, Brooklyn Museum of Art; Rebecca Davis and Melissa Wolfe, The Butler Institute of American Art; Joseph Caldwell, The Caldwell Gallery; James Crawford, Canajoharie Library and Art Gallery; Judith McColloch, Cape Ann Historical Society;

Jonathan Harding, The Century Club; Jane Padelford, Christie's Images; Linda Cagney, William Hennessey, Lynn Marsden-Atlass, Irene Roughton, and Catherine Jordan Wass, Chrysler Museum of Art; Julie Aronson, Jennifer Reis, and Gretchen Shie, Cincinnati Art Museum; Carol Clark; Henry Adams, Joanne Fenn, Carter Foster, and Mary Lineberger, The Cleveland Museum of Art; Claire A. Conway; Konstanze Bachmann, Jill Bloomer, Floramae Cates, Gail Davidson, Steve Langehough, and Marilyn Symmes, Cooper-Hewitt, National Design Museum, Smithsonian Institution; Carol Salomon, The Cooper Union Library; Sarah Cash, Eric Denker, Kimberly S. Liddle, and Cristina Segovia, The Corcoran Gallery of Art; Mary F. Holahan and Paula L. De Stefano, Delaware Art Museum; Sylvia Inwood, The Detroit Institute of Arts; Angela Waldron, Farnsworth Art Museum; Mary Haas and Stephen Lockwood, The Fine Arts Museums of San Francisco; Evelyn Bavier, Ada Bortoluzzi, and Miriam Stewart, Fogg Art Museum; Tricia Miller and Lynne Perdue, Georgia Museum of Art, University of Georgia; Sandra Hilderbrand and Anne Morand, Gilcrease Museum; Meredith Miller and Cameron Shay, James Graham & Sons; Laura Landau, Henry Art Gallery, University of Washington; Amy Densford, Margaret Dong, Phyllis Rosensweig, and Judith Zilczer, Hirshhorn Museum and Sculpture Garden, Smithsonian Institution; Janine Culligan and Linda Sanns, Huntington Museum of Art; Sarah Burns, Indiana University; Kathy Jamieson; Anne Adams, Kimball Museum of Art; Kathleen Jones and Eunice Maguire, Krannert Art Museum, University of Illinois; Michael Lafferty; Meredith Long and Martha Staley, Meredith Long Gallery; Maria Buszek, Shaula Coyl, Ilene Fort, Ted Greenberg, and Beverly Sabo, Los Angeles County Museum of Art; Carol Lowrey; Carolyn LoGuirato; Nikki Bunnell and Linda Lavin, Lyman Allyn Museum of Art; Maura McCarthy and Hillary Thomas, Maryland Commission on Artistic Property of the Maryland State Archives; Arturo R. Melosi; Heather Lammers and Lyle Williams, McNay Art Museum; Beverly Carter and Michelle C. Tompkins, Estate of Paul Mellon; Suzanne Silvester, Melton Park Gallery; Carrie Rebora Barratt, Deanna Cross, Suzanne L. Shenton, and H. Barbara Weinberg, The Metropolitan Museum of Art; Katherine B. Crum, Mills College Art Museum; Lily Milroy; Judith Palmese, Milwaukee Art Museum; Col. Merl M. Moore; Erica Hirshler, Kim Pashko, Sue Walsh Reed, Leah Ross, and Jim Wright, Museum of Fine Arts, Boston; Barbara Plante, Museum of Fine Arts, Springfield; Susan Talbot-Stanaway and Babs Vaughan, Muskegon Museum of Art; David Dearinger, National Academy of Design; Nancy Anderson, Heidi Applegate, Stephanie Belt, Nicolai Cikovsky, Jr., Barbara C. Goldstein, Franklin Kelly, Carlotta Owens, Alicia Thomas, and Judith Walsh, National Gallery of Art; Nicole Wells, New-York Historical Society; Joyce P. Kobasa, New York State Office of Parks, Recreation and Historic Preservation; Lila Hall and Susan Shockley, The Parthenon; Barbara Katus, Pennsylvania Academy of the Fine Arts; Stacy Bomento, Darell Sewall, Mark Tucker, and Nancy Wulbrecht, Philadelphia Museum of Art; Ronald Pisano; Calvin Brown, Maureen McCormick, and Karen Richter, The Art Museum, Princeton University; Michael Quick; Cornelia Homburg, Diane Mallow, and Patricia Woods, The Saint Louis Art Museum; Cynthia Sanford; John Davis, Smith College; Cecilia Chinn, Kimball Clark, George Gurney, Kristen L. Kertsos, Patricia Lynagh, Richard Murray, Quentin Rankin, Stephano Scafetta, and Abby Terrones, Smithsonian American Art Museum; Lyrinda Snyderman; Nan Chisolm and Valerie Westcott, Sotheby's; Brian Allen, Martha Asher, Mattie Kelley, and Richard Rand, Sterling and Francine Clark Art Institute; David Tatham, Syracuse University; Fred Henshaw and Helen Rowe, The Taubman Company; Sarah Hadley, John Neff, and Cathy Ricciardelli, Terra Foundation for the Arts; Christine Bader Nicoli, Thyssen-Bornemisza Collection; James Petersen, Timken Museum of Art; Arthur Lawrence, The Union League Club; David Cateforis and Charles Eldredge, University of Kansas; David Marquis, Upper Midwest Conservation Association; Lynn Mervosh, Wadsworth Atheneum; Cynthia Pratt, The Walters Art Gallery; Beth Wees; Robert S. Weil, Sr.; Douglas W. Evans, Barbara L. Jones and Judith O'Toole, Westmoreland Museum of American Art; David M. Reel, West Point Museum; Tanya Whetsel; Nelson H. White; Diane Agee and Vivian Patterson, Williams College Museum of Art; Michael Heslip, Williamstown Art Conservation Laboratory; David Brigham and Nancy Swallow, Worcester Art

Museum; Jane Wyeth; Phyllis Wyeth; and Suzanne Warner, Yale University Art Gallery. The periodicals divisions and interlibrary loan departments of the Library of Congress, New York Public Library, State Library of New York, and the Williams College library were especially helpful during the course of my research. In the Kansas City region, I am indebted to the staffs at both the University of Kansas and University of Missouri, Kansas City libraries. My initial research was aided by a generous Henry Luce Foundation Dissertation Grant.

This project has engaged many staff members at the Nelson-Atkins Museum of Art. I appreciate the continual support of Director Marc Wilson. Randall Griffey and Carrie Morgan of the American art department have provided excellent support in the final stages of the project. Carol Inge Hockett of the education department has been dedicated to connecting our community with the exhibition. I also thank Karen Christiansen, chief operating officer; Deborah Emont Scott, chief curator; Elisabeth Batchelor and Scott Heffley of the conservation department; Cindy Cart, curator of exhibitions management; Michele Boeckholt, Joseph LaCrue, Trang Nguyen, and Susan Patterson in the design department; DeeDee Adams, Dawn Biegelsen, Sharon Greenwood, Ann Kaufmann, and Brenda McCurry in the development office; Colleen Naylor in the director's office; Cammie Downing, Kate Livers, Nancy Nowiescewski, and Rebecca Ofiesh in the education department; Dawn Sanders and Jeffrey Weidman in the library; Paul Churchill and the preparation and installation staff; Jamison Miller, Robert Newcombe, Samar Qandil, and Stacey Sherman in the photography department; Gina Kelley and Jennifer Nauss in the public information office; and J. J. Beall, Christine Droll, Ann Erbacher, and Mary Ellen Goeke in the registrar's office. I am also grateful for the assistance of former staff members: Maria Buczek, Sarah Burt, Daniel D'Alonzo, Josie Gordon, Kent Minturn, Susan Moon, Rebecca Prestwood, Mary Ellen Young, and especially Julie Aronson, Laura Morris, Amy Scott, and Maggie Stenz.

Princeton University Press has produced a handsome book, the beautiful design of which is the result of Patrick Dooley's considerable talent. Patricia Fidler deserves special mention for shepherding the manuscript from beginning to end. I also thank Kathleen Friello, Nancy Grubb, Sarah Henry, Devra Kupor, Kate Zanzucchi, and especially Ken Wong for their parts in the book's production. John Davis, as an outside reader, and Jana Stone, as editor, were instrumental in guiding the manuscript to its final shape.

A few individuals have lived with this project as long as I have. William H. Gerdts, professor emeritus, City University of New York, has provided constant and wise counsel throughout the entire project. I am also indebted to Jan Schall for her professional and personal support. David, Lee, and Kim Conrads have graciously allowed Mr. Homer to be a member of our household for many years, and so, to them, I offer my deepest gratitude.

M. C. C.

Unknown Photographer, *Winslow Homer as a Young Man*, 1867.

Bowdoin College Museum of Art, Brunswick, Maine. Gift of the Homer Family

Introduction

IN 1911, ON THE OCCASION OF THE MEMORIAL EXHIBITION FOR WINSLOW HOMER AT THE METROPOLITAN MUSEUM OF ART, the painter-critic Arthur Hoeber proclaimed that "Homer was one of the few artists in the history of his profession who did not have to die to be fully appreciated. . . . [R]arely has there been a man upon whose work nearly everyone so agreed in appreciation."[1] This high approbation for Homer continued through the twentieth century, and today he remains one of America's best-known and most-loved artists. Homer's unquestioned position among America's top-ranking artists, however, did not occur until the mid-1890s, in response to his epic seascapes painted at Prout's Neck, Maine. With their success, the painter's earlier work and the struggles he encountered in New York during his first two decades as a painter were mostly forgotten. The art criticism of the newspapers and magazines of the 1870s reveals that Homer's status as America's leading painter in the years following the Civil War was not yet secure as he found himself caught in the cross fire of the aesthetic battles that were raging in America.

In 1868, Homer was thirty-two years old and a celebrated, rising artist just returned from a year abroad. By early 1881, at age forty-five and about to embark on his second and final European sojourn, Homer found himself in a class alone—at once, radical and old guard, controversial and status quo. In the intervening dozen years, he actively participated in the New York art world, and his work attracted the most sustained and penetrating commentary in the art writings of the day. This book and the accompanying exhibition draw attention to this discrete and understudied period of Homer's otherwise well-known career. Only those works by Homer or incidents of his life that were discussed in newspapers and magazines between 1868 and 1881 will be found here. These limits engender his public persona to form the center of this project, enabling us to view Homer once again as he was seen and understood by his contemporaries. From this vantage point, we get a picture of Homer and his art in the 1870s that, until recently, has only been intimated.

The majority of studies on Homer's art and life have primarily focused on his work after 1883, when he settled at Prout's Neck, Maine. In these volumes, the important role Homer played in the larger construct of American art and the richness of his paintings during his years in New York, especially the 1870s, were given only cursory treatment because the earlier body of work was generally considered a prelude to his great opus of sea paintings. Over the last fifteen years, this viewpoint has been tempered as scholars have examined individual canvases or small groups of paintings from Homer's first productions.[2] The present study grows out of this broadening perspective.

There is no doubt that looking at Homer through the eyes of his critics is just one way to approach the subject. In Homer's case, particularly, it helps us immeasurably since he left almost no primary documents apart from his paintings. The firsthand reviews of his early works provide an essential and previously underutilized

guide to understanding the context in which he created them and how they may have motivated him to paint and behave as he did.[5] These contemporary sources are important tools for defining and clarifying his growth as a painter when his status as America's most promising artist was both most evident and hotly debated.

The path that led Homer to this prominent position in his early career began in Boston. Growing up in Cambridge, Massachusetts, he displayed an early interest in art. He served a two-year apprenticeship at a lithography shop in Boston before beginning, in 1857, more than fifteen years of work as a freelance illustrator for such magazines as *Harper's Weekly*. A move to New York in 1859 brought Homer to the center of both the magazine publishing and art communities.[4] By the early 1860s, Homer had begun to paint in oil as he continued to make illustrations. He spent the years of the Civil War shuttling between New York and the battlegrounds of Virginia, producing a well-known series of illustrations of army life for *Harper's Weekly* and his first group of paintings, also of war-related topics. By 1865, Homer was fully integrated into the fabric of the New York art world. The following year, he catapulted to fame when *Prisoners from the Front* (fig. 1) appeared at the National Academy of Design.

The New York art community of the 1860s and 1870s was still relatively small and tight-knit. It was physically centered between Twenty-third and Tenth Streets at the north and south, with its eastern and western boundaries at Fourth (now Madison) and Sixth Avenues, respectively.[5] The key exhibition venues, artist studios, and the Metropolitan Museum of Art were all located within this area. The National Academy of Design, at the northern end of the district, was the locus of art activities. It served as the professional society for artists, ran the only full-fledged art school in the city, and held the most prestigious art exhibition annually in the spring. A number of men's clubs devoted to supporting the arts also were located in this neighborhood. The Century Club, founded in 1847, was dedicated to advancing culture and had among its members the most influential players in fine arts, literary, and business circles. The Century was notable for both its exhibitions, held monthly in concert with its regular meetings, and its collection. Other clubs, such as the Union League Club, Lotos Club, and Salmagundi Club, played a similar but less prominent role to the Century's in encouraging the arts. Artists' studios, most notably the Tenth Street Studio Building (in which Homer would take residence in 1872), provided not only work spaces but, in the years before a sophisticated art market system was launched, were also important venues for sales. During the 1870s, there was tremendous growth of both dealers' galleries and auctions that contributed to significant changes and competition for the Academy.[6] The Metropolitan Museum of Art, first located on Fourteenth Street, was only founded in 1870, but in its first decade began to make its mark on the city's artistic culture.

As the business of art was blossoming in 1860s New York, America and American art began a period of significant transformation. In the decade following the Civil War, the nation struggled with how to best reunite the North and the South, and how practically to integrate the African-American population into daily life. Unprecedented industrialization occurred at the same time as the worst financial panics in United States history, wreaking havoc on business and labor. Record immigration, the growing disjunction in thought between those who favored a scientific over a theological system of belief, rampant materialism, and class conflicts were just a few of the challenges that created a society in flux.[7]

The changes in art, while not as momentous as changes in the country at large, were no less comprehensive. By the close of the Civil War and after three decades of artistic supremacy, the Hudson River School of landscape painting began to wane, but with no single aesthetic available to replace it.[8] A variety of differing principles arose, chiefly due to an expanded awareness of European art. John Ruskin and the Pre-Raphaelitism of England as well as the Aesthetic Movement and British academic painting; the Barbizon and academic schools of France; the academy at Munich and the more radical strains produced elsewhere in that city in the studios of artists such as Wilhelm Leibl; and the art of Mariano Fortuny and his followers, who painted in Paris and Rome, all had a noteworthy impact on the development of American art.[9]

As American artists grappled with how their art would intersect with the wide array of new influences, the art institutions in which they were involved underwent their own metamorphoses. Of greatest significance to this era were the changes at the National Academy of Design, the agency through which much of the American art world was negotiated. Multiple strands of problems, all closely interwoven, ran through the Academy in the years immediately following the Civil War. The organization was in dire financial straits after it occupied its new building on Twenty-third Street in 1865, jeopardizing and finally paralyzing its ability to operate its art school. Along with its financial difficulties, the institution's membership experienced a generational shift that pitted not only younger against older artists, but those who sought a more national role for the Academy against those who resisted change on any front. On a practical level, the tensions caused by the conflicts between the two camps of artists were located in the policies of the Academy, especially the privileges afforded the academicians, as members of the Academy were known, and in the powers of the hanging committee, the group charged with choosing and installing the annual exhibitions. In artistic matters, the forward-thinking were generally more liberal in their outlook and embraced greater variety of artistic modes unlike the conservative artists who clung to long-accepted subjects and techniques of painting and sculpture. Two of the most notable results of the difficulties within the Academy were the organization of the Art Students League in 1875, when the Academy school suspended its classes, and the formation in 1877 of the Society of American Artists, an association and exhibition outlet serving the more vanguard artists.[10] In this expansive and sometimes highly charged art atmosphere, nearly every component of artmaking and art agency in America came under scrutiny, and Homer worked determinedly to find his place.[11]

The art Homer produced during the 1870s varied widely in media, subject, and style.[12] The themes he explored in his oils, watercolors, and drawings—women, children, African-American life, farming, and the wilderness—were all drawn from current events and topics of contemporary concern. As Homer's themes connected directly to these contemporary interests, his stylistic treatments and technique alternated between or combined experimental and standard practice. Homer's art thus challenged the art press and elicited greater or lesser degrees of critical understanding and acceptance. Responses to his work ran both very hot and very cold, sometimes simultaneously from the same critic.

Homer's emergence as a key figure in American art coincided with tremendous growth in the field of American journalism, particularly art criticism. "During the last twenty years," wrote editorial writer Charles F. Wingate in 1875, "journalism has become prominent, if not pre-eminent, as a profession. The press is to-day the most potent agency for good or evil."[13] Referring primarily to the press's role and power in politics, Wingate's words also apply to the art press. Art writers of the 1870s were their own kind of agents for good and evil as they were instrumental in constructing and articulating America's attitudes towards art.

Ten daily New York City newspapers included art articles in their pages in 1868.[14] Over the next thirteen years, the amount of attention given to the art world grew tremendously, a result, in part, of changes at four of the most influential dailies. Between 1869 and 1872, Henry Raymond of the *Times*, James Gordon Bennett, Sr., of the *Herald*, and Horace Greeley of the *Tribune* all died. William Cullen Bryant, longtime editor of the *Post*, increasingly relaxed his control of that paper in the late 1860s and, in effect, was retired by 1874, although he remained editor in name until his death in 1878. These men had shaped the world of New York journalism from the middle of the century, and their individual and collective departures from the newspaper scene eased the way for a new generation of editors and writers. Among the most significant changes was that party journalism—that is, a newspaper's alignment with and function as a voice for a specific political party—effectively ended.[15] Hard news reporting, greatly enhanced by the increased use of the telegraph, replaced newspapers' dependence on party affiliations for their content.[16] Consequently, the position of newspaper reporter achieved a higher status and their

numbers expanded.[17] Simultaneously, arts editors and art writer-critics were more frequently found on newspaper staffs as these fundamental changes coupled with a greater public interest in art.[18] In these new circumstances, the daily papers expanded their coverage of the New York art world through increased reporting, criticism, and commentary on art issues.

Magazines experienced an expansion similar to newspapers. Eight general magazines had an ongoing, if irregular, commitment to the visual arts between 1868 and 1881.[19] Even though magazines provided the first venues for art criticism from the early nineteenth century, five of these periodicals began publication in 1865 or later.[20] These magazines were primarily New York based, but a few out-of-town monthlies, such as the *Atlantic* from Boston, covered New York, and their readership and scope were increasingly national (at least East Coast) rather than strictly local during this period.[21] The contributions on art in general magazines varied from occasional articles on specific topics to regular art columns and exhibition reviews. As with newspapers, some magazines had editors with art writing as their specific duties or had appointed art editors. Others used a stable of freelancers.

Art magazines developed as a new genre in the periodical literature of the 1870s.[22] The *Aldine, American Art Review, Art Amateur, Art Interchange,* and the New York edition of the *Art Journal* were all newcomers during this period, and, with the exception of the *Aldine,* only appeared between 1875 and 1878. Although not exclusively devoted to the fine arts, *American Architect and Building News* must be included in this list because of its commitment to reviewing New York exhibitions. Thus, by the end of the decade a solid foundation had been laid for what became the art magazine as we know it today.

No tight linear progression in critical thinking can be charted during this period, but a collective awakening among most members of the art press occurred parallel to the upheavals in the art world on which they reported and critically debated. Thus, the body of art criticism produced in the 1870s outlines and illuminates the contending issues of Homer's day. Chief among these was the desire for a national art. What American art was and what it should be sparked key questions about how best to define the chief characteristics of American art: What was its purpose? What were signs of progress? What were appropriate subjects, materials, and techniques, and what was their proper relationship? What were the roles of the artist, originality, and the place of thought, truth, nature, and imagination in art? What constituted completeness in art? The important factors shaping the discussion included the effect of the transition from an older generation of American artists to its successor; the increased availability of foreign art and training; and the rise of watercolor and drawing as legitimate and exhibitable media in their own rights. The individuals who shepherded American art criticism through this growth and change were a dedicated band whose shared mission was to educate the public about art. Many agreed that the duty of the art critic was to "instruct the ignorant in art, to interest the careless of art, and especially to guide the enquirer concerning art."[23] In this role, critics served as crucial mediators between the artist and the public.

Exactly who formed the coterie of art critics in the 1870s is not always easy to identify because of the then-popular convention of author anonymity. Art writing in newspapers rarely had any identifying tag, and while magazine articles on specific topics were sometimes published with a byline, regular art columns and exhibition reviews were generally printed unsigned. Further confusing issues of authorship is the fact that many writers worked freelance and for multiple periodicals simultaneously. Nonetheless, many publications developed distinct aesthetic identities, of which a number can be attributed to the writings of their primary critics. The appendix, located at the back of this volume, provides information about the writers and critics discussed throughout the book.

Of all the newspapers, the *Post* had, perhaps, the longest history of publishing art news. George Sheldon, who was appointed the *Post* art critic in 1873, maintained an evenhanded approach in his writings. While he

appreciated the availability of European models and commended excellence in technique, in the later seventies he increasingly searched for meaningful content in painting. The *Post*, the *Tribune*, and the *World* formed the trio of papers that had the deepest ongoing commitment to art writing. Clarence Cook was the critic of the *Tribune* from the early 1860s. Well known for his strong opinions and sharp tongue, he served as an important critical voice and tastemaker. In Cook's writings, his change in attitude from requiring the depiction of fact in art to accepting and then championing the picturing of inner truths can be charted through the period. Always insistent that American art rest on native qualities, Cook also recognized that the techniques of European art could provide important tools for the creation of a national art, an art that he desired to be both truthful and beautiful. Like Cook, William Crary Brownell of the *World* held his position as art critic through the 1870s. A voice for the younger artists, Brownell often focused on identifying generational differences, which he saw manifested most clearly in the younger painters' use of technique as a means of expression rather than a reliance on subject matter for meaning. Unity and completeness in art and their manifestation in an object's design and visual conception were paramount in his view. The *Times* and the *Sun* were also papers that generally embraced a cosmopolitan outlook and supported the endeavors of the younger artists, but their appearance as substantive voices only occurred after the middle of the decade with the appointments of Charles DeKay and William Laffan, respectively, as critics.

Most of the other forward-thinking critics wrote for magazines. This group included such writers as Eugene Benson, writing early in the decade for the *Galaxy* and *Appleton's*; Earl Shinn of the *Nation* and later *Art Amateur*; Susan Nichols Carter, an artist and art teacher whose criticism appeared in *Appleton's* and the *Art Journal*; Richard Watson Gilder in *Scribner's*; Samuel Greene Wheeler Benjamin in a number of serials including *American Art Review*; and Mariana Griswold van Rensselaer in *American Architect and Building News*. These critics shared the belief that if America was to be a contender in the international art arena, its productions must reflect a synthetic blend of excellent technique and substantive ideas. However, each writer brought distinctive aesthetic preferences to his critiques, and their opinions varied considerably with regard to which rising artists deserved the greatest commendation, which European art provided the best model, and what constituted appropriate finish and subjects.

The most conservative voices appeared in the columns of the *Commercial Advertiser*, the *Herald*, the *Telegram*, and the *Express*. Theodore Grannis of the *Commercial Advertiser*, although a member of the younger generation, was the most consistent voice for the old guard, home subjects, the belief that art should be based in the careful and factual representation of the natural world, and that European influence should be kept to a minimum. His viewpoint was shared especially by D. O'C. Townley, who wrote for numerous publications, and George Hows of the *Express*. Both Grannis and Townley also contributed to the *Aldine*, the conservatism of which was reflected in its appreciation of European art of only the classical or academic traditions.

Homer's situation in the 1870s was integrally tied to his identification by the critics as the artist who personified the promise of a successful future for American art, and his work provided art writers with examples against which to test their most pressing concerns. In the early 1870s, subject matter predominated as the determining factor of a painting's success, and Homer's images of contemporary life were valued especially when they resonated with national issues. At a time when most critics considered American art to be languishing, Homer's work was appreciated in part for its unconventionality, even as his palette, loose painting style, and unusual design aesthetic repeatedly came under attack. As European paintings and young European-trained artists infiltrated the American art world of the mid-1870s, the critical body focused more closely on technical and stylistic issues. As the definition of finish shifted from one dependent on careful details to one grounded in ideas, Homer experimented with varying means of attaining a sense of completeness in his work. His use of light, color, paint application, and compositional design vied for attention with his unmistakably homegrown subjects, and by the

middle of the decade, Homer received great acclaim as well as harsh criticism. With the rise of a new generation of artists, Homer was no longer a young artist of promise, yet he stood somewhat distanced from the older guard. At the end of the 1870s, both Homer and the critics worked hard to come to terms with the vast array of international influences flooding New York. As artists absorbed, with heightened intensity, elements of the art of Munich, Paris, London, and Rome, an emphasis on formal qualities rubbed against the call for deeper thought in art. Often working at a frantic pace, Homer refashioned identifiably American subjects in a variety of modes. At certain times, Homer was singled out as an antidote to the most radical practitioners even as he experimented with the most contemporary ideas and techniques. At others, his style and technique were considered simply bad and his subjects meaningless. Homer's tremendously varied output received vastly different responses. While many qualities or individual works were highly acclaimed, the artist never fully met the critics' high expectations.

"What shall we say about Winslow Homer?" queried Clarence Cook of the *Tribune* in an 1870 review.[24] While Cook's question suggests that Homer's work left the critics speechless, it had, in fact, the opposite effect, forcing the art press to find a new critical vocabulary that matched the variety of changes in his art and American art at large. The vocabulary that critics used to discuss his art mirrored the rhetoric that was employed to articulate American national identity as the country searched for stability. For better and for worse, Homer's art was repeatedly called original, individual, free, honest, truthful, strong, vigorous, pure, natural, unconventional, masculine, crude, and uncouth.

Homer's relationship with the press corps was symbiotic. At different times, his work seems to have helped the critics come to terms with certain issues; at others, he clearly adjusted his brush to accommodate critical commentary. While certain perceptions prevailed about Homer's painting—it was distinctive, native in subject, looked unfinished, and was deficient in color—reactions to individual elements varied tremendously depending on the media and subject to which it was applied. Viewing Homer's creative output through the lens of contemporaneous criticism highlights his pivotal role in shaping a national art that the majority of critics required to be morally sound, intellectually or emotionally compelling, and aesthetically pleasing. At once America's art hero and renegade, Homer struggled with and against the critics at a defining moment in the development of American art.

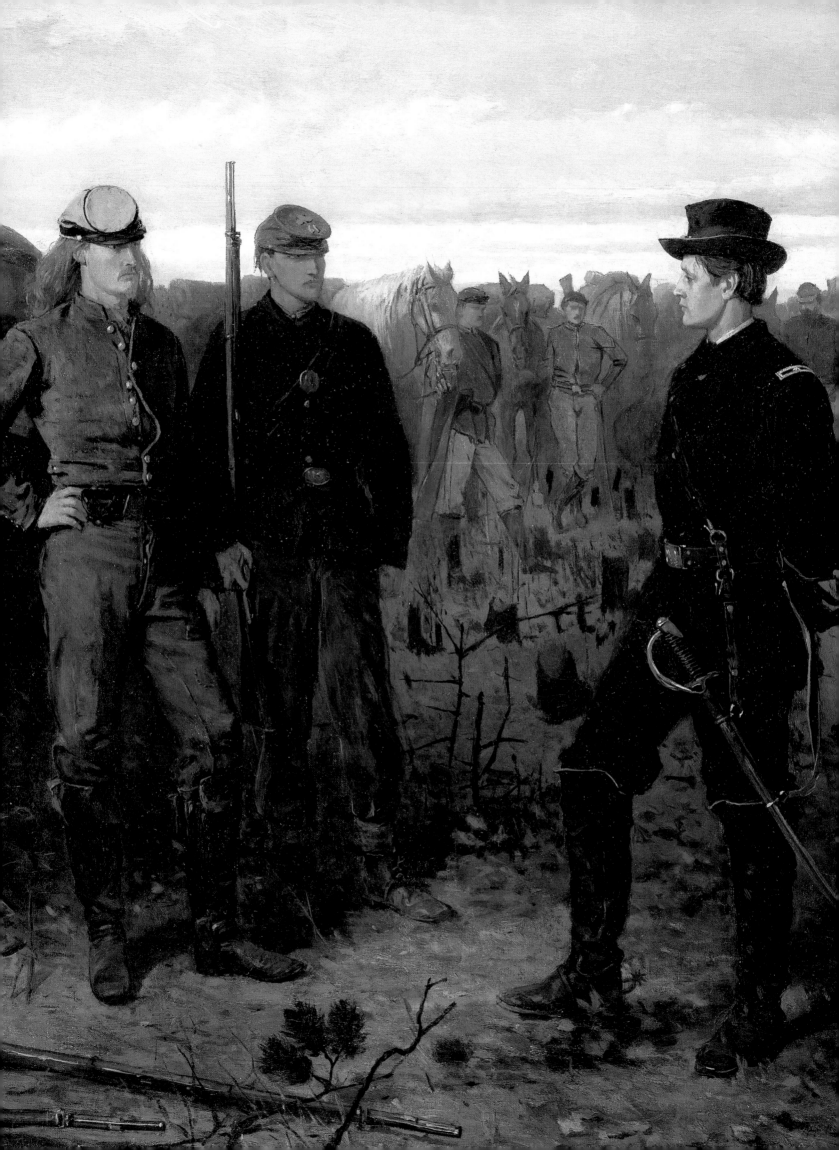

CHAPTER 1

1868–69

"Mr. Winslow Homer . . . Is at Home Once More"

WINSLOW HOMER REENTERED THE NEW YORK ART WORLD IN 1868, AFTER A YEAR IN EUROPE, NOT WITH NEW PAINTINGS, but with the exhibition of *Prisoners from the Front* (fig. 1), the canvas that had single-handedly catapulted him to fame in 1866.[1] The picture reappeared in January 1868 at the National Academy of Design in a show of the American paintings that had just returned from the Paris Exposition Universelle. In Paris, the American entries were condemned for lacking native qualities or for being insufficiently cosmopolitan.[2] At a time when America excelled in a number of fields on the international scene, it was perceived as lagging far behind in cultural matters.[3] From this position, some American critics used the return of the paintings from Paris as an occasion to reassess how American art fared in relation to its European counterparts.

From its first showing in 1866, *Prisoners from the Front* was hailed as unsurpassed both as a figure painting and as an example of the high hopes held for American art.[4] Every critic who noticed *Prisoners from the Front* in 1866 indicated that the key to its success was Homer's ability to render the figures simultaneously as individuals and as representatives of northern and southern characteristics. It was understood that the faces were drawn from life, but also that the men Homer chose to portray were exemplary emblematic types. George William Curtis of *Harper's New Monthly Magazine* pointed out, as did many others, that the Union officer portrayed was Francis Channing Barlow, commander of the Sixty-first New York Infantry. He also detailed for his readers the recognizable social classifications of each man:

> The central figure of the group is a young South Carolinian of gentle breeding and graceful aspect, whose fair hair flows backward in a heavy sweep, and who stands, in his rusty gray uniform, erect and defiant, without insolence, a truly chivalric and manly figure. Next to him, on the right, is an old man, and beyond him the very antipodal figure of the youth in front–a "corncracker"–rough, uncouth, shambling, the type of those who have been true victims of the war and of the slavery that led to it. At the left of the young Carolinian is a Union soldier–one of the Yankees, whose face shows why the Yankees won, it is so cool and clear and steady. Opposite this group stands the officer with sheathed sword. His composed, lithe, and alert figure, and a certain grave and cheerful confidence of face, with an air of reserved and tranquil power, are contrasted with the subdued eagerness of the foremost prisoner. The men are both young; they both understand each other.[5]

With these kinds of descriptions, the political and social discourse of the day was unfurled on canvas. Thus, the painting was accepted as not strictly recording an actual incident during the Civil War but, as Eugene Benson

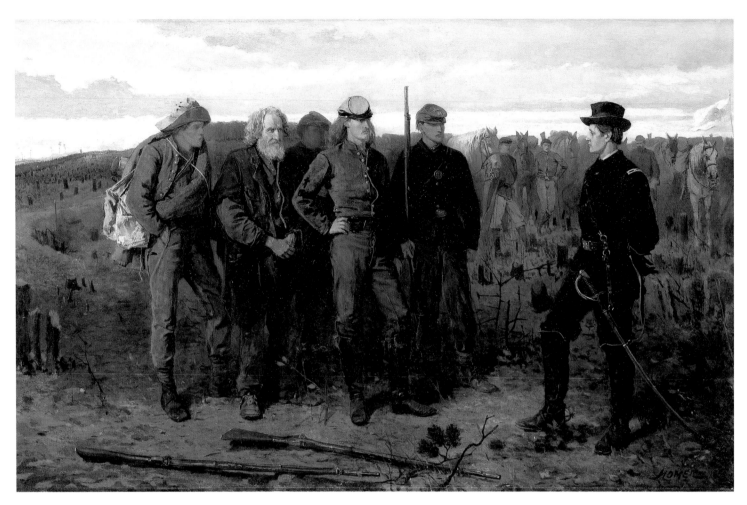

Fig. 1. *Prisoners from the Front*, 1866. Oil on canvas, 24 x 38 in. (61 x 96.5 cm). The Metropolitan Museum of Art, New York.

Gift of Mrs. Frank B. Porter, 1922 (22.207)

noted, "[the most] comprehensive art work that has been painted to express some of the most vital facts of our war."[6] By combining elements drawn from actual observations within a larger creative construction, Homer articulated the factual and symbolic representation of the war in a way no other American painting had heretofore accomplished.[7] For that reason Benson applauded the painting as "a genuine example of true historical art" even with a subject so contemporary.[8]

Homer was also praised for the artistic treatment of *Prisoners from the Front*, which was perceived as contributing significantly to the image's truthfulness in both its literal and symbolic aspects. Plain and clear drawing was often mentioned as the primary vehicle through which the frank and accurate portrayal of the subject was accomplished.[9] His painting technique, as well, was recognized as appropriate for the subject matter, even if it appeared to some critics as somewhat rough in execution.[10] Critics most often pointed to Homer's use of color in *Prisoners from the Front* as his primary artistic offense. It was derided for its opacity, or, as the writer for the *Albion* called it, "leadenness of tone."[11] However, such shortcomings did not detract from the overall triumph of the picture.

Prisoners from the Front was again recognized as a first-rate canvas when it was shown in Paris in 1867.[12] When it returned to America in 1868 and was shown at the National Academy of Design, the painting was especially praised for its American qualities and was held up as proof that American art was not imitative of Europe's.[13] Indeed, the *Mail* pointed out that the subject was "entirely characteristic of our national life" and that

its Americanness was further validated by French reactions to the painting. It noted that in contrast to most of the other American pictures shown at the Exposition Universelle, the French critics had given *Prisoners from the Front* high marks for its national qualities–again defined by subject matter–and for the bright future it suggested for American art.[14] Similarly, the *Post* stated that the selection of work, including *Prisoners from the Front*, Frederic Church's *Niagara* (Corcoran Gallery of Art; Washington, D.C.), and Eastman Johnson's *Negro Life at the South* (The New-York Historical Society), soundly rebuffed the frequent criticism that American art mirrored that of Europe, noting that the elements similar to all three canvases were those that made American art uniquely American: a measure of originality, the absence of outside influence, and a visible connection through subject to America and its people.[15] Thus, with *Prisoners from the Front*, Homer was identified as one of America's most promising artists; and, as the definition of American art and how it was manifested in Homer's work was keenly debated over the next decade, it became the canvas against which all of his work of the 1870s was measured. From this moment, critics had extremely high expectations for the artist's future work. These expectations, however, were difficult, if not impossible, for Homer to meet because of the critics' continued inferiority complex about the nation's cultural status.

At the National Academy of Design's annual exhibition in the spring of 1868, Homer presented two new works resulting from his European sojourn–*Picardie, France* (most likely the painting now known as *Cernay la Ville–French Farm*; fig. 2)[16] and *The Studio* (fig. 3).[17] They elicited strong responses from the three critics who commented on these modest-sized canvases. As Clarence Cook of the *Tribune* noted, it was "impossible to be indifferent" to Homer's work.[18] Critics tended to be passionate about Homer's art, and their reactions throughout the 1870s were rarely ambivalent.

"Good Pictures May Be Expected"

———— • ————

The reviewers of the 1868 Academy exhibition considered the exhibited works in relation to the most pressing artistic issues of the day: evaluating the present state of American art; assessing, to a lesser extent, the position of the National Academy as the corporate body in charge of mediating that state; and debating what elements contributed to creating a national art. Closely linked to these issues were the comparison of younger artists to older ones and the examination of the relationship of American to European art–both qualitatively and with regard to influence.[19] This year the show was considered generally improved over the previous year, although the praise was often tempered. Clarence Cook found the exhibition better simply because he saw fewer terrible pictures than usual, while other critics were heartened by a higher quality of genre and figure pictures.[20] Some writers praised the show for the strong appearance by younger artists and a greater variety of subject matter.[21] This interest in the younger artists was, in part, a function of the widespread concern that American art was stale and stagnant, and the *Nation* most harshly condemned the 1868 exhibition for this reason. It criticized the top-ranking artists for not sending their best work, indicating this was both a symptom and a cause for the potential failure of the Academy.[22] *Putnam's* took a more philosophical stance, stating that the show reflected the present, immature state of American art and culture.[23] In their assessments of American art and of individual artists, critics frequently mentioned youthfulness and a lack of maturity, and almost every review of the Academy exhibitions from the end of the Civil War through the 1870s touched on how the younger artists were faring.

A division between the older and younger artistic generations, which would become prominent in the mid-1870s, was already apparent by 1868. In fact, Clarence Cook remarked in an 1868 review that "the Exhibitions of the last five years have given evidence that the Fine Arts in this country are in a state of revolution" and that the preeminent names of the previous decade, including Thomas Rossiter, Thomas Hicks, Asher B. Durand, David

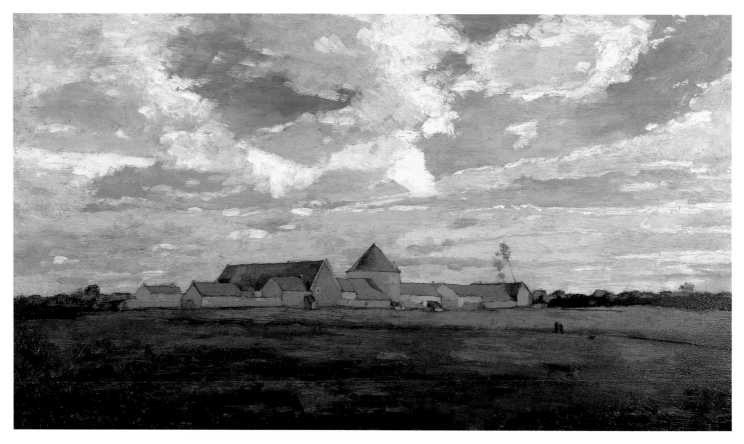

Fig. 2. *Cernay la Ville–French Farm*, 1867. Oil on panel, 10 %₆ x 18 %₆ in. (26.8 x 45.9 cm).
Krannert Art Museum, University of Illinois, Urbana-Champaign. Trees Collection

Huntington, and John Kensett, were no longer at the forefront of discussions on art. Cook admitted that he could not name the precise reason for this shift, but he felt it was connected to the greater presence of European art, art in which he found true artistic skill.[24] On a separate occasion, the writer for the *World*, also noticing differences between the rising generation of figure painters and their older colleagues, questioned whether the divide may have been caused by the younger artists' involvement with the Civil War, just as they were coming of age.[25] Furthermore, as Carol Troyen has suggested, the wedge between artistic generations may have been driven deeper by the response to the 1867 Paris Exposition Universelle. The perceived inferiority of the American section may have encouraged younger artists to pursue alternate types of training and artistic influences, particularly French.[26] Whatever the reasons, by 1868 the hope for American art was seen to lie in artists at the outset of their careers.[27]

All three commentators who mentioned Homer in their reviews of the 1868 Academy exhibition made some reference to his position as an artist of promise. This pronouncement was one of the most consistently repeated observations about him through the first half of the seventies. Typical were the words of the *Nation*, which ended its review, noting: "Mr. Winslow Homer, one of the strongest of American figure painters . . . is much needed here. His slight contributions to this exhibition remind us that he is at home once more, and that good pictures may be expected from him."[28] Even as he was being lauded, Homer was repeatedly plagued throughout the 1870s by critics who used his current paintings as a vehicle to ponder his past and future efforts and also used *Prisoners from the Front* as a barometer of his success.[29]

Painting nature truthfully was at issue for Clarence Cook in Homer's landscape of Picardie. The *Tribune* critic lamented: "Homer's *Picardie, France*, is naught, is naught. Nature is loyal to herself in Picardie as well as in

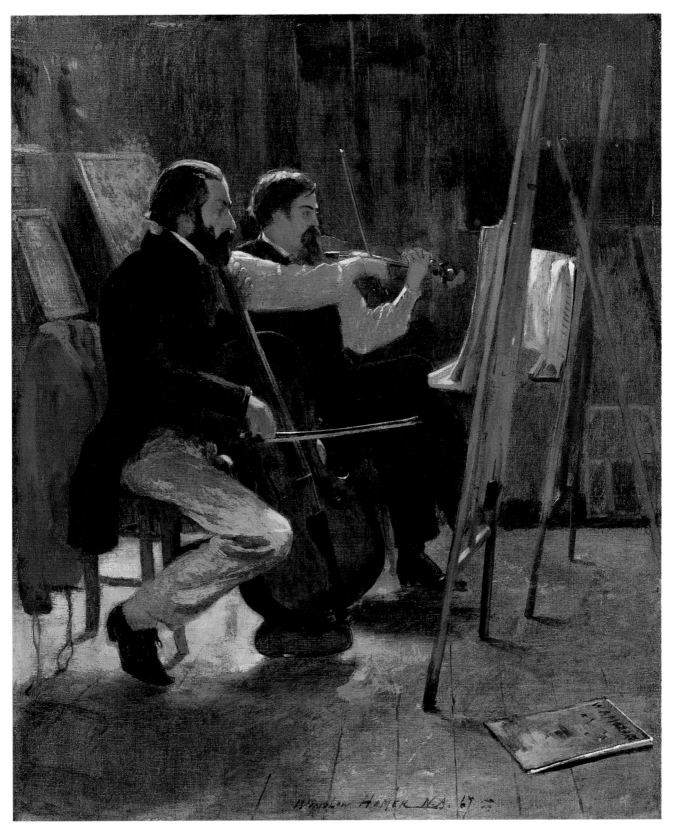

Fig. 3. *The Studio*, 1867. Oil on canvas, 18 x 15 in. (45.7 x 38.1 cm). The Metropolitan Museum of Art, New York.

Samuel D. Lee Fund, 1939 (39.14)

Fig. 4. *The Briarwood Pipe*, 1864. Oil on canvas,
16 ⅞ x 14 ¾ in. (42.8 x 37.5 cm). The Cleveland Museum of Art.
Mr. and Mrs. William H. Marlatt Fund, 1944.524

Fig. 5. Seymour Joseph Guy (American, 1824–
1910), *Evening*, 1867. Oil on panel, 14 ½ x 12 ½ in.
(36.8 x 31.8 cm). Worcester Art Museum,
Massachusetts. Stoddard Acquisition Fund, 1985.302

New Jersey, Mr. Homer, and she couldn't make a landscape like this even if she were to try."[30] The flat areas of color defining the farm buildings and the broadly painted expanse of landscape in *Cernay la Ville* would have appeared nondescript and false, as did *Picardie*. Cook's objections were grounded in his difficulty finding a precise identification of the particular locale and in a perceived dishonesty of artistic treatment. Cook repeatedly criticized American artists who imitated other artists, especially foreign, rather than depending on their own response to nature.[31] Here he seems to have found Homer guilty not only of not following nature's lead but also of looking elsewhere for his artistic example. Accusations were leveled throughout the 1870s that Homer relied on foreign models for his work, and in *Cernay la Ville*, as in much of Homer's output during the decade, those models were French.[32]

If Cook framed his complaint of *Picardie* in terms of truth and foreign influence, Theodore Grannis of the *Commercial Advertiser* condemned the painting on technical grounds, arguing "in it there is some fine color, but with not enough elaboration to even give an idea of what the artist was trying to do."[33] The condemnation of Homer's work as unfinished, which first occurred with *The Briarwood Pipe* of 1864 (fig. 4), was perhaps the most constant complaint about his art through the 1870s.[34] Such criticism was indicated by a variety of words, including "slight," "unfinished," "sketchy," and "incomplete," among others. This vocabulary was employed to cover a wide variety of stylistic methods all connected to the perception, similar to that of Grannis's, that Homer stopped short in the exposition of his images. As the controversy over appropriate finish played out from the mid-1860s on, Homer's paintings were among those at the center of it.

Although only Clarence Cook mentioned it in passing, Homer fared better with *The Studio* (fig. 3). The *Tribune* critic suggested it was the best figure picture in the show, along with Seymour Joseph Guy's *Evening* (fig. 5). Cook recognized that the subject of Guy's painting would be the more appealing of the two canvases. Its image of

an art-filled parlor with a woman reading a newspaper, her sewing at hand, suggests the genteel life of the educated classes. *Evening* also paid homage to the beloved American hearth and home, thus fulfilling the expectation that images from daily life teach a lesson or support national ideals.[35] Homer's musicians, playing in an artist's studio, gave a glimpse of a more bohemian existence most closely associated with the French avant-garde world of artists such as Edgar Degas, but Cook had to admit "in essentially artistic qualities probably Mr. Homer bears the palm."[36] The diagonal view into the compressed picture space; backlighting that glances off variously textured surfaces; and the warm tonal palette were likely some of the elements Cook found intriguing. For the moment, however, subject matter was the main criterion for a picture's success. Artistic qualities would soon become increasingly important.

For Homer, life in 1869 continued much as it had in 1868. Illustration commanded a considerable portion of his time as it provided much needed income.[37] Nonetheless, his output in oil increased substantially; he painted nineteen canvases in 1869 compared to just four known paintings of the previous year. Many of the 1869 canvases are related and were developed from Homer's summer travels to New Hampshire; Manchester, Massachusetts; Long Branch, New Jersey; and Lake George, New York, in 1868 and 1869.[38] These out-of-town experiences—all rural or suburban in location—provided the basis for his most recent work.

Homer's level of exhibiting in 1869 remained on par with that of the previous year. He placed works in some of the monthly exhibitions at the Century Club, but as private venues, they received little publicity.[39] Not surprisingly, Homer received his greatest critical attention at the annual exhibition of the National Academy of Design. He exhibited a work entitled *Manchester Coast*, which was likely painted during his summer visit to Massachusetts in 1868. The canvas, which the *World* described as "a coast scene, with gulls lighting down upon a lonely beach," is probably the one known today as *Rocky Coast and Gulls* (fig. 6).[40]

Although the critics felt the 1869 exhibition showed a general improvement over the previous year, they also collectively remarked on the merely average merit of the pictures.[41] The contributions of the younger artists again garnered the more positive comments.[42] The generally tepid response to the works in the exhibition was accompanied by a more passionate concern for the corporate body that organized the show. It turns out that the Academy structure was under attack from the inside as well as from the critics, and by June, three reforms were enacted to improve the quality of the exhibitions and to make the Academy less a New York City club and more a national organization. The reforms were: first, a limit of two successive terms for the office of the president; second, all American artists were eligible for membership (previously non–New York residents could exhibit, but not become members); and third, the hanging committee was reduced in number from thirteen members to only three.[43]

The absence of entries by a number of the most revered older artists—notably Frederic Church, Albert Bierstadt, and Jasper Cropsey—also may explain the lukewarm response by the critics to the 1869 show.[44] The lack of monumental canvases by the old guard forced the press to look elsewhere for their commentary. Half of the critics reviewing the show wrote about Homer's *Manchester Coast*. The critic for the *Nation* hailed the painting as "the most important [landscape] in the galleries . . . full of interest and of excellent qualities, and repays careful examination." Yet, this sole instance of praise came with no concrete justification. Instead, the writer used his brief remarks to point out what he perceived as faulty relationships among the color, light, and shadows in the painting. He particularly noted that, even though the scene depicted was a gray, cloudy day, shadows were cast across the image, suggesting sunlight.[45] The writer does not seem to have understood that while Homer's scene depicted

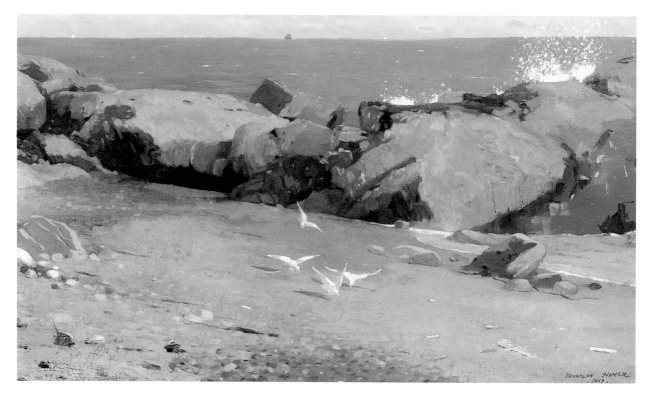

Fig. 6. *Rocky Coast and Gulls*, 1869. Oil on canvas, 16 ¼ x 28 ⅛ in. (41.3 x 71.4 cm).

Museum of Fine Arts, Boston. Bequest of Grenville H. Norcross, 37.486

an overcast sky, it pictured a moment at midday with the sun filtering straight down through the clouds to cast the strong shadows we see playing across the beach, rocks, and water.

The critics who condemned the painting did so because it looked unfinished. The conservative critic of the *Times* found the painting "not an agreeable picture. It has an unfinished appearance in color and details of drawing that vexes the eye." Instead, the writer preferred the carefully painted details and "picturesque and animated" general effect of Samuel Colman's *The Narrows and Fort Lafayette, New York Harbor* (fig. 7) and the "certain tone of refinement and repose" of Asher B. Durand's color, which contrasted markedly with the younger generation's "brilliant and startling effects."[46] The *Herald* articulated its discontent with the unfinished quality of *Manchester Coast* by calling it "strong, but blotchy, as it must be by the system on which it is painted–a system which runs into superficial rendering." This writer also preferred detailed drawing combined with a cohesive composition founded on linear perspective.[47] What primarily differentiated Homer in *Manchester Coast* from artists like Colman and Durand was his defining the view in terms other than drawing and traditional perspective as well as a bold palette. The methods objected to by the *Herald* were likely those of French artists, especially Claude Monet (*Pointe de la Hève at Low Tide*; fig. 8), the first examples of whose seacoast scenes could be seen in New York in 1866.[48] Like Monet, Homer painted very directly, stacking areas of broadly applied color, alternating light and dark, to create form and space. Additionally, Homer, as did Monet, carefully placed small daubs of paint, often white or bright contrasting colors, as his last brush strokes. These final touches, seen in *Manchester Coast* as spray in the upper right, as bits of detritus on the beach at the lower left, and as facets of the rocks at the lower right, equally enliven the subject and the canvas surface. However, the materiality and physical force of Homer's paint appeared messy and raw when compared to the smooth surfaces of the work of his American peers including Colman.

Homer's style of painting hit a particularly raw nerve with Theodore Grannis, who participated in the exhibition not only as a reviewer for the *Commercial Advertiser* but also as an exhibiting artist.[49] Grannis had been criti-

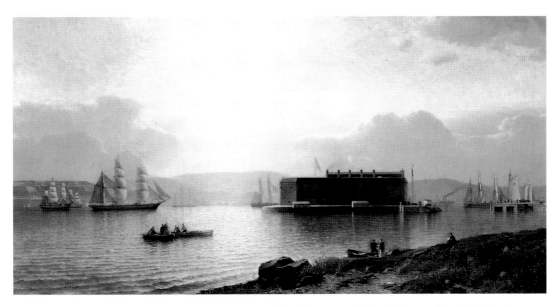

Fig. 7. Samuel Colman (American, 1832–1920), *The Narrows and Fort Lafayette, New York Harbor,*
c. 1868. Oil on linen, 30 x 60 in. (76.2 x 152.4 cm). Collection of The New-York Historical Society, 1976.2

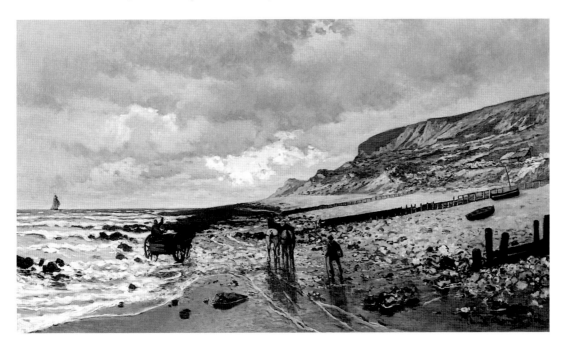

Fig. 8. Claude Monet (French, 1840–1926), *Pointe de la Hève at Low Tide,* 1865. Oil on canvas,
35 ½ x 59 ¼ in. (90.2 x 150.5 cm). Kimbell Art Museum, Fort Worth, Texas

cal of Homer's lack of finish in 1868, tolerating it as a momentary lapse. Seeing it manifested again, and perhaps in his mind to a greater degree this year, Grannis was incensed and, accordingly, added sarcasm to his remarks:

> *We cannot refrain from calling attention to the lamentable example . . . painted by Winslow*
> *Homer, and entitled "Manchester Coast." Mr. Homer has at times produced works of great merit,*
> *but of late, the inspiration which formerly guided his pencil, appears to have left him. . . . In the*
> *present work, the most noticeable points [sic] appears to be the dashing of the ocean's spray*
> *above the rocks, but as indicated by Mr. Homer, it resembles the work of a boy who has dashed*
> *a "spitball" upon a newly papered wall.*[50]

Grannis, too, attached great importance to careful and detailed delineation, preferring works that indicated "judicious labor."[51] Homer's thick, staccato strokes of white paint indicating the spray could not have been farther removed from Grannis's standards for good painting. In addition, Grannis's snide remarks about Homer's carelessness were double-edged. They suggested that it not only caused *Manchester Coast* to be poorly executed, but also, because it lacked Homer's previous good qualities, it indicated a perversion of his art. Such criticism of Homer himself through the critique of his paintings would not be uncommon over the next decade.

Clarence Cook's attack on Homer in the *Tribune* was especially personal. Cook argued that *Manchester Coast* was not only a disappointment, but it was also one "which the artist had no right to inflict upon that portion of the public that takes a strong interest in him."[52] If Grannis was disappointed by *Manchester Coast* because it did not measure up to Homer's previous productions, Cook was insulted by the painting because he felt Homer could do much better. Although Cook had to admit he saw good work in the canvas, he complained:

> *Not but what there is of it, is good, only, there is nothing of it but the mere first intention. . . . If this be the coast of Massachusetts' Manchester, we know it intimately enough to know that it is much better worth painting than Mr. Homer would seem to allow it. But, the truth is, this sketch may be of any rocky sea-coast. . . . It is not a daub, because such lines as these are put on with deliberate intention, but, it is a sketch too slight to offer the public, a mere memorandum for the artists' portfolio. If Mr. Homer has adopted the notion that he can put down . . . all that is worth recording, in a half-dozen strokes of his brush, he makes a blunder.*[53]

The painting's non-specificity clearly raised Cook's hackles. *Manchester Coast*'s high viewpoint and cropped edges, which removed any known landmarks from the scene, may have been a particular source of annoyance. Cook's notice of James Hope's *Gem of the Forest* (location unknown) in this same show hints at what he sought in landscape painting. The critic had warm praise for Hope's detail and careful painting, yet he faulted the canvas as solely "a map of a place–too matter-of-fact to be true, for, in art, only what is poetical, is counted true."[54] Here Cook gave a brief synopsis of the two competing camps of artistic thought in the 1860s. One was grounded in a definition of truth-to-nature as mimetic and founded in material fact, while the other allowed for the subjective interpretation of the landscape.[55] Cook, who was squarely positioned on the side of literal truth in the early 1860s, now was seeking a better balance between factual description and the poetic expression of a locale. In this regard, the selection of the view was an important factor. It not only supported the identification of a location but also enabled the representation of a deeper understanding of the landscape beyond the facts of its topography. According to Cook, Homer, with his broad painting method and reductive depiction of the Manchester, Massachusetts, coastline, denied both. Constructed in this way, Homer's canvas simply appeared confounding in the context of this exhibition.

Perhaps most infuriating to the *Tribune* critic was that both the extremity of Homer's sketchiness and his presentation of the view were not caused by carelessness or incompetence, but rather were due to Homer's intentional subordination of detail and scope of image in favor of general effect and a flattened perspective. Thus, Cook concluded his comments by noting the dilemma that Homer created for him. He really did admire the painter, but he lamented, "we cannot reconcile ourselves to having an artist of real ability–and we have very few men so able as Mr. Homer–snuff himself out with a theory in this way. We will hope that he is only suffering from an attack of whim."[56]

It is doubtful that anything in *Manchester Coast* was a result of whim for Homer's work consistently displays tremendous discipline and control. Among the many decisions Homer made with *Manchester Coast* and *Picardie, France*, was to exhibit landscapes, even though he had distinguished himself exclusively with genre subjects prior to his trip to Europe. At this juncture, however, landscape offered Homer the opportunity to put forth

Fig. 9. *Long Branch, New Jersey*, 1869. Oil on canvas, 16 x 21 ¾ in. (40.6 x 55.2 cm). Museum of Fine Arts, Boston. The Hayden Collection, 41.631

aesthetic experiments without completely alienating his viewers–both critics and, perhaps most importantly, patrons. As Homer sought to reestablish himself in New York, he understood that landscape had been the reigning subject in American art for thirty years. As the subject considered most national and the one that to this point received the lion's share of the critics' attention, exhibiting landscape placed Homer squarely within the heart of American art. Yet, in his own landscape presentations, Homer showed canvases in which he experimented with a direct painting method similar to trends in recent French painting. Homer, perhaps cautious that he not be forsaken by critics or patrons, consciously seems to have located his work within the norm even as he took his most radical excursions. Homer's paintings would time and again straddle the traditional and the new, the accepted and the radical, as he tried to come to terms with the changes taking place in art.

Key among those changes was that landscape was being challenged by figure work both in numbers and attention. At the 1869 Academy annual the *Nation* noted that landscape "disappears year by year from our exhibitions" and that "painted stories" were taking over in place of importance.[57] Reflecting this shift, genre painting received a considerable amount of commentary this year, and artists such as Eastman Johnson and Enoch Wood Perry were among those most thoroughly discussed.[58] It was these men who were Homer's closest colleagues and competitors. Homer soon rejoined them in consistently exhibiting genre subjects.

The Third Winter Exhibition at the National Academy opened during the first week of November 1869.[59] Although it was intended to bolster the art season, the winter exhibition had neither the cachet nor the broad selection of its spring sister. This year it included a selection of European works as well as many American canvases that had already been shown. It did not, therefore, garner the same kind of attention that the spring show did, and it was considered a lamentable failure by those writers assigned to review it.[60] The newly exhibited works tended to get the most notice, among which was Homer's *Low Tide* (destroyed; fig. 10).

Low Tide made a significant impression, provoking strong–mostly negative–reviews. The adverse reactions of the critics may have caused Homer not only to withdraw that canvas prior to the end of the exhibition's long run, but they also may have inspired him to finally destroy the painting.[61] The critics focused on *Low Tide* so completely that they ignored Homer's other entry *Long Branch*, which, although there are no descriptions, may have been *Long Branch, New Jersey* (fig. 9).[62]

In the *World*, *Low Tide* was cited with William M. Davis's *Woods in March* (location unknown) and N. A. Moore's *Lake George* (location unknown) as "unworthy of any collection of works of art, even that which is sometimes made by the second hand furniture dealer, and we feel sure these will attract the attention of everybody."[63] The writer for the *Mail*, likely D. O'C. Townley, weighed in with the following:

> We would pass this by without a word of comment were it not evidently a picture which by its size and show of color challenges criticism, even as the impress of an unclean hand upon a newly painted wall does. How an artist of acknowledged worth in a certain field of art, could permit this horror to leave his studio is simply incomprehensible to us. Here we have three grand horizontal layers of color–like rock strata. The upper is of brownish gray and dirty white with a suggestion of vermilion now and then–like the marble of Brachificari. This is the sky. The next lower layer is of dark greenish blue, like some coal layers we have seen. On this there are dashes of flake white here and there which remind us of the story of how the artist succeeded in getting the foam on the mouth of a mad dog he was painting–by throwing his dirty sponge in indignation at the canvas. This second layer is the sea. The third is a belt of brown of many shades, and this is the beach; and to do it justice it looks like a beach, but it is the only division of the picture which taken apart has any evidence of design in it. The rest suggests unhappy accident on canvas only.[64]

The use of vertically stacked, canvas-wide bands of color as the foundation for the compositional structure condensed the perspectival space in *Low Tide*, and the picture plane was flattened considerably. This design strategy of asserting the two-dimensionality of the canvas, one that Homer used repeatedly throughout the seventies, was radical for American painting in 1869 as was the asymmetrical composition, with its heavily populated left side rendering the right half empty by comparison. In fact, James Whistler, whose work was yet little known in America, was the only other American painter pushing similar design concepts to such an extreme degree. Compared to landscape canvases constructed with traditional linear perspective, Homer's composition again appeared significantly different.

The *Mail* printed further criticism of *Low Tide*'s spatial relationships:

> On the wet sand, and on the dry sand, and further out toward those mysterious white places, are children bathing or about to bathe. Many of these are charmingly posed little pictures in them-

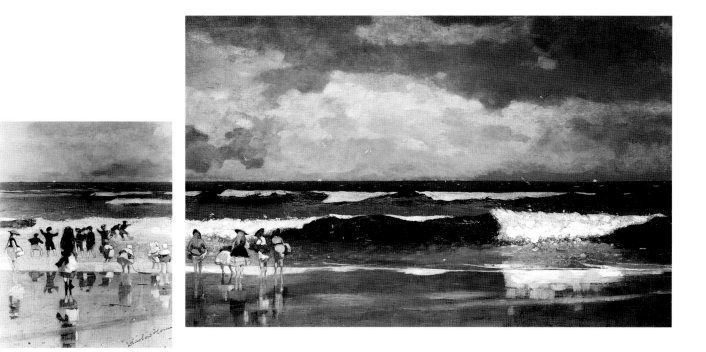

Fig. 10. Possible partial reconstruction of *Low Tide*

selves. . . . But among these figures is one to whose presence we object. . . . We don't object to her
presence because her back is towards us, but because of her height–she is seven feet tall. . . . On
the strand are children's boots and things, and these and the strata make up a picture which
covers some twelve square feet of canvas at the least.

Furthermore, the painting's palette was condemned as unnatural. The paint application was abhorred for its combination of opacity, broad brush strokes, and dabbed-on accents of color.[65]

Such biting criticism took its toll on Homer and *Low Tide*. By the early 1870s Homer had cut up the canvas; *Beach Scene* (fig. 11) and *On the Beach* (fig. 12) are all that remain of it.[66] As Nicolai Cikovsky has pointed out, Homer may have divided the canvas to preserve the "charmingly posed little pictures."[67] The reapportionment of the image broke the long horizontal expanse of the original composition and minimized the objectionable flattened perspective.

What the *Mail*'s critic found most unconscionable–Homer's lack of conventionality in compositional structure–the writers for the *Post* and *Express* offered as the reason for the work's success despite its many problems. The *Post* announced: "We like this picture because it indicates power beyond that of such an odd and imperfect conception."[68] The *Express* critic gave the painting the longest notice of any single work he mentioned. He began: "Perhaps one of the most original pictures in the collection is No. 106, 'Low Tide,' by Winslow Homer. Mr. Homer has here flown in the face of all the accredited rules of art; his color is cold and crude and his drawing is bad. . . . Yet, with all this there is an irresistible something in the whole that rivets the beholder." This writer agreed with the *Mail*'s critic that, particularly in color and drawing, *Low Tide* failed in a certain regard. But he explained that its failure was in relation to traditional notions about painting. The *Express* continued:

The great secrets of the work are its force and its originality. The water is expressed by almost
black and white; a murky, copperish tinge runs through the sky; the figures in the middle distance

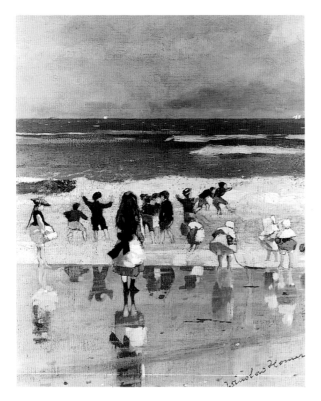

Fig. 11. *Beach Scene (Children in the Surf)*, c. 1869.
Oil on canvas, 11 ½ x 9 ½ in. (29.3 x 24 cm).
Thyssen-Bornemisza Collection

are merely spots of high light, while the sandy beach is one broad mass of color. The whole picture, in fact, is painted in the broadest manner imaginable, and herein, and in its total disregard of all conventionality, lies the secret of its success. It is not a great, nor can it justly be termed a good picture, but it possesses, withal, such a vast amount of strength, of manly vigor, and of originality, that by those it commands attention, and wins for itself a notoriety altogether remarkable.[69]

Homer's choice of rich tones, painted in large swatches or patterned light against dark, ran completely counter to the prevailing practice of grading tones incrementally. For the critics of the *Post* and *Express, Low Tide*'s unconventional design, color, and paint application indicated originality, forcefulness, and dynamic energy. These qualities took the picture to a level of achievement that offset nearly all its conventional technical faults.

Although Clarence Cook had objections to *Low Tide*, especially its handling of perspective, he also praised some aspects of the canvas. In it, Cook found "the merit of sincerity," which came from "an evident honesty of intention—a purpose to paint just what the eye saw, neither more, neither less," and this saved the painting.[70] Cook's vague language leaves us with no specific clues about what in *Low Tide* appeared sincere and honest. However, given his earlier responses to *Picardie, France*, and *Manchester Coast*, we can presume that he thought *Low Tide* revealed an unadulterated response to nature itself with no taint of the outside influence he found so distasteful in the former canvases. In contrast to how harshly Cook had condemned Homer's other efforts, his praise here suggests how important truth in art and individual honesty were to him. Honesty, too, was a quality with which Homer was increasingly associated, and ultimately, originality and honesty were two primary traits inextricably linked to the identity of America's national character. Their identification in Homer's work automatically attached to it an Americanness that was at the core of the definition of the nation's art. Therefore, their appearance in paintings could exact positive responses despite harsh reactions to other shortcomings.

The exhibition of *Low Tide* and *Long Branch* marked Homer's return to the public showing of contemporary American genre subjects. It also reinserted him into the discussions surrounding originality in which he had figured prominently with his Civil War paintings, discussions that would continue through his entire career. The critical commentaries of *Low Tide* and the other paintings Homer exhibited in 1868 and 1869 exemplify the patterns and types of reactions his work would elicit. They also suggest the greatly varied responses that particular qualities in his work prompted and underscore the wide spectrum of viewpoints found among those remarking on art. Mixed reviews would become a hallmark of the commentary on Homer's art of the seventies. He would

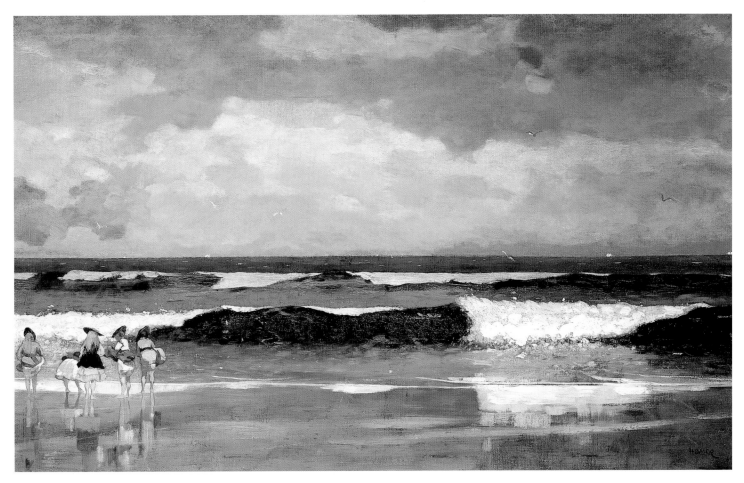

Fig. 12. *On the Beach (On the Beach, Long Branch, New Jersey)*, c. 1869. Oil on canvas, 16 x 22 ½ in. (40.6 x 57.2 cm).
Canajoharie Library and Art Gallery, New York

receive more harsh criticism, but when he was successful and the critics understood what he was trying to achieve, he received some of the heartiest praise of any artist during the period. In these first two years after his return from Europe, Homer, himself, seems to have been testing his place in American art. In 1870, he aggressively set out to claim it.

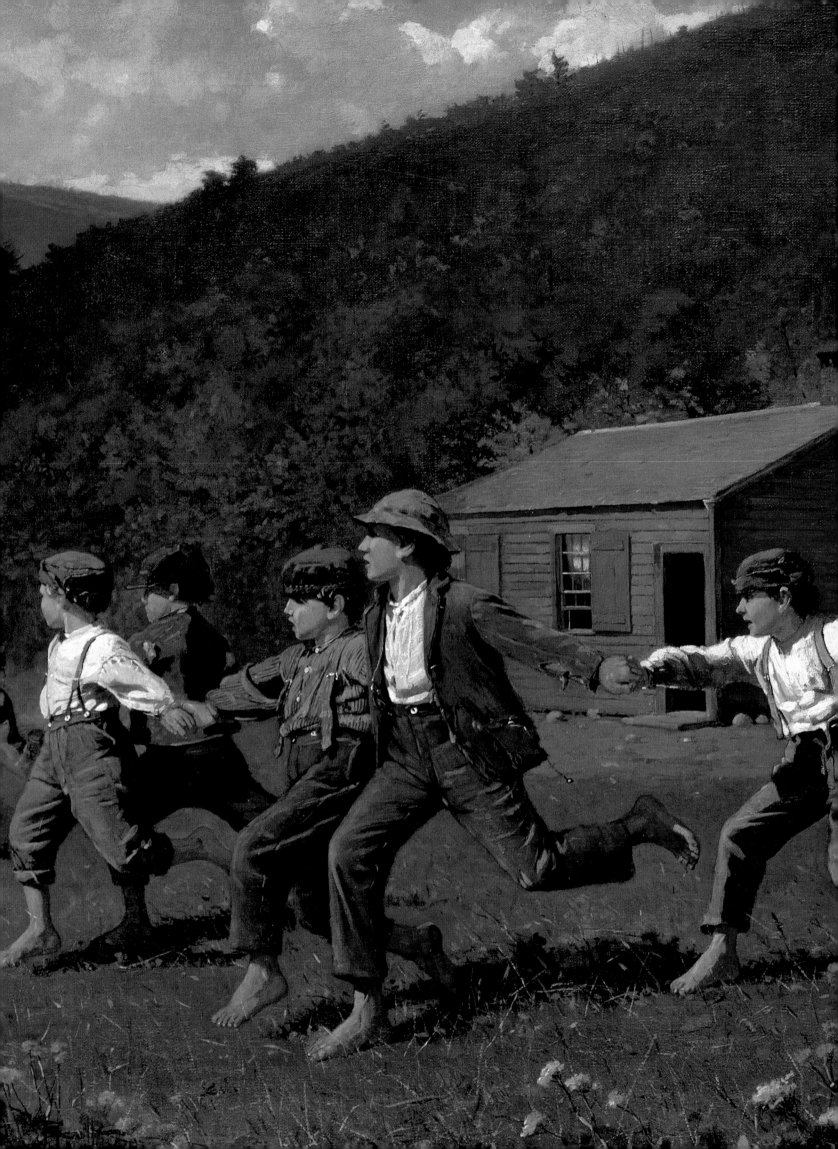

CHAPTER 2

1870–72

Commanding Respect and Challenging Admiration

AFTER TAKING TWO YEARS TO REESTABLISH HIMSELF IN NEW YORK, HOMER BEGAN 1870 COMMITTED TO PURSUING A career as a painter.[1] Over the next four years, he experimented with subject matter and artistic treatment with a vigor previously unknown in his work. Although he was painting in what appears to be a steady stream, he developed patterns of working and exhibiting that made his canvases available to the public in waves. Homer's working mode included the creation of groups of related works, in which he investigated specific artistic problems. The more investigative excursions appeared in tandem with paintings where his solutions to the problems were capitalized on and often synthesized. As he wrestled with his art, Homer would alternately send a flood tide of work into the public arena and then retreat. The peaks and valleys of his exhibiting pattern reveal periods of intense artmaking alternated with periods of reflection.

When Homer's art is aligned with the commentary it received, a symbiotic relationship between his working process and the press seems evident. As both he and his critics grappled with the changes occurring in painting and in his own work in particular, Homer received both high praise and harsh criticism. Not surprisingly, he received the highest praise when his work reflected his absorption of the critics' reactions to prior work. The strongest criticism was directed at paintings that were explorations of a problem not yet entirely resolved or were resolutions that went counter to prevailing taste. During the early seventies, Homer pushed at the boundaries of American art. Criticism of his paintings reveals where his imagery and methods challenged as well as respected them.

The results of Homer's surge of painting between the 1869 and 1870 National Academy annual exhibitions appeared in the 1870 show, where he exhibited eleven canvases: *The White Mountains* (now known as *The Bridle Path, White Mountains*; fig. 15); *Eagle Head, Manchester, Massachusetts* (fig. 16); *Lobster Cove* (fig. 19); *White Mountain Wagon* (fig. 20); *Sawkill River, Pennsylvania* (private collection); *Manners and Customs at the Seaside*; *Sketch from Nature*; *Mount Adams*; *Sail Boat*; *Salem Harbor*; and *As You Like It*.[2] These works constituted the single largest group of oils Homer would ever exhibit at the Academy. Even though eight of the works fell into the category of "sketches and studies," it was still a prodigious output. Both the exhibition and Homer were heavily noticed in the newspapers.[3]

Responses to the 1870 annual were mainly positive. While a few writers simply gave the show an unqualified stamp of approval, the majority framed their laudatory comments around notices of progress.[4] The focus on progress, although an ongoing passion, may have been especially on the critics' minds this year following the publication of James Jackson Jarves's *Art Thoughts* at the end of 1869. In his chapter "Art in America," Jarves continued his decade-and-a-half condemnation of American art; but with it, he also meted out a considerable measure

Fig. 13. Albert Bierstadt (American, 1830–1902), *Sierra Nevada Morning*, 1870. Oil on canvas, 56 x 84 in. (142.2 x 213.4 cm). From the collection of Gilcrease Museum, Tulsa, Oklahoma

Fig. 14. Frederic E. Church (American, 1826–1900), *The After Glow*, 1867. Oil on canvas, 31 ¼ x 48 ¾ in. (79.4 x 123.8 cm). New York State Office of Parks, Recreation and Historic Preservation, Olana State Historic Site, Taconic Region

Fig. 15. *The Bridle Path, White Mountains (The White Mountains)*, 1868. Oil on canvas, 24 ⅛ x 38 in. (61.3 x 96.5 cm).
Sterling and Francine Clark Art Institute, Williamstown, Massachusetts, 1955.2

of praise for and proof of its visible and implied promise. While Jarves felt that the American art sent to the Paris 1867 exposition proved "our actual mediocrity," he also noted a handful of artists who exhibited an infusion of fresh life and promise for the future. Jarves especially liked George Inness, Elihu Vedder, and John La Farge, but he also found Eastman Johnson and Homer interesting. He was most critical of the landscape painters such as Church and Bierstadt for being cold, untruthful, and soulless.[5] Agreeing with Jarves's baseline attitude towards American art, nearly half of the critics of the 1870 exhibition who cast the show in a positive light did so with qualifications. As Jarves asserted for American art on the whole, reviewers in 1870 found evidence of progress only in the canvases of individual artists, especially younger ones, and not in the exhibition overall.[6]

The 1870 show was primarily criticized for a lack of truthfulness in the exhibited works. Although it was agreed that greater study was the remedy for this problem, both the problem itself and the proper solution were articulated in multiple ways.[7] On a philosophical level, the discussion was based on the role of truth in art; its practical correlative investigated how it could best be achieved in visual presentations. While critics had touched on this issue in the context of the unfinished appearance of Homer's 1868 and 1869 offerings, it was central to their reactions in 1870.

Some critics still believed literal representation served as the best foundation for art, and in their reviews they pleaded for verisimilitude. These writers continued to cling to such statements as "the only test of Art is its

truth to Nature," penned by Clarence Cook in 1864,[8] and they fretted over the lack of thorough study of the material object being pictured. The *Telegram* expressed such a viewpoint in its criticism of the technique it found on the Academy walls: "There does not appear . . . that careful study, without which no artist can hope to do himself justice. The greatest evident fault seems to lie in a proneness to overpaint. . . . Another fault seems to be a want of distinction–or, perhaps, we should say sharpness of outline. . . . For instance, three daubs with a brush . . . will not make a figure."[9] Like-minded critics insisted that the representation of truth be grounded in material fact, and that it was only through studying, understanding, and duplicating the natural world that true understanding of the universe could be gained.[10]

The opposing point of view was most fully developed by Jarves and was rooted in the belief that art should be based on universal truths through which nature is interpreted. Jarves wrote in *Art Hints*:

> *The failures . . . of Art generally, arise chiefly from commencing at the wrong end. Instead of first studying the great principles of Nature, upon which all Art is founded, and working from them* outwardly, *artists too commonly are led by their blind impulses; and looking first to external expression, begin on the* outside *of Art, applying to it primarily the technical rules of material excellence; as it were, building their house before they knew what kind of spirit is to occupy it. This is working in the dark. The meaning of the work must first be considered.*[11]

Other critics agreed and stressed that truth was no less essential for them than for their matter-bound peers. However, they began with a set of universal truths and looked to nature for their expression.[12] In short, the two sides were divided over a material or spiritual basis for truth and art.

In 1870, the discussion about truth in art was carried on particularly in the reviews of the landscape paintings, which predominated at the Academy and were the most valued canvases.[13] Albert Bierstadt and Frederic Church, whose rivalry had shaped many of the discussions on landscape and truth in art in the 1860s, still commanded attention, but the landscape that garnered the greatest praise and from the widest range of critics was *San Giorgio* (1869–70; location unknown) by Sanford Gifford.[14] Gifford's *San Giorgio* came closest to interweaving the variety of artistic means and philosophical goals outlined by the art critics.[15] The *Post* hailed the work as "a pictorial poem founded on fact."[16] Although we do not know this painting today, it seems that in it, Gifford successfully blended careful drawing, which satisfied the need for fidelity to locale, with a pervading light and integrated color scheme to create a permeating atmosphere that resonated truthfully. The result simulated actual facts, evoked universal truths, and appealingly suggested sentiment without sensationalism. Thus, it satisfied the notion of completion for nearly every critic no matter where his opinion lay on the spectrum of defining truth in art.

Bierstadt's *Sierra Nevada Mountains* (now known as *Sierra Nevada Morning*; fig. 13) failed for the very reasons Gifford's canvas succeeded, with critics mainly faulting it as artificial.[17] For most writers, the cumulative effect of finicky minuteness and over-magnification of natural phenomena ultimately rendered the canvas both false and without poetry.[18] Church fared somewhat better than Bierstadt. His *The After Glow* (fig. 14) was unanimously praised for the truthfulness and degree of detail in his explication of nature.[19] Opinions divided, where they did not with Gifford's painting, over whether the selection and depiction of such a vivid sunset were too sensational and, therefore, melodramatic rather than poetic.[20]

In 1870, the responses to Homer's eleven works generated the most column inches for the artist since the showing of *Prisoners from the Front* in 1866.[21] There is the sense that most critics sought out Homer's entries, and this year they provoked the press to an even greater degree than in the two previous years. As a group, Homer's pictures elicited strong reactions directly related to the issues of truth and completeness.

Veracity in Homer's art was derived, as Clarence Cook explained, from his "vivid presentation of things, as they appear to the naked eye." His "direct, bold look into the face of things" convinced viewers that his primary aim was to obtain "the bare vivid reality."[22] Eugene Benson perceptively noted in *Putnam's* that Homer's ability to depict his subjects truthfully was rooted in the artist's keen and unique sense of observation.[23] These critics recognized that Homer's truthfulness depended on closely observing the material world but that it was not delineated through the detailed representation of material fact.

Even more so than with Homer's *Low Tide* of 1869, critics noted the artist's unconventional means of conveying his observations in his 1870 Academy pictures. Homer's unconventionality was tied to issues of intent, technique, and subject matter. It secured his position as individual and independent and caused him to be labeled defiant, reckless, and a breaker of the rules of art. The *Tribune* recognized that Homer was trying new approaches: "His eleven pieces show industry; better than that, they show earnestness, a defiance of conventionality, a disregard of fashionable precedent . . . that commands respect and challenges admiration."[24] This unconventionality garnered both praise and criticism, sometimes simultaneously from the same critic.

The writer for the *World*, possibly William Hurlbert, found Homer's pictures "incomprehensible . . . indeed difficult to find terms in which to speak of this artist's work." Despite his feelings of inadequacy, this critic felt compelled to further discuss the work because of its originality.[25] Originality occupied the center of much thinking in American arts and letters during the nineteenth century. It was seen, especially in literature, as a crucial component in the creation of a distinct American idiom. Ralph Waldo Emerson defined the term in 1868: "And what is Originality? It is being, being one's self, and reporting accurately what we see and are."[26] It followed, therefore, that if one were an American reporting on any aspect of America—people, life, or place—an authentic and unique national statement would be truthfully realized if that statement were reported accurately. Above all, recognizable home subjects were requisite. Thomas W. Higginson, in his call for originality in literature, echoed Emerson's definition, and, using Harriet Beecher Stowe as an example, he asserted that it was achieved through "daring Americanism of subject . . . not of new tribes alone, but of the American spirit."[27] Originality, as an American characteristic, thus was ultimately related to the ideas and ideals of freedom, democracy, and a national identity different from that of the Old World.[28] It was especially valued in the early seventies when American art was perceived to be in a deep rut. Clarence Cook noted: "The call now is for original work; not necessarily for great work, for that demands genius . . . but for fresh work, original in the sense of being independent." Cook also considered "the protest against monotony everywhere . . . a good protest," and thought it bode well for the future of American art. Homer's work seemed to represent that protest and, for it, he was found to be "a reformer, and a brave one."[29]

Homer broke the traditions of art in multiple ways. In this regard, his choice of themes for his three largest canvases—*The Bridle Path* (fig. 15), *Eagle Head, Manchester, Massachusetts* (fig. 16), and *Manners and Customs at the Seaside* (location unknown)—caused considerable consternation as they contributed to his being labeled original.[30] Homer was condemned for wasting his talent on them. The *Post* exclaimed: "what a pity to see such trifling subjects from a really clever hand!"[31] These three canvases all featured contemporary women engaged in outdoor activities. Recreational riding in rugged topography, as pictured in *The Bridle Path*, and the public sea-bathing of

Fig. 16. *Eagle Head, Manchester, Massachusetts (High Tide)*, 1870. Oil on canvas, 26 x 38 in. (66 x 96.5 cm). The Metropolitan Museum of Art, New York. Gift of Mrs. William F. Milton, 1923 (23.77.2)

Eagle Head and *Manners and Customs at the Seaside*, were relatively recent undertakings for women. To picture these pastimes, especially bathing scenes, and to show them in the preeminent exhibition of the year was to border on the inappropriate.[32]

Reflecting their greater audacity, the subjects of *Eagle Head* and *Manners and Customs at the Seaside* received the harshest criticism. The young women in *Eagle Head* were considered to be slaves to fashion or *en déshabillé*.[33] D. O'C. Townley of the *Mail* was most pointed in saying what he found unsavory, noting "other puppies are presumed to be on the beach with opera glasses."[34] Townley objected even more strongly to the overtly risqué presentation of the bathing subject in *Manners and Customs at the Seaside*. Perceiving relaxed morals in the "thinly and wetly clad" women of this canvas, he further observed that "[there are] very inquisitive spectators of the fun . . . two 'swells' with parasols," and that, despite these circumstances, "there is an *abandon* about all the ladies." In his mind, this image deserved to be called "a *spicy* picture."[35] The writer for the *Herald* wondered if such scenes of bold, bare-legged women were the unpleasant result of the "ballet and burlesque recently so popular," and he hoped that such scenes were the exception rather than the rule at the better seaside resorts.[36]

All these negative remarks responded, in some form, to the frankness of Homer's portrayal of contemporary resort life. In *Eagle Head*, not only were the women's bathing costumes of the day recognized as cumbersome,

but in posing the figures swathed in yards of flannel, wringing out a skirt, and removing sand from a shoe, the artist highlighted the absurdities of such fashions. Other objections may have stemmed from the women's apparent lack of stockings, which were an important item of bathing costumes through the end of the century.[37] The implied voyeurism reflected the real concern that women were subjected to intense scrutiny by men at the beach. From the eighteenth century, men took spyglasses to the shore expressly for this purpose.[38] Homer's tightly cropped foreground encourages such a reading.

Unlike his colleagues, Eugene Benson embraced rather than condemned the modernity of Homer's subjects. In his review of *Manners and Customs*, he complained about American prudishness and praised the subject as being "very real." Most of all, he celebrated *Bridle Path*'s modernity because its "contemporary nature, [was] something that will never become stale. . . . Here is no faded, trite, flavorless figure, as if from English illustrated magazines; but an American girl out-of-doors, by an American artist with American characteristics." The only complaint Benson leveled at *Eagle Head* was that the girls lacked beauty. Above all, he endorsed the cardinal rule that the purpose of picturing female subjects was to present the lovely and the beautiful.[39]

Fig. 17. Thomas Waterman Wood (American, 1823–1903), *The Return of the Flags*, 1869. Oil on canvas, 37 x 30 in. (94 x 76.2 cm). West Point Museum Collection, United States Military Academy, New York

In subject matter alone, *Bridle Path*, *Eagle Head*, and *Manners and Customs* differed from the rest of the show.[40] Other genre subjects commanding attention were Seymour Joseph Guy's *Little Stranger* (location unknown), which pictured a newborn being examined by his older sister; Enoch Wood Perry's *Huldy* (location unknown), based on the rustic character of that name in a James Russell Lowell poem; and Thomas Waterman Wood's *The Return of the Flags* (fig. 17), a Civil War image.[41] In contrast to Homer's contemporary subjects, those of his peers depicted overt narratives, chosen to evoke the warm sentiment associated with their deep-rooted family, romantic, and national themes. Likewise in artistic treatment, Homer's colleagues were generally praised for their more traditional, careful attention to detail, while Homer was not.[42]

Eugene Benson, again, had the most affirmative reaction to Homer's methods, which he felt, along with his subjects, made his canvases both American and original. He explained: "Mr. Homer is a positive, a real, a natural painter. His work is always good as far as it goes; and generally it falls below the standard of finish and detail which is within the reach of our most childish and mediocre painters, and which misleads many, and deceives painters with the thought that by going from particular to particular, of itself insures a fine result in art."[43] It was no coincidence that Benson had both a more positive reaction and a vocabulary with which to express his appreciation of Homer. More than any other American critic to date, Benson was familiar with and had championed the work of Gustave Courbet for its strength, power, modernity, and realism. In 1867, Benson had noted there were two lessons an artist could learn from Courbet: "free use of the brush," and "free choice of subject." He felt, too, that Courbet was "immense in his vigor and frankness. In spite of many canvases full of bad . . . drawing and the

crudest brush work, he is a strong man; strong as a painter, and strong in his hold on reality."[44] As in Courbet, Benson could find in Homer a similar approach to subject and careful observation described not in details but in masses of light, shade, and color to make his works truthful, original, and American. For these reasons Benson considered Homer on the path to achieving the status of America's master figure painter.[45]

Other critics more often roundly condemned Homer's artistic treatment even when the results could be praised as powerful.[46] Cook in the *Tribune* summarized the double-edged response the paintings elicited: "[Homer's works] attract and rivet attention by their vivid presentation of things, as they appear to the naked eye. There is no flinching in his realism, however the uninitiated may flinch from it."[47] What contributed to that flinching, for the *Tribune*, was a "hardness" and "crudity," especially of color, as well as a habit of stopping short. These stylistic defects made Homer's work seem angular and awkward.[48] The *Express*, like the *Tribune*, was bothered by certain errors in Homer's painting and fascinated by others. Noting that Homer's broad painting methods were similar to those of contemporary French art, it faulted the artist for strong contrasts of color and light and shade, muddy color, and frequent theatrical exaggeration. Nonetheless, the writer could not deny perceiving an energy in the work as he also acknowledged Homer as a still immature but promising artist.[49]

For most critics, *Bridle Path*'s primary technical shortcoming was its palette. The *Mail* called its color "absurd."[50] The writer for the *World* described the canvas as "a woman on horseback looking resignedly at a bank of frozen oatmeal into which her horse is carrying her . . . seeking to express itself in flakes and even in glacial bursts of pigment." Even though he truly admired the direct painting method that rendered the figure tender and beautiful, he found that the contrast of the highlighted and more descriptive depiction of the figure against the broadly painted landscape gave the painting "a crude perverse originality."[51] This writer seems to have been reacting to the play between the golden light that, with the low viewpoint, flattens the perspective as it permeates the canvas and the strategically placed patches of bright colors throughout the fore- and middle grounds that move the viewer's eye through illusionistic space. Such partial satisfaction with his canvases plagued Homer throughout these years.

Eagle Head, even more than *Bridle Path*, was denounced for its palette, especially the color of the girls' legs. The *Times*, even though it admired Homer's use of light and shade overall, wrote, "the brickdust color of the young lady bather's legs is not pleasant to look upon."[52] The *World* reacted to *Eagle Head* as it had to *Bridle Path*. It had to admit the figures were well drawn, but said the picture was "atrociously colored" with the sea "a pool of ice cream" and the girls' legs "exceedingly red."[53] The opposition to the redness of the girls' legs might have reflected the critics' perceptions that Homer had strayed from cultural as well as aesthetic norms. The coloration of their legs may have indicated not only that they were stockingless but also that they were suntanned, a condition that in the 1870s suggested menial, outdoor laborers rather than the assumed gentility of the subjects. And even though urbanites flocked to beach resorts in the nineteenth century, excessive exposure to the sun was believed to cause not only physical ailments but also moral corruption. Tanning did not become popular until World War I, the period in which bathing suit styles were reformed as well.[54]

The *Mail* had mixed feelings about *Eagle Head* as well. It shared with the *World* a distaste for the execution of the landscape. The various broadly modulated areas of color suggested to this writer mud, gloomy form, German toy clocks, and slime. Nonetheless, he credited Homer for the daring composition and energetic paint application, although he felt the figures were painted "in reckless disregard of all truth–in defiance of all law."[55] In *Eagle Head*, the dynamism of Homer's authoritative, freely, and widely brushed strokes applied to a composition grounded in a low viewpoint and Z-shaped progression into space were admirable characteristics. However, the palette, mainly variations of browns and blues, and the overall effect of the broad slices of color fit together like puzzle pieces ultimately caused the critics to declare the canvas a disappointment.

Homer's eight other paintings on view at the Academy were all judged to be sketches or studies. They were counted among a larger group of similar work that was relegated to the corridor—long considered the least desirable exhibition space at the Academy.[56] The *Nation* characterized the guiding principle of many of these works: "scarcely a study on these Academy walls is a study of drawing. They do not pretend to be; they are all, or nearly all, alike, memoranda of effects of light and shade and hue."[57] While the *Nation* was decidedly uneasy about the scope of the sketches, a number of critics admired them for capturing the essential qualities of nature rather than depicting literal specifics through careful drawing.[58] They applauded the sketches' depth of conception, truthfulness, and animated spirit that was not only present here, but which they felt was often absent in the usually more smoothly executed finished paintings.[59]

Despite their inconspicuous installation, the hanging of the studies together raised the question of whether or not sketches and studies were acceptable as exhibitable works of art in their own right.[60] The real dilemma for the critics was that they simply could not accept the sketches as completed works. "A painter's memoranda and notebooks are essential to his pictures; but they are not pictures," stated *Harper's Weekly*.[61] Such an attitude was derived from the long-held notion that sketches and studies were solely preparatory or preliminary excursions. The critic for the *World*, holding to the traditional idea of the function of sketches, referred to the entire group as "omnibus panels and signboards" and also criticized the artists for showing things that "have not yet attained the significance of pictures."[62] For this writer and others, it was the public showing, not always the works themselves, that was offensive.[63] Cook argued that since these sketches certainly would not sell nor could they be admired as finished works of art, there was no point in exhibiting them.[64]

Homer was singled out as the most extreme practitioner of the study/sketch. The *Nation* noted that some of his offerings were the least finished that he ever had shown in public.[65] To the critic for the *World*, Homer's works in the corridor were shocking. They looked as if they were created by "a man's shutting his eyes and rubbing all his pencils and pigments at once over a canvas in a conglomerate frenzy." In a word, they were "grotesque." Yet for all this criticism, he admitted they were original and powerful.[66] The *World* much preferred the studies by Asher B. Durand, John Kensett, and Jervis McEntee, which were acceptable for exhibition because they followed the mid-century recipe for preparatory work, and it found in them the artists' love and understanding of the landscape.[67] Durand's studies were often called *Study from Nature* (as was number 135 in the 1870 annual) and like *Chapel Pond Brook, Keene Flats, Adirondack Mountains, N.Y.* (fig. 18), generally focused his viewers' attention not on identifying a familiar place but rather on the universal qualities of nature found in that place.[68] For Durand, conveying the essential qualities of nature did not necessitate a relaxation in detailed execution. Durand's studies, as Eleanor Harvey has noted, conjoined small scale with an intimate view, a sense of immediacy, and a high level of surface finish to create objects more like small finished pictures rather than cursory sketches.[69]

Lobster Cove (fig. 19) and *White Mountain Wagon* (fig. 20), two of the studies Homer showed in 1870, are evidence of how radically different his technique and approach to subject were from artists like Durand. More so than in *Manchester Coast* and *Low Tide*, both *White Mountain Wagon* and *Lobster Cove* depend on light and color, not detail, to capture the essential qualities of an experienced moment. The two paintings' rough-hewn wood surfaces were first painted with a red-brown imprimatura layer that serves as both ground and a tone integral to the color scheme.[70] In *White Mountain Wagon*, this mahogany-like tone is left bare across the entire bottom edge, filling about one-quarter of the panel. Also halfway up the right side, a large area, broadly brushed with the same tone, gives the scene a decidedly incomplete look. In addition, the figures are only summarily defined with short brush strokes of color, alternating light and dark.[71] In *Lobster Cove*, the first layer of paint is completely integrated

Fig. 18. Asher B. Durand (American, 1796–1886), *Chapel Pond Brook, Keene Flats, Adirondack Mountains, N.Y.*,
c. 1870. Oil on canvas, 17 x 24 in. (43.2 x 61 cm).
Collection of The New-York Historical Society, 1932, 1932.13

into the compositional design, which appears as four bands of modulating color, also alternating light and dark. The warm tone, here, permeates the whole panel, suggesting the deep red glow often cast over the landscape at sundown. To the writer of the *World*, the combination of the flattened perspective and tonal palette caused him to declare that "'Lobster Cove' . . . represents nothing on or under the earth but a dirty door-mat."[72] Only Eugene Benson commended Homer's reliance on color, rather than line and detail, to truthfully convey his subjects, and he was the only critic to fully accept Homer's sketches as exhibitable works of art.[73]

Homer has left us no explanation of what emboldened him to send such daring work to the Academy. Perhaps he received encouragement when the paintings were viewed in his studio. Market issues and the hope of a sale may also have played a role. Perhaps presenting such paintings gave Homer another avenue for pushing the boundaries of American art, a role that he increasingly accepted for himself. Whatever his reasons for offering these works, Homer was undoubtedly stirred by the critics' responses. He must have been heartened by their praise for his originality and for his ability to capture reality. However, he could not have ignored the criticism of his use of color, exhibition of sketches, and especially his choice of subject matter–the very issues with which he was clearly experimenting. Nor could he disregard the comments by some critics that none of his offerings met their expectations. Since the critics believed Homer represented the promise for American art, they often expected more from him than from his peers.[74]

Fig. 19. *Lobster Cove, Manchester, Massachusetts*, 1869. Oil on wood panel, 12 ³⁄₁₆ x 21 ¼ in. (31.3 x 54 cm).

Cooper-Hewitt, National Design Museum, Smithsonian Institution, New York.

Gift of Charles Savage Homer, Jr., 1915-17-1

Fig. 20. *White Mountain Wagon*, c. 1869. Oil on wood panel, 11 ¾ x 15 ¹³⁄₁₆ in. (29.8 x 40.2 cm).

Cooper-Hewitt, National Design Museum, Smithsonian Institution, New York.

Gift of Mrs. Charles Savage Homer, Jr., 1918-20-9

Fig. 21. *A Rainy Day in Camp (Camp at Yorktown)*, 1871. Oil on canvas, 19 ⅞ x 36 in. (50.5 x 91.4 cm).
The Metropolitan Museum of Art, New York. Gift of Mrs. William F. Milton, 1923 (23.77.1)

Fig. 22. Eastman Johnson (American, 1824–1906), *The Old Stagecoach*, 1871. Oil on canvas,
36 ¼ x 60 ⅛ in. (92.1 x 152.7 cm). Milwaukee Art Museum. Gift of Frederick Layton

Fig. 23. *An Adirondack Lake*, 1870. Oil on canvas, 24 ¼ x 38 ¼ in. (61.6 x 97.2 cm).
Henry Art Gallery, University of Washington, Seattle. Horace C. Henry Collection

In contrast to the way Homer had boldly and publicly put himself forward in 1870, he was notice-
ably absent in 1871. He painted and illustrated fewer works and exhibited in a smaller number of
public forums. Only five oils are dated 1871 and only seven new drawings were created for publi-
cation.[75] Although Homer did not exhibit at the 1871 National Academy exhibition, he was not
entirely disengaged from the art world. Instead the Century Club, which offered monthly opportu-
nities for artist-members to receive informal opinions about paintings in progress, after changes,
or as previews of the Academy's spring exhibition, served as the primary venue for exhibiting his
new work.[76] Homer also contributed work to a new art society created to benefit artists themselves,
to a benefit for the family of the late artist James Cafferty, and to a number of auction sales.[77]

At the Century Club in February, Homer exhibited *Girl in the Surf* (location unknown) and
Camp at Yorktown (now known as *A Rainy Day in Camp*; fig. 21). *Girl in the Surf*, certainly another
seaside picture, was called ugly and a "silly trifle."[78] *Camp at Yorktown* received a more mixed
review, one that mirrored the reactions to Homer's larger canvases at the Academy the previous spring. The critic
from the *Mail* felt *Camp at Yorktown*'s depiction of the hardships of daily life during the Civil War was an admirable
subject, but he found its presentation a failure.[79] In contrast to *Prisoners from the Front*, in which the story was
laid out clearly through the composition, *Camp at Yorktown*'s narrative was suppressed through its envelopment,

Noticeably
Absent

even absorption, into the broader setting, one primarily composed of vast areas of gray and brown. This type of pictorial approach dissipated the subject across the canvas, both literally and figuratively. The use of atmosphere instead of direct narration for a genre subject and the application of paint in such broad areas of mottled color were unacceptable in 1871. Homer had taken an incontestably winning subject–the Civil War–and rendered it objectionable.

By contrast, Eastman Johnson's *The Old Stagecoach* (fig. 22), shown at the Century in an unfinished state, triumphed where Homer's work failed and was said to "mark an Art epoch with us; an epoch from which we shall date the commencement of our rivalry with the best of the modern schools of figure painting."[80] *The Old Stagecoach*'s success grew out of the presentation of an American subject, which was complemented by fine color and a charming landscape. Johnson used an abandoned, disintegrating stagecoach as the centerpiece of imaginative playacting by a group of children. The stagecoach no doubt represented the recent changes in transportation. While in the 1870s stagecoaches still served as the most basic form of local mass transportation, they had been supplanted almost entirely by railroads for long-distance travel.[81] With the children, Johnson touched on the nostalgia felt for the simplicity of earlier times, the identification of youth as the hope of the future, and current issues. At least one writer recognized the little girl in front, playing a horse, as a child of mixed-race heritage, thus connecting the image to present and future racial issues.[82] As a group, the children were understood to be emblematic of both past and future citizens and to represent "Young America."[83] The capitalization of the narrative; its expression of American themes, past, present, and future; the clarity of the drawing and the grace of the figures; and appropriate color separated Johnson's work from Homer's recently exhibited paintings.[84]

Homer fared better at the Century in April with the showing of a painting descriptively titled *A River Scene with a Man on a Decayed Trunk Guiding a Boat*, which was either the work known today as *An Adirondack Lake* (fig. 23) or its near twin, *The Trapper, Adirondacks* (Colby College Museum of Art).[85] Whichever canvas appeared, the writer for the *Mail* found: "No picture in the gallery attracted more attention than that contributed by Mr. Winslow Homer; nor was there one which better merited complimentary notice." He liked it both in its own right and for the bright future it suggested for the artist. A well-drawn figure, sparkling light, and the "charming realism of the marshy foreground" all contributed to the critic's positive response.[86] In the Henry Art Gallery version, especially, Homer described the lake vegetation in the painting with calligraphic lines and short, precisely placed dashes of paint in a variety of colors, while scattered touches of white suggest the play of sunlight. Details such as the small frog sitting on the lily pad near the bottom left of the painting add an immediacy and appeal to the scene. *A River Scene with a Man on a Decayed Trunk Guiding a Boat* would have been a reasonable entry for the Academy exhibition, but Homer stayed entirely away from it in 1871. Exactly why he chose not to exhibit is unknown. However, if one or both versions of this painting were in private collections, they may not have been readily available. Besides these two works, Homer may not have had another canvas finished in time for the opening of the show. He was intently planning his next major painting.

Once Again in Force

Spending the summer of 1871 in the Catskills, Homer worked unencumbered by public appearances.[87] On his return, he moved into a studio at the Tenth Street Studio Building, the premier location for New York artists. Many of Homer's fellow tenants were members or associates of the Academy as well as members of New York's most elite social clubs.[88] Best known as the unofficial headquarters of the second generation of Hudson River landscapists, the Tenth Street Studio Building also housed a number of the genre painters with whom Homer would be increasingly

compared, including John George Brown, Seymour Joseph Guy, Enoch Wood Perry, and Thomas Waterman Wood. Residing here, too, were artists with whom Homer was known to be friendly, including John La Farge, John Lee Fitch, and Homer Dodge Martin.[89] Homer now was surrounded by friends, peers, and competitors on a daily basis.

In his new residence, Homer worked and reworked a group of paintings, several of which had their genesis in his previous summer's travels. These included *The Country School* (fig. 24), *Crossing the Pasture* (fig. 28), *Old Mill* (now known as *The Morning Bell*; fig. 29), and *The Country Store* (fig. 30). When these four paintings, along with *Camp at Yorktown*, newly renamed *A Rainy Day in Camp*, appeared at the National Academy in April 1872, some were already familiar to the members of the Century and Union League clubs.[90]

The 1872 Academy annual exhibition was well reviewed, but neither the show nor Homer was written up as extensively as in 1870.[91] Current events and changes in the complexion of the art world may have led to a reduction in the number of lengthy notices. Just two weeks after the exhibition opened, on May 1, 1872, the party conventions for the presidential campaign began in earnest; the hotly contested race commanded many columns of newsprint.[92] More directly affecting the art press was the fact that the National Academy's activities were no longer the only significant art events of the spring season. There was little doubt that the Academy show was the centerpiece of the art season, but other venues now provided competition. A sale of European pictures contributed to support the victims of the Great Chicago Fire; the sales of the LeGrand Lockwood and the Vanderlip collections; and important dealers' sales by Avery, Snedecor, and Leavitt all took place in late March or April.[93] In addition, some artists chose to exhibit their newest works in solo settings.

Although nearly all the reviews of the 1872 exhibition commented on the quality of the show, they were less preoccupied with it. The general opinion of the press was that it was slightly above average in its own right and in comparison with other recent shows.[94] The only truly dissenting voice was that of the *Post*'s, which criticized the show for its provincialness and plethora of foreign imitators, both indications of no further progress toward a national art.[95] Those critics who approved of the show attributed its success to a perceived advancement, especially among the younger artists.[96] Such progress was heartening for two reasons: the actual quality of art was considered to be improved, and it proved that the native school was rapidly advancing toward a respectable place in world art.[97] Although it was not as loudly articulated as in 1868, the concern for America's standing in the larger art world remained real.

Some writers felt that the show's excellence was compromised due to the absence of entries by important artists or their appearance with only minor work. Although some of the missing painters were traveling, the conflicts within the Academy were also acknowledged as contributing to their truancy.[98] Among those repeatedly cited in the lists of absentees or the poorly represented were Church, Bierstadt, William and James Hart, Samuel Colman, and George Inness.[99] Church, in particular, was criticized for what appeared as snubbing the exhibition, since he chose to show his new magnum opus, *The Parthenon* (1871; The Metropolitan Museum of Art), in a solo exhibition.[100] Since most of the absent artists were landscapists, figure painters, including Homer, Eastman Johnson, Seymour Guy, John Beaufain Irving, and Enoch Wood Perry, received more attention.[101]

Homer received substantial press in the 1872 reviews.[102] The majority of them focused on *The Country School*, which was considered the top-ranking genre painting in the entire Academy exhibition.[103] It appeared with Eastman Johnson's *The Wounded Drummer Boy* (fig. 25); Seymour Joseph Guy's *A Knot in the Skein* (fig. 26); John Beaufain Irving's *The End of the Game* (location unknown); and Enoch Wood Perry's *Thanksgiving Time* (fig. 27) (often lumped together with his other entry, *Talking It Over* [location unknown]). Whereas Homer's peers were criticized for their entries, *The Country School* was unanimously well received.

Fig. 24. *The Country School*, 1871. Oil on canvas, 21 ⅜ x 38 ⅛ in. (54.3 x 97.5 cm). The Saint Louis Art Museum. Purchase

"Thoroughly National"

———————•———————

The Country School was, in effect, Homer's answer to the criticism he had received for his 1870 Academy offerings. Picturing a class in session in a rural, one-room schoolhouse, the canvas was described in many reviews. They included remarks on the setting—both on its particulars and its overall appearance—as well as detailed descriptions of the figures.[104] After the 1870 criticisms that his subjects were "trifling" and "vapid," Homer responded with one in *The Country School* that critics considered "thoroughly national."[105] While the subject matter clearly won the critics' affection, the appropriateness of its artistic treatment reinforced their overwhelmingly positive assessments.

The image of a one-room school, an icon of America's unique system of education, automatically identified *The Country School* as specifically American.[106] With such a strong national association, the subject could be construed more broadly as symbolic of the American democratic system. Furthermore, the painting was acclaimed as showing a "thorough acquaintance with our life as a people."[107] Critics confirmed that the image connected with the public and this recognition of the theme as populist may have also united the picture with accepted assumptions about American culture and democracy.[108]

The reading of *The Country School* as emblematic of a national art profited from a subject that bridged the past and present of American life. As had Eastman Johnson's *The Old Stagecoach*, Homer's *The Country School* simultaneously fed the nostalgia for happier past times while exploring contemporary issues.[109] The *Aldine* wrote of the comprehensive recognition of the sentiment such a school elicited: "Every person from the country knows the powerful associations lingering around the old red schoolhouse . . . no spot in the whole world is so full of histories and memories."[110] At the same time that it tugged at viewers' hearts, Homer's country schoolhouse also likely

suggested such contemporary issues as the 1872 National Education Bill, which addressed the issue of funding rural schools from the sale of public lands.[111] The inclusion of a female teacher also made the scene unmistakably contemporary. By 1870, American women teachers outnumbered their male counterparts by two to one.[112]

Homer embedded the multiple possible meanings for *The Country School* in an image that first and foremost told a story. Interestingly, while nearly every reviewer identified the narrative as the key to the painting's success, they did not agree on its specifics. The aspect of the narrative that was most contested–the interaction between the little boy and girl seated to the teacher's left–was also the detail that heightened the appeal of the image. The interpretations varied from the belief that the two children were siblings to their identification as feuding members of the opposite sex.[113] While the specific roles of the two children may have been left to viewers' imaginations, there was no question as to the types the individual figures represented. As the *Telegram* noted: "When we come to the *personnel* of the school there is not an attitude, a suggestion, that we can say is out of place. There is the good boy who knows his lesson, the sulky boy who does not, the studious boy, with the

Fig. 25. Eastman Johnson (American, 1824–1906), *The Wounded Drummer Boy*, 1871. Oil on canvas, 47 ¾ x 38 ½ in. (121.3 x 97.8 cm). Collections of the Union League Club, New York

hole in his knee, that we can fairly hear syllabling his lesson, after the manner of spasmodic students; and there is the little boy sniffing."[114] Clarence Cook identified the teacher as a representative type, noting she was "an allegory of New England: prim, neat, brisk, a little angular, and thoroughly aware of her authority."[115] Thus Homer told his story through combining a suggestive narrative with the delineation of the figures as character types. By leaving part of the narrative ambiguous, Homer encouraged viewer participation in constructing the meaning of the painting. The multiplicity of possible narratives, together with the characterizations of the figures, could stimulate the viewer's imagination while Homer retained control of the overall meaning. Thus, the painting was ensured wide appeal as it suggested national concerns.

The artistic treatment through which Homer conveyed the layers of the school subject was very satisfying to most of the critics. Its realism–overall, in part, and in spirit–was unanimously agreed upon. It was "a page taken out bodily from the book of nature," according to the *Express*.[116] The "book of nature" now referred not simply to the outdoors, as it had in the 1850s, but also to the everyday life of the people.[117] As was noted with regard to landscape painting in 1870, the realistic portrayal of the "book of nature" no longer just depended on factual rendering, but also on capturing the essential spirit of a subject. The *Telegram* detailed how, in its view, this was accomplished in *The Country School*: "All the little phases of school life . . . all the little details are there in rightful relations to the general idea."[118] One detail in the painting that was likely not lost on viewers was the strategic placement of sprigs of cherry blossoms. Under the purview of the teacher in a vase on her desk, this symbol of good education appears upright, lovely, and highlighted, but where dropped on the floor on the outer edge of the classroom, it is isolated, wilting, and cast in the shadow.[119]

Fig. 26. Seymour Joseph Guy (American, 1824–1910), *A Knot in the Skein*, 1870. Oil on panel, 30 x 24 ¼ in. (76.2 x 61.6 cm). Wadsworth Atheneum, Hartford, Connecticut. The Ella Gallup Sumner and Mary Catlin Sumner Collection Fund, 1986.27

As in 1870, Homer's unique observations were once again commended. This time, however, the technical means by which he created this original vision were well received. His methods were lauded for their simplicity and directness; for the fact that groupings as well as individual figures contributed to the whole of the story; that the story was strongly told by drawing; and that the drawing itself was crisp and confident.[120] The critics' reaction to the painting's state of finish was the most remarkable difference between the response to Homer's technique in *The Country School* and that of the works of the past few years.[121] Homer's canvas was preferred over Eastman Johnson's *The Wounded Drummer Boy* (fig. 25) because it exuded more character, even though it was less finished.[122] Supporting his looser paint application, some writers took more radical positions, suggesting that Homer's style was not only appropriate but also necessary for the best treatment of the rural subject.[123] The *Telegram* clearly approved of Homer's technique: "Mr. Homer's subjects are such that elaborate finish would be out of place; but in treating them, while adhering strictly to truthfulness in rendering their plain matter-of-fact-ness, they are lifted entirely out of the region of the commonplace and approach the idyllic."[124]

In *The Country School*, Homer may have been responding to previous criticisms–of *Eagle Head*, for instance–by adjusting the broadness of his brush and by choosing a narrative more acceptable to his critics. Although the interior setting of *The Country School* as well as the view out the window are broadly articulated through light and shade and some of the children's faces, figures, and clothing are only summarily defined, Homer's inclusion of some careful delineation of selected faces and costumes, as well as the composition's more forthright exposition of a story, ameliorated, in most critics' eyes, his attempts of two years earlier. Too, the critics may have recognized, as Nicolai Cikovsky has suggested, that the coarseness of Homer's style in the school picture was a conscious construction of a "national artistic policy" appropriate for national subjects and similar to that being created in poetry by Walt Whitman.[125] All these changes allowed Homer to receive praise as well as to retain a certain amount of artistic freedom.

Not all critics, however, embraced Homer's technique in 1872. Earl Shinn, who was well acquainted with academic French methods, was most bothered:

> Homer has learned to see Nature in breadths; this faculty, admirable for a sketcher and for a colorist, he joins to a fair dramatic sense, and to an unusual power of balance and self-repression. . . . His sense of character is so keen, that, without sense of beauty, he arrives at beauty merely by feeling for character; . . . These are the virtues of a sincere, direct style and an unsophisticated way of looking at things. But it is a pity to find Mr. Homer resting year

Fig. 27. Enoch Wood Perry (American, 1831–1915), *Thanksgiving Time (Preparing for Thanksgiving)*, c. 1872. Oil on canvas, 28 x 36 in. (71.1 x 91.4 cm). Location unknown

after year in the state of ébaucheur, *sending to exhibitions works which show all the ravellings and loose ends of execution.*[126]

For Shinn, Homer's work remained in the sketch (*ébauche*) state that preceded the finished work of French artists, such as Thomas Couture or Shinn's own teacher, Jean-Léon Gérôme.[127]

Overall, the complementary, symbiotic relationship between content and execution in *The Country School* was successful in ways that were not found in any other genre picture in the exhibition. Although a number of other genre paintings were well received, their deficiencies of subject, technique, or presentation lowered their rankings in the minds of the art press, and they received far less attention than Homer's work. Johnson's *The Wounded Drummer Boy* was not considered a major canvas.[128] The homely subject of Seymour Guy's *A Knot in the Skein* (fig. 26) was popular, but the canvas achieved only moderate success. It not only lacked the deeper resonance of Homer's school picture, but critics were displeased with Guy's emphasis on surface finish.[129] If Guy was chastised mainly for concentrating too much on his artistry, Enoch Wood Perry was faulted for the mundane character of his subject in *Thanksgiving Time* (fig. 27).[130] The relationships among subject, imagination, thought, the need for literal representation, and the importance of artistic treatment in painting were continually modulating in the arena of genre painting through the seventies. The 1872 Academy exhibition prompted several critics to voice the concern that technical interests would overshadow thought in painting.[131] The struggle to find the appropriate balance between subject matter and artistic means escalated for the rest of the decade.

Fig. 28. *Crossing the Pasture*, 1872. Oil on canvas, 26 ¼ x 38 ⅛ in. (66.7 x 96.8 cm). Amon Carter Museum, Fort Worth, Texas, 1976.37

With *The Country School*, Homer nearly reached the heights of praise accorded him for *Prisoners from the Front*.[132] As in 1866, he had achieved it with a subject that touched the hearts and the minds of its viewers and was unquestionably American. With this strong foundation, he was also able to incorporate elements of unconventional artistic treatment without undue criticism. Homer seems to have realized that if he hooked his viewers through subject matter, he might gain more latitude for artistic treatment.

Despite the grand success of *The Country School*, Homer's four other entries to the Academy exhibition were virtually ignored. The little notice they received was in line with what had been written about Homer's work in the previous few years. Interest in subject matter and the exposition of its narrative content continued to shape the direction of the commentary. Paintings with unclear stories were more likely to be criticized. This was the case with *Old Mill* (fig. 29), which, now renamed simply *The Mill*, was considered the worst of the group. The figures were said to suggest no motive for the painting and seemed to appear simply as an excuse to paint the background. In addition, the girls pictured were condemned for lack of grace.[133] *Crossing the Pasture* (fig. 28) failed on both thematic and technical grounds. It was censured for having no narrative and for a "disagreeable hardness throughout."[134] The image of the boys enveloped by the landscape that today appears so monumental and modern in its reductive composition of large shapes seemed empty and meaningless to Homer's contemporaries. *A Rainy*

Fig. 29. *The Morning Bell (Old Mill)*, 1871. Oil on canvas, 24 x 38 ¼ in. (61 x 97.2 cm).

Yale University Art Gallery, New Haven, Connecticut. Bequest of Stephen Carlton Clark, B.A., 1903

Fig. 30. *The Country Store*, 1872. Oil on wood panel, 11 ⅞ x 18 ⅛ in. (30.2 x 46.1 cm).

Hirshhorn Museum and Sculpture Garden, Smithsonian Institution, Washington, D.C.

Gift of Joseph H. Hirshhorn, 1966

Fig. 31. *Snap the Whip*, 1872. Oil on canvas, 22 x 36 in. (55.9 x 91.4 cm).
The Butler Institute of American Art, Youngstown, Ohio. Museum Purchase, 1919

Day in Camp (fig. 21) and *The Country Store* (fig. 30) were slightly better received, since they depicted more compelling, contemporary subjects with discernible stories. Homer's truthfulness in telling those narratives garnered some measure of approval, although the critics could find nothing beyond transcriptional realism to praise.[135] While Homer must have been pleased with the responses to *The Country School*, the paucity of comment and unfavorable remarks about his other pictures surely tempered his joy.

On the heels of the success of *The Country School*, Homer set out to create his next major work, and the art world carefully watched its development. That painting was *Snap the Whip* (fig. 31). Repeating the general rural schoolchildren theme of *The Country School*, it pictures schoolboys playing the popular game of its title, with the schoolhouse framed behind them. Drawings for the canvas were in progress in New York City in early June 1872.[136] From at least early July until mid-October, Homer took his usual hiatus from the city and again visited the Catskills, where he resided at Hurley in Ulster County with fellow artist Enoch Wood Perry.[137] Although Homer clearly had *Snap the Whip* in his mind and partly on canvas prior to his summer travels, the surroundings at Hurley surely played a role in the continued development of the image.

Snap the Whip was noticed in Homer's studio as he worked on it through the fall and when he exhibited it at the December exhibitions of the Century and Union League clubs.[138] Like *The Country School*, it was immediately recognized and praised as American. Like its companion (as *The Country School* was called), it achieved that goal, in part, through a subject that conjured a nostalgic view of the past as it connected to contemporary issues and reverberated with recognizably larger national themes and distinguishing characteristics.[139] The primary

difference between the critical reactions to *The Country School* and *Snap the Whip* is that the latter work was perceived to have noticeable faults in its artistic treatment. Once again Homer's use of color and "crudities and apparent carelessness of execution" were his downfall.[140] While none of the commentators went into much detail about the faults of the color, their negative reactions may have stemmed from the brightness of the outdoor light depicted in *Snap the Whip*, which presented more accentuated contrasts of color and tone than in *The Country School*. Nonetheless, although it did not measure up in artistic quality to the earlier canvas, *Snap the Whip* was not considered a complete technical failure. Even those writers who criticized its carelessness remarked upon its fine drawing, particularly of the individual figures.[141]

Between 1870 and 1872 Homer had grappled with subject and artistic issues with nearly equal intensity. Certain of his subjects had the greatest success in finding favor with the critics. His artistic treatment and technique had caused considerable discussion and consternation. If in 1870 the critics had been appalled by the extreme sketchiness of Homer's eight studies at the Academy, by 1872 they accepted a somewhat greater measure of broad paint application in *The Country School*. On the one hand, it seems Homer tempered his loose brush as carefully as he had chosen his subject for *The Country School*. On the other, it seems that the critics now, perhaps because of Homer's earlier very sketchy excursions, were more willing to accommodate freer styles in painting when it was appropriate for the subject and integrated into the overall artistic treatment. In the coming years, the interrelationship of style and subject and the notion of completion commanded the attention of Homer and the art press to a much greater degree.

CHAPTER 3

1873–74

On Shifting Ground

THE UNITED STATES, THE NEW YORK ART WORLD, AND WINSLOW HOMER ALL EXPERIENCED SIGNIFICANT CHANGES IN the middle years of the 1870s. The Panic of 1873 marked the beginning of the most serious financial crisis in American history. Set off by the failure of Jay Cooke's powerful banking firm after a period of unbridled railroad speculation, the panic led to the collapse of the securities market and rampant unemployment.[1] The National Academy of Design faced its own crisis in 1874 after the rejection of two paintings submitted by John La Farge for the annual exhibition. The artist's protest was double-edged. As an active member of the Academy, La Farge was incensed at his shabby treatment. Additionally, as a leading representative of the more forward-thinking painters, La Farge accused the Academy of suppressing the exhibition of cutting-edge art.[2] This incident was the most ostensible evidence of the rift growing between the older and younger artists.

Homer engaged in these challenging times with his own set of alterations. He expanded his involvement with the art world in unprecedented ways, both within the Academy and in the larger art market. Most important for his art was that he began his long engagement with watercolor, the medium in which he would make his most varied and bold experiments.

In 1873, the majority of Homer's work was most frequently seen at the Century Club and in sales.[3] In the new work Homer exhibited at the Century, he introduced an expanded investigation of images of women, one that would increase through the rest of the decade. *Female Figure in Black near a Window* (now known as *Looking Out to Sea*; fig. 32); *Girl Reading on a Stone Porch* (fig. 33); and *Girl in a Hammock* (probably *Sunlight and Shadow*; fig. 46) all picture a single, contemplative female figure.[4] At the Somerville Gallery, Homer offered courting images, such as *Waiting for an Answer* (fig. 34), which also shows a woman in focused introspection.[5] The increased appearance of female figures in Homer's work mirrored a general trend in American painting. Yet, as always, he would explore the theme on his own terms.[6] Increasingly, his subjects moved away from narrative content and turned instead toward suggesting universal experiences found in everyday life.

Typical of works appearing in club exhibitions and sales, these paintings were not much noticed in the press. If there was a distinguishing note to the scattered reviews, it was not the recognition of Homer's subject matter, but of his prominent use of light. The *Post*, the only reviewer of the Century shows this year, remarked on this phenomenon. *Female Figure in Black near a Window* and *Girl Reading on a Stone Porch* were particularly recognized for their brilliant effects of light and shade.[7] In *Female Figure in Black*, the woman's dark costume and the shadowy interior are contrasted against, and also enlivened by, the bright light pouring through the window. The sharp angle of the light bathes the woman's face and white fichu and surrounds the plant on the windowsill, connecting the symbolism of the geranium–gentility and expected meeting–with the woman's station and situation.[8] The light further

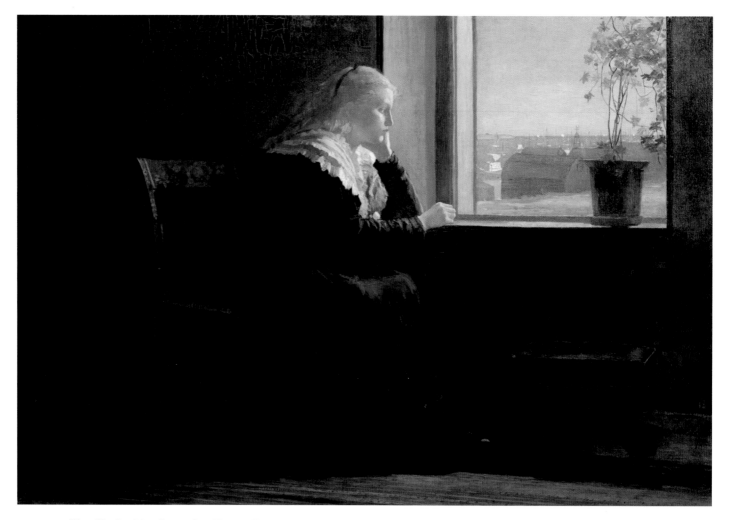

Fig. 32. *Looking Out to Sea (Female Figure in Black near a Window)*, 1872. Oil on canvas, 15 ½ x 22 ½ in. (39.4 x 57.2 cm).
Private collection. Courtesy Berry-Hill Galleries, New York

plays an important role in this carefully balanced composition, where horizontal and vertical, round and straight, and light and dark interweave across the entire canvas to tell the story of watching and longing. The light in *Girl Reading on a Stone Porch*, while less dramatic than in the image of the woman in black, also works to multiple purposes. It beautifully articulates the folds of the young woman's dress and apron, adding a grace and vitality to the figure's relaxed pose. The brightly lit sliver of landscape, seen through the doorway, illuminates both the visual and emotional content of the scene, suggesting perhaps the contrast not only between the young woman's actual domestic setting and the surrounding countryside, but also the difference between her interior and exterior experiences.

In *Waiting for an Answer*, Homer used light in several roles. In this courtship scene, it is perhaps the best clue to the narrative. The young man, in light, appears modest but hopeful; the young woman, in shadow, seems lost in thought and doubtful. At the Somerville sale, the painting was specifically noticed for its brightness.[9] Indeed, bright light alternates with deep shadow across the canvas, both defining the spaces and flattening the perspective. The resulting composition creates a sense of abstract design as well as a tension that mirrors the subject.[10] When Homer exhibited his first watercolors the following winter, his use of light would again be recognized as a distinguishing feature of his work.

Following his great success with *The Country School* at the 1872 Academy exhibition, Homer had been elected to the next year's hanging committee.[11] His election confirmed that he now held a certain position of

Fig. 33. *Girl Reading on a Stone Porch*, 1872. Oil on panel, 6 x 8 ½ in. (15.2 x 21.6 cm). Private collection

esteem among his colleagues and that he was willing to become involved in organizational politics. Even so, he did not show any work in the 1873 Academy exhibition. Why Homer did not exhibit remains a mystery, but the decision to be absent may have depended on several factors. For one, he had no new major painting to show. *Snap the Whip* would have been the logical entry, but one version was included in the sale of John Sherwood's collection during the same period.[12] Perhaps also influencing his choice to withhold his art was the fact that he was a member of the hanging committee. He may have felt that it was important to appear impartial, even if fellow committee members Worthington Whittredge and W. O. Stone did not.[13] Financial considerations may also have had an impact on his selection of venues for his work, for six canvases, which might have been at the Academy, were offered in a Somerville Gallery sale held in early April.[14]

Even though Homer's art did not appear at the Academy, he received both direct and indirect criticism in the reviews. He was reprimanded directly for not showing.[15] As a member of the hanging committee, he was also censured. The show was considered a disaster. Among the reasons given to explain its poor quality was that a number of well-known artists, including Bierstadt, Church, George Boughton, William and James Hart, and George Inness, chose to stay away. The committee was not directly blamed for the absentees, but it was condemned for hanging foreign pictures on the center line and padding the show with European work.[16] Homer must have been stung by these strong criticisms. Yet, despite this skinning in the press, Homer was elected to the Academy Council for the coming year.[17]

His experience on the hanging committee behind him, Homer may have particularly relished his departure from the city when the summer exodus began. By late June, he was settled in Gloucester, Massachusetts,

Fig. 34. *Waiting for an Answer*, 1872. Oil on canvas, 12 x 17 in. (30.5 x 43.2 cm). Peabody Collection.
Courtesy of the Maryland Commission on Artistic Property of the Maryland State Archives

where he remained possibly until late August.[18] Homer also visited other parts of New England, and in the early fall he traveled to the Catskills. He did not return to the city until early November.[19] By the early winter of 1874, the importance of his summer travels was apparent.

"Rooms . . .
Full of
Hope"

The results of Homer's summer sojourn were first seen with his debut at the American Watercolor Society in January 1874. With its first exhibition only in 1868, the society's show was a comparatively new venue for a medium that, itself, was relatively recent on the American art scene. As late as 1860 America did not have one major painter working earnestly in watercolor.[20] American interest in watercolor as a respectable vehicle for serious artistic expression only began with an exhibition of British art, including many watercolors, that toured Boston, New York, and Philadelphia during 1857–58.[21] From the early 1860s, English watercolors reflecting the writings of art-theorist John Ruskin and his call for the meticulous study of nature most prominently influenced American practitioners of the medium.[22] In the mid-1860s, a parallel strain of British-influenced

Fig. 35. *Boys and Kitten*, 1873. Watercolor and gouache over graphite on paper, 9 ⅝ x 13 ⅝ in. (24.4 x 34.6 cm).
Worcester Art Museum, Massachusetts. Sustaining Membership Fund, 1911.1

watercolorists, inspired by the picturesque tradition in English landscape art, also developed in New York. It impelled artists, most notably Alfred Bellows, to paint pastoral watercolor images.

American watercolor received an additional boost in 1873. That winter the entire suite of National Academy of Design galleries was filled with watercolors, including another large showing of British works. This event not only fostered a surge in the professional practice of watercolor by Americans but also paved the way for regularly including significant examples of European art in the Society's annual shows.[23] In 1874, a considerable number of foreign works were hung. British and French sheets were on view as well as works by the Spaniard Mariano Fortuny and his followers, known as the Roman school, who appeared for the first time and were especially noticed.[24] In this context, questions of refinement of technique and the relationship of American to European art were keenly discussed.

The critical assessments of the Watercolor Society exhibitions were constructed similarly to those of the Academy. In 1874, Clarence Cook declared their "rooms are full of hope," and the 1874 watercolor show was praised both for its completeness and the advances discernible in the American work.[25] At a time when native oil painting and the institution of the National Academy of Design were considered stagnant, watercolor and the society of its practitioners were heralded as forums in which American artists could distinguish themselves. Yet, despite this support, the watery medium was not considered to be the equal of oil, and certain prejudices, such as its being viable only as a sketching tool, prevailed.[26] In contrast to the reviews of the Academy exhibitions, comparisons with foreign works served as a springboard for many watercolor reviews. Most critics were glad for the inclusion of European art, which was appreciated for its array of techniques and, thereby, the useful comparisons

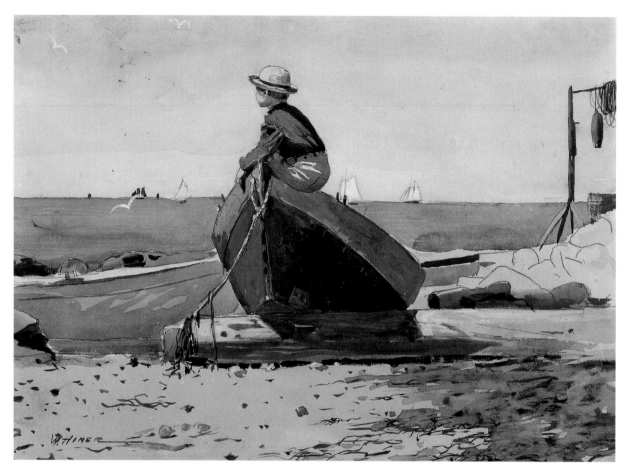

Fig. 36. *Waiting for Dad (Longing)*, 1873. Watercolor and gouache on paper, 9 ¾ x 13 ¾ in. (24.8 x 34.9 cm). Mills College Art Museum, Oakland, California. Gift of Jane C. Tolman

it allowed. Among the Europeans, Fortuny, Edouard Detaille, and Attilio Simonetti were favored. The praise they received focused on the technical aspects of their work. Fortuny was considered the master of light and shade; Detaille of detail; and Simonetti for the transparency of his color.[27] Overall, the American work compared favorably with the foreign, and was considered to be strong enough both in numbers and quality to satisfy the desire that national character pervade the show.[28]

"Almost Content Not to Ask . . . for a Finished Piece"

Homer's entries to the 1874 American Watercolor Society annual exhibition may have marked his first appearance at the society, but he was no stranger to the medium. His mother, an accomplished amateur flower painter, likely introduced him to it, and he then made wash an integral part of both the aesthetic and technique of his illustrative work.[29] His plunge into watercolor, however, does not seem to have occurred until the summer of 1873, and with the fruits of that work, he felt confident to go public.[30]

Exactly what Homer sent to the 1874 Watercolor Society exhibition is not entirely clear. His name was listed five times in the catalogue, each entry simply titled *Leaves from a Sketchbook*.[31] Treated as a group by the critics, only one review mentioned a specific scene–boys with a kitten, which most likely is the watercolor owned by the Worcester Museum (fig. 35).[32] Another reviewer identified an entry as a scene with girls, and *Waiting for Dad* (fig. 36) must also have been in the

Fig. 37. *The Farmyard Wall*, 1873. Watercolor and gouache on paper, 7 ⅝ x 13 ½ in. (19.4 x 34.3 cm).

Private collection. Courtesy of The Caldwell Gallery, Manlius, New York

show, for in his review of the next Academy exhibition in the spring, Clarence Cook mentioned that the watercolor related to the oil *Dad's Coming* (fig. 45) appeared at the Watercolor Society.[33]

This first showing of watercolors was met with applause, and, as with his oils, originality, distinctiveness, vitality, and strength were the labels critics most often used when writing about them.[34] Critics explained that it was Homer's individual manner of observing nature and how he conveyed it that made the sheets unique and truthful. The writer for the *Mail* "worship[ed] the genius . . . in sketches like these." He found Homer "grabs nature and dabs her on his paper and as you look at his work you feel the blow of the salt sea breezes and shade your eyes from the dazzling sun glare."[35] Perhaps also in the exhibition was Homer's *The Farmyard Wall* (fig. 37), which, with its cropped edges, compressed space, visibly layered and broad washes, and dazzling light contrasted against deep shadows, achieves just such a feeling. In *Waiting for Dad*, Homer carefully composed a non-traditional design similar to the oils exhibited in 1870. He set the pyramidal form of the boy atop the tethered boat in nearly empty surroundings, the space of which is considerably flattened by its low viewpoint and construction of three bands of blue and cream. Counterbalancing this monumentalizing composition, squiggling lines of paint in the foreground and pencil used sparingly at the middle right convincingly define beach debris and rocks. The alternation of nearly white areas with darker blues and browns heightens the intensity of the light in the image. These strategies allow *Waiting for Dad* to read as intimate and epic simultaneously. The apparent truth, directness, and freedom from foreign influence in a sheet such as this one was so pleasing to Cook that he was "almost content not to ask Mr. Homer for a finished piece."[36] The *Tribune* critic believed Homer was so rooted in actual observation that he did not see (or ignored) any specific artistic influences. In Cook's mind, Homer's acute and independent vision especially separated him from other artists and elicited praise for the originality of his work. For the critics who were not bothered by overlaps with foreign work, Homer's sheets were seen as related to but not influenced by it. The *Mail*, for

Fig. 38. William Trost Richards (American, 1833–1905), *A High Tide at Atlantic City*, 1873.

Opaque watercolor on paper, 8 ⁷⁄₁₆ x 13 ⁵⁄₁₆ in. (21.4 x 33.8 cm). Brooklyn Museum of Art.

Purchased with funds given by Mr. and Mrs. Leonard L. Milberg

example, remarked: "Winslow Homer exhibits a set of sketches which are superb in strength, brilliancy, vigor and suggestiveness and entitle this artist to the rank as the Fortuny of America."[37]

Homer's first watercolor images suggest a sense of intimacy and depend on ostensibly prosaic subjects. There is no doubt *Waiting for Dad, Boys and Kitten*, and *The Farmyard Wall* all looked markedly different from the other sheets on view in 1874. For instance, even though William Trost Richards's *A High Tide at Atlantic City* (fig. 38) matches Homer's three watercolors in size, it uses an expansive view to suggest its homage to nature. The two artists' methods were equally at odds. Richards employed sharply defined individual elements in the foreground, linear perspective, nearly invisible brushwork, and a pervasive golden light, blending fact and poetry harmoniously akin to Sanford Gifford's Venetian oil of 1870. Richards's sheets were praised especially for their beauty and their expression of the serenity found in nature.[38] Homer's watercolors were equally distinctive from those of Alfred Bellows, who was considered the head of the American watercolor school. Bellows's work was most often praised for its delicacy, a quality highly prized in watercolor.[39] Beautiful and delicate, however, were adjectives rarely attached to Homer's art.

Homer's unique means of manipulating the watercolor medium especially captured the critics' eyes. The acceptance of a lesser degree of surface finish for sketches, which Homer may have consciously tried to capitalize on in the titling of his entries, also must have contributed to their success with the critics.[40] Receiving such a positive response, after almost two years of minimal notice, must have encouraged Homer to further pursue watercolor as well as to consider its further implications for his career.

Although Homer's watercolors made a noticeable splash at the 1874 Watercolor Society exhibition, his oils at the Academy show that year fell flat.[41] Homer's choice of works, in light of the circumstances surrounding the

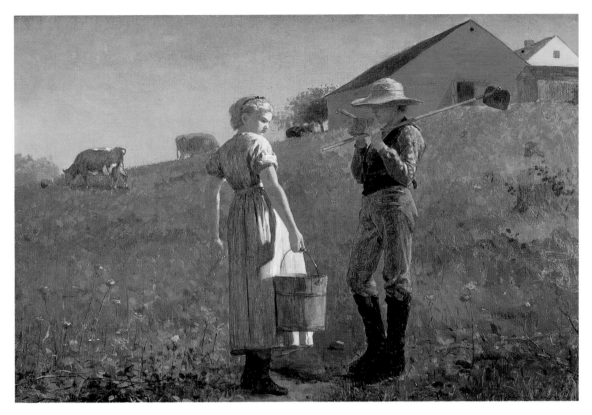

Fig. 39. *A Temperance Meeting*, 1874. Oil on canvas, 20 ⅜ x 30 ⅛ in. (51.8 x 76.5 cm).

Philadelphia Museum of Art. Purchased with the John Howard McFadden, Jr. Fund

Fig. 40. *Gloucester Harbor*, 1873. Oil on canvas, 15 ½ x 22 ½ in. (39.4 x 57.2 cm).

The Nelson-Atkins Museum of Art, Kansas City, Missouri. Gift of the Enid and Crosby Kemper Foundation

Fig. 41. August F. A. Schenck (German, 1828–1901), *Lost–Souvenir of Auvergne*, c. 1874. Oil on canvas. Location unknown

exhibition and his relationship with it, is curious. A special effort was made by the Academy to ensure that the 1874 annual exhibition was of higher quality than in recent years. Academy president J.Q.A. Ward, along with the hanging committee and council, of which Homer was a member, had encouraged artists during the winter to send their best work.[42] Yet, his own submissions, *School Time* (fig. 44), *Dad's Coming* (fig. 45), *Girl in a Hammock* (probably *Sunlight and Shadow*; fig. 46), and *Sunday Morning* (possibly private collection), were relatively modest in scale and scope.[43] Why Homer sent these canvases to the Academy instead of the larger *A Temperance Meeting* (fig. 39) can only be guessed at, but such behavior raises the question of whether he was uncomfortable with his position within the Academy hierarchy. The potential for financial gain at dealers' auctions may have also been enticing. *A Temperance Meeting* appeared at Leavitt's Art Rooms in early March.[44] Homer may have applied similar reasoning to his choice of also placing *Gloucester Harbor* (fig. 40) at Leavitt's, where it and *Temperance Meeting* received positive, if brief, notice.[45]

At the Academy: "A New Departure"

Even if Homer assumed a low profile at the exhibition, the Academy showing attracted considerable attention in 1874. Critics warmly praised the effort made by the Academy to convince the public that it was a vital organization.[46] They understood that this effort was not simply about redeeming the Academy as an institution but also about the position of American art as well. Thus, despite the praise given to this exhibition, the concern for the position of American art was raised by individual writers. In this context, the placement of a foreign canvas in the exhibition's place of honor caused particular controversy. The reactions to August Schenck's *Lost–Souvenir of*

Fig. 42. Frederic E. Church (American,
1826–1900), *El Khasné, Petra*, 1874. Oil on
canvas, 60 ½ x 50 ¼ in. (153.7 x 127.6 cm).
New York State Office of Parks, Recreation
and Historic Preservation, Olana State
Historic Site, Taconic Region

Fig. 43. Seymour Joseph Guy (American, 1824–1910), *Going to the
Opera–Family Portrait*, 1873. Oil on canvas, 42 ½ x 54 in. (108 x 137.2 cm).
Biltmore Estate, Asheville, North Carolina

Auvergne (fig. 41)–both its quality and its being hung in the central spot in the most prominent gallery–greatly varied.[47] If, by highlighting Schenck's canvas, the conservative hanging committee of David Johnson, John Beaufain Irving, and Carl Brandt implied that American art was substandard to the academic traditions of Europe, some writers noted "a new departure" stirring both within the Academy and among the artists.[48] Perceptions of progress among the younger artists were key in the identification of the changes afoot, and they were identified as responsible for the better quality of the show.[49] The championing, by even a handful of critics, of artists like John La Farge, Elihu Vedder, Charles C. Coleman, and James Whistler also suggests a changing tide.[50] Interwoven with these discussions was commentary on the rejected paintings. The writer for the *Daily Graphic* wished that more canvases had been cut, but he did not elaborate on which ones should have been omitted. The *Herald* applauded the rejections, while Clarence Cook was disturbed by them, especially the refusal of all but one of La Farge's pictures.[51] The diversity of entries as well as the critical opinions of this exhibition signaled the beginning of significant changes to come.

Still, though, it was the dramatic canvases by Americans, such as Frederic Church's *El Khasné, Petra* (fig. 42), William Page's *Shakespeare Reading* (Folger Library, Washington, D.C.), George Boughton's *The March of Miles Standish* (location unknown), and Seymour Joseph Guy's *Going to the Opera–Family Portrait* (fig. 43), that received most of the attention. Even though Church's *Petra* received less commentary than had his work in years past, it was still widely written about and generally praised. The critics who found it inspiring lauded both its subject, which captured the sentiment of a doomed civilization, and its artistic treatment, which was considered simple yet powerful.[52] Those less enamored with the picture criticized its methods, from lacking in pictorial interest to condemnation of the paint application as too loose with too broad areas of light and shadow.[53]

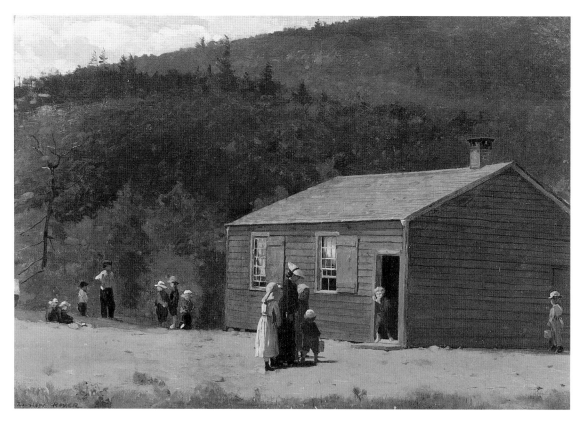

Fig. 44. *School Time*, c. 1874. Oil on canvas, 12 ½ x 19 ¼ in. (32.7 x 48.9 cm).

Collection of Mr. and Mrs. Paul Mellon, Upperville, Virginia

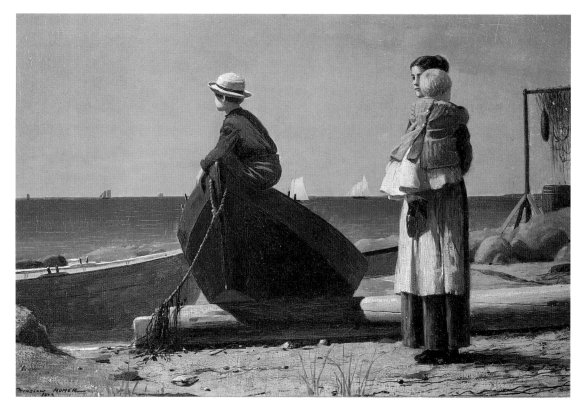

Fig. 45. *Dad's Coming*, 1873. Oil on panel, 9 x 13 ¾ in. (22.9 x 34.9 cm).

Collection of Mr. and Mrs. Paul Mellon, Upperville, Virginia

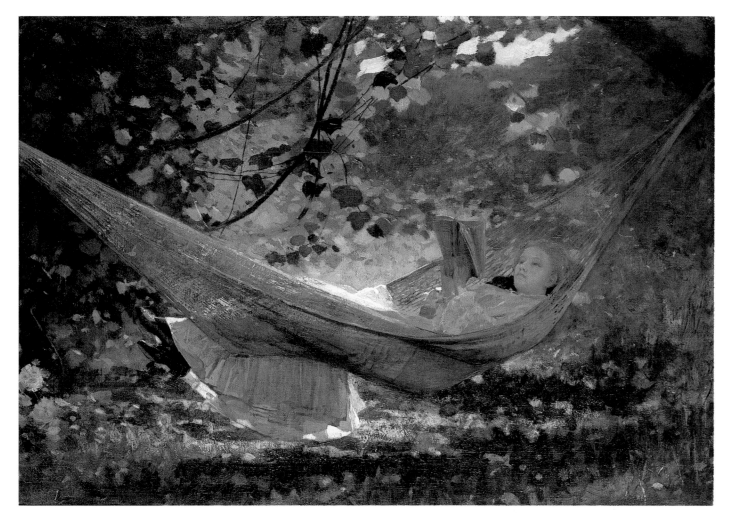

Fig. 46. *Sunlight and Shadow*, c. 1872. Oil on canvas, 15 ¹³⁄₁₆ x 22 ¹¹⁄₁₆ in. (40.2 x 57.6 cm). Cooper-Hewitt, National Design Museum, Smithsonian Institution, New York. Gift of Charles Savage Homer, Jr., 1917-14-7

Of the subject pictures, Guy's *Going to the Opera* along with Boughton's *Miles Standish* commanded most of the attention. The problem of designing a balanced ensemble plagued Guy's *Going to the Opera*, which pictured fifteen members of the Vanderbilt family. It was portraiture; it was genre; it was a commission from a very prominent New Yorker; and it commanded very diverse reactions. Most critics were sympathetic to the task presented to the artist; however, some critics took Guy severely to task for the awkward groupings of the figures, the figures' lack of character, and problems of perspective.[54]

Within this show of multiple monumental canvases, Homer's entries were virtually ignored.[55] Size and, perhaps, the placement of Homer's canvases may have contributed to their going unnoticed. *Watson's Art Journal*, for example, noted that it had nearly overlooked *Sunday Morning*.[56] No one discussed *School Time* (fig. 44). After the popularity of *The Country School* (fig. 24) and, to a degree, *Snap the Whip* (fig. 31), Homer might have expected it to draw notice even though it was only half the size of the earlier pictures. Yet, *School Time*, although it ostensibly reiterated the popular subject of children and education, differed from *The Country School* and *Snap the Whip* in its lack of a focused narrative. *School Time* is composed of series of vignettes spread across the

Nearly
Overlooked

———— • ————

canvas's light-filled fore- and middle grounds. Such a design not only fragmented the telling of any particular story, but also may have diluted its visual impact on a picture-filled wall at the Academy.

Dad's Coming (fig. 45), which has a prominent central figure group and a discernible if ambiguous narrative motif, was at least noticed by a few critics. It was praised for its carefully constructed ensemble of composition and story as well as its suggestion of character in a show that at least one critic felt was too crowded with sentimental platitudes.[57] It was, however, Homer's level of finish, especially in *Girl in a Hammock* (probably *Sunlight and Shadow*; fig. 46), over which the critics divided. While the freedom and sketchiness of Homer's watercolors found approval, his oils were once again condemned by Clarence Cook for not being finished enough. Cook appreciated *Girl in a Hammock* as a "sketch in oils," but wished to see it as a finished picture.[58] His colleague at the *Times* was less bothered by its unfinished quality because an underlying idea was fully enough expressed through good drawing and color even if the methods were sketchy.[59] The face of the girl in the hammock appears more carefully rendered than many of Homer's visages, but the leafy background is painted with very abbreviated brush strokes. The individual leaves are described with alternating dabs of different shades of green. For Cook, if serpentine lines were effective descriptors in a watercolor, such shorthand notation in oil was unacceptable. For the writer of the *Times*, the technique was appropriate for the delightful subject.[60]

By mid-May 1874, Homer had already begun his summer travels. He visited his friend and patron Lawson Valentine at Walden, New York, probably on his way to the Adirondacks.[61] He arrived at Thomas Baker's farm in Essex County, New York, on the fourteenth; he stayed for about a month and was joined by his fellow artists John Lee Fitch and Eliphalet Terry.[62] Homer returned to the Adirondacks for September and October, staying near the village center of Keene Valley. His companions on this second visit included the artists J. Francis Murphy, Kruseman Van Elten, and Roswell Shurtleff.[63] While the company was artistic, no images by Homer are known from this second 1874 Adirondack trip. Fishing, Homer's favorite pastime and easily done in Keene Valley, may have been his primary activity. In between his Adirondack excursions and by the third week in July, Homer, again with Terry but also with Enoch Wood Perry, was visiting East Hampton on Long Island.[64] Although the length of his stay at East Hampton is unknown, his summer artistic activity seems to have been centered there, for much of the season's labor was said to be of East Hampton subjects.[65]

When Homer returned to his studio around the first of November, he began a period of intense painting and exhibiting. This new work came after nearly twenty-four months of the most active involvement in service of the Academy he would ever undertake. There is the sense that as Homer served as a hanging committee and council member, he was seeking his appropriate place in the art community. Perhaps unable to find a comfortable niche for his independent outlook in the politics of the New York art world, he turned away and made his art the sole vehicle for presenting his stance toward the variety of competing issues. The positive response to his watercolors and his use of light in all media gave him indications of where he might take his art with satisfying results. He likely recognized that watercolor gave him an avenue where experimentation was more accepted, and as a new medium where he was immediately identified as original, strong, and honest, it also allowed him additional means to fulfill his role as the artist who gave the best hope for a successful American art.

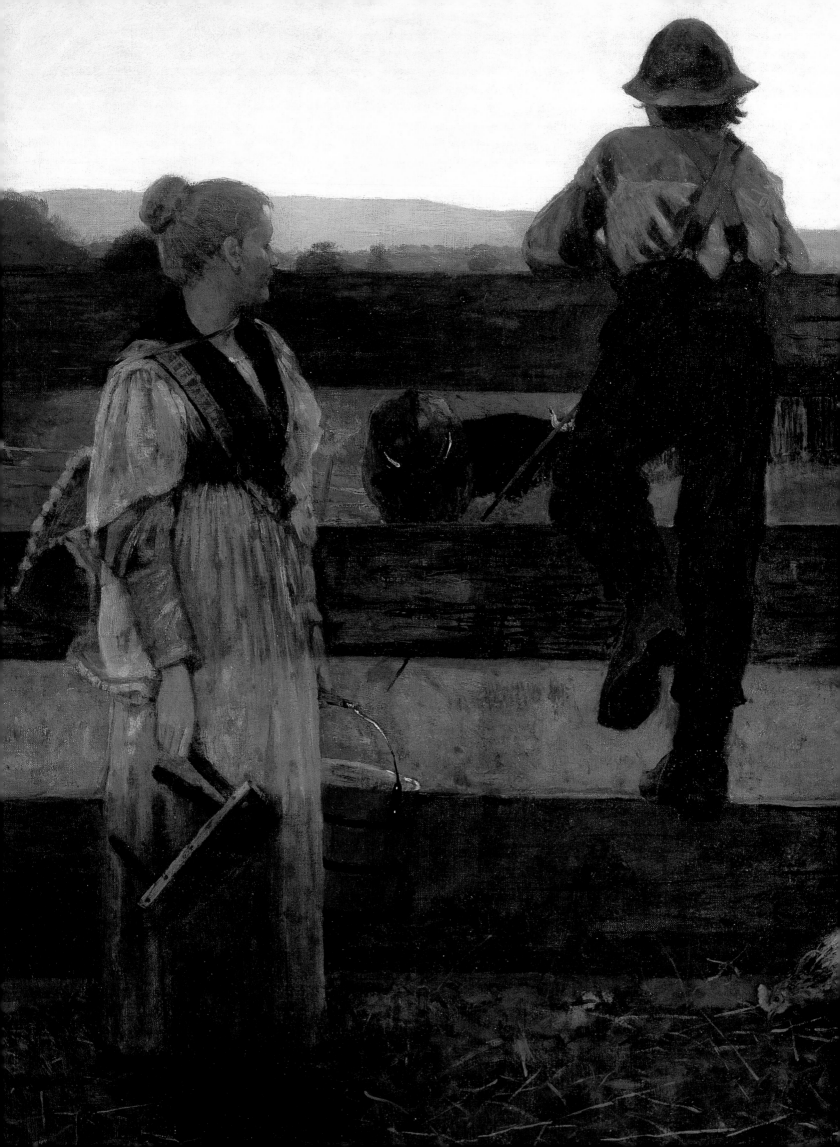

CHAPTER 4 *"In the Midst of an*

1875 *Era of Revolution"*

BY 1875 HOMER REALIZED THAT THE ART WORLD AND ITS IDEALS HAD CHANGED SIGNIFICANTLY SINCE HE BEGAN HIS painting career a dozen years earlier.[1] The roller-coaster ride of the final years of Reconstruction–alternately wild successes and failures in the economic, political, and social arenas–conjoined with a changing artistic landscape to create an atmosphere of uncertainty for the generation that entered adulthood during the Civil War.[2] Most notably, contemporary European subjects and styles were increasingly sought by patrons and as models for American art. In the spring of 1875, the New York art world was shaken when a group of young, Munich-trained artists, most notably William Merritt Chase and Frank Duveneck, exhibited their European productions at the Academy for the first time. The press kept pace with these rapid changes in art, and the volume of coverage increased significantly. New magazines specifically devoted to art, such as the *Art Journal*, arrived on the scene, and general periodicals paid more attention to art matters. Critical debates diversified and intensified as a result.

In these unstable times, Homer made further changes in his art-life. He drew his last two illustrations for *Harper's Weekly* in 1875, ending his career as a freelance illustrator. Assignments on urban subjects, so antithetical to Homer's usually rural-based themes, and the necessary constraints of collaboration in commercial illustration likely contributed to Homer's decision. It is clear, however, that the primary reason that Homer stopped creating illustrative work was his desire for more freedom to pursue his own artistic path.[3] His new path was visible in both his watercolors and oils. In the coming year, he especially concentrated on a greater emphasis on light and design as core elements of his painting. At the same time, he expanded the scope of his subject matter as he kept it centered on distinctly American themes. The work Homer exhibited in 1875 brought him an even more prominent position in the critical discussions. In this pivotal role, he received both the ire and the applause of the art press.

The intensity with which Homer pursued his new path is suggested by the large number of his offerings to the Watercolor Society in 1875: thirty-four sheets were shown.[4] His prodigious output was matched by an equally increased volume of art writing.[5] The overall response to the show was extremely favorable. A number of commentators interpreted the appearance of greater numbers of watercolorists as well as improved quality in the sheets as evidence of progress in American watercolor.[6] Critics acknowledged a wider acceptance of watercolor as a bona fide medium, which they saw demonstrated in the increased attendance and sales at the exhibition.[7]

An increase in figure painting may have contributed to the show's success and watercolor's acceptance. An influx of new practioners in watercolor, including the genre painters

The Watercolor
School Can
No Longer
Be Ignored

———————•———————

Fig. 47. Mariano Fortuny (Spanish, 1838–1874), *Masquerade*, c. 1860s. Watercolor on paper, 17 ⅝ x 24 ¼ in.

(44.8 x 62.9 cm). The Metropolitan Museum of Art, New York. Bequest of Mary Livingstone Willard, 1926 (26.186.2)

Enoch Wood Perry, John Ehninger, and Julian Scott, among others, was mentioned as a welcome addition to the watercolor scene.[8] The increase of figure work in watercolor matched that which was already being noticed in oil painting. This was particularly significant for watercolor since the first wave of American watercolorists had concentrated almost exclusively on studies from nature. The *Art Journal* viewed the greater numbers of figure pieces as an opportunity to urge the use of watercolor for "the production of pictures," not just for sketches.[9]

The European contributions to the exhibition commanded considerable attention. The first question asked was whether European work should have been included in the exhibition at all. Some critics opposed the inclusion of European art altogether because they thought it distracted from both the importance of the society and the ability to ascertain the progress made by the Americans.[10] Others found its inclusion instructive and useful for comparison's sake.[11] Many critics acknowledged the general superiority of European art, especially in figure work and the use of color.[12]

Many of the remarks on technical matters, especially the relative benefits of using gouache or transparent washes, were guided by the reactions to the French, Spanish, and Italian followers of Mariano Fortuny, who flaunted transparent, brilliant color in their work.[13] For many critics, the special appeal of watercolor came from its transparency, the brilliance of its color, and its ability to suggest transitory effects, especially that of reflected light.[14] Henry James especially championed these features of the medium because he accepted that "a picture is . . . essentially a diversion." He wholeheartedly embraced the Roman school's virtuoso style in which he found cunning poses, expressive compositions, beautiful surfaces, and a marvelous fluidity of color that made their

Fig. 48. *A Clam-Bake*, 1873. Watercolor, gouache, and graphite on paper, 7 ⅝ x 13 ⅝ in. (19.7 x 34.6 cm).
The Cleveland Museum of Art. Gift of Mrs. Homer H. Johnson, 1945.229

work exceedingly charming and worthwhile simply because it was delightful.[15] Clarence Cook felt very differ-
ently. Although he applauded the international flavor of the exhibition, he thought that American artists were too
impressed by Fortuny's flashy style (*Masquerade*; fig. 47), especially his arranging bits of color to suggest glittering
light. Cook did not deny that the Spaniard had talent, but he thought it was applied to lightweight subjects. If
Americans were going to look to Europe for guidance, he hoped that they would look to the French painters of
noble subjects, especially Jean-François Millet, Gustave Courbet, and Jean-Baptiste-Camille Corot, in whose work
he found "manly thoughts and feelings, and experiences–with convictions in short, and not mere craftsmen, how-
ever clever."[16] For James, watercolor pictures were valid simply as objects of aesthetic pleasure. For Cook, a paint-
ing needed a meaningful subject. The *Tribune* critic did not require narrative exposition, but in naming thought,
feeling, and experience as necessary components of art, he required a connection to human intellect and soul
beyond what he saw offered by bravura technique. Out of this debate, which essentially pitted art-for-art's-sake
against art as a means of edification, the writer for the *Atlantic* suggested that a conflation of commitments to con-
ception and technique, drawing and effect, would be the best solution for watercolor and that from these combi-
nations a particularly American idiom for the medium could develop. The hope was that American art might
assimilate the best of every culture to create art both aesthetically pleasing and morally sound.[17]

The reactions to Homer's thirty-four entries aligned directly with the points of discussion raised with
regard to the European entries. His sheets, depicting the sea, children, women, farm life, and men in the woods of
Gloucester, Long Island, the Adirondacks, and probably the Catskills, displayed a range of technical applications,

Fig. 49. *Waiting for a Bite (Why Don't the Suckers Bite?)*, c. 1874. Watercolor and graphite on paper, 7 ⁵⁄₁₆ x 13 ⁵⁄₁₆ in. (18.6 x 33.8 cm).

Addison Gallery of American Art, Phillips Academy, Andover, Massachusetts. Gift of Mary D. and Arthur L. Williston, 1948.28

from basically colored drawings to the use of a variety of transparent and opaque applications. As a group, they represented a diversity of both subject and technique that offered the critics much food for thought and prevented Homer's work from being corralled into any one camp.

A "Cloud of
Sketches" or
"Wonderfully
Vigorous and
Original"

Before they delved into the critique of Homer's watercolors, a number of reviewers offered explanations for the artist's large contribution to the show. Homer often produced a great deal of work when he grappled with particular issues, but one critic sensed that the high volume indicated a "sudden and desperate plunge," while others interpreted it as the result of a novice's enthusiasm for a newfound endeavor or a search for artistic materials.[18] Perhaps because of the abundance of Homer's entries, the critics responded to them as a single body of work rather than as individual sheets. This treatment en masse differed from that of his fellow exhibitors, whose entries, even if multiple, were considered individually. The critics addressed broader issues in relation to Homer's art while focusing more narrowly on specific aspects of his peers' work in a way that mirrored the difference between the actual works. In the mass of reviews, the discussions about his pieces were distinguished from those of other artists, and that difference in treatment gave the attention to Homer a certain cachet.

Homer did, indeed, receive some very complimentary responses for his watercolors, but less flattering remarks were significantly more plentiful. Clarence Cook was the most vocal of the discontented. Cook's first attack, fueled by the fact that Homer again did not meet his expectations, focused on the watercolors' lack of finish.

Fig. 50. *In Charge of Baby*, 1873. Watercolor on paper, 8 ½ x 13 ½ in. (21.6 x 34.3 cm). Mr. A. Alfred Taubman

Fig. 51. *Children on a Fence*, 1874. Watercolor over pencil on paper, 7 ³⁄₁₆ x 11 ⅞ in. (18.3 x 30.2 cm).

Williams College Museum of Art, Williamstown, Massachusetts. Museum purchase

with funds provided by the Assyrian Relief Exchange, 41.2

Fig. 52. Pierre Edouard Frère (French, 1819–1886),
The Little Cook (La petite Cuisinière), 1858. Oil on
panel, 12⅛ x 9¼ in. (30.8 x 23.5 cm). Brooklyn
Museum of Art. Bequest of Robert B. Woodward

Although he admired the artist for his powers of observation and his ability to articulate that vision, he was frustrated by what he saw. To him, the watercolors appeared only as a "cloud of sketches" and remained in a skeletal form.[19] Although Cook did not mention any of Homer's works by title, sheets such as *A Clam-Bake* (fig. 48) or *Why Don't the Suckers Bite?* (now known as *Waiting for a Bite*; fig. 49) may have caused his anger. To describe the figures in both sheets, but especially in *Why Don't the Suckers Bite?*, Homer gave form to the boys' bodies and faces through the juxtaposition of light and dark washes with only a barely visible outline in pencil. Their clothing equally lacks detail in a traditional sense and depends on highlights placed on flat blocks of color for its modeling. Likewise, the backgrounds capture their sense of place not through careful details or outlined topography, but with essential landscape elements—such as the log in *Why Don't the Sucker's Bite?*—strategically placed in or created out of flattening broad washes. Cook could not accept that light, shade, and color without a foundation of drawing could form the basis for a picture, yet he did not insist on descriptive replication. Ultimately, he wished for a balance in finish.

Annoyed as he was with Homer's technique, Cook, as well as a number of other critics, found greater fault in his choice of themes. Having condemned Fortuny's subjects as flimsy, he found Homer's too ordinary. He gave Homer credit for capturing national characteristics, but that alone did not make a subject worthy for the *Tribune* critic. Cook felt the underlying problem in Homer's images was that his selection of a country child as a theme had no artistic merit. As Cook outlined: "[t]here's nothing pathetic in him; he is too well fed even when he is worst fed, his rags are too much like good clothes, his dirty face and hands are merely dirty, not picturesque, and his hair is as prosaic when 'tis uncombed as when it is slicked for Sunday."[20] American country children were too robust and commonplace. Even though Cook does not connect his complaint to specific sheets, we can imagine that *In Charge of Baby* (fig. 50) or *Children on a Fence* (fig. 51) simply had no compelling subject-feature in their depictions of a simple moment of everyday American childhood and, therefore, evoked no deep feelings. Cook much preferred the French peasant children of Edouard Frère (*The Little Cook*; fig. 52). Although Cook believed Homer matched Frère in the quality of his artistic treatment, he found the situation of the Frenchman's subjects both exotic and extreme. Instructive in their humble circumstances, Frère's children touched his soul, stirring it to pity and sympathy.[21] Of the American watercolors, Cook lauded Julian Scott's *New England Turkey Shoot,* which also appeared as a wood engraving (fig. 53), as "good in every way—good in color, good in drawing, true to human character, and true to the locality," in a way that reminded him of *Prisoners from the Front.*[22] Scott's work pictured an old-fashioned turkey shoot, which, despite the fact that it had neither the moral nor historic import of Homer's 1866 canvas, successfully merged, for Cook, moment and place with a larger expression of thought, in this case the superiority of America depicted through a scene of quintessential male power.[23]

While a few critics concerned themselves with Homer's subjects, most reviewers concentrated on the unusual style of the watercolors. What little wholehearted praise there was of Homer's means came from those writers for whom specificity of subject or finish was not important. The critics who most highly commended the Roman school (and European contributions on the whole) were especially attracted to Homer's ability to render light and air, which, in turn, were seen to express energy and truth in the images. These perceptions, recognized in both Homer's sketchiest and more finished contributions, gave rise to praise for their freshness as well as recognition of individuality and originality in the work.[24] Several critics tied Homer's success to his economy of means. They accepted that Homer's chosen methods did not demand the carefulness others depended on.[25] The reduced setting, composition, and palette in *Boy on the Rocks* (fig. 54) might have been appreciated for its spareness for the distilled means fit the contemplative subject perfectly.

Fig. 53. Julian Scott (American, 1846–1901), *Turkey Shooting*, wood engraving, *Harper's Weekly*, 18 (17 January 1874), 60

Some critics clearly preferred Homer's more highly developed sheets, whether their greater completeness came as a result of a more explicit narrative or more detail. *Man in a Punt, Fishing* (fig. 55), *The Sick Chicken* (fig. 56), *A Basket of Clams* (fig. 57), and *How Many Eggs?* (fig. 58) all suggest incidents around which particular stories can quite easily be constructed. Homer's use of particularly bold and rich colors and bright light that accentuates their subjects as well as creates complex patterns of lines and shapes throughout the sheets was found to be particularly appealing.[26] Other reviewers reiterated the complaint that they felt Homer stopped short in his efforts, even when they found other aspects of the work pleasing. Noticing especially *A Fisherman's Daughter* (now known as *Girls with Lobster*; fig. 59), the *Art Journal* appreciated the uniqueness and liveliness of Homer's style, but the lack of detail in drawing and traditional modeling caused the image to only hint at its story and, thus, was "a mistaken eccentricity."[27] *A Basket of Clams* received similar criticism from Earl Shinn of the *Nation*. Even though there was much Shinn liked in the image, he felt that "at present his highest exercise is to lay silhouettes of pasteboard on a ground of pasteboard differently tinted, and with these admirably-cut jumping-jacks to go through the various evolutions of life as given 'in the flat.'"[28] In *A Basket of Clams*, the boys with the pail are placed at an angle in the center of a nearly empty expanse of sand. That blankness, in turn, is balanced with the depiction of the boatyard in the background. As a result, we perceive the figures as both resting on the sheet's surface as well as within the space of the image. Clearly highlighted through pose, light, and color, the boys are contrasted against the flattened background, which depicts the boatyard and reads as a complex weave of lines and shapes. Shinn seems to have objected most strongly to the way the combination of design, lighting, and coloration caused the image to shimmer between flat plane and illusionistic space.

While most of the critiques of Homer's technique centered around the issue of finish, the critic for the *Mail* felt that the present watercolors were less spirited and inspired than the entries of 1874. This writer especially liked the brilliancy and transparency particular to watercolor, and so may have been less satisfied with the more

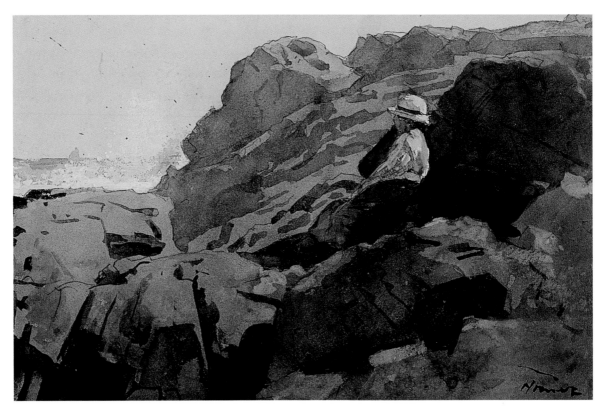

Fig. 54. *Boy on the Rocks*, 1873. Watercolor on paper, 8 ½ x 13 ¼ in. (21.6 x 33.7 cm).
Canajoharie Library and Art Gallery, New York

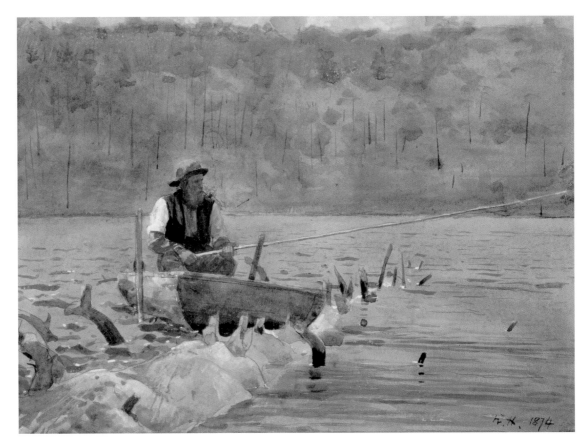

Fig. 55. *Man in a Punt, Fishing*, 1874. Watercolor over graphite on paper,
9 ¾ x 13 ½ in. (24.8 x 34.3 cm). Private collection

opaquely painted sheets. What was most disturbing to him, however, was that he believed the decline in quality was due to the fact that some of the pictures were "copies" of sketches, not the original drawings.[29] Unfortunately, the critic did not mention any specific sheets, but he may have been distinguishing between Homer's plein air studies and studio creations in which he often combined or revisited images. Such a case in the extreme is *Three Boys in a Dory with Lobster Pots* (fig. 60), which, although a Gloucester image, was not painted until 1875. Unlike the spontaneity of the view in the 1873 watercolor *Seven Boys in a Dory* (fig. 61), to which it is related, it presents a more carefully delineated image in a more formal composition that may have seemed static next to the broader washes and contrapuntal balance of its predecessor.

Homer's watercolors and drawings at the 1875 Watercolor Society exhibition, indeed, presented many permutations that works on paper could take. Similarly, the critics offered a wide variety of responses. Many of them could not deny their appreciation of them, even when they did not fit their definition of appropriate representation of themes. Too, the majority could not ignore the visual interest of Homer's style even, or especially, in those sheets that pushed beyond the limits of acceptable practice. Critics allowed for more technical freedom in watercolor, but not to the degree that Homer took it and not in combination with the compositions that accentuated design to the extent that it vied in importance with the subject matter. The more readable narratives, whether due to subject or the exposition of it, always garnered the most praise. Nonetheless, a realignment of subject and style, relative to the greater number of European works now available, was clearly underway and it placed both Homer and the critics in a state of flux. They were all forced to consider more deeply these issues, particularly the definition of completeness and what constituted appropriate subject matter, at the 1875 Academy exhibition.

The National Academy of Design's 1875 annual exhibition celebrated the institution's fiftieth anniversary. The import of this milestone was reflected in the voluminous assessments of the show. As usual, comparisons with the previous year's exhibition served as the starting point for much of the commentary. In the main, writers noted they saw indications of progress, but only one-quarter of the publications reviewing the show were forthrightly positive in their assessments. The reasons given for the show's success, according to those who praised it unequivocally, fell into very generalized categories: more pictures were smaller in scale; a greater variety (mainly of subjects) was displayed; and technical efforts showed improvement.[30] Few critics disagreed that these elements were worthy of praise, but a number felt that these qualities alone did not warrant giving the show high marks. A new rule that forbade the exhibition from including any previously shown work was found by some critics to severely compromise both the selection of canvases and the health of the Academy.[31] Only the *Sun* saw a positive effect of the requirement, crediting it with creating a "freshness" in the exhibition.[32]

While the Academy's anniversary and the implementation of the "no previous show" rule were topics written about repeatedly, the reviews were most attentive to the appearance of a large number of paintings by young Americans studying abroad, especially in Munich. So marked was the effect of these works that Clarence Cook proclaimed: "we are in the midst of an era of revolution."[33] While today the formation of the Society of American Artists and its first exhibition in 1878 are acknowledged as the significant markers of the changes sweeping American art in the second half of the nineteenth century, the 1875 annual stands as the first time the younger generation of European-trained artists, including William Merritt Chase, David Neal, Toby Rosenthal, Frederick Bridgman, Wyatt Eaton, and Edgar Ward, was visible as a new coalition. Their strength, in numbers and images, forced them into the forefront of most critics' articles, and their appearance colored the response to the entire

The National
Academy of
Design at Fifty

——— • ———

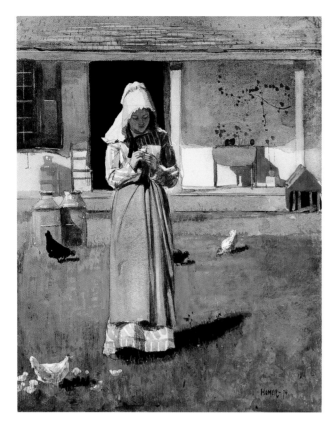

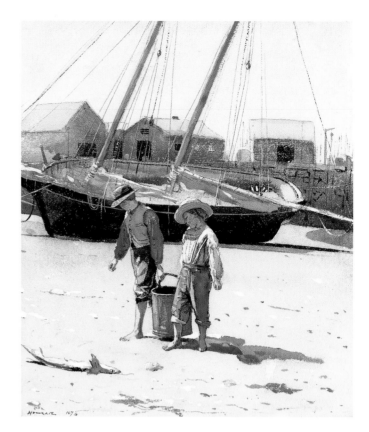

Fig. 56. *The Sick Chicken*, 1874. Watercolor, gouache, and graphite on paper, 9 ¾ x 7 ¾ in. (24.7 x 19.7 cm). National Gallery of Art, Washington, D.C. Collection of Mr. and Mrs. Paul Mellon

Fig. 57. *A Basket of Clams*, 1873. Watercolor on paper, 11 ½ x 9 ¾ in. (29.2 x 24.8 cm). The Metropolitan Museum of Art, New York. Gift of Arthur G. Altschul, 1995 (1995.378)

exhibition. The spectrum of reactions to the younger artists was wide. A number of writers claimed these artists offered the best work while the older generation wallowed in stagnation.[34] With the fiftieth annual exhibition of the National Academy, the split between old and new men became even more notable than in recent years.

The appearance in force of the young, foreign-trained artists added new dimensions to the already complex task of reviewing an Academy show, and the reaction to the entire exhibition outlined the issues that would receive increasing attention through the end of the decade. With the 1875 annual, the various directions taking form in American art were fully apparent. With this variety came a multiplicity of interests, more fragmentation of topical discussions, and an increasing plurality of approaches in the assessment of a single object. The questions fostered by increased evidence of foreign training became paramount and included its general value; the relative virtues and vices of German and French art and the implications of their influence; and the desirability of home or foreign subjects. In this context, discussions of the merits of differing technical applications arose as did ones surrounding subject matter and its relationship to style. Heated debates quickly ensued.[35]

The impact of foreign influence was addressed both generally and specifically with regard to issues such as technique, subject, schools, and individual artists. The critics mainly approved of foreign training. In an atmosphere of frequent complaints that the technical flaws of American painting were due to lack of instruction and the absence of a truly professional art school, foreign influence provided the much sought after "look of training."[36] Complicating the matter was the fact that critics had to consider the influence of a number of foreign cultures, primarily those of Germany and France. The highest praise for the Munich-based artists came from the

Fig. 58. *How Many Eggs?*, 1873. Watercolor on paper, 13 ⅛ x 9 ⅜ in. (33.3 x 24.4 cm). Private collection.

Courtesy of James Graham & Sons Gallery, New York

Fig. 59. *Girls with Lobster (A Fisherman's Daughter)*, 1873. Watercolor and gouache over graphite on paper, 9 ½ x 12 ¹⁵⁄₁₆ in. (24.2 x 32.9 cm). The Cleveland Museum of Art. Purchase from the J. H. Wade Fund, 1943.660

perception that they presented a more sophisticated technique. Yet, the advanced methods were sometimes criticized because their manner appeared too imitative of their teachers.[37] Henry James, however, liked the directness and reality of the Munich-trained artists, but, as he would with Homer's entries, he found their subjects ugly.[38]

William Merritt Chase, who exhibited *The Dowager* (fig. 62), received the most notice of the Munich students. The reason for the attraction to his work was summarized by Susan Nichols Carter: "The touch of the painter is immensely interesting. Paint under his hand has lost its paint-like qualities, and it is spread in flesh, skin, bone and clothing upon the canvas with the nicest feeling to represent qualities and different textures."[39] Other critics reacted similarly to Chase's colleagues, David Neal and Toby Rosenthal.[40] In sum, it was the manner in which these artists used the physical properties of paint—color, thickness of application, and length of brush stroke—to suggest palpable, living flesh that separated them from their home-schooled peers.[41]

Although not commented upon as widely as that of Munich, the effect of French influence was not ignored. Several critics admired Frederick Bridgman's *American Circus in Brittany* (fig. 63) for its superb finish, in a manner similar to but not imitative of his teacher Jean-Léon Gérôme, and especially for its clearly evoked story.[42] Edgar Ward's *Washing Day* (location unknown), an image of Brittany peasants, presented another avenue of French influence, that of Jules Breton. Ward's solid figures and use of reflected light to model forms were favored by a number of critics because they were methods believed to express the "nobility found in the unspoiled peasant."[43] The perceived simplicity and naturalness of *Washing Day* allowed it to be admired for its honesty, defined

Fig. 60. *Three Boys in a Dory with Lobster Pots,* 1875. Watercolor and gouache over graphite on paper, 13 ⁹⁄₁₆ x 20 ½ in.

(34.4 x 52.1 cm). The Nelson-Atkins Museum of Art, Kansas City, Missouri. Purchase: Nelson Trust

not in the sense of the Munich men's honesty of technique through brash paint application, but rather due to the artist's having truthfully painted his observations.[44] Depending on the viewpoint of the critic, different elements contributed to the success of Ward's image. All of them, however, were perceived as visual and artistic honesty that illuminated the essential meaning of his well-chosen subject. Clarence Cook was so pleased with the work that he encouraged Ward to come home and paint similarly with American subjects.[45]

French influence, like that of Munich, was not embraced by all. While the writer for the *Express* saw the most progress and interesting work from the younger artists, he sounded a warning to them. He urged them to be careful of appropriating too much European influence because he believed it was imperative that each

Fig. 61. *Seven Boys in a Dory,* 1873. Watercolor
on paper, 9 ½ x 13 ½ in. (24.1 x 34.3 cm).
Collection of the Farnsworth Art Museum,
Rockland, Maine. Anonymous gift, 1999

Fig. 62. William Merritt Chase (American, 1849–1916), *The Dowager*, 1874. Oil on canvas, 36 x 24 in. (91.4 x 61 cm). Melton Park Gallery, Oklahoma City, Oklahoma

Fig. 63. Frederick Bridgman (American, 1847–1928), *American Circus in Brittany*, 1869–70. Oil on canvas, 23 x 48 in. (58.4 x 121.9 cm). Private collection

culture have its own unique style as each culture itself was unique. At the top of his list of artists needing to temper the French influence in their work was Homer, whom he felt "has gone over to it bag and baggage." Underneath Homer's unmistakably native subjects, the *Express* detected methods "pre-eminently French."[46] In the mind of this critic, recognizably European technique would only contaminate national artistic expression and thus hamper the creation of a national art.

<div style="float:left; width:25%">

"A Very Different Talent"

———•———

</div>

Within this large constellation of new types of painting, the critics also had to grapple with new developments in Homer's own entries: *Landscape* (probably *Haystacks and Children*; fig. 64), *Milking Time* (fig. 66), *Uncle Ned at Home* (fig. 67), and *The Course of True Love* (location unknown).[47] These works brought Homer the first thorough notice of his oil painting since the 1872 showing of *The Country School* (fig. 24).[48] For all the critics, his work was increasingly difficult to fit into existing niches. Thus, like the reviews of his watercolors earlier in the year and those of the young European-trained artists appearing at the Academy now, the remarks on Homer's oils stood apart. The *Nation* called its readers' attention to "a very different talent" as it began to discuss Homer's entries.[49] Other critics, too, were struck by their strong and individual expression.[50]

If the general effect of Homer's work had an air of difference about it, his subjects were all similar, rooted in the familiar, and tied to important contemporary issues. All four of his entries shared common daily farm life as their subject, aligning them to a recognizably American and somewhat charged theme. While the subjects of the canvases were related, they examined a variety of incidents found on a farm. *Landscape* depicts childhood.[51] *Milking Time* pictures everyday chores. *Uncle Ned*, titled after the popular Stephen Foster song of 1848, investigates the interrelations of blacks and whites, and *The Course of True Love* centers on

Fig. 64. *Haystacks and Children*, 1874. Oil on canvas, 15 ½ x 22 ½ in. (39.2 x 57.4 cm). Cooper-Hewitt, National Design Museum, Smithsonian Institution, New York. Gift of Mrs. Charles Savage Homer, Jr., 1918-20-3

romance and features a young man and woman husking corn as they engage in some kind of quarrel.[52] Homer's treatment of these subjects varied considerably. The differences among the four works gave rise to a wide range of comments on many issues and created scattered and sometimes contradictory responses.

The subject of *The Course of True Love* first attracted the critics' attention. Its narrative was found to be Homer's most captivating since *The Country School*. Descriptions of the painting abounded. *Appleton's* detailed the narrative most comprehensively:

> On the edge of a cornfield, a New-England farmer and a country-girl are sitting shaded by the
> tall grain. Ears of corn are scattered on the ground, and the woman, a true type of New England,
> is chewing, in country fashion, on a bit of straw she holds in her hand, and at the same time,
> apparently, she is chewing the cud of disagreeable thoughts. Her lover, a manly looking fellow,
> is twisted about, embarrassment peeping from every feature and even from the toes of his cow-
> hide boots.[53]

The Course of True Love's subject of a troubled romance on a New England farm had special resonance for its viewers.[54] New England, marriage, and farming, were current and integrally related topics of discussion in the decade following the Civil War. New England, long recognized as the seat of America's national identity, experienced greater industrialization, causing a dramatic shift away from its historically agriculture-based economy. Significant shifts in the demographic composition of the region occurred simultaneously. Most notably, rural populations decreased as urban ones increased.[55] At the same time, the number of potential partners for New England women decreased as New England-born men, whose numbers had been decimated by the Civil War,

Fig. 65. Enoch Wood Perry (American, 1831–1915), *The Old Story*, 1875. Oil on canvas. Illustrated in George Sheldon, *American Painters*, (New York: Appleton and Co., 1878), 68

headed West. Amid these changes, the patterns of relationships between men and women, especially with regard to the institution of marriage, entered a state of flux. Single life became more common for both sexes as did marriage at an older age.[56] In the face of the loss of "old" New England and with such institutions as marriage at stake, *The Course of True Love* raised for its viewers contemporary home issues in the guise of a warm remembrance of less complicated times. The commentary on it played into and off this duality.

 The Course of True Love was unanimously recognized as depicting a specific narrative that combined romance, humor, and the characters and characteristics of rural New England. In this way, Homer followed the traditional elements of popular genre painting, like those found in works by Eastman Johnson and Enoch Wood Perry, among others.[57] The subject of *The Course of True Love*, like the subject of *The Country School*, was a winning one.[58] The recognition of the subject as incontestably American pleased the many writers who agreed on the necessity of American subjects for American art, as did the writer for the *Express* above and the one for *Scribner's* who, later in the year, insisted: "Nature, as she speaks in America to those who listen with their own ears, and report with their own ingenuities; life as it is embodied in our political, social, and religious institutions; life as it is lived upon our own soil, and in our own homes—these are the basis of an American school of art."[59] American subject matter was believed to be the gateway to successful American art. Like Perry's *Heart's Ease* (location unknown) and *The Old Story* (fig. 65), also at the Academy, *The Course of True Love* was praised for its familiarity to all viewers and for its presentation of aspects of American life worth preserving.[60] Surrounded by numbers of canvases quoting European themes and methods, *The Course of True Love* offered a stridently American art.

 Henry James was the only writer to criticize the subject of *The Course of True Love*. James felt strongly about Homer's subjects:

> *We frankly confess that we detest his subjects—his barren plank fences, his glaring, bald, blue skies, his big, dreary, vacant lots of meadows, his freckled, straight-haired Yankee urchins, his flat-breasted maidens, suggestive of a dish of rural doughnuts and pie, his calico sun-bonnets, his flannel shirts, his cowhide boots. He has chosen the least pictorial features of the least pictorial range of scenery and civilization . . . [and in* The Course of True Love*] . . . it is damnably ugly.*[61]

Subjects were, in James's mind, to be selected for their inherent beauty, imaginative concept, or aesthetic possibilities.[62] James could not see any vestige of the imaginative or beautiful in Homer's choice of subject.

 If most writers praised the subject of *The Course of True Love*, its artistic treatment received mixed responses. Some critics did acclaim its treatment, including Earl Shinn in the *Nation*, who having recently criticized Homer's lack of finish, could happily report: "The finish is for once carried to an expressive and satisfactory

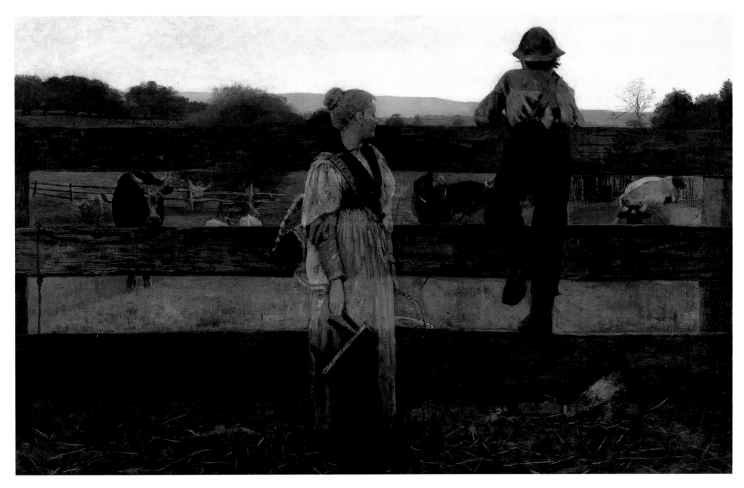

Fig. 66. *Milking Time*, 1875. Oil on canvas, 24 x 38 ¼ in. (61 x 97.2 cm). Delaware Art Museum, Wilmington.
Gift of the Friends of Art and other donors

point, and nothing can be more plainly set down than Mr. Homer's idyl of ill-temper, wherein we can see the acme of endurance accurately reached, and almost hear the rough Hosea-Bigelow [*sic*] patois as these immobile domestic Memnons clasp their knees in the sunshine."[63] The satisfactory finish was defined here in terms of the artist's wholly capturing the construct of emotions behind the narrative and was dependent on pose, gesture, and simplicity of the figure not simply rendered detail.[64] However, a number of critics disagreed with Shinn and instead found the depiction of the couple poorly modeled and crudely painted.[65]

While *The Course of True Love* received only a modicum of criticism for its artistic aspects, *Milking Time* (fig. 66) elicited strong and contradictory reactions. Its subject of a woman and boy watching the cows come home was also familiar and connected to the concerns for the decline of New England farms. Most important, however, was that *Milking Time* was Homer's most daring composition in oil to date. A three-board plank fence stretches across the entire width of the canvas and blatantly serves as the main compositional element. By positioning the fence so prominently, Homer forced the critics to consider the issue of design in his work. The placement of the fence right across the front of the picture plane pushes the illusion of perspectival space into the background. It divides the canvas into two realms and creates a dramatic tension between the actual flatness of the canvas and the three-dimensional space suggested in the image.

Complaints about *Milking Time* were plentiful. William Brownell of the *World* proclaimed the painting to be a disaster because the triple-rail fence gave "the whole composition the 'tender grace of a gridiron.'"[66] For him

and his colleague at the *Times*, such a compositional design showed flawed taste. Both writers preferred the work of artists whose designs were based in a desire to create illusionistic three-dimensional space.[67] The *Sun* lodged a different sort of complaint. It saw nothing dramatic or pictorial in *Milking Time*. It was coarsely painted and too literal, not in its detail, but in recounting a particular observation. The writer, thereby, found the scene devoid of sentiment.[68] Whereas in 1870 Homer's contemporary themes had been too pedestrian or bordered on the inappropriate, now his artistic treatment was condemned as equally so. The literalness of Homer's realism, its bearing on his subjects, and its reconciliation with his artistic treatment were continually thorny issues for critics.

Although the *Sun, World,* and *Times* were critical of the composition and realism of *Milking Time,* others found it interesting, even as they recognized it as radically different from the rest of the paintings in the exhibition. In fact, Homer's difference, as it had before, was seen in itself as a positive quality in this context and was related to his status as an original artist. Earl Shinn in the *Nation* found it extraordinary that Homer made a motif out of the horizontal stripes of the fence, almost in relief against a background of a very similar tone, so that the figures "appear like a decoration wrought upon a barred ribbon."[69] Shinn recognized that Homer's interests here were forthrightly pictorial and that he wedded a highly abstracted design to a familiar subject. Even though he detested Homer's subjects, Henry James, too, appreciated Homer's design vision and also his ability to replicate on canvas how his eye observed the natural world. Homer created a dilemma for James because Homer's brand of realism "cares not a jot for such fantastic hairsplitting as the distinction between beauty and ugliness. He is a genuine painter; that is, to see, and to reproduce what he sees, is his only care." James did not find the expected artistic strategies such as selection, refinement, composition, and imagination traditionally employed in *Milking Time.* This made Homer, according to James, "almost barbarously simple and . . . horribly ugly." There was, nonetheless, something in Homer's work that James liked.[70]

While James ignored or could not accept the fact that Homer's canvas was the result of conscious decisions driven by a pictorial vision, he admired the outcome as artistic in spite of both the flawed subject and what he perceived as the artist's refusal to incorporate the expected artistic devices in his treatment of it. He commended Homer's audacity of treating wretched themes as if they deserved full artistic consideration, and he believed Homer's daring succeeded. Painting in this way, according to James, insured, above all, an artist's originality. He also identified a key factor in Homer's success as an "envelope of light and air" that embraced his entire composition so that every element was integrated visually.[71]

James, like Shinn, applauded a synthetic artistic treatment with the different object masses connected through form, color, and light. Reality came not, then, from detailed delineation replicating facts of the actual world but through a combination of artistic strategies–light, color, form, and paint application, to name a few– which suggested the essence of a person, place, or moment. These reactions to Homer's work mirror those mentioned earlier about the French-trained Edgar Ward's that Shinn and James especially liked.[72] It is also likely that it was this same kind of massing and connecting that alarmed the writer for the *Express* quoted previously and caused him to exclaim that Homer had gone over to the French method "bag and baggage."[73]

Although *Milking Time*'s composition commanded the greatest percentage of remarks, the special quality and unifying effect of its light was noted as well.[74] Whereas Shinn and James saw the modalities of its tone as harmonious and an important structural element, others commended it for how the atmospheric effect contributed to the subject. *Appleton's* called *Milking Time* a "fresh, racy" painting as it noted that "the after-glow of twilight is reflected back from the country-folks, the rail-fence, the silent cattle, lighting up a key of paint which is not soft nor sweet, but which has a sort of peculiar harmony of its own: resembling, though in a different way, the mixture of aromatic, salt, and earthy odors of the New-England country air–air which, too, has its whiffs of pleasant clover scents and fragrance of orchards."[75] Homer's raciness lay in his distinctively strong-flavored artistic treatment

Fig. 67. *Uncle Ned at Home*, 1875. Oil on canvas, 14 x 22 in. (35.6 x 55.9 cm).
Private collection. Courtesy of The Caldwell Gallery, Manlius, New York

through a light and color scheme that successfully brought together the whole constellation of smells of the quin-
tessential American farm, suggesting reality through a visceral response.

Brownell in the *World* continued to be the most cross with Homer, warning him that he was "in very
imminent danger of becoming one of the most tedious and repulsive of painters." Brownell accused the artist of
whimsical ideas in his subjects and color tricks in his treatment and was especially annoyed because he felt
Homer was wasting his talent "content apparently if, like Hodge's razors, his hasty and thoughtless pictures do but
sell."[76] Although Brownell did not specifically outline how these faults were manifested in *Milking Time*, it seems
he saw Homer's composition, spatial relationships, and color as slapped together and deceptive rather than as a
unique and truthful means of presenting a familiar subject. Adding to the critic's irritation was that he thought
Homer was pandering to the market.

The issue of finish, often considered Homer's downfall, was connected directly to many of the already
mentioned remarks. For those less insistent on a traditional surface finish, Homer's sketchier ways were viewed
as a sign of his originality. James, in his call for freer brushwork and breaking up of masses, was the least con-
cerned with traditional surface finish and thus, because of Homer's unique stylistic approach, the critic liked him
mainly for the originality he saw in those methods. *Scribner's* framed the issue in relation to the productions of the
older artists. By comparison, Homer's work was decidedly refreshing. While this critic called Homer's canvases
"only enlarged sketches," he saw in them a "fresh way of looking at things" by virtue of a style that was not only

appropriate, but original and individual "that makes their assistance at exhibitions always valuable."[77] The *Art Journal*, however, was clearly bothered by what it perceived as the unfinished quality of *Milking Time*, an element it found typical in Homer's productions. For this writer, finish was not only found on the surface of a canvas but in the explication of the subject. An unattractive girl, a homely boy, a line indicating a fence with bits of green and cows peeking through did not make a satisfactorily complete picture, even if it were full of spirit.[78]

The *Sun* framed its complaints about Homer's lack of finish in one of the few, short mentions of *Uncle Ned* (fig. 67). Comparing his 1875 entries with earlier canvases, the writer felt Homer showed no technical improvement and observed: "provided the main idea is clearly expressed he seems wholly indifferent to details." Such was the problem with *Uncle Ned*, the painting of which this writer called "slovenly" with the accessories "careless." Yet, the painting's subject and Homer's success "as a delineator of negro character and physiognomy" allowed the *Sun* to call it "a homely idyll, in which sentiment, nature, and character are equally combined."[79] If *The Course of True Love* offered a readable narrative and *Milking Time* investigated the power of composition, then *Uncle Ned* represented the exploration of other artistic concerns, particularly the picturing of bright light. The canvas was not widely discussed and, with the exception of the comment by the *Sun* above, no one noted its African-American subject beyond mere description. The critics noticed, most of all, *Uncle Ned*'s broken light and varied palette. A close look at the painting reveals how Homer dabbed bits of color and white across the canvas, giving it a stippled, sunlit effect, quite opposite from the overall glow found in *Milking Time*. Such an emphasis on light, color, and broken brushwork garnered Homer both praise and condemnation. Whereas one critic found their effects dazzling, Shinn, in the *Nation*, was bothered by the painting's memoranda quality, lack of compositional structure like that he had admired in *Milking Time*, and what he saw as too regularly placed bits of white across the canvas.[80] For Shinn, *Uncle Ned* combined the faults of sketchiness, for which he had earlier condemned Homer, with a patterning of light, perhaps also too bright, that he found distracting.

Working within the boundaries of acceptable subject matter, Homer's entries to the Academy's 1875 annual suggested the variety of artistic interests commanding his attention. With *The Course of True Love* he took the most traditional path, grounding the canvas in a narrative meaningful for the broad public. For this reason, it received praise from the more conservative writers even though they criticized it for its crudeness of style. *Milking Time*, with its daring design, challenged current assumptions about compositional treatment. *Uncle Ned* explored alternative types of paint application, especially with bright color, and though it was only half the size of *Milking Time*, it added to the overall effect of Homer's contributions. In these three canvases, Homer presented his reactions to the complicated artistic issues at hand.[81] He was aware of many different possibilities of presentation as he was trying to define for himself the best way to create meaningful paintings.

Because Homer did not follow any single set of art rules and he so greatly varied his output, the critics still struggled with finding the appropriate language and paradigms within which to situate him. Thus, in 1875 the responses to his work–both watercolors and oils–often reflected contradictory or uncertain feelings, and much of the art writing remained vague. Often those writers who considered Homer the best or most interesting painter simultaneously found his work ugly and uneven. Those who were most critical generally preferred either the older generation of American painters or a more traditional academic European approach. The highest praise came from those who endorsed new ways of visual expression. Homer, having chosen to experiment with different combinations of technique, material, and subject, illuminated the quandaries that American artists were facing in 1875. A decade after the close of the Civil War, nothing was simple or clear in art, as in life.

CHAPTER 5

1876 *The Centennial Year*

THE CELEBRATION OF AMERICA'S CENTENNIAL OCCUPIED THE ENTIRE COUNTRY THROUGHOUT 1876. THIS EXCITING TIME brought a reinvigorated concentration on the state of American affairs and an evaluation of America's character and progress in all fields including art. The primary event of the year for artists was the commemorative exhibition held in Philadelphia during the summer. At the Philadelphia Exposition, the ancillary loan shows it spawned, as well as the annual exhibitions of the Watercolor Society and the National Academy, Homer had opportunities to receive assessments of his works, past and present. In essence, the events of 1876 offered Homer a summary evaluation of his work as they did for American art in general.

Homer's adherence to forthrightly national subjects continued through the centennial year, a period during which taste in art continued to rapidly evolve. The rise of foreign-trained artists was startling, and the simultaneous influx of and interest in foreign canvases both increased and shifted. The *Independent* noted in the first week of 1876: "There is a fashion in art, and just now it is the fashion to buy the pictures of Meissonnier and Gérôme, as it was a few years ago to become possessed of a painting by Edouard Frère or Rosa Bonheur, who are now neglected. Church and Bierstadt were paid what might be well characterized as 'fabulous prices' ten years ago for pictures that would not now sell for a tenth of their former market value."[1] While this remark is explicit about the market, it also reflects the changes occurring in criticism. Within this state of affairs, Homer continued to search for both subject matter and styles that satisfied himself and the critics.

Opening at the end of January, the Watercolor Society exhibition was, as usual, the first major art event of the winter of 1876. Interest in the show remained high, but there were fewer newspaper reviews than in the last two years. One cause for the drop in coverage may have been the impeachment trial of Secretary of War William W. Belknap. The proceedings leading up to his impeachment on March 2, 1876, garnered heavy attention, especially during February, the month through which the watercolor show was on view.[2] Magazines, which were not tethered to daily news, gave the exhibition their regular coverage. Dropping out of the picture, however, was the *Galaxy*, which did not cover art at all in 1876 and ceased publication the following year.

The watercolor show was universally commended. Praise was showered on the success and progress of both the art of watercolor and of the Watercolor Society, the camaraderie of which was seen as in distinct contrast to the fighting within the ranks of the National Academy.[3] The amount of foreign art and how American work compared to it were still topics of interest, but the subject

"Now or Never
Is the Time
to Justify the
Wishes and
Expectations"

———•———

Fig. 68. *Fiction*, 1875. Watercolor on paper, 10 x 11 in. (25.4 x 27.9 cm). The Detroit Institute of Arts. Gift of Robert H. Tannahill

appeared with much less intensity. For one, there were significantly fewer foreign works on view–only about one hundred out of six hundred sheets. More important, there was a greater confidence in American watercolor, which led to a higher comfort level when making comparisons, and a growing appreciation for the foreign works, especially as stimuli for learning.[4] The discussion of opaque versus transparent color also only occurred in passing, most often within the context of discussing a specific artist. There was now clearly a wider spectrum of acceptable techniques for watercolor, and with this came greater approval of the Fortuny circle.[5]

A special interest in new subject matter appeared in the commentary. Some critics suggested that many familiar landscape subjects, such as Lake George or the Hudson River, were overworked and should be replaced with images of life in the West and South. It was pointed out that "the time when an artist could make a name by painting little bits of landscape or marine pieces is, we believe, almost gone by. Some few of our painters have begun to appreciate this fact, and are turning their attention, as we know, in other directions." Homer was named as one of those artists moving in new directions and, with Thomas Waterman Wood, was applauded for his African-American subjects, which were always associated with the South.[6] This call for explicitly contemporary subjects reflected two of the most discussed topics of the day: the exploration of the West and the plight of African-Americans as they faced the harsh realities of the failed policies of Reconstruction.[7]

Another factor contributing to the commendations of the exhibition was the perception that a number of artists had consciously exerted a special effort this year. The suggestion was made that, in addition to growing competition with foreign artists, the upcoming centennial exhibition inspired the heightened exertion. The *Telegram* explained: "Probably some of the painters at present represented on the walls of the Academy do feel that now or never is the time to justify the wishes and expectations that have been formed for them."[8] Homer could easily fit the profile of such an artist. He turned forty years old during the course of the watercolor exhibition, on February 24, 1876, and the combination of that milestone with the centennial, repeated criticism that he had not painted anything really substantive since *Prisoners from the Front*, and the mixed reviews he had received over the past several years may well have caused him to feel that he was at a decisive moment in his career.

"Would Finish Have Spoiled the Charm?"

⎯⎯⎯⎯ • ⎯⎯⎯⎯

Homer exhibited fourteen watercolors and drawings at the 1876 Watercolor Society show.[9] *Fiction* (fig. 68), *Study* (location unknown), *Too Thoughtful for Her Years* (location unknown), *Furling the Jib* (fig. 69), and *A Fish Story* (private collection) were called "pencil tinted studies"; the first three were noted as remarkably finished and strong while the latter were referred to as "two of the most suggestive sketches we have seen for a long time."[10] Of the other works exhibited, *The Busy Bee* (fig. 70), *Contraband* (fig. 71), and *A Flower for the Teacher* (now known as *Taking Sunflower to Teacher*; fig. 73) were fully colored and pictured African-American boys, Homer's first

Fig. 69. *Furling the Jib*, 1875. Pencil and Chinese white on paper, 8 ⅜ x 12 ¼ in. (21.3 x 31.1 cm). Private collection

essays of this subject in watercolor. *The Gardener's Daughter* (location unknown), *Too Thoughtful for Her Years*, and *Fiction* were images of women. *Furling the Jib* was a marine subject, as was *A Fish Story*. *A Glimpse from a Railroad Train* (location unknown) showed boys swimming.[11] Once again, Homer displayed diverse subjects and styles, an indication not only of his own broad interests, but perhaps also a reflection of his desire to ensure a measure of acceptance with the critics.

The number and length of the reviews of Homer's watercolors paralleled the smaller number of overall reviews. There were, nonetheless, some thorough considerations of his work.[12] As in the past, the sheer numbers and visual distinctiveness of Homer's sheets set them apart. Once again, they were primarily dealt with as a group. The critics' assessments of Homer's work were complicated by the fact that his watercolors covered a wide range of subject matter and did not single-mindedly follow any one aesthetic or technique. This multiplicity confounded the critics as they tried to make definitive statements about his work.

The issue of finish was prominent in the reviews of the 1876 Watercolor Society annual. The press's view that Homer's sheets lacked it dogged him to a greater degree than previously. A reason for the critics' heightened concern with finish may have been that as watercolor became more acceptable as a legitimate medium, they had less tolerance for works that appeared sketchy or incomplete unless they were specifically identified as studies.[13] Whether subjects were architectural, native genre, military, or land- or seascapes, the critics praised those with visual completion. Of the Europeans, Jean Vibert, Edouard Detaille, and Killingworth Johnson were named as the best. The elaborate subjects and careful finish of works by the Americans Samuel Colman and Edwin Austin Abbey were remarked on repeatedly and often favorably.[14]

In this context, Homer's sheets appeared decidedly unfinished. But they were also the ones critics found

Fig. 70. *The Busy Bee*, 1875. Watercolor and gouache
on paper, 10 ⅛ x 9 ½ in. (25.7 x 24.1 cm).

Private collection

most interesting and were often considered the best. Earl Shinn, in the *Nation*, was most articulate about the conflict this created:

> It is hard to say whether irritation or pleasure prevails in contemplating the present works of this artist, they go so nimbly up to a certain point and stop so definitively within the gaol [sic]. It may, perhaps, be acknowledged that his pictures are the only figure-pictures by an American exhibitor which are grasped with the real dramatic force. . . . But each is shouted out of breath so hastily and rawly that the prevailing impression perhaps is a sense that we are defrauded. . . . Would finish have spoiled the charm? If so, the shortcoming of Mr. Homer's art is confessed.[15]

Elements of *The Busy Bee* (fig. 70) and *Taking Sunflower to Teacher* (fig. 73) were particularly pleasing to Shinn. He commended the ideas behind the images and how they were expressed through pose. The statuesque stance of the boy in *The Busy Bee* endows the image with a nobility that raises the mundane incident to a higher level of contemplation. The suggestion of hope coupled with an equal measure of defeat and despair in *Taking Sunflower to Teacher* also was accomplished through pose and gesture. The boy's shoulders appear buckling under some unseen weight, evoking resignation, at the same time his upturned glance indicates both doubt and a glimmer of innocent optimism. Shinn found the desired character, appropriate surroundings, correct degree of expression, atmosphere, and color in both these sheets, but for a critic who noted "[t]he patient pursuit of detail cannot be too highly commended," the modeling of the figures mainly through color and the definition of the settings with broad washes overlaid with dots of complementary or contrasting colors was seriously compromising.[16] Shinn used the work of Detaille and Thomas Eakins as exemplary models, and although Eakins's work was sadly noted as absent, he may have had in mind sheets such as Eakins's *Whistling for Plover* (fig. 72), in which line and traditional modeling define the figure. In comparison, Homer's figures were decidedly flattened, as were the backgrounds. It was only in the soldier of *Contraband* (fig. 71)—a figure reminiscent of those painted by Europeans like Detaille—that Shinn found an analogous degree of finish through modeling that met his requirements.[17]

Other critics were also troubled, as they had been with the recent oils, by Homer's lack of finish because it compromised the full articulation of his subjects. They looked for a sense of completion, both visual and of thought.[18] The *Art Journal* explained that "the ordinary observer needs more than a few wild strokes with the crayon or other medium to command admiration or attention," and, even though the writer found the watercolors charming, he faulted Homer for presenting only a glimmer of an idea and not taking it to the point where his viewers could understand it.[19] From a similar viewpoint, Erastus South of the *Daily Graphic* suggested that

Homer might have better success if he would concentrate on one single figure and finish that one satisfactorily.[20] A variety of techniques was gaining acceptance as vehicles for successful finish, but completion of both thought and outward image was necessary to warrant public showing.

Clarence Cook took a somewhat different position regarding Homer's finish. He found Homer's entries "not as conspicuously sketchy as they were on the last occasion" and admitted that "Mr. Homer is easily the first man we have in figure subjects."[21] The *Tribune* critic regretted that Homer's sheets were not more finished or of more interesting subjects, but he championed Homer because "he is rarely stupid and never dull; he loves his work and communicates hi[s] own interest to us. Let him keep his drawings away from our exhibitions and we should soon find out what we had lost."[22] Cook's unusually forgiving (though still somewhat backhanded) response was, in effect, a reply to the *Mail*'s criticism of Homer that suggested the artist had lost the freshness of his first exhibited watercolors. The problem for the unidentified critic of the *Mail* was not just that Homer was sketchy, but that he continued to tread over familiar territory to accommodate public taste. He accused Homer of creating lifeless replicas of his work to assure their marketability. Unfortunately, this writer did not tie his remarks to any specific sheets and only indicated that the present work denied the "snap" of his earlier ventures and thus appeared "tame" as well as careless.[23] The only specific complaint aired by the *Mail* was that Homer mixed the methods used for oil with those of watercolor, and such practice prevented them from being "entitled to rank as pictures." However, this critic's reactions to other works in the show suggest that what was perhaps most bothersome to him was his perception that Homer's emphasis on technique caused him to explore only insubstantive subjects. He claimed about the show overall: "There are too many purposeless pictures, which have no meaning, no intention to them," and his most positive remarks were for images that held moral stories within them.[24]

Although Clarence Cook could not find a single subject in the exhibition worthy of wholehearted praise, he and his colleague at the *Mail* shared a devotion to the importance of thoughtful subject matter and a concern that it was being overshadowed by technical achievements. Even as he defended Homer as an artist, Cook found his subjects only semi-comical or ridiculous and, therefore, appalling. Cook's language, including the calling of the figure in *Taking Sunflower to Teacher* "a monkeyish little darky-boy," indicates the larger problem of a discomfort with Homer's choice of African-Americans as valid subjects for art.[25] Cook found all of Homer's subjects only commonplace at best. To his eyes, they lacked the poetry and emotional and intellectual content he continually sought in art, but his apparent prejudice against African-Americans sank his distaste for those subjects even deeper.[26]

Fig. 71. *Contraband*, 1875. Watercolor on paper, 8 ¾ x 7 ⅞ in. (22.2 x 20 cm). Canajoharie Library and Art Gallery, New York

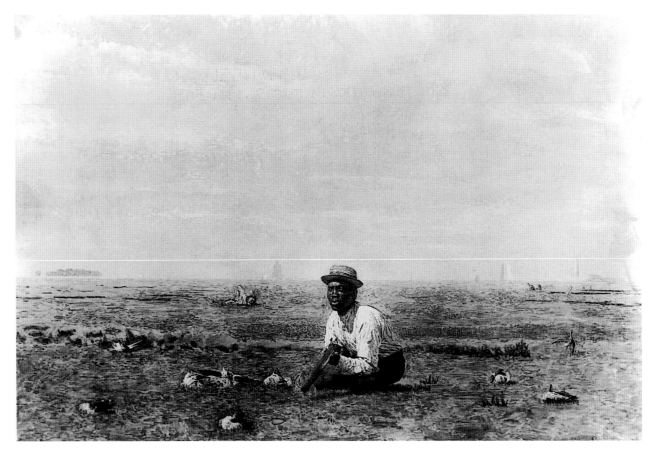

Fig. 72. Thomas Eakins (American, 1844–1916), *Whistling for Plover*, 1874.
Watercolor over graphite on paper, 11 ⁵⁄₁₆ x 16 ¹¹⁄₁₆ in. (28.7 x 42.4 cm).
Brooklyn Museum of Art. Museum Collection Fund

Cook's and the writer for the *Mail*'s responses to Homer's African-American themes were atypical. *Contraband*, *The Busy Bee*, and *Taking Sunflower to Teacher* were the three of Homer's contributions whose subjects received the most positive attention, and a number of critics singled them out as both appropriate and especially worthy of celebration.[27] Their popularity stemmed, in part, from their meeting the call for images related to the South. Even though these watercolors were most likely based on New York experiences, they addressed current racial issues such as education and labor for freed African-Americans, which had special associations for the South.[28] As white Americans grappled with the practical integration of African-Americans in everyday life,[29] Homer's African-American subjects were so welcomed for their combination of topicality, humor, and pathos as to override any technical deficiencies. Framing these charged subjects to evoke perceptions of humor made them especially successful. Critics saw a measure of levity in the discomfort of the boy in *The Busy Bee* as well as what was seen as the figure's distinctive characteristics through narrative and attributes, today recognized as stereotypical. Yet, these writers also found underneath their first lighthearted response a more serious tone that kept the images from parody or caricature.[30] Although these critics did not tie their reactions to Homer's artistic treatment, it was surely from the effects of his methods, outlined earlier by the *Nation*, that encouraged such responses.[31] The acknowledgment and approbation of the serious undercurrent of Homer's African-American images were most obvious in *Contraband* (fig. 71). As a subject directly referencing the Civil War, it was specifically connected to *Prisoners from the Front* (fig. 1), the canvas that had made Homer's reputation, a fact Homer was unlikely to have forgotten.[32]

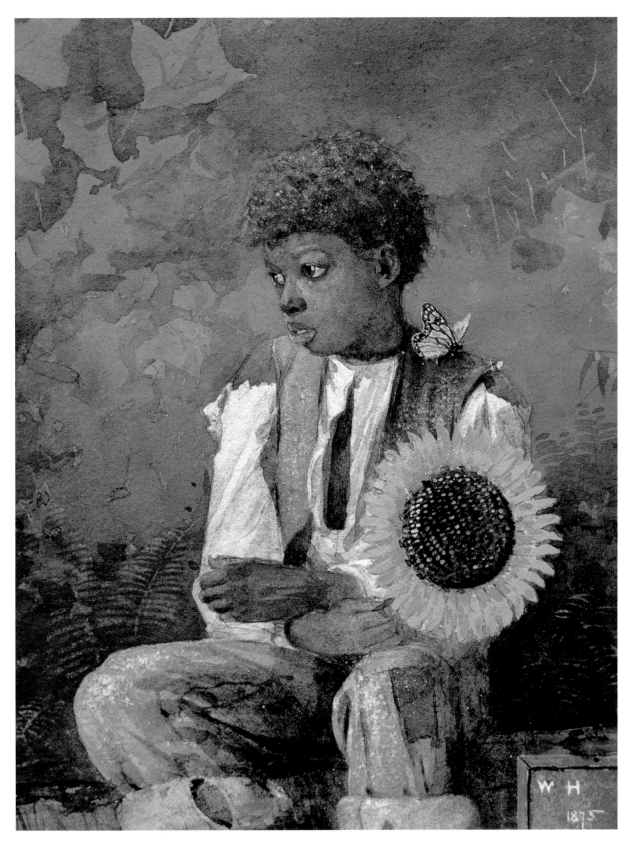

Fig. 73. *Taking Sunflower to Teacher (A Flower for the Teacher)*, 1875. Watercolor on paper, 7 ⅝ x 6 ³⁄₁₆ in.

(19.4 x 15.7 cm). Georgia Museum of Art, University of Georgia, Athens. Eva Underhill Holbrook

Memorial Collection of American Art. Gift of Alfred H. Holbrook, GMOA 45.50

There was no topic more national or contested than the situation of African-Americans in the immediate post–Civil War era. Homer's three sheets picturing African-American youths thus overshadowed his eleven other offerings. The responses they elicited outline the diversity of issues–artistic, political, and social–that were constantly being negotiated. Homer's presentations elevated his images to a level that required serious contemplation. Depending, in part, on the personal politics of the critic, responses varied. Overall, the timeliness of Homer's African-American subjects, along with the rising acceptance of watercolor as a medium equal in status to oil, caused the reviews of Homer's watercolors to follow a pattern more similar to that of his oils. Although ostensibly it was his lack of finish that, for most writers, kept his pictures from belonging to the highest rank, his subjects, even though they were appreciated, caused a tension in the responses. Again, Homer supplied the critics with art that was undeniably fulfilling the call for uniquely American art. Yet, in doing so, he challenged the critical body both with his subjects and style to such a degree that it once again compromised his position as the top-ranking artist.

"The Tide Has Turned"

———— • ————

The National Academy of Design annual exhibition for 1876 opened about a month after the watercolor show closed. Like the watercolor exhibition, the Academy show suffered from somewhat fewer reviews.[33] The opening of the Centennial Exposition in early May likely shifted the focus away from the Academy and towards the art exhibition in Philadelphia.

Reactions to the 1876 annual were mixed. Praise outweighed complaints, but much of the general response was related to the fact that older artists were seen in smaller proportion to the new generation.[34] Accompanying this reaction was the view, shared by all, that the younger artists had made considerable progress. Cook was the most excited by what he saw:

> *The present exhibition of the Academy . . . will make itself remembered . . . as one in which for the first time the influence of the new generation of painters has made itself distinctly felt . . . [and despite reflecting much foreign influence] . . . there is so much independence and so much feeling shown as to justify us in the hope that the tide has turned and that we shall soon be no more bound in the flats and shallows of the last ten years.[35]*

Whereas in 1875, the younger men had provided the shock of the new, they were now embraced as offering the possibility of salvation for American art not unlike the way children were viewed as redeemers for America at large in the post–Civil War era.[36] From this viewpoint, commentary often focused on finding evidence that American artists were achieving parity with their European counterparts, rather than on what they were actually painting at this moment.[37] The political situation at the Academy was also folded into this discussion. Some of the bright outlook was grounded in the critic's perception that the younger artists received better treatment than in 1875.[38] Others, however, saw evidence of jealousies in the hanging of the show and also felt it did not represent American or metropolitan art.[39]

The sobriquet of "new men" in 1875 was virtually synonymous with those artists studying in Munich, but by 1876 its definition had been broadened to include more of the art students in Paris as well as younger artists working in America. The names repeatedly mentioned in this context included Edward Moran, Charles H. Miller, Daniel Ridgway Knight, Thomas Hovenden, Enoch Wood Perry, Maria Oakey, A. T. Bricher, William Magrath, and Homer.[40] Munich-trained artists, in fact, faded somewhat into the background this year as their numbers were fewer. Although the younger artists were praised as a group, opinions varied as to which were the best pictures, sub-

jects, and styles. In some cases, praise came almost by default.[41] Some writers felt the show's primary problem was the lack of individual great pictures, but *Appleton's* found it to be redeemed by eight specific canvases: Eastman Johnson's *Husking Bee, Island of Nantucket* (fig. 79), William Page's portrait of Charles William Eliot (1875; Harvard University), John La Farge's *New England Pasture-Land* (now known as *Paradise Valley*; fig. 74), J. Lieck's *Cupid* (location unknown), Maria Oakey's *Woman Serving* (location unknown), Jenny Brownscombe's *Grandmother's Treasure* (location unknown), and William Sartain's *Italian Head* (location unknown). To this group the writer was willing to consider including Lemuel Wilmarth's two works, *"There Is Music in All Things if Men Had Ears"* (location unknown) and *Practical Joke on the Pioneer: An Incident on the Morning of a Target Excursion* (location unknown), and Homer's *A Fair Wind* (now known as *Breezing Up*; fig. 76).[42] Out of this group, Johnson's and La Farge's canvases received the most plentiful and positive attention. Even so, Homer's *A Fair Wind* was widely appreciated.

Fig. 74. John La Farge (American, 1835–1910),
Paradise Valley (New England Pasture-Land), c. 1865.
Oil on canvas, 32 ½ x 42 in. (82.6 x 106.7 cm).
Terra Foundation for the Arts, Chicago.
Daniel J. Terra Collection, 1996.92

Homer exhibited five paintings at the Academy in 1876: *A Fair Wind, Cattle Piece* (now known as *Unruly Calf*; fig. 77), *Over the Hills* (now known as *Rab and the Girls*; fig. 78), *Foraging* (location unknown), depicting an African-American boy and a Zouave, and *Old Boat* (possibly *Calling the Pilot*; private collection).[43] The writers who thoroughly reviewed the show carefully studied Homer's paintings, and it is clear his contributions attracted special notice.[44] *A Fair Wind* received the lion's share of that attention. It received very high marks overall, but overwhelming success was not yet to be Homer's. Many writers could not help but note some reservations, nearly equally divided, about its subject or technique. Despite these complaints, *A Fair Wind* was held up as Homer's best picture since *Prisoners from the Front* and almost as important.[45] For most critics, it was *A Fair Wind*'s combination of an unquestionably American subject and appropriate execution, riding in a wonderful symbiotic balance, that made it extraordinary. Clarence Cook, who had recently been so critical about Homer's subjects, was finally pleased. He found in this canvas that Homer "at last painted a picture, a marine subject, that will at once delight and surprise those who have feared we were never to have anything from his hand but sketches."[46] Cook elaborated in the second installment of his reviews:

> *No eye that delights in salt water, and in the sight at least of a sail-boat bounding over it; and no eye that can take pleasure in seeing the human body painted with a master hand, with absolute truth of motion, with energetic restraint of muscle, with freedom of life to move or not to move, and all as if in play, but must admit . . . that there is not anywhere–at home, in France,*

"At Last Painted a Picture . . . That Will at Once Delight and Surprise"

Fig. 75. Enoch Wood Perry (American, 1831–1915), *A Quilting Party*, 1876. Oil on canvas, 25 x 30 ¼ in. (63.5 x 76.8 cm). Location unknown

or even in England–a painter capable of its mate. It has always been reckoned a difficult task to paint people in a boat . . . yet here we see it done to perfection, and the people, for all the difficulties of their attitudes, placed with such ease and yet such certainty that we make one with them and cut the foam as glad as they.[47]

Cook thought a large part of the canvas's power resided in Homer's ability to find a subject to which nearly every viewer could feel a positive emotional connection (and here what was captured was the zest of life). But it was Homer's artistic solutions, which this time did not betray the artist's usual lack of refinement of line and color, that ensured the subject's success.[48]

Vitality in painting was of paramount importance to Cook, and in this exhibition he compared Homer to Enoch Wood Perry to underscore why *A Fair Wind* fulfilled that requirement. Cook appreciated Perry's carefulness and attention to American subjects in a work like *A Quilting Party* (fig. 75), also at the Academy, but the critic noted that the problem with Perry's paintings was not a result of his subject's basis in the past, as one might assume, but in contrast to Homer's figures, Perry's had no sign of life.[49] Cook looked for the sense of vitality to emanate from a painting's style and technique as well as its subject, and such a concern seems connected to the larger one that American art be vital itself, especially in the centennial year.[50] Cook's call, ultimately, was for art that stirred both the human heart and the eyes.

Other critics equally praised the animated power of *A Fair Wind* for its expression of feeling that was positively exhilarating and familiar. The *Sun* found the painting's evocation of life in the sense of motion it conveyed and that its positive force overcame the deficiencies of Homer's technique. The writer for the *Sun* was, on the whole, tired of the conventional treatment found in most American art, especially landscape painting. He called, instead, for artists to follow Hippolyte Taine's directive to "'experience original sensation in confronting objects' . . . [to] receive 'a strong peculiar impression.'" This, according to Taine and the *Sun*, would prevent imitation and ensure originality.[51] The *Sun* ranked *A Fair Wind* as one of the best pictures in the show and consonant with Taine's theories, noting it "is painted in his customary coarse and negligé style, but suggests with unmistakable force the life and motion of a breezy summer day off the coast. . . . There is no truer or heartier work in the present exhibition."[52]

The remarks by Cook and the writer for the *Sun* suggest the complexities of determining what made a work worthy of praise. As the array of technical methods commanded more attention, subject and style were increasingly linked, and the manner in which they supported or were appropriate to each other was more frequently discussed. But, as both these writers also pointed out, achieving proper finish, that is, presenting completeness of idea in an appropriate style, was the key to success. Failure in either regard hindered the other and thus compromised the work overall. Other critics added to this discussion. Earl Shinn remarked that, although he thought the hanging of Homer's work was unfortunate, *A Fair Wind* "gives us this spring the most admirable

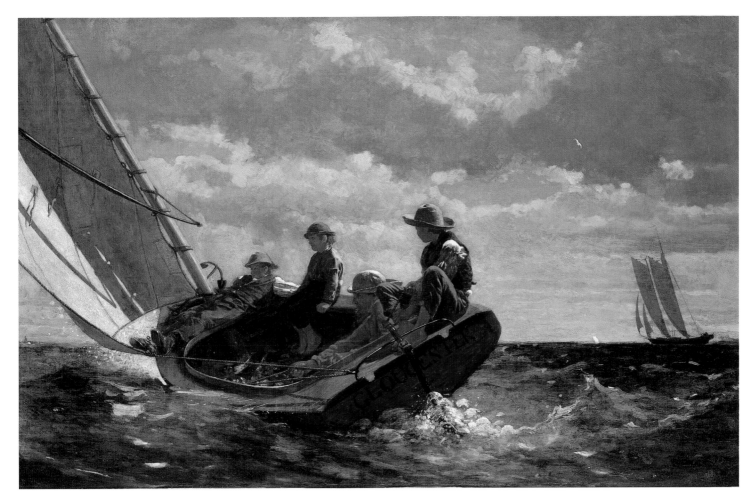

Fig. 76. *Breezing Up (A Fair Wind)*, 1873–76. Oil on canvas, 24 ⁹⁄₁₆ x 38 ⁵⁄₁₆ in. (61.5 x 97 cm).
National Gallery of Art, Washington, D.C. Gift of the W. L. and May T. Mellon Foundation

sketch he has made since the period of his war-pictures. The exulting freedom with which his brush ripples over the canvas . . . is for Mr. Homer a revelation. He has never told a story so well, nor has his pithy economy of expression in telling a story ever become him more." The clean outlines of the figures, the sense of motion, and the alternating areas of light and shade made the painting a "thorough-built marine" despite the fact that he only still considered it a sketch and could not consider it a fully realized painting. The successful outcome of this painting coupled with the perception that it was yet only a sketch caused Shinn to ponder why Homer did not paint this well all the time.[53] The writer for the *Times* agreed with Shinn but more pointedly outlined the problems of Homer's style: "The great trouble with this gentleman is that he has an admirable facility which tempts him to half do things."[54]

While Shinn's criticism appeared in the context of very high praise for *A Fair Wind*, the *Art Journal* could not move beyond its repulsion for Homer's treatment even though it liked the painting's subject very much. Even though this writer perceived truth and energy in the canvas, he found the handling only partly expressed a subject deserving thorough treatment. It is hard to know exactly what constituted the "eccentric" drawing he saw, but his distaste for the "rude" handling in light of his general preference for more tightly finished work suggests that the overall level of detail in *A Fair Wind* was not crisp enough to meet his requirements. Echoing, it seems, the sentiments of many of his colleagues, he felt: "It is impossible to deny Mr. Homer's genius; it is equally impossible

Fig. 77. *Unruly Calf (Cattle Piece)*, 1875. Oil on canvas, 24 ¼ x 38 ½ in. (61.6 x 97.8 cm). Private collection, Chicago

to be always satisfied with what he puts on canvas."[55] Even with all its positive elements and as it gained for him some of his greatest acclaim to date, *A Fair Wind* still sustained certain criticisms and was used as a platform to discuss the faults of Homer's art in general.

Comparing *A Fair Wind* with *Milking Time* (fig. 66) of the previous year, it seems likely that in the 1876 painting, Homer was responding to some of the criticism of the earlier picture. It is well known that he worked several years on *A Fair Wind*.[56] Such labor suggests a determination to improve his work. After receiving negative responses, Homer seems to have adjusted his subject matter and artistic treatment to better agree with the critics' viewpoints, similarly to the way he responded with *The Country School* in 1872 after the scathing reviews of 1870. Here, in *A Fair Wind*, Homer again capitalized on the positive response he had garnered with subjects immediately identifiable as American and ones to which the public could relate. It appears Homer understood the effect of the contentiousness of African-American subjects, the importance the expression of vitality held for nearly all critics, and that it was his life- and nation-affirming themes that saved him from even his most strident detractors. Thus, in *A Fair Wind*, he put forth a subject in which action was central for the display of positive American characteristics and experiences. The compositional design of *A Fair Wind*–most notably the placement of the boat on an acute diagonal–created an image of three-dimensional reality against a flattened background. Such a design, which exactly reverses the spatial relationships of *Milking Time* that were so criticized, charged the subject with energy. Another complaint of the earlier work that Homer seems to have addressed was the appearance of the

figures' faces. The features of the sailors in *A Fair Wind*, even though the ruddy skin tone is derived from a red-dish underlayer of paint, are not only much more visible due to their poses but are more carefully delineated than in *Milking Time*'s farmers.

Homer's other entries in the 1876 Academy exhibition, however, added fuel to the critics' frustrations with the artist. Less noticed—in itself a kind of negative criticism—they received a greater variety of responses, with the balance decidedly unfavorable. Some writers who had discussed *A Fair Wind* at some length dispensed with his other canvases in a single phrase or sentence, and often unflatteringly.[57] Subject matter, which had been univer-sally admired in *A Fair Wind*, was considerably criticized, especially in *Cattle Piece* (fig. 77) and *Foraging*. Cook found them uninteresting.[58] The writer for the *Atlantic* agreed and, especially in the case of *Foraging*, was partic-ularly annoyed with Homer because he felt he applied a very successful treatment to an undeserving subject. The *Atlantic* acknowledged that Homer was not the only artist who had failed in this regard: "Thus far there has been no one of eminence in the profession who has been inspired by the picturesqueness found here to immortalize types and scenes in the same way that [Jean-François] Millet, [Jules] Breton, [Josef] Israels, and other men have been called to perpetuate certain characteristics of their countrymen."[59] As Cook had complained about Homer's rural children in the watercolors exhibited in 1875, Homer's subjects, most notably the humorous incident in the otherwise drab daily life of wartime, were again too ordinary. Similarly, the *Atlantic* writer was looking for an artist who painted recognizably American subjects but, as Sarah Burns has pointed out, within the framework of an older agrarian ideal, where a peaceful atmosphere, harmonious with nature, conveyed a spiritual dimension akin to that which informed the peasant subjects of European artists, especially those of Millet.[60]

Vitality again partially saved Homer's *Cattle Piece*. Its uniquely American subject, spirit, narrative action, and design energy were recognized as its redeeming features by a number of critics when it was first seen in Homer's studio.[61] Cook's demand that art be alive allowed him to admire both *Cattle Piece* and *Foraging*, even though they portrayed subjects he could not tolerate. In them, Cook found Homer had nothing to say, but the action depicted in *Cattle Piece* alone repeatedly attracted him.[62] Cook responded to the tangible feeling of tension Homer created through the painting's composition. The placement of the incident, slightly to the right of center, combined with the weighted stances of both the boy and calf set up the image to focus on a story of opposing forces. The low viewpoint, high horizon, and tight cropping that place the action against the background of grass intensify the image of struggle by containing it in a compressed space. There is hardly room for escape on any side without falling outside the picture plane. However, the *Art Journal*, admitting the painting's action was admirable, still found it trying. The writer, who preferred the work of Seymour Joseph Guy, Enoch Wood Perry, and Eastman Johnson, was clearly attracted to more detail and surface finish, even though he did not feel that a polished, lapidary quality was entirely necessary. The critic praised Johnson's *Husking Bee* (fig. 79) because its breadth of handling, appropriately suggesting the atmosphere of the outdoors, was conjoined with a depth of per-spective through which the story of the figures unfolded both literally and figuratively. In contrast, the tight flat-tening perspective and patterning of small bits of color and light throughout the landscape of *Cattle Piece*, fractured rather than completed the image.[63]

The few remarks about Homer's *Over the Hills* (fig. 78) pulled his canvases into the larger discussions about design. First exhibited before the dog was painted in, the figures juxtaposed against the flat background attracted the critics' attention.[64] There is no doubt that the design of *Over the Hills* stands out distinctly even from Homer's own canvases of this time. It shares all the compositional elements that over the last few years had become familiar: low viewpoint, high horizon, cropped edges, and tonal values in the landscape countered with light and dark contrasts. Here, however, the placement of much more highly modeled figures right up to the front edge of the canvas, along with the now signature design strategies, brought the two women into much higher

Fig. 78. *Rab and the Girls (Over the Hills)*, 1875. Oil on canvas, 24 x 37 ⅞ in. (61 x 98.7 cm).

The Parthenon, Nashville, Tennessee. James M. Cowan Collection

relief than any picture heretofore. Earl Shinn liked the two women's "handsome hardness" and the atmosphere of "dustless air" in the painting, but he felt that it was at a cost to the work on the whole. Noting that the canvas was very typical for Homer, he likened its design to a Japanese lacquer box, where not only was the perspective significantly condensed, but also the tonal palette further integrated the compositional elements to make an image in which subject and artistic treatment equally vied for attention.[65]

Instead, it was Johnson's *Husking Bee* that Shinn and many other critics preferred.[66] Shinn saw in Johnson's design a successfully integrated idea, proper relation of figures to their surroundings, compositional design, and light, but in Homer's canvas, the flatness of the design overpowered the subject's conception. The objection to Homer's two-dimensionality (rightly recognized by Shinn as derived from Japanese examples) in *Over the Hills* was more strongly voiced by Clarence Cook and connected to his distaste of the subject: "[T]wo girls stuck bolt upright in the middle of a barren canvas, can be interesting to nobody, neither painter nor laymen; it is Mr. Homer when he has nothing to say and persists in taking a big canvas to say it in."[67]

Shinn and Cook also praised La Farge's *New England Pasture-Land* (fig. 74). Its "bald" features made it American, and while Shinn praised the high horizon for the unusual viewpoint it presented, Cook, not quite able to articulate what he liked specifically, noted its beauty and truth.[68] Although La Farge's canvas shares basic compositional features with *Over the Hills*, the fact that La Farge's image is pure landscape (and perhaps hallowed because of its identification as New England) seems to have enabled these critics to enjoy the visual impact of the design without reservation. If *A Fair Wind* displayed physical and emotional vitality, *New England Pasture-Land* exuded soul. Clarence Cook and Earl Shinn thought that both canvases had individual elements combined into a well-integrated whole, thus meeting their varied requirements for American art. Both canvases' adequate

Fig. 79. Eastman Johnson (American, 1824–1906), *Husking Bee, Island of Nantucket*, 1876. Oil on canvas, 27 ¼ x 54 ⁵⁄₁₆ in. (69.2 x 137.6 cm). The Art Institute of Chicago. Potter Palmer Collection, 1922.444

completeness of thought and finish allowed the critics to hail them as original and American as they recognized that different subjects required different treatments.

The *Times* was the only paper to give *Over the Hills* substantial praise. It called the canvas "an excellent production," and responding to the greater degree of modeling it detected, especially lauded the admirable drawing of the figures. Although the writer criticized the lowered tone of Homer's colors, he commended him for the careful delineation of shadows in the figures, which he described in terms of traditional modeling and as an improvement over Homer's usual treatment. Nonetheless, the picture had serious faults in the "hasty and imperfect painting" of the foreground clover and background hill, and, in the end, the painting only suggested that Homer "is on the path of progress and will mount much higher yet."[69] Homer, once again, could get it only partially right. But, even so, his work still offered hope for the future.

The various criticisms of Homer's 1876 Academy pictures illuminate the fact that, while critics were more consistently favoring certain subjects or techniques, they did not coalesce along any definable party lines, especially on the issue of finish. For example, a critic's preference for native genre subjects did not always go hand in hand with one for tight technique. The press acknowledged that the rapidly changing face of American art was blurring many of the traditional positions and also that personal politics played a significant role in creating an emotionally charged atmosphere in art criticism.[70] In this arena of critical uncertainty, Homer received a high measure of praise, but rarely without qualifiers. Despite the criticisms, the reviewers seem to have better understood what he was doing and the sources of his inspiration. Homer had also hit upon individual subjects, like that of *A Fair Wind*, that, for most critics, were not only acceptable but also praiseworthy. He was still considered a "younger man," and, for a number of writers, he was not yet meeting their expectations. There is no doubt that the range of Homer's work presented contrasts and contradictions. If John La Farge and Enoch Wood Perry represented the opposing ends of the artistic spectrum, we can see Homer playing into and out of both camps in a variety of ways. He continued to seek an artistic vocabulary and subjects that suited him aesthetically and intellectually, but it also seems that, at times, such as with *A Fair Wind*, he consciously worked hard to accommodate critical and public taste.

Fig. 80. *The Trysting Place*, 1875. Watercolor on paper, 12 x 8 ¹⁄₁₆ in.
(30.5 x 20.5 cm). Princeton University Library, Department of Rare Books
and Special Collections. Gift of the Estate of Laurence Hutton in 1913;
on long-term loan to The Art Museum, Princeton University, New Jersey

With the opening of the centennial exhibition at Philadelphia in early May 1876, yet another layer of commentary about American art was added to the body of criticism. The international fair had been anticipated for several years, and the opening of its doors offered a multitude of opportunities. The exposition, of which the art exhibition was only a small, though important, portion, presented an overview of one hundred years of American productivity.[71] The assessment of American creation and invention took place within this wide array of goods. Inherent quality was not the sole consideration. How these objects reflected American culture or national character and how they compared to their European counterparts were also important factors.

The art exhibition at the centennial fair included the works of twenty nations, and while it allowed, as the *New York Times* pointed out, "the first great opportunity . . . to the whole American people to see much of the very best that Europe has to show," the quality of the foreign contributions was considered uneven.[72] Although the French showing was the most eagerly awaited, it was also the most disappointing. The British section received the most universal praise for overall quality.[73] The American exhibition included 760 paintings and 162 sculptures.[74] The collection, gathered primarily from private sources, was nominally a historical survey of American art and included few new works.[75]

The press coverage of the entire exposition was extensive. Of the art notices, the European contributions and media other than painting, especially the decorative arts, attracted much of the attention. The American group of paintings and sculpture received only a modicum of notice and it was mixed in its assessment. At one end of the spectrum was Clarence Cook, who was not only disappointed, but also so mortified by the American canvases that he "hesitated to speak of [them]."[76] Susan Nichols Carter offered the opposite viewpoint, believing that this was the best selection of American art ever seen.[77] Many critics wrote about their attitudes toward the entire showing (including how they felt about the pre-exhibition politics) rather than about their responses to individual pictures. Thus, reviews tended to be sweeping overviews rather than the in-depth examinations written for the exhibitions of the National Academy or Watercolor Society.[78] The American picture that received the most attention was Peter Rothermel's *Battle of Gettysburg* (1870; Pennsylvania State Capitol, Harrisburg), which was almost unanimously condemned as bad painting and in bad taste since its subject had the potential to raise the specter of the sectional rifts that the centennial celebrations worked hard to erase. The selection committee was lambasted for allowing the work to be shown.[79]

The reviews of the American art at the Centennial Exposition are revealing because they summarized particular attitudes towards art in general and the state of American art. Suggestions were given for what American artists should strive towards. In concert with these summations came some definitions for American art with Homer's work upheld as an example. Not surprisingly, foremost among the discussions was the question of national characteristics—both of their possibility and what, if accepted as a possibility, they might be.[80] Now, in the mid-1870s, the issue was increasingly codified as the philosophy of Hippolyte Taine gained acceptance. Taine proposed that great art had the ability to represent national character through each particular culture's "race, milieu, and moment." Art's success, then, depended upon the extent to which a universal standard for art could be reconciled with its historical variations.[81] Up to 1875, the critics wrestled separately with the notion of what made universally great art from what made American art, but with the greater influx of the European-trained artists, the rise of a more international sensibility further complicated the issue for artists and critics alike. As Linda Docherty has pointed out, the dilemma was increasingly constructed around the question of how American art could remain distinctive and, at the same time, stand as the aesthetic equal of the great artistic traditions of Europe.[82] As a result, the implications of the absorption of European technique continued to be central in the minds of many critics, and opinions were divided as to its acceptability. While most critics agreed that the acquisition of European methods was a necessity to

achieve technical skill, they continually worried that American artists would hold on to them too tightly and not move on to achieve their own distinct idiom.[83]

As some critics used their reviews of the centennial art show as a platform to define what constituted art, notions about the role of the artist came to the fore. Susan Nichols Carter suggested that distillation must occur in concert with the artist's own reaction to his subject.[84] How an artist manipulated a subject was increasingly crucial. Earl Shinn, in *Masterpieces of the International Exposition*, wrote the most in-depth study of the art contributions. In it, he characterized the predominant approaches to art, stating that a true artist's three chief concerns did not include narrative, but were "the coloring of his picture, the lighting of his picture, and its plastic difficulties or difficulties of drawing."[85] Shinn, agreeing with his colleagues, then pointed out the importance of an artist's personal insight:

> In art, there is no glory in making conventional beauty; without there is something of real piercing insight in our copies from nature, they had better not be published. Unless the painter can get at some seldom-observed and essential characteristic of his model . . . there is nothing gained. . . . But let him once express, with insight and authority, a subtle natural fact; let him indicate the pearly reflection and blood-fed quality of human flesh in light or shadow, let him remind us of the value of natural lights and darks in objects seen against the sky; let him touch us with the reminiscence of his own personal discoveries in the aspects of nature, and we recognize him immediately, and forgive a deal of puerility or haste.[86]

Shinn's comments raise the suspicion that he had Homer specifically in mind as he described the artist's struggle to balance the narrative and aesthetic aspects in a personalized expression of visual and emotional experience. For Shinn and his colleagues, there was a growing emphasis on the importance of the maker and the individuality of his imagination, inspiration, and manner.

Homer was represented in Philadelphia by two oils–*Snap the Whip* (fig. 31) and *The American Type*, which may have been *The Course of True Love* renamed or a closely related image–and four watercolors–*The Busy Bee* (fig. 70), *Taking Sunflower to Teacher* (fig. 73), *The Trysting Place* (fig. 80), and *In the Garden* (fig. 81).[87] In the reviews, his name was invoked several times when American characteristics were noted in works on display. Homer's home subjects, along with those of Eastman Johnson and John George Brown, served as examples of quintessential and representative American art. *Snap the Whip* was singled out as particularly American because it pictured American boys engaged in an American game. The writer for the *Mail* pointed out that the image was national in essence because "foreign boys don't play as our boys play."[88] Whereas subject matter was the primary element that defined American art, "Gar" in the *Times* suggested that a national school was asserting itself in other ways: "The prevailing idea of this school is an exuberant sense of sunshine, and of sympathy with nature." *Snap the Whip* and Johnson's *The Old Stagecoach* were cited as excellent examples of such an expression.[89] "Gar's" comment suggests not only that the places and scenes depicted in these canvases were recognizably American, but also that the use of bright, outdoor light as an integral element of a picture's subject and artistic construction was a distinguishing national characteristic.

Individual discussions of Homer were minimal in the centennial show reviews, although he was often listed as represented. When he was mentioned, the writers often rehashed or reconfirmed their usual commentary about his work. Homer's unconventionality, freshness of subject and treatment, free and bold handling, and genuine motive were all mentioned positively. The negative comments all focused on his technical deficiencies.[90] In one case, however, *Snap the Whip* was listed as one of the works that "helped to make the fame of some of the older artists."[91] This was the first time Homer was identified with the older generation. As recently as the 1876 National Academy exhibition

reviews, he had been considered a younger man. Thus, this moment marks the first indication of a change in Homer's position among his peers–from younger to older and from front-runner to one belonging to the status quo.

Whether or not Homer visited the Centennial Exposition is unknown. "They [the artists] are all taking a run down to Philadelphia," quipped the *Herald*, and given Philadelphia's proximity to New York, Homer easily could have been among those who went.[92] At the height of the summer, however, he returned to the Catskills and was reported to be visiting at both Leeds and Hurley in July and August.[93] In the fall of 1876, Homer made his first documented visit to Houghton Farm, his patron Lawson Valentine's new country property at Mountainville, near West Point, New York.[94] This locale would play an important role in Homer's development through the end of the decade.

Homer remained out of the city until almost the middle of November this year.[95] The main art event of the early winter season was the John Taylor Johnston Sale, held December 19–20. Although most reports of the sale focused on the market aspect, the reappearance of *Prisoners from the Front* again affirmed its position as Homer's first important and still best painting. The *Telegram* reiterated what had been repeated so many times over the past decade: "Winslow Homer's 'Prisoners from the

Fig. 81. *In the Garden*, 1874. Watercolor on paper, 9 1/16 x 6 11/16 in. (23 x 17 cm). Mr. Arthur G. Altschul

Front', though one of the first works which earned a good reputation for an artist who is still a young man, remains his best picture, in spite of its bad drawing, and we think it is the best picture which has yet been occasioned by our civil war."[96] Even with the acclaim *A Fair Wind* had received barely six months earlier, *Prisoners from the Front* still stood as Homer's crowning achievement and perpetuated his identification as a developing painter.

Despite the feelings of national pride generated by the Centennial Exposition, 1876 was a hard year for America. As the centennial celebration focused on the accomplishments of the last hundred years, the reality of another possible financial panic loomed large. The economic situation and its effect on the art world were liberally discussed in the press.[97] Homer, no doubt, was among those affected. Clarence Cook, after a visit to Homer's studio, noted that the artist had commented on his disappointment that there was "not only a dull market for pictures, but what was of still more consequence, people seemed to have lost interest in the progress of artists in New-York."[98] Homer, no doubt, recognized the powerful impact of American artists working abroad. In the face of their effect, he was surely aware that his position as young or old (and respectively innovative or more conventional) was in flux. In 1876, Homer received the highest praise for an oil in a number of years, but a painting ten years old was still considered his best and his watercolors had been criticized as never before. All told, the responses to Homer's art were a mix of praise and condemnation and related to wide-ranging issues, all of which suggest the considerable upheaval the New York art world was experiencing. In the coming year, Homer, American art, and its critics would all embark on a new chapter as a number of things came to a head, most notably with the formation of the Society of American Artists.

CHAPTER 6

Facing the

1877–78

"New Departure"

THERE WAS A WIDELY SHARED FEELING THAT 1877 MARKED A WATERSHED FOR AMERICAN ART.[1] THE CENTENNIAL exhibition had offered unprecedented exposure to European art, most notably British, German, and French. In this atmosphere, artists and critics debated the pros and cons of the influence of European art with increased intensity. The lines dividing opinions were generally drawn according to whether European influence was viewed as good in itself; a necessary step in order to achieve technical skill; or an evil in any form because it was un-American. A pro-European editorial, for instance, condemned the "nativists," the faction defined as those individuals wanting either no contact with Europe or a return to the schools of Copley and Stuart (which, even though they were European in base, stood as the first American school). Furthermore, the necessity of European training as the means to achieve a "thorough mastery of technique" was insisted, as was the creation of a generation of teachers to train those at home.[2]

In the face of this debate, critics generally agreed that the international exposition had created "newly awakened energies."[3] Indeed, a "new departure" in art was a constant topic of discussion.[4] A wave of foreign-trained artists, who not only exhibited their work in New York, but also returned home to live, was responsible in large part for the changes in the artistic climate. At the same time, widespread enthusiasm for the decorative arts and the concept of the decorative arose. The impulse here, too, came from the Centennial Exposition, where the large international displays of goods captured the interest of broad segments of the population.[5] Large-scale interior design projects such as James Abbott McNeill Whistler's Peacock Room in London and John La Farge's decorations for Trinity Church in Boston were closely watched. As a writer for the *Independent* noted, "The art of decorating . . . is now classed among the fine arts, and the decorator is no longer regarded as an upholsterer, but as an artist."[6] The new premium placed on the decorative was variously embraced. Its positive effects included bringing beauty into everyday life. On the negative side, it raised the concern–one that would heighten in the 1880s–that the compulsion to decorate connoted excessive materialism and moral decay.

With this rich variety of art issues to consider, discussions intensified. Convinced of the necessity of a national school, the critics centered their dialogue on whether an American school currently existed and, if so, what made it and, if not, what prevented it. The inquiry into what constituted good art accompanied this debate. Such questions aroused infighting among the press that would last for several years, and with this unrest came greater concern for the profession of critic and the nature of criticism. The question of whether or not critics should also be artists was repeatedly raised in this context.[7]

As the discourse on American art became more heated, Homer worked vigorously, measuring the effect and import of those conflicts on his work. He engaged in a series of plunges into and retreats from his art, painting

sometimes at a more frantic pace than ever before to expand, experiment, and reinvestigate his subjects and techniques. In his response to outside influences, he became chameleon-like at times, adopting influences in his art in an unprecedented way. At other times, he seemed to be working in his most individualistic manner and, to some critics, he appeared antagonistic. In these last years of the centennial decade, Homer was an artist in an agitated state.

In 1877, Homer increased his creative production from fifteen works in the previous year to twenty-seven, painting in oils and watercolor in nearly equal numbers. In this burst of creativity, Homer experimented with a greater variety of subjects, including farm life; men (and, occasionally, women) in the wilderness of the Adirondacks; African-Americans; middle-class women at leisure; and some truly unusual subjects for him, such as *The Arrival of the French Ambassador in Madrid* (location unknown) and *The Old Cavalier* (location unknown).[8] The critics recognized Homer's greater diversity of subject as well as expanded artistic experiments, which included a greater absorption of European methods of modeling and paint application, compositional approaches similar to those found in both European and Japanese art, and decorative schemes related to the rising Aesthetic Movement. Homer thus appeared fully engaged with the most recent trends in art in 1877. Yet, the fractured nature of his creativity suggests that the vast possibilities of themes and modes caused him anxiety as he tried to please everyone—the public, the critics, and especially himself.[9]

The Tenth Anniversary of the American Watercolor Society

The annual exhibition of the American Watercolor Society in 1877 provided, as usual, the first venue of the year at which a number of Homer's works could be seen. This year marked the group's tenth anniversary, but the milestone was honored with only a paucity of substantial criticism. All the New York papers except the *Sun* mentioned the exhibition, but the coverage was abbreviated and generally less probing than in recent years.[10] One likely cause of this malaise in art writing was the political instability arising from the disputed results of the 1876 presidential race between Samuel J. Tilden and Rutherford B. Hayes. This controversy commanded much of the news and editorial writing in January and February 1877, and was not resolved until March 2, 1877, when Hayes was formally declared the winner.[11] The watercolor show closed two days later. Another explanation for the lack of coverage of the Watercolor Society show may have been the greater number of coincident art events. For example, a group of foreign watercolors on view at the Kurtz Gallery in late January was noticed by the *Herald* and *Tribune*, seemingly at the expense of the Watercolor Society.[12]

Even so, the Watercolor Society's exhibition still received commendations, and the show was generally praised.[13] The issues discussed by all writers were familiar ones. The question of whether foreign works should be included was raised but caused much less concern than in previous years.[14] The more conservative and pro-European writers found the European work to be the strongest, but they preferred not to see it in the context of an American organization's event. The most vocal boosters of American art believed the home productions held their own against the European works.[15]

Watercolor was increasingly being considered appropriate for more serious work, and expectations for the aqueous medium continued to shift in the same direction as they were for oil.[16] Many critics preferred the larger and more elaborate watercolors and were heartened by the greater number of sheets in the exhibition that displayed subjects rooted in large ideas and methods that expressed more than flashy technique. There was, however, no consensus on which artists provided the best examples. Opinions still divided between those critics who required a certain measure of narrative and detailed description and those who did not.[17] Yet, the critics shared a

Fig. 82. William Trost Richards (American, 1833–1905), *A Sketch*, c. 1877. Watercolor and gouache on paper.
Location unknown. Illustrated in *Catalogue of the Tenth Exhibition of the American Society
of Painters in Water Colors* (New York: privately printed, 1877), n.p.

growing interest in work that evoked emotion and flaunted the unique qualities of the watercolor medium. The mandates for appropriate subjects or techniques varied, but it was clear that the literal representation of nature was no longer an effective subject or technique for watercolor. Such thinking turned a number of critics to a sheet in a new, more gestural style on rough, textured paper by William Trost Richards (*A Sketch*; fig. 82). The artist was admired for exhibiting a radical change, and the sheet was praised for its power, even if it was not considered beautiful. Critics as diverse as cosmopolite Susan Nichols Carter in the *Art Journal* and conservative Theodore Grannis in the *Commercial Advertiser* perceived a strength and vitality in Richards's new approach.[18]

The critics agreed that the sheets by American artists at the Watercolor Society exhibited a higher than usual percentage of native qualities. The Americans' styles, methods, and subjects were proudly asserted to be free from foreign influence.[19] Homer was chief among those artists identified as uniquely American. In this exhibition, he showed only five works: *Rattlesnake* (location unknown), *Blackboard* (fig. 83), *Lemon* (now known as *Woman Peeling a Lemon*; fig. 84), *Backgammon* (fig. 85), and *Book* (now known as *The New Novel*; fig. 86). This number of contributions was modest compared to his offerings of the previous two years when he showed thirty-four and fifteen sheets, respectively. By showing fewer entries and finishing his figures more thoroughly, Homer, it seems, took to heart the specific suggestions made by critics in 1876.[20]

Although fewer in number, Homer's works received considerable attention in the reviews of the exhibition. Half of the reviewing publications printed substantial remarks on Homer specif-

"He Always
Has Something
to Say"

———— • ————

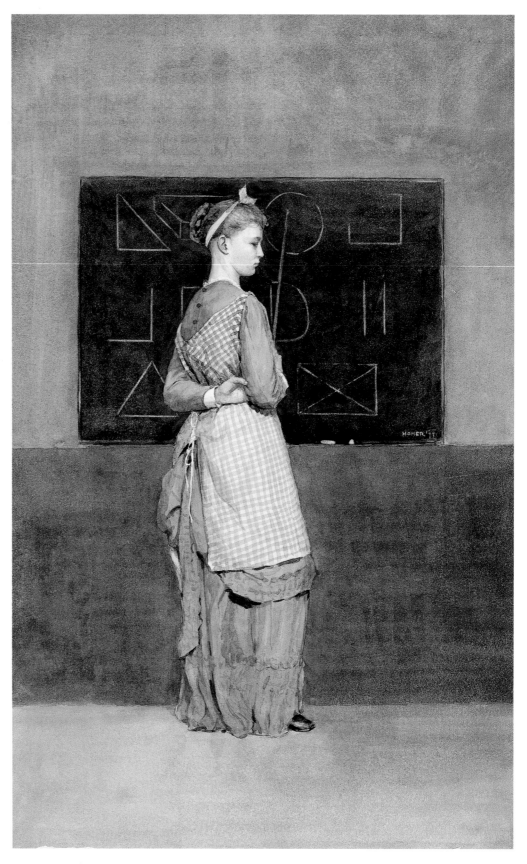

Fig. 83. *Blackboard*, 1877. Watercolor on paper, 19 ⁷⁄₁₆ x 12 ³⁄₁₆ in. (49.4 x 31 cm).
National Gallery of Art, Washington, D.C. Gift (partial and promised) of Jo Ann and
Julian Ganz, Jr., in honor of the fiftieth anniversary of the National Gallery of Art

ically; one was overwhelmingly positive; one negative; and, as he had become accustomed, the majority were mixed. In all these discussions, the single most important characteristic attributed to Homer's work—the one that commanded the highest praise, redeemed his faults, and identified him as quintessentially American—was his individuality. This quality made his works unmistakable and distinctive.[21] Even the writer for the *Post*, who did not like the work, gave Homer credit for being idiosyncratic.[22] For *Scribner's*, too, the watercolors were redeemed by their uniqueness. Although that writer found *Rattlesnake* "beyond redemption," he located something worthwhile in the other four sheets. *Backgammon* might have no background and several of the girls might be pictured with green cheeks ("a poor joke"), but Homer, in these, and especially in *Book* and *Blackboard*, appeared "himself again—one of the few American painters of originality and force."[23] In the reviews, Homer's individuality was further accentuated by writers treating his work without reference to that of his peers.

Individuality and originality were increasingly important ingredients for American art in the late 1870s.[24] These terms, however, had multiple definitions and carried varied importance in the different critical camps. On the one hand, individuality was a key component of the definition of American art and the identification of a national school, for it implied distinct differences from other nations and, thus, was a characteristic in which America could take pride. For those unable to accept European influence, individuality had the added benefit of implying freedom from that tradition. Yet, for

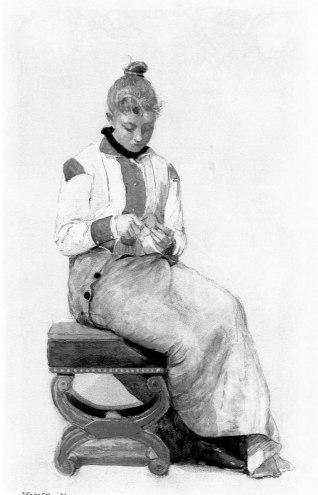

Fig. 84. *Woman Peeling a Lemon (Lemon)*, 1876. Watercolor over chalk on paper, 18 ⅞ x 12 in. (47.9 x 30.5 cm). Sterling and Francine Clark Art Institute, Williamstown, Massachusetts, 1955.1494

the more cosmopolitan reviewers, individuality had other, though equally positive, connotations. The *Times* noted: "A painter's individuality, whether cultivated or inherited, must tell in his pictures."[25] The belief in the importance of an artist's personal identity would intensify through the 1880s.[26] Homer's watercolors met all these various requirements.

For the critics who advocated that national characteristics in art were of paramount importance, Homer's subjects remained key to their assessment of him as distinctly American and continued to redeem his work even when it was criticized for technical shortcomings.[27] Homer's figure types in the sheets exhibited in 1877 were identified as especially American. The *Art Journal* described the girl in *Lemon*: "a typical American country-girl in a common calico 'blouse' waist, a buff stuff skirt, and a Yankee face."[28] It was implicit that the schoolteacher in *Blackboard* was both contemporary and particularly American. The subject of a schoolteacher with a drawing lesson on the board was of particular currency at this time because its appearance coincided with the removal of drawing from public schools.[29] The *Times*, for example, called her "so stiff and individual, so true," that is, so

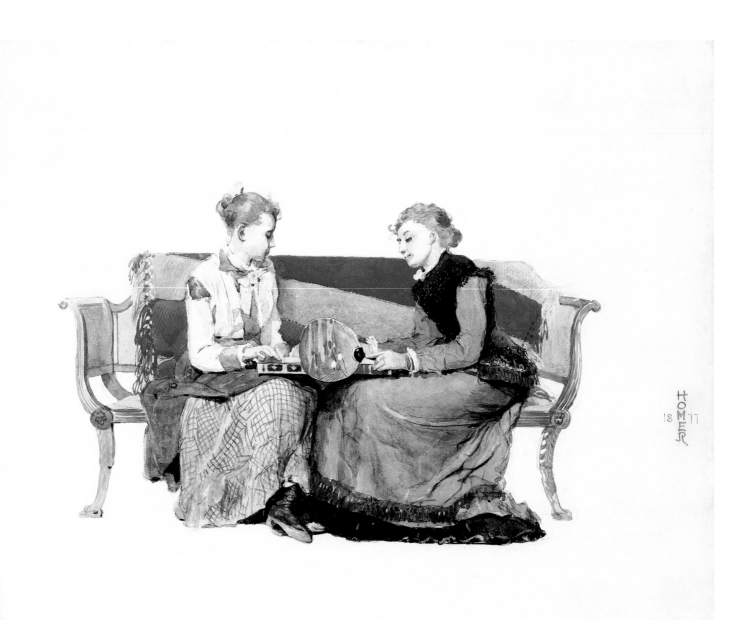

Fig. 85. *Backgammon*, 1877. Watercolor over charcoal on paper, 17 ¾ x 22 ¼ in. (45.2 x 56.4 cm). Fine Arts Museums of San Francisco. Achenbach Foundation for Graphic Arts. Gift of Mr. and Mrs. John D. Rockefeller, 3rd, 1993.35.15

American.[30] Such unquestionable Americanness may have been why *Blackboard* was several critics' favorite entry by Homer, even though they gave no explicit reason.[31]

These watercolors' subjects, however, were not their most compelling feature. Homer's aesthetic approach and technique were instrumental in defining his individuality this year. His quintessentially American subjects appeared in a variety of forms, including new and recognizably international modes, earning him both positive and negative reactions. Following the pattern of previous years, when his methods were approved, he was considered bold; when he was disliked, he was coarse; and when he confounded a critic, he was simply eccentric.[32] This year, for instance, the visual impact of Homer's images of women was considerable. With their striking coloration and spare, noticeably flat backgrounds, the effects were for better or for worse, depending on the critic.

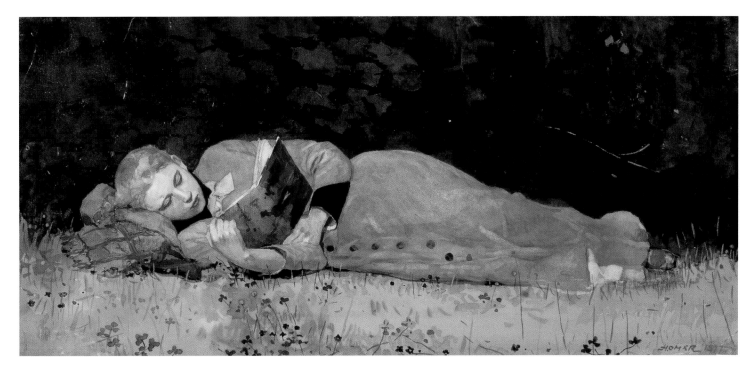

Fig. 86. *The New Novel (Book)*, 1877. Watercolor, 9 ½ x 20 ½ in. (24.1 x 52.1 cm).
Museum of Fine Arts, Springfield, Massachusetts. Horace P. Wright Collection

Homer's use of color caused the most controversy. Some critics were unsure of their reactions to the intense oranges, yellows, reds, and especially the green skin tones found in the pictures. The *Post* clearly found Homer's color distasteful, stating: "[W]e notice that the hands and feet are enormous and coarse, and that three of the faces display large, sickly, dirty, faint green patches. . . . [W]e never saw the like of them on canvas or on epidermis."[33] When positively predisposed toward the work, critics championed his color usage as bold and noted it as a positive feature of Homer's individuality.[34] Susan Nichols Carter attributed the great success of these works wholly to Homer's color. Of all the sheets, *Lemon* was her favorite. She admired its American subject, so codified by the costume worn by the figure, but most of all, she extolled the color, which was so striking that she thought "some new artist had dawned upon the French or Roman world [and] . . . was in entire accord with the methods of the best of the foreign aquarellists." She applauded Homer for "exhausting his palette with every tint" to create the most "vigorous treatment of the human form." Recognizing that Homer had achieved expressive action in canvases such as *Snap the Whip* (fig. 31), she noted that *Lemon*'s achievement came not through the devices of the subject, pose, composition, or details but through "a scale of refined color and tone," which, for example, articulated the pull of the subject's skirt around her figure in the most marvelous way imaginable.[35] Indeed, the gradations of tone in the woman's skirt rise and fall from light to dark in gentle waves across the fabric in concert with the figure's shape, eloquently describing the seated woman both truthfully and beautifully.

Carter identified with the cosmopolitan spirit in Homer's work. *Blackboard, Lemon, Backgammon,* and *Book,* as well as *Woman and Elephant* (fig. 87) and *Woman Sewing* (fig. 88), were members of the growing body of images of genteel women pictured against flattened backgrounds. This approach was seen not only in the works of the Fortuny circle (as Carter implied), but also in images by other European artists including Alfred

Fig. 87. *Woman and Elephant*, c. 1877. Watercolor on paper on linen, 11 ¾ x 8 ¾ in. (29.8 x 22.2 cm).

Albright-Knox Art Gallery, Buffalo, New York. Gift of Mrs. John W. Ames, 1959

Fig. 88. *Woman Sewing,* 1878–79. Watercolor over pencil on paper, 9 ¾ x 7 ¾ in. (24.8 x 19.7 cm).

The Corcoran Gallery of Art, Washington, D.C. Bequest of James Parmelee, 41.15

Stevens and Albert Moore.[36] Carter and Charles DeKay, who now served as the *Times*'s art critic, also noticed how Homer incorporated elements associated with the nascent Aesthetic Movement into his works, such as the fact that the color of the girl's dress matched her hair in *Book*.[37] American aestheticism was a product of the influence of recent British artistic reform movements and strove to harmoniously express the beautiful through design that integrated color, pattern, and form.[38] The critics, who were sympathetic to Homer's use of Aesthetic Movement strategies, did not accuse him of undue foreign influence. Instead, his subjects secured his status as uniquely American and individual at the same time his absorption of current international trends was acknowledged and praised.

Other critics negatively responded to Homer's aesthetic tendencies. *Scribner's* found *Backgammon* odd for lacking any suggestion of background space, and the *Nation* called all of Homer's entries "capricious" and "trying," perhaps also due to the blank backgrounds.[39] The *Times* perceptively recognized Japanese art as the source for Homer's backgrounds, but condemned them nonetheless for lacking traditionally defined space and additionally criticized the Japanese flatness of the figures, even while praising the harmonized colors.[40] The inclusion of a sofa with only two legs added to the peculiarity of *Backgammon*. Such an image was perceived as willfully inaccurate, not a sign of artistic license; it was proof of Homer's eccentricity, and although it caused criticism, was not an entirely negative trait because it suggested individuality, originality, and, ultimately, Americanness.[41] The *Times* summed up its feelings about Homer's 1877 watercolors by saying that the reason that Homer's work is always remembered is because "he always has something to say."[42] With these watercolors, Homer appears to have been saying the incorporation of European artistic strategies did not necessarily compromise the creation of an identifiable American art.

Identifying specifically American traits in art continued as a predominant theme in press notices during the month between the Watercolor Society and Academy annual exhibitions. Several critics made a special point to mention the American flavor of certain auctions and of specific works therein. The Kurtz Gallery sale held March 2, 1877, received more coverage than usual. It was noted as a wholly American sale, with no foreign works included. The critic "Waterloo" used the sale as an example to prove there was an American school of art. He defined the evidence of native qualities in style as well as subject matter. He wrote that each artist possessed "a style, decided and of much originality and individuality and yet thoroughly representing American taste and feeling and American character and scenes." He credited American artists' greater sympathy with nature as a trait distinguishing them from their European counterparts.[43] Key among the works exemplifying such a definition of American art was *A Fair Wind* (fig. 76), one of the stellar lots of the sale. William Brownell of the *World* reprised his 1876 commendations of the picture, calling the canvas "entirely characteristic . . . fresh, breezy and natural . . . an open air look of the whole picture." Such a viewpoint was derived from the critic's perception that the positioning and painting of the figures were completely natural.[44] What made a picture American was increasingly tied to perceived originality, individuality, honesty, vitality, and naturalness, which might be discerned in a painting's simplicity of composition, careful and insightful but not overly detailed presentation of nature, and the evocation of fresh air and outdoor light. When these artistic strategies were wedded to a home subject, they almost always brought the picture high praise.[45]

The exhibition of Homer's *The Cotton Pickers* (fig. 89) at the Century Club in March also provided an image that could be embraced as thoroughly national. The 1876 canvas brought a monumental scale to the picturing of African-Americans. Seen only briefly at the Century, it received only one notice. In that article, the writer for the *Post* understood the figures in *The Cotton Pickers* to be slaves, expressing emotions appropriate for indentured persons. One woman was described as "unhappy and disheartened," while the other was "defiant and full of hatred." He continued:

Fig. 89. *The Cotton Pickers*, 1876. Oil on canvas, 24 ¹⁄₁₆ x 38 ⅛ in. (61.1 x 96.8 cm). Los Angeles County Museum of Art.

Acquisition made possible through Museum Trustees: Robert O. Anderson, R. Stanton Avery, B. Gerald Cantor, Edward W. Carter,

Justin Dart, Charles E. Ducommun, Camilla Chandler Frost, Julian Ganz, Jr., Dr. Armand Hammer, Harry Lenart,

Dr. Franklin D. Murphy, Mrs. Joan Palevsky, Richard E. Sherwood, Maynard J. Toll, and Hal B. Wallis, M.77.68

The story is one not only worth telling, but one that can be told better by the artist than by the historian. Its deep meaning stares you in the face. . . . The composition is simple, unpretentious, natural, and the technical execution is brilliant and complete. The scene was painted outdoors, and it looks outdoors. Like most good things, also, the picture is finely original and alluring, and when across the sea, will do honor to the land that made it.[46]

These five sentences suggested a recipe for American art with which many critics would have agreed. The subject was the best type of home theme because it reflected an important phase of American history (even if not its most pleasant). The deep meaning was accessible but not sentimental. Finally, its presentation depended upon simplicity, truth, and originality–qualities associated with American identity. These national qualities were so strong and so significant that they overrode any acknowledgment of the French influence that, no doubt, contributed to the positive comments about technical execution.[47] *The Cotton Pickers* was not only a good painting but also one that would resonate with American characteristics in England, where it would reside for more than thirty years.[48]

Homer's blending of American subjects with an awareness of contemporary European art continued in *Answering the Horn* (fig. 93) and *Landscape* (now known as *Twilight at Leeds, New York*; fig. 94), his two entries to the 1877 National Academy exhibition. The uproar caused by this show is well known, and the climate it created affected responses to Homer's pictures and helped to shift American art deeper into its new phase.[49] Among the works that created the stir, all by young artists trained in Munich, were the Turkish page subjects by William Merritt Chase and Frank Duveneck (fig. 90) as well as Walter Shirlaw's *Sheep Shearing in the Bavarian Highlands* (fig. 91). Among the compositions by French-trained painters, which added to the discussion, was Wyatt Eaton's *Harvesters at Rest* (fig. 92). The large number of entries by European-trained, younger artists and their prominent installation were the most notable features of the exhibition. Critics considered the contents of the exhibition to be among or even the finest ever, but they deemed the installation to be the worst ever.[50]

Fig. 90. Frank Duveneck (American, 1848–1919),
The Turkish Page, 1876. Oil on canvas, 42 x 58 ¼ in.
(106.7 x 148 cm). Courtesy of the Pennsylvania
Academy of the Fine Arts, Philadelphia.
Joseph E. Temple Fund, 1894.1

The perception of this new departure in American art was strong in the 1877 Academy exhibition.[51] Indications of its arrival had been evident since the first public exhibition of pictures by Munich-trained artists in 1875.[52] The Centennial Exposition had further accelerated both the call for change and its manifestations, and it now appeared in full force. Variety of theme and treatment was its defining feature as was the division between older and younger artists. Whether an artist was considered old or young no longer simply depended on the personal factors of birth date, place of training, current address, what subjects he portrayed, or what methods he used, but was based on his whole approach to art. The definition of the split was described by the *World*:

All men who care for art at all, and who think about it at all, divide roughly into two classes. Consciously or unconsciously they care for what we call imitation (in its narrower and conventional sense) or for what we call ideality, for logic or for feeling, for truth (also in its narrower sense) or for beauty, for reason or for poetry, for exactness or for freedom, for reproduction or for production, for the tangible thing or the suggestive thing, for representation or for illusion . . . a class which leans towards correctness and a class which leans towards beauty. . . . Hitherto it has been–broadly speaking–the delight of American painters to imitate nature. The delight of the new painters is to express feeling . . . our admiration [of the American school of painting] . . . has resulted from our supposition that they were "lifelike." It has not occurred to us . . . to ask if they were living. The distinction has obviously been made for us by these young men.[53]

While the *World* identified the old school as grounded in the correct reproduction of tangible things and the new departure as dedicated to capturing the suggestion of things to express feeling, beauty, and poetry, in reality, the division was never so clear-cut.

Fig. 91. Walter Shirlaw (American, 1838–1909), *Sheep Shearing in the Bavarian Highlands*, c. 1877.

Oil on canvas, 50 x 84 in. (127 x 213.4 cm). Private collection

Most critics embraced this shift from fact to feeling as a positive stimulus despite the varied responses to individual artists and works. The *World* appreciated that "people's minds are occupied with thinking about aesthetic things, and the more they do think about them in such a country so conditioned as ours is the better we think it will be for the country as a country."[54] As they had from the first of the year, the most prominent topics in reviews, editorials, and feature articles continued to be the progress of American art and the appropriateness of European influence.[55] Many reviewers frequently reiterated that the ingredient of European training was essential to the creation of a worthy American school of art. Coincident with this viewpoint was the feeling that European training was best used as a tool applied to home subjects.[56]

The younger artists exhibiting at the Academy were again lauded for displaying a vitality in their work that represented a

Fig. 92. Engraving after Wyatt Eaton (American, 1849–1896), *Harvesters at Rest*, c. 1877.

Oil on canvas. Location unknown

promising future for American art and a national school. Clarence Cook enthusiastically wrote: "Whoever is broadly interested in Art as a high and necessary form of national development, will find this year's exhibition full of quickening suggestions."[57] Many reviewers of the 1877 Academy show treated the younger, European-trained artists separately, and often first. The *Times* noted that this approach was "not . . . without reason. Since Europe is

Fig. 93. *Answering the Horn (The Home Signal)*, 1876. Oil on canvas, 38 ¼ x 24 ¼ in. (97.2 x 61.6 cm).

Muskegon Museum of Art, Michigan. Hackley Picture Fund

the place where the best masters, the best models, and perhaps, the only 'art atmosphere' can be got, we must look to Americans who have studied in Europe for a new departure in art. There is plenty of originality and inventiveness among Americans; what they chiefly need is thorough instruction and such associations as shall awaken the right kind of originality."[58]

If there was nearly unanimous agreement on the importance of European training, there were disagreements as to which of the European schools provided the best models. Among the most enthusiastic voices for the Munich-trained artists, some critics wondered if the theory behind their work—to keep the spirit of their first intentions—could always be borne out.[59] Others continued to prefer the more carefully drawn efforts of French-trained artists and rejected the Munich men, especially Duveneck, as ugly and imitative.[60] There were also those critics, however, who were cautious in their optimism, derided change, or simply did not approve of the foreign tone of the exhibition.[61] In the end, the critics' responses ran the gamut, with many finding some good and some bad in each of the entries.

Amid all this talk about Europe, home artists asserted their own impact on the show. Homer's *Answering the Horn*, along with George Inness's *Autumn* (now known as *Autumn Landscape with Cattle*; fig. 95), Eastman Johnson's several offerings, but especially *Tramp* (Flower Memorial Library, Watertown, N.Y.), and landscapes by William Trost Richards, received repeated attention. In the complex, European-focused atmosphere, Homer's *Answering the Horn* and, to a lesser extent, *Landscape* (fig. 94), continued to engage the critic's thinking about what made American art distinctive. In the reviews of Homer's canvases, it was again American characteristics, especially the individuality of his work, that were the common denominator.

Answering the Horn was received as wonderfully American despite a number of similarities with contemporary French painting. The canvas pictures a young man and woman walking forward in a field. Holding a scythe under one arm, the man gestures with his free hand. Looking beyond the viewer, he appears to be answering the horn of the title.[62] The young woman, positioned slightly behind the man, covers her mouth, and her gaze is downward to avert any possible eye contact with the viewer. While the location of the scene in a field is clearly identifiable, the painting's low viewpoint and horizon that bisects the canvas almost exactly at midpoint cause the illusion of space to collapse so that the background reads alternately as a two-toned screen and a landscape.[63] As the perception of space shimmies between two and three dimensions, the narrative of the image likewise vibrates with uncertainties. In fact, a number of critics found the narrative even more inscrutable than that of *The Course of True Love* in 1875.[64] The *Mail* questioned: "Why he answers the horn by a motion of his arm, and why his face wears such a cross, almost sinister expression, and why the maiden seems desirous of getting behind him, and why she holds her fingers over her mouth—these things we don't profess to understand."[65]

Despite the impenetrable narrative, Homer's farmer and farm girl appeared quintessentially American, and the painting was highly praised. The painting achieved its national identity especially through the physical bearing of the figures. Clarence Cook commended the figures not on account of the excellence of their painting but because of the type of people he believed they portrayed. He explained that "The man is a good typical American, with both '76 and '61 in his blood, lord (or ought to be) of the acre he treads, and hungrily glad as the failing twilight deepens over the harvest field. The girl, in her sunbonnet and plain country dress, frank yet half-shy in her simple purity."[66] For Cook and others, the representative American man—tall, straight-backed, ruggedly handsome, and strong—was of deep-rooted stock, a veteran, owner of his land, and a hard worker.[67] The prototypical

"We Know of No Painter . . . Who Has Made So Great and So Consistent Improvement"

———— • ————

Fig. 94. *Twilight at Leeds, New York (Landscape)*, 1876. Oil on canvas mounted on fiberboard, 24 ⅛ x 28 in. (61.3 x 71.1 cm). Museum of Fine Arts, Boston. Bequest of David P. Kimball in memory of his wife Clara Bertram Kimball, 23.521

American girl was primarily defined by her costume and demeanor. She was described by some critics as somewhat reserved, known for her frankness, and picturesque in her simple muslin outfit.[68] Homer had, in fact, followed the description of the characteristic American given in an article called "What is an American?" in which an American, regardless of gender, was described as tall, straight, slender yet muscular in form, with large deep eyes with sweeping lashes, a clear complexion, splendid teeth, and a calm and serious mien.[69]

Answering the Horn was praised not only for its national characteristics, but also because it showed that American subjects were as aesthetically viable as European ones.[70] Even though it had found the narrative of *Answering the Horn* murky, the *Mail* identified Homer as worthy of special consideration "because of efforts impelled by a desire to render picturesque, not only the natural features, but also the life of our country, by portraying its incidents and their surroundings." For this writer, *Answering the Horn*, as a representative moment out of American agricultural life, was considered as interesting as scenes from Germany, France, Italy or Spain. Because such a scene underscored Homer's originality, he was urged to continue work in this vein.[71] Even Clarence Cook, who had earlier condemned Homer's images of children as unable to compete with their Euro-

Fig. 95. George Inness (American, 1825–1894), *Autumn Landscape with Cattle*, c. 1877.

Oil on canvas, 36 ½ x 54 ½ in. (92.7 x 138.4 cm). Location unknown

pean counterparts, agreed. He felt that the girl in *Answering the Horn* "is as picturesque as any Breton peasant or Italian contadina; and we do not see why she should not have the same value in art."[72]

The power of Homer's observations again was noted as an important ingredient to the originality and overall success of the painting, but his vision also again brought notices of his manner being peculiar and crude. The *Post* asserted that Homer's pictures, "so honest, so abhorrent of 'clap-trap,'" would never be mistaken for another artist's work.[73] Brownell of the *World*, who generally found American genre painting "more stupid" than its foreign counterparts, especially praised Homer's canvas for its distinctiveness. Yet, he could not ignore that part of Homer's uniqueness was a crudity. He then questioned whether Homer's crudeness was intentional and was part of a conscious construction of an expression of individuality and originality, or was it merely due to ineptitude, as others had suggested over the years. Realizing he agreed with his first supposition, Brownell admitted misunderstanding the impetus for Homer's style and apologized for his peers as well.[74]

In one way or another, all ten commentaries on *Answering the Horn* singled out its individuality, originality, and native qualities. Implicit in some critics' remarks was the continued belief in Homer's freedom from foreign influences. The *Art Journal* suggested that Homer's work was not corrupted by any foreign methods and saw evidence of this in Homer's rigid adherence to his own observations. To this writer, Homer painted "the life that he sees as he sees it. . . . He is wholly in sympathy with the rude and uncouth conditions of American life."[75] Such assertions of Homer's artistic purity were made in the face of the very direct quotations from European art visible in the works of Duveneck, Shirlaw, and Eaton. Yet, there is no doubt that *Answering the Horn* also depended on European examples, as did *The Cotton Pickers* and his entries in the 1877 watercolor show. Sarah Burns has pointed out the canvas's many connections with contemporary French peasant pictures, especially its

debt to similar themes and monumental figural presentations found in the work of Jean-François Millet.[76] Additionally, Kathleen Pyne connected the specific subject of Homer's painting to works such as Jules Breton's *The Recall of the Gleaners* (Musée des Beaux Arts, Arras).[77] However, Homer's image and treatment could be considered unique rather than imitative because his use of European sources appeared fully absorbed as he synthesized a variety of approaches, including some European, within the parameters of unmistakably American subjects. Homer's genre subjects were, above all, democratic, that is of the people and able to be appreciated by those without specialized knowledge. Such a foundation gave his work a caliber of national identity that was unsurpassed despite its French associations.[78]

The manner in which Homer painted the figures added further to *Answering the Horn*'s positive reception. The farmer and the girl were considered "well and freely drawn," and a number of reviewers recognized that they had been painted with more care than usual.[79] The modeling of both figures is, indeed, more traditionally and highly finished than often found in Homer's paintings. Cook saw *Answering the Horn* as evidence of the artist's "returning from his many experimental trips in the lands of grotesque reality or coarse imagination."[80] Enabling Cook to feel this way was the fact that Homer's depiction of the farmer in *Answering the Horn* surpassed factual realism and pedantic narrative to enter into the realm of the poetic and symbolic. Thus the painting pleased Cook and other critics such as William Brownell for whom beauty and poetry were necessities for true art. In Homer's greater carefulness in the figures, Brownell also saw the signs of a maturing artist. Long an admirer of Homer's unconventionality, he could now assert: "we know of no painter of similar ability who has made so great and so consistent improvement."[81] Compared to the slapdash approach the Munich-trained artists displayed at the Academy, Homer's work now looked finished.

Only the palette of *Answering the Horn* was repeatedly scorned. As with his watercolors shown earlier in the year, the critics particularly criticized the coloring of the faces. "The science of his flesh tints we never yet could fathom," cried the *Post*, suggesting that it was understood that the application of color theory was at work.[82] The *Art Journal* worried that "his faces are always like Joseph's coat, of many colours," and the *Mail* found too much iron and rust in the faces as well as in the field.[83] Again, it was likely Homer's own experiments with the color theories of Michel Chevreul that brought these remarks.

Landscape (fig. 94), Homer's other entry to the 1877 Academy annual received considerably less notice than *Answering the Horn*, and the reactions were divided. As with *Milking Time* (fig. 64), the design of this canvas first commands the viewer's attention. Although the painting is ten inches narrower today than originally, the low viewpoint, mid-canvas horizon, and grouping of forms remain striking.[84] The effect of the shadows, mirroring the dark massing of the trees, was especially praised by the *Times*, while *Scribner's* briefly named it among the "freshest and strongest" landscapes.[85] The *World* particularly liked the painting, stating, "[i]t is one of the best landscapes we have seen from Mr. Homer's hand." The picture was then favorably compared in its simplicity and broad treatment with the work of Inness (fig. 95), not suggesting an influence, but rather noting that they aspired to and reached similar artistic goals.[86]

By contrast, Clarence Cook called *Landscape* "a willfully mannered study . . . which is not a picture." Cook preferred the "imaginative understanding of nature."[87] While it is difficult to discern the reason behind the *Tribune* critic's negative response, perhaps it was Homer's assertion of the flat picture plane, made prominent by the banding of sky, land, and reflection. Another biting criticism came from the *Sun*, which called Homer's landscape "as slovenly a bit of painting as an artist of reputation would choose to put his name to."[88] That this writer, possibly the newly appointed William Laffan, would have such a reaction to Homer's broad areas of color, fit together like puzzle pieces, is perfectly in character for someone who loathed Duveneck and held up the detailed and traditionally composed landscapes of John Bristol as the exemplar of truthfulness. This same critic also liked the careful treatments of the French-trained Eaton and Will Low as well as the Dutch-inspired Thomas Hovenden. The *Sun* writer

longed for the day when careful drawing and treatment, such as that found in the work of French academic artists, might be applied to home subjects.[89]

In the combination of its subject and treatment, *Answering the Horn*, if not *Landscape*, provided an example of what might constitute a new post-centennial national art. The subject, simultaneously contemporary and emblematic of America, fulfilled the requirement for meaningful home subjects. Homer's appropriation of European, specifically French, elements was better understood and now embraced by the critics who supported European models. Homer no longer appeared radical but was still positively individual and original. At this crucial juncture in American art, Homer continued to negotiate the competing desires for American art: relevant subjects and artistic treatment that equaled but did not imitate those of Europe. In 1877, he sat squarely between the native and the international.

Homer spent the month of May 1877 in Virginia.[90] His return to the South was likely inspired by the winning reception (and sale) of *The Cotton Pickers* and the repeated requests for fresh home subjects. Homer's summer travels also included a visit to the Adirondacks. Although the precise itinerary of his Adirondack stay is unknown, pictures related to this trip suggest that he stopped at both Keene Valley and the Beaver Mountain area.[91] Homer was back in his New York studio by the end of September, and the experiences gathered during the summer would provide the inspirations for his art for the next year.[92]

Hard at Work

———— • ————

Homer retreated into his studio in the winter of 1877–78. In January and February he did not participate in any of the club shows or, more important, the American Watercolor Society's annual exhibition. In fact, Homer's work appeared in fewer venues in 1878 than it had in a number of years.[93] The Academy exhibition and Paris Exposition Universelle, held in the spring and summer, respectively, were his only two significant appearances. The work in oil, which formed his contributions to these shows, was likely time consuming. Even with considerably less new work on view, Homer was neither isolated from his peers nor ignored by the press.[94]

Two sets of new paintings attracted attention in early 1878. *Autumn* (fig. 96) and *Summer* (now known as *Butterfly Girl*; New Britain Museum of American Art), oils of fashionable women presented as metaphors for the seasons, were noticed both in progress in his studio and when they appeared at Leavitt's Art Rooms in a sale at the end of January. Writers in the *Daily Graphic* and the *Post* noted that these paintings depicted beautiful women and embraced an overt art-for-art's-sake aesthetic. They also acknowledged that these two attributes were rarely seen in Homer's work and were more expected in that of his European colleagues.[95] Over the years, Homer's women had been remarkable most often for their plainness (a quality often underscoring their Americanness), but now a critic noted, "Unlike many of his productions, they introduce us to women of some physical beauty."[96] The *Daily Graphic* detailed its understanding of what Homer intended in the canvases: "The pictures do not profess to tell any story, for which true art has no necessity, and the adjuncts are simply used to intensify the attitude and beauty of the figures, which possess a strong vitality and interest."[97] The appearance of beauty for its own sake was increasingly discussed in artistic circles, and Homer's work and its critique suggest the extent to which attitudes toward art had changed from ten years before, when he had just returned from Europe and every picture was expected to tell a story or teach a lesson.[98]

If Homer's beautiful women attracted attention in early 1878, his African-American subjects, which would be sent to the Exposition Universelle in Paris in the spring, also received considerable notice when they were seen in the artist's studio. Glimpses of *Sunday Morning in Virginia* (fig. 98) raised the expectations of a number of

Fig. 96. *Autumn*, 1877. Oil on canvas, 38 ¼ x 24 ³⁄₁₆ in. (97.2 x 61.4 cm).

National Gallery of Art, Washington, D.C. Collection of Mr. and Mrs. Paul Mellon

Fig. 97. *A Visit from the Old Mistress,* 1876. Oil on canvas, 18 x 24 ⅛ in. (45.7 x 61.3 cm).
Smithsonian American Art Museum, Washington, D.C. Gift of William T. Evans

writers.[99] In an extended commentary, the *Post* detailed many of the components of this picture and *A Visit from the Old Mistress* (fig. 97) as well as how the public might react to them:

> *Mr. Winslow Homer is giving the finishing touches to two pictorial representations of negro life in Virginia which he expects to send to the Paris Exhibition. In one of the canvases he introduces us to the interior of a shanty where a sable girl of twelve summers or so is reading from a large Bible to a group of her kinswomen of various ages and sizes. It is Sunday morning, and what pieces of gaudy ribbon and other adornment were available have been brought into use on the persons whose swarthy faces enhance the effect by contrast. The other canvas shows us a similar interior, where a not dissimilar company are receiving a visit from an elderly, kindly disposed gentlewoman once their owner and mistress. Mr. Homer has treated these simple themes with fidelity and freshness. His negroes are real negroes, children of the southern soil. . . . The figures possess remarkable roundness and relief, and the facial expressions are distinct studies for the spectator. In subject, conception and execution these works are most refreshingly original."[100]*

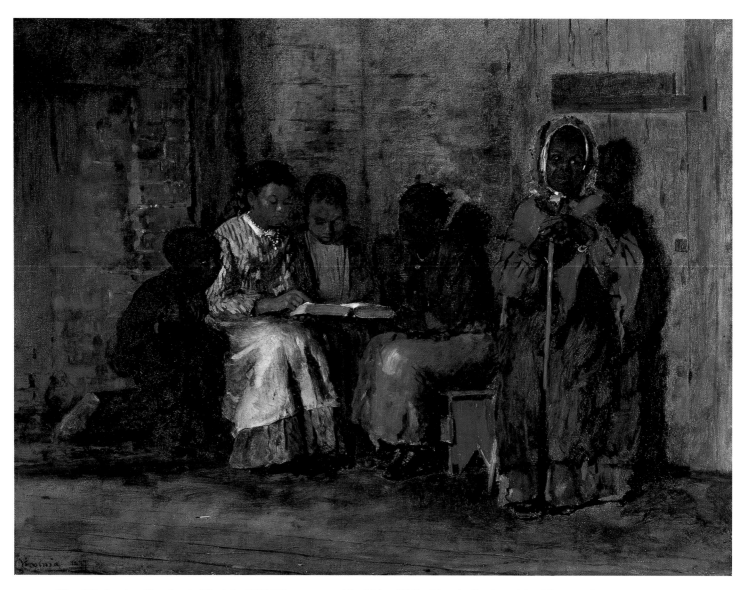

Fig. 98. *Sunday Morning in Virginia*, 1877. Oil on canvas, 18 x 24 in. (45.7 x 61 cm). Cincinnati Art Museum. John J. Emery Fund

These new paintings of African-Americans appeared as both the government and general populace were retreating from the ideas and programs instituted to reconstruct America after the Civil War. Homer's canvases resonated with the depth and breadth of the issues–literacy, domestic labor, the relative status of African-Americans and whites in daily life, and the impact of scientific racism. It is worthwhile to note how Homer attended to the serious side of his African-American subjects in an unprecedented way.[101] Homer moved away from the narrative traditions of the genre and eschewed slapstick humor, the prevalent vehicle through which the majority of African-American subjects were portrayed.[102] Homer subdued his interior settings and focused on conveying the emotions of his figures through facial expression, pose, and compositional design to an even greater degree than Thomas Waterman Wood's equally sympathetic *Sunday Morning* (fig. 99). The empty spaces alone–between the children and the older woman in Homer's *Sunday Morning* and between the white and African-American women in *A Visit from the Old Mistress*–add a tension within the images unusual for the day. Additionally, Homer's African-American women, especially in *A Visit from the Old Mistress*, assert a monumentality and individuality of character that set them apart from other images where stereotypes prevailed.[103]

Homer's absence from the 1878 American Watercolor Society annual exhibition caused something of a stir. While his truancy from the 1873 Academy exhibition was only summarily noted, now, five years later, the expectations had grown considerably, and the press raised issues about Homer personally as well as the general state of American art when he chose not to exhibit.

The 1878 watercolor show was generally criticized, and Homer was one of a number of artists who showed only minor works or did not appear at all.[104] The reason for these absences was not explained, but when they were noted, it was clear that Homer, one of the most highly regarded watercolorists, was missed.[105] He was often the first artist mentioned by those writers who enumerated the names of the missing, and in this context he was generally praised for his watercolor productions.[106]

The *Post* as well as the *Nation* raised other issues that may have had a bearing on Homer's situation. The *Post* quipped, "Mr. Winslow Homer . . . has not cared to trouble himself to put in an appearance. His health may be supposed to be satisfactory, for he has been doing much fine work of late in oils; and his pictures in last year's exhibition, in spite of a certain occasional unhappy mannerism, were widely appreciated and praised."[107] The *Post* rightly recognized that Homer's energies were focused on his oil painting. From the end of the summer of 1877, Homer worked on at least seven major oils: *Dressing for the Carnival* (The Metropolitan Museum of Art), *Sunday Morning in Virginia, A Visit from the Old Mistress, Autumn, Summer, Camp Fire* (fig. 126), and *Two Guides* (fig. 103). In these canvases, Homer explored subjects and methods that he may have felt could be investigated only in the medium of oil. Earl Shinn of the *Nation* offered an expanded view of the situation. Noting first that Homer's truancy was the most conspicuous, he continued to explain that lack of sales from the 1877 watercolor exhibition had caused "the leader of the invading school [to withdraw] into his tent to ponder on the bad faith of the champions of bric-a-brac." By referring to Homer as the "leader of the invading school," he located the artist squarely at the head of the changes in American watercolor art. Yet, he also pointed out that "[c]ertain foreign contributors, however, have planted the standards and the disturbed colors of the orientalists, and the Exhibition does not quite lack the peculiar and stimulating accent which it was the wont of Mr. Homer to confer on the yearly display."[108] The recognition of Homer as a leader of the newest trends in watercolor, but no longer the only provider of distinctive work, prefigured the larger struggle that would come to a head in a year.

"Mr. Winslow Homer . . . Has not Cared to Trouble Himself to Put in an Appearance"

Fig. 99. Thomas Waterman Wood (American, 1823–1903), *Sunday Morning,* c. 1875. Oil on canvas, 14 x 10 in. (35.6 x 25.4 cm). Smithsonian American Art Museum, Washington, D.C. Gift of Mrs. Francis P. Garvan

A New Position for the National Academy of Design

In 1878, the National Academy of Design annual exhibition found itself in direct competition with that of the Society of American Artists. The Society, organized the previous year, was formed in direct response to the perceived ill-treatment of the younger and more forward-thinking artists by the Academy. The conflict had come to a head in the spring of 1877, when many members of the Academy felt the hanging of their work had been slighted in favor of the younger painters. A new rule resulted that entitled every member to have two paintings hung on the centerline (the most valued position) in the annual exhibition. Knowing that this new statute would take effect in 1878, the more progressive—and mostly European-trained—artists reacted by creating the Society of American Artists and holding its first exhibition the month before the 1878 Academy show opened.[109] The Society's first president was Walter Shirlaw and among its members were John La Farge, George Inness, and William Merritt Chase.[110] More than simply a protest against the Academy, the Society of American Artists would play a pivotal role in shaping American artistic identity around the acceptance of a more universal concept of art that shared in the history of western civilization.[111]

The critics were not immune to aligning themselves with the increasingly separate artistic factions. Both Clarence Cook and Charles DeKay actively participated in the formation of the Society of American Artists and were great champions of the organization as well as the work of its members.[112] The critics' own in-fighting appeared in the press. An editorial in the *Telegram* complained that "opinion in art matters is worth less than nothing," because critics were either ignorant or pompous windbags. The writer then called for impartiality as well as broader knowledge to leaven the field.[113] Mariana Griswold van Rensselaer framed the issue more sympathetically, focusing on the challenges facing the critics. She noted that a reviewer's duty was to consider both the relative quality of the works as well as measure them against the highest standards of art.[114] No doubt, the critics were also caught up in the Academy's politics as they sought to identify individual, national, and universal artistic achievements. Thus, their writings often reflect their own conflicts and contradictions. And in addition, as the press reminded its readers, the ongoing economic depression did not spare the art world.[115]

In this charged atmosphere, the Academy opened its 1878 exhibition. Not surprisingly, the show had a somewhat different cast than the previous two years. Munich-trained artists, many of whom sent their most daring canvases to the Society of American Artists, caused less of a sensation at the Academy than in 1877. More Paris-trained artists exhibited, including Wyatt Eaton, Abbott Thayer, Julian Alden Weir, Thomas Eakins, and Mary Cassatt. Without the stylistic pyrotechnics of the Munich men consuming the critics' attention, paintings expressing the poetic and the imagination, such as the canvases by La Farge, Inness, Homer Martin, and George Fuller, captured a greater share of the reviews. Well-known academicians, including Homer, Guy, Wood, Brown, Eastman Johnson, and Robert Swain Gifford, also participated. Thus, the 1878 Academy exhibition had a greater variety of contributions with no single faction overpowering it.

With the art and the opinions about it diversifying, the number and types of reviews of the 1878 Academy exhibition were varied. Some periodicals lost interest in the Academy. The *Atlantic* and *Scribner's* did not report on it at all, choosing instead to focus on the upcoming Paris exposition. The *Commercial Advertiser* reviewed the exhibition, but mainly addressed larger topics and focused on fewer individual artists and works.[116] Those papers and magazines most committed to covering the fine arts, notably the *World, Tribune, Times, Nation,* and *Art Journal,* gave the show their full attention. Yet, although some critics wrote with passion on certain topics, the overall tenor of the reviews was one of exhaustion.

Having just completed its reviews of the inaugural Society of American Artists exhibition, the art press found the Academy show to be simply less exciting than in the past. No heated discussions of either its excellence

Fig. 100. *Shepherdess*, 1878. Ceramic tile, 7 ¾ x 7 ¾ in. (19.7 x 19.7 cm).
Lyman Allyn Museum of Art at Connecticut College, New London

or inferiority ensued. Responses ran along the centerline, some slightly more complimentary, others more critical. Faint praise was meted out in proportion to mild disappointment. Those who praised the exhibition generally wrote for the periodicals that had more cursory or reportorial coverage of the show. Their favorable impressions simply suggested an openness to a variety of approaches.[117] Many of the writers less enamored of the exhibition characterized it as mediocre, noting that it would have been difficult to create a show matching the impact of that of 1877. In fact, Brownell of the *World* understood the show as a reaction against that of the previous year. He identified the conservative hanging committee–Aaron Draper Shattuck, John Casilear, and Henry Augustus Loop–as well as the new rule ensuring space on the line for the academicians as signaling a "return of the natives," and he found the result was much less interesting.[118] Others also felt the show was lacking but attributed this to varying causes. The absence of a notable work like Duveneck's *Turkish Page* was cited as a decided weakness in the show, as were the figure pictures overall and the seemingly less ambitious effort by older and younger artists alike.[119] No doubt, the preparation of work for the Paris exposition, opening in early summer, also had captured the energies of the artists.

Fig. 101. *The Watermelon Boys*, 1876. Oil on canvas, 24 ⅛ x 38 ⅛ in. (61.3 x 96.8 cm).
Cooper-Hewitt, National Design Museum, Smithsonian Institution, New York. Gift of Charles Savage Homer, Jr., 1917-14-6

"Winslow Homer
. . . Interests Us
Unfailingly, but
in the Presence of
Whose Paintings
We Are Infallibly
Thinking of
Something Else"

Homer's contributions to the 1878 Academy exhibition and the responses they evoked suggest how his own situation in the art world was shifting as he continued his search for viable subjects and artistic treatment. He exhibited five paintings (several of which were more than a year old) and a ceramic tile. *Morning* was the title of the exhibited tile. While that particular tile is not identified today, *Shepherdess* (fig. 100) dates to this same year. Of the paintings, *The Watermelon Boys* (fig. 101), an image of rural prankster-children, including both African-American and white youths, had first been shown at the Brooklyn Art Association in December 1876. It appeared now in a possibly altered form.[120] *Shall I Tell Your Fortune?* (fig. 102), first shown at the Century Club in January 1877, pictures a young woman holding a hand of cards. *In the Field* (fig. 104) had been shown previously as *Song of the Lark* at both the Century and Union League Club in February 1877. *Two Guides* (fig. 103) and *Fresh Morning* (location unknown) were both Adirondack subjects and were the only works on view that can be definitely tied to his previous summer's excursions. Armed with this array of subjects, Homer, it appears, was hedging his bets, hoping that one of these themes would hit the right chord with the critics or that different ones would please different tastes (and patrons, too). For example, the boys eating watermelon had a humorous veneer

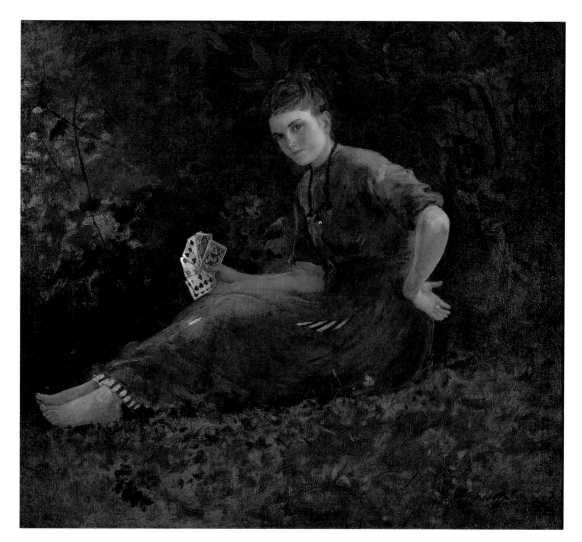

Fig. 102. *Shall I Tell Your Fortune?*, 1876. Oil on canvas, 24 x 27 in. (61 x 68.6 cm).

Fayez Sarofim Collection

that had proven popular with African-American images. Farm subjects had been perennially successful. *Answering the Horn* had proven their continued popularity in 1877, and *In the Field* was a related composition. Homer's fortune-teller intersected with the growing interest in alluring images of women, while the Adirondack themes were increasingly appealing to men as outdoor wilderness experiences became an increasingly favored leisure-time activity.[121] These subjects also gave Homer the opportunity to investigate his growing interest in depicting different types of outdoor light, its effect on color, and its ability to suggest atmosphere. The entry of a tile placed Homer firmly within the decorative movement and asserted his desire to be associated with the most fashionably artistic.[122] Ironically, this wide variety of offerings resulted in considerably fewer extended notices of his work.[123] Homer's position in the entire suite of reviews was more peripheral than usual. This minimalized response was caused or aggravated by the fact that four out of his five canvases hung in the corridor—"an unusual place for an academician to occupy," noted the *Sun*.[124] The end result was that Homer's entries were far less prominent overall.

As the press focused more intensely on explicating the purpose of art, discussions about proper subject matter and technique now occurred with regard to discerning the artist's intention for his work as either the expression of individual creativity and emotional states or of art-for-art's-sake with an emphasis on sheer beauty. In this context, Homer was received by the critics as he was seen to engage or ignore these rising concerns while

still exploring those issues with which he, alone, was so often identified. Once again, mixed results prevailed. Of the six in-depth reviews, two were very positive, one was cruelly negative, and the rest found both good and bad elements in the work. Four of the six brief notes were laudatory.[125] Of the others, the *Mail* had mixed feelings while Mariana Griswold van Rensselaer in the *American Architect and Building News* was overtly negative.[126] Again, the comments large and small often discussed Homer in general terms as much as they addressed specific pictures. Earl Shinn in the *Nation* shed some light on why this was the case: "We may begin with those artists, such as Homer and La Farge, whose works the connoisseur does not regard, but rather the works expected of them . . . Winslow Homer, again, is an artist who interests us unfailingly, but in the presence of whose paintings we are infallibly thinking of something else."[127] For Shinn, that "something else" towards which Homer's art made him turn was the hope for a national art. While Homer's entries in this exhibition did not provide Shinn with much hope due to their perceived technical defects, their sheer presence caused him to deliver an eloquent essay on Homer and national art:

> *We always think of Mr. Homer when we feel hopeful of the uprising of a national expression in art. . . . America, born without a past, and a mere recipient of impartial influences from all the world, is rather more hapless in this respect than others amongst the civilizations. Still, in art, we do notice, although all schools must be based alike on the Italians and on the Greeks, that an individual or a group will generally arise whose studies have taken a bent so particular, and so much in harmony with race-character, as to get accepted as typical. . . . America has not yet contributed, but whenever we . . . cast about for the coming man who will represent her, we are as apt to think of Mr. Homer as of any one else. He selects purely national subjects, and he paints them with a style quite his own, a style that has never felt the style of foreign teachers to a controlling point.*[128]

Shinn's viewpoint, which blended his cosmopolitanism; his embracing of Hippolyte Taine's notions that national characteristics rise out of race, milieu, and moment; his agreement with Matthew Arnold that the highest art draws upon the best of all civilizations through time; and his great desire for a recognizably American art, elaborated the challenges and cures for a national school. Shinn found in Homer's work the necessary ingredients to fulfill his hopes by virtue of his subject matter as well as a style that, although it might make use of foreign elements, retained its individuality.

A number of other critics also did not feel that Homer's 1878 Academy entries were his best technical efforts. William Laffan of the *Sun* admitted that Homer was one of the best painters of American home subjects, but he criticized the works on view for their "more sketchy and slovenly style than usual."[129] Criticism for crudity, hardness, and disagreeable color was handed out in considerable measure for *The Watermelon Boys* and *Shall I Tell Your Fortune?*. The *Independent* felt its eyes had been "lashed" by the latter.[130] Clarence Cook was the most terse and critical of all, dispensing with Homer's technique overall with the word "vapid."[131] Common to *The Watermelon Boys, Shall I Tell Your Fortune?*, and *Two Guides* is that large portions of the canvases are very thinly painted.[132] In all of them, Homer used a reddish-brown wash as both an imprimatura layer and as an integrated tone of the final color scheme. The visual result, particularly in the legs of the figures in each of them, is a melding with the background and a blurring of the relationship of the figure to the background. Conversely, the faces of the fortune-teller and the kneeling boy with the watermelon, areas with greater definition through outline and traditional modeling, stand out in contrast. In addition, the juxtapositions of colors in all three paintings place red-browns next to varieties of greens, creating an intense contrasting of colors that, while we see them as richly resonating today, may have garnered the criticism of being disagreeable.

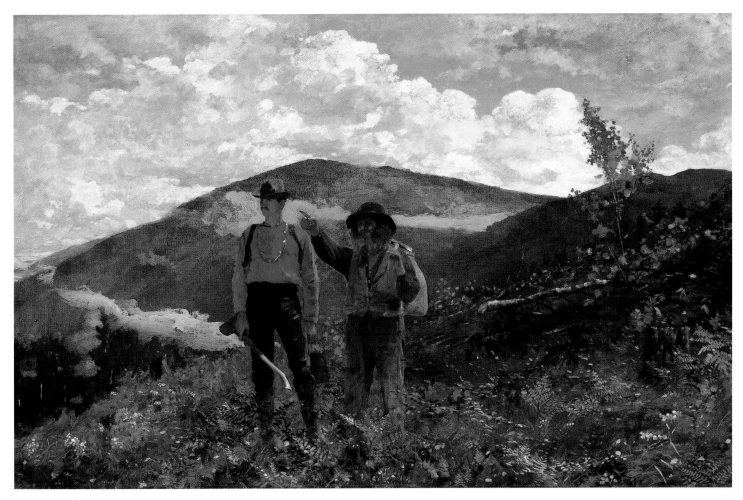

Fig. 103. *Two Guides*, 1877. Oil on canvas, 24 ¼ x 38 ¼ in. (61.5 x 97.2 cm).
Sterling and Francine Clark Art Institute, Williamstown, Massachusetts, 1955.3

The one true booster for Homer's technique and its effects was again Susan Nichols Carter. She explained:

This year, more than in any previous exhibition, his paintings have acquired such freedom as almost to warrant them in being called "impressionist" pictures. In the one in the corridor, of some boys sucking away at strips of watermelon, the whole question of the technique *is lost in the vivacity of the figures; and, at the same time, half a glance reveals to the visitor that it possesses great merits of style both in drawing and colour.*[133]

Carter's "impressionism" predates the later, now accepted, use of the term associated with the aesthetic and movement first centered in France and then popular on both sides of the Atlantic after 1885. This better-known Impressionism dissolves form into light through the application of pure, unmixed color directly to the canvas with limited use of black or other neutral tones. For Carter and her colleagues in the late 1870s, a work was impressionist if the artist simply employed looser, boldly and broadly applied strokes to define a subject. The term was most often used to describe the work of the Munich-trained artists, who not only heavily relied on black and brown in their palettes, but also used light to shape form rather than dissolve it.[134] In fact, the undeniable presence of foreign-trained painters on the exhibition's walls caused concern that technique would become an

overriding principle of art. With scores of American artists returning home from Munich and Paris, it was clear that Americans could learn the technical means to paint. It was the goal towards which that technique should be applied that was becoming more hotly debated. Even Carter, a lover of the freer styles, admitted: "if a person really desires to create a picture, it must be under the influence of an impassioned impression, and not with simple manufacturing of skill." In *The Watermelon Boys*, Carter discerned the deeper situation implied in the scene through the successful conjoining of these two elements.[135]

As changes in styles and subject interests moved farther away from the detailed and narrative toward the looser and more conceptual, the quality or substance of ideas was more closely scrutinized. There was a nearly unanimous voice among the critics that treatment must be tied to substantive ideas. The *Sun* noted:

> *The mediocrity in the display of genre pictures . . . is particularly noticeable in the works of home-bred painters, but is by no means confined to them. . . . We look for invention, for original ideas, humorous or otherwise, and fail to find them. Pictures, as a rule, do not tell a story or even suggest an incident of importance, and as this defect is not redeemed by superior drawing, coloring, or composition, the result is peculiarly dissatisfying.*[136]

This lack of ideas (also called motive or conception) was found in artists young and old, foreign and home-trained. The *Daily Graphic* said that the works in this Academy showing attracted viewers because they were pleasant to look at, but there were few canvases with "any abiding art value, [due to] the slimness of idea underlying the vast majority."[137] James Jackson Jarves reminded readers in the *Independent* later in the year that the worthwhile idea went beyond the record of factual truth and incorporated the artist's imagination. "Fine art, indeed," he noted, "includes Nature's truth; but something more. Its highest qualities imply the existence of independent *'creative'* forces of the human mind, capable of fashioning Nature's forms to its own meaning and of reshaping them to its own concrete ends. This alone is high art."[138] The *Independent*'s reviewer of the Academy exhibition held a similar viewpoint. Thus, Homer fell short for this writer, who only saw factual truth in the work. He mourned: "we fear that Mr. Homer is 'ower auld to larn,' and will never realize that his work has truth to Nature in spite of, and not on account of, its unatmospheric hardness and utter absence of beauty. He does not tell the whole truth, even if he tells nothing but the truth."[139]

The belief that it was necessary for art to connect with human emotions–both its maker's and viewer's–had been rising steadily over the past several years, and in 1878 both artists and critics were focused on it. The call for reflections of the human condition in art included *Appleton's* insistence that "there should be in every painting some connection with man's doings, or else the work loses its pictorial interest. . . . The true and lasting value of a painting must be its power to suggest, to awaken, to touch the imagination or the sympathies, to link itself closely to the heart of the spectator."[140] It was a plea for the poetic in art. Depending on the critic, it could be located in subject, treatment, or both.[141]

With notions of the poetic dominating the 1878 Academy, Homer's *In the Field* received his most positive reviews. Dated 1876, the canvas depicts a subject and composition closely related to *Answering the Horn. In the Field*, however, pictures only a single figure, thereby simplifying the narrative. The image stirred critics' feelings. Earl Shinn said that the painting's real merit was "the young farmer, striding through the dew of dawn and impulsively taking off his hat to the Te Deum of the birds." Although he couched it in narrative terms, Shinn responded to the poetic emotion of the moment suggested by the image. He also noted that aiding the canvas were an energy and insight put forth in "a personal and unborrowed" manner.[142] Even the otherwise cruel Clarence Cook gave his one positive word to *In the Field*. He said it achieved a "pleasant sentiment," making it the only one of Homer's entries worthy of his reputation.[143]

Fig. 104. *Song of the Lark (In the Field)*, 1876. Oil on canvas, 38 ⅜ x 24 ¼ in. (98.1 x 61.5 cm).
Chrysler Museum of Art, Norfolk, Virginia. Gift of Walter P. Chrysler, Jr.,
in honor of Dr. T. Lane Stokes, 83.590

As the power of the poetic took hold, the American qualities of Homer's subject matter were discussed less vigorously than in previous years. The *Nation*, nonetheless, commended Homer for his generally national subjects, and the *Sun* recognized Homer and Eastman Johnson as positive examples of how to properly paint American subjects, despite the fact that they were always less picturesque than foreign ones.[144] Clarence Cook, however, again condemned Homer's subjects outright. After praising the sentiment in *In the Field*, he lamented the rest of Homer's group of entries: "The subjects of some of these are mean; those of all of them are uninteresting."[145] Cook could not find in the subjects of rural life and American daily experience the historical interest or poetic sentiment he preferred. In fact, he had difficulty finding his poetic ideal in this exhibition at all. It was only refined technique that drew his praise. He now preferred Chase, Shirlaw, and Neal for their technical merits, but their emphasis on technique put their works on the verge of having no purpose, and thus their canvases, too, ultimately failed as art.[146] He considered Thomas Eakins's *Chess Players* (fig. 105) to be one of the few really good pictures in the exhibition. Although its color was faulty, "in drawing, in truth of action, and in the depicting of character in the heads," Eakins's entry was "exceedingly clever."[147] Cook made no mention of the painting's subject, but Eakins's French academic training, where drawing and figure study were paramount, clearly made the canvas a technical success.

Cook's reaction to Homer's subjects contained an extremely harsh personal attack on the artist. He claimed:

> *For an artist who has done such clever things as Mr. Homer, and who has always found the public more than ready to welcome him, it looks like trifling both with himself and his friends when he sends such things as are hung. . . . It may be that the public does not deserve respectful treatment, but it is not in the interest of art for artists to deal with the public on that theory. We have no intention to intrude our advice upon the artists, but we may at least be allowed to speak in self-defense. . . . What has come over this artist of late years that he sulks in his tent, and seems to take pleasure in painting as badly as he can! . . . But the reason why it is so bad is because we see plainly how good it might have been had the artist chosen to put himself into his work, and not played at chuck-farthing with his talent.*[148]

Although Cook framed his protest on behalf of the public and the whole body of critics, a personal anger prevailed, the roots of which are unknown today. Perhaps it related to Homer's not heeding the critic's advice.[149]

Within the assessments of the 1878 Academy show, notices of Homer's work still often intersected with the prevalent issues of the day, but a number of critics now placed him in the circle of the older generation. Mariana Griswold van Rensselaer, for instance, lumped him with the other academicians, whom she saw as not only older but doing worse work.[150] The *Times* agreed that Homer was a member of the older guard, who now seemed less ambitious, and it viewed works like *The Watermelon Boys* as serving a public taste that wanted pictures to amuse, thrill, and instruct with a story.[151]

In sum, Homer's work at the 1878 Academy exhibition connected to the plurality of concerns for art, but in many cases, his position was marginalized as his works were physically distanced from the main exhibition rooms. George William Sheldon, investigating the reasons for the founding of the Society of American Artists, understood the position of certain academicians, including Homer, George Inness, William Trost Richards, and John Quincy Adams Ward. He noted that these artists were creating enduring work and that, even though they "are not found in the 'new departure' of which we have been speaking . . . they have all of them, perhaps more than once, taken new departures of their own; and whatever things are true and honest and lovely in the present new departure are, we may be assured, neither strange nor unwelcome to them."[152] This statement held true for Homer more than for almost any other artist Sheldon listed.

If Homer was on the cusp of being thrown into the camp of old fogies at the Academy, he participated in

Fig. 105. Thomas Eakins (American, 1844–1916), *Chess Players*, 1876. Oil on wood, 11 ¾ x 16 ¾ in. (29.8 x 42.5 cm).
The Metropolitan Museum of Art, New York. Gift of the artist, 1881 (81.14)

other activities that ran counter to such an image. In the first week of May, Homer hosted the Tile Club's last meeting of the season with a dinner at his studio. A few days later, a year's worth of the club's productions were on view, including three sets of three tiles each by Homer.[153] Homer's excursion into the decorative arts was acknowledged in an article that noted a number of artists had added decoration to their regular work in the past season. It was pointed out that the artists were not simply ladies painting pottery, but included "some, like Mr. Homer, who are no neophytes in the mysteries of design, are applying their knowledge and experience in practical production."[154] In addition to his involvement in the Tile Club, Homer also contributed some watercolors to the May reception of the Art Students League, a recognized center of the newer trends. At about the same time, Homer's work was included in the first black-and-white exhibition of the Salmagundi Club, a new venture devoted to supporting drawing as an art form in and of itself.[155] Nonetheless, Homer continued supporting the Academy. He attended the annual meeting on May 8, where it was noted that his colleagues Eastman Johnson, John La Farge, and Albert Bierstadt were noticeably absent.[156]

Despite the range of reports of Homer's activities in early May 1878, the writer for the *Mail* was intimate enough with him to report: "Mr. Winslow Homer, feeling a little under the weather, will go into the country on a fishing excursion of a week or two."[157] Whether or not Homer took that fishing trip is unknown, but he was likely occupied with sending work to Boston, where there was a sale of his works on paper at the end of the month at C. F. Libbie's auction rooms. The *Boston Daily Evening Transcript* reported that "There are eighty-four in pencil, crayon, charcoal and watercolor, embracing bits of army life, and life (especially child-life) at the seashore and in the country, all as American, as Yankee in character as the 'stars and stripes,' but without a particle of vulgar forcing of that idea."[158] From the variety of subject matter mentioned—Civil War scenes, children at the shore, and rural settings—it appears that Homer was cleaning out his studio. Auctions were efficient vehicles for artists to make money and consolidate their belongings. It was common practice to hold a sale in preparation to travel or move, and it is possible Homer considered returning to Paris on the occasion of the 1878 Exposition Universelle as he had visited the 1867 fair.[159] Homer's 1878 Academy entries indicated shifting interests in subject and style, and so this sale also may have provided Homer with a means of removing, literally and symbolically, those items no longer relevant to his art.

Homer at the Paris Exposition Universelle

—————— • ——————

The art exhibition at the 1878 Exposition Universelle, on view in Paris during the summer, held great significance for American artists. Not since 1867 had such a large selection of American works traveled to Europe, and, as Jennifer Bienenstock has pointed out, the American showing was understood to present the "opportunity for the first international and large-scale display of America's alignment of its artistic goals with those of Europe."[160] The reviews of the exposition, however, were not as voluminous as one might expect. Practical considerations of overseas travel prevented many New York critics from seeing the installation. Reports, especially in the newspapers, came instead from foreign correspondents or were quotations from the foreign press.

Although the exposition did not open until June, discussions of the contents of the American section began in earnest in mid-March, when the final selection was announced. Eighty pictures, including twelve watercolors, were to be sent.[161] The selection of works was divided between two committees, one headquartered in New York and the other in Paris. In New York, an advisory committee of ten prominent individuals—E. D. Morgan, J. W. Pinchot, Parke Godwin, J. T. Johnston, H. Q. Marchand, Robert G. Dun, Robert Gordon, John Sherwood, N. M. Beckwith, and Charles S. Smith—selected work from their own collections as well as solicited works from individual artists and private galleries. In Paris, Augustus Saint-Gaudens, D. Maitland Armstrong, and Christian Detmold were charged with making the selection of works from the artists working abroad. For some writers, the absence of certain names, especially from the older generation, made the selection incomplete. Jasper Cropsey, William Hart, David Johnson, and Albert Bierstadt were repeatedly mentioned as having been unfairly overlooked. In their opinion, the imbalance was enhanced by the inclusion of three or more examples of works by certain artists, including Homer, Samuel Colman, Robert Swain Gifford, Seymour Guy, Louis Comfort Tiffany, and Thomas Waterman Wood.[162] Homer's contributions— *The Country School* (fig. 24), *Snap the Whip* (fig. 31), *Bright Side* (The Fine Arts Museums of San Francisco), *A Visit from the Old Mistress* (fig. 97), and *Sunday Morning in Virginia* (fig. 98), were singled out as representative of this problem.[163] In the eyes of the conservative *Commercial Advertiser*, the poor selection stemmed from "too many pictures painted by certain favorites who are inferior artists, and by sending none of the examples of our very best men. For instance, four [*sic*] works by Winslow Homer are selected, one or two of which are old-fashioned, unimportant pictures which we have seen offered and hawked about for sale for several years past; but

Albert Bierstadt, our great artist . . . has . . . no picture going. . . . David Johnson is left out in the cold."[164] Charles DeKay of the *Times* offered another viewpoint, suggesting that the selection committee had sought out the best in American art. He noted that while this method did not follow the democratic process, the results were acceptable even though not representative.[165]

The overriding complaint about the American showing in Paris was its lack of national characteristics. Many critics agreed with Philadelphian Lucy Hooper, the Paris correspondent for the *Art Journal*, who complained: "[T]he greatest defect of our Art exhibit does not lie in its meagerness, but rather in its lack of national characterization. . . . [W]e had a right to expect that at least American artists would paint American subjects. . . . The blood in our painters' veins may be American, but the visions that throng their brains are European."[166] There was the additional criticism not only that the selection was not American enough but that the representations of national characteristics were poor. William James Stillman, writing for the *Nation*, stated that "The work that smells of the soil and could not be mistaken for anything but American is not abundant and is mostly very bad."[167]

David Maitland Armstrong, writing in *Scribner's*, presented a different viewpoint. Having served on the Paris selection committee, he, not surprisingly, found individuality, originality, and variety in the American section compared to other countries.[168] Russell Sturgis, also writing for the *Nation*, agreed, but he suggested that it was not necessary to be so overwrought about evidence of "the national" in our art:

> The only fault which, as it is urged, sounds formidable, is that the pictures chosen are not "national," not American enough. . . . It is not important that our painters should seek to be national, or that they should seek to resist foreign influences. It is the important thing that they should seek to be skillful in work and simple in design; nationalism will come as imagination, as invention, as power, as "genius" will come, of itself, in its own good time.[169]

Sturgis accepted that American art was at an immature stage of development, and that national character as well as imagination would come in their own time.

For those searching for national characteristics at the exposition, Homer's contributions were seen as among the most quintessentially American. The European critics' responses reiterated the commonly accepted hallmarks of Homer's Americanness: his subjects, spirit of originality, simple-heartedness, honesty (though considered gauche by some), truth of sentiment and treatment, and strong local character.[170] Homer's recent African-American images held a special attraction for Paul LeFort, whose *Gazette des Beaux-Arts* reviews were reprinted in the *Tribune*. In *A Visit from the Old Mistress* and *Sunday Morning in Virginia*, he observed that Homer's originality and national identity were born out of his combination of subject and treatment, particularly through the design and coloring of the canvases.[171]

The Americans' responses to Homer also reiterated familiar reactions, and, as usual, their comments were mixed. Some considered the group of Homer's contributions a disappointment. The *Aldine* lamented: "Another of those 'buds of promise' (occupying the 'line'), fallen like autumn leaves with the first frost, is Winslow Homer. What excuse can a painter offer for sending, and our 'judge and jury' for accepting, under the head of Fine Arts, such nondescripts as those which bear Mr. Homer's name?"[172] The inclusion of *Snap the Whip* was specifically criticized by William James Stillman. To him, the six-year-old canvas appeared old-fashioned and lacked the proper ingredients for art. Yet Stillman found the painting clever and pleasant, but only as a realistic portrayal of an everyday incident. It lacked the element of imagination he required for true art.[173]

While the native quality of Homer's canvases was undeniable, the appropriateness of the finish of his work continued to be questioned. Lucy Hooper was among those who felt Homer's work was hurt by his sloppy paint

application: "Mr. Winslow Homer's pictures of negro life are exceedingly faithful and characteristic, but err by a too great hastiness and thinness of execution. Mr. Homer would probably have received a gold medal, I am told, had he sent more carefully-finished examples of his very real and decided talent."[174] Hooper felt that Homer's faulty artistic treatment compromised the quality of his work and suggested that in painting as he did, he betrayed his country. The opposing viewpoint was offered by the European correspondent "Gar" in the *Times*: "[T]his artist's careless breadth is much more artistic and much more valuable than the sham finish and pretense at texture of many French and Belgian pictures greatly admired in America, and of Beaufain Irving, an American artist, who adopted their style."[175] Homer never fit comfortably in one or the other camp of the finish controversy. In the coming season, the gulf between sides on the issue of completeness would deepen and heated discussions would ensue in which Homer figured prominently.[176]

While his paintings were in Paris for the summer, Homer visited his friend and patron Lawson Valentine at his new country property, Houghton Farm.[177] The pictures resulting from this trip were seen in his studio, at the Century Club in November, and at the reception of the Art Students League in December. They were immediately noticed as interesting and appealing. In less than four weeks' time, five art writers made special mention of them. The *Sun*, reporting on Homer's "water color drawings" of children, sheep, and pure landscapes at the Art Students League in December, explained why they were so captivating: "These comprise much of the best work Mr. Homer has yet done. They are full of refined and delicate telling; they convey a very touching and pleasing sentiment; and what is both unusual and unexpected, they are distinctly American in their quality. . . . [N]ot at any time has his work shown so much seriousness or such a depth of motive and completeness of expression."[178] Qualities that critics felt had been lacking in Homer's art were now appearing here: greater attention to conventional beauty (refinement and delicate telling), emotional impact, the poetic, seriousness of intent, and completeness of thought through the artistic treatment. These characteristics conjoined with Homer's signature feature, a distinctive Americanness. The result was that, according to the *Herald*, "the little drawings are extremely *chic*," and the eye of the *Art Interchange* writer "could not but linger" on them.[179] Homer continued to work on these sheets through the fall and winter. They formed the core of his 1879 offerings to the American Watercolor Society annual exhibition, where they would elicit much commentary.

During the summer of 1878, a monographic article on Homer–the most comprehensive article to date–was published in the August installment of an *Art Journal* series on contemporary artists by George Sheldon. Illustrations of *The Watermelon Boys* (fig. 101) and *In the Field* (fig. 104), most recently exhibited at the Academy, were included. The article ended with a commentary by Sheldon that both praised and gave a cogent assessment of Homer's current work. He wrote:

> *Homer is not wholly a master of* technique, *but he understands the nature and the aims of Art; he can see and lay hold of the essentials of character, and he paints his own thoughts. . . . Every canvas with his name attached bears the reflex of a distinct artistic impression. . . . [W]hile in the best of them may be recognised [sic] a certain noble simplicity, quietude, and sobriety, that one feels grateful for in an age of gilded-age spread-eagleism, together with an abundance of free touches made in inspired unconsciousness of rules, and sometimes fine enough almost to atone for insufficiency of textures and feebleness of relation of colour to sentiment.*[180]

Sheldon placed Homer squarely in terms of the most current interests and ideas, and in that context praised his individuality, naturalism, breadth of style, and ability to use light as a defining characteristic. He was also commended for a sobriety that counteracted the perceived rising materialism of the day so that, despite his technical deficiencies (especially with color), Homer satisfied this critic's requirements necessary for good art.

Sheldon's article appeared three-quarters of the way through a year that was challenging for both Homer and American art. If in 1877 Homer had effectively balanced competing interests, his artistic methods in 1878 divided the critics into those who accepted his level of finish and those who could not. His subjects submitted to similar treatment, and although there were pockets of high praise, he was repeatedly criticized. Too, his position in the constellation of artists had somewhat shifted, out of the younger towards the older camp. He was faulted for his absence at the Watercolor Society and for not behaving up to expectations. Yet, his work was positively recognized as increasingly poetic and in some cases, such as his tiles, striding into new territories. And still, as always, he held most firmly his distinction as the most "American" of artists.

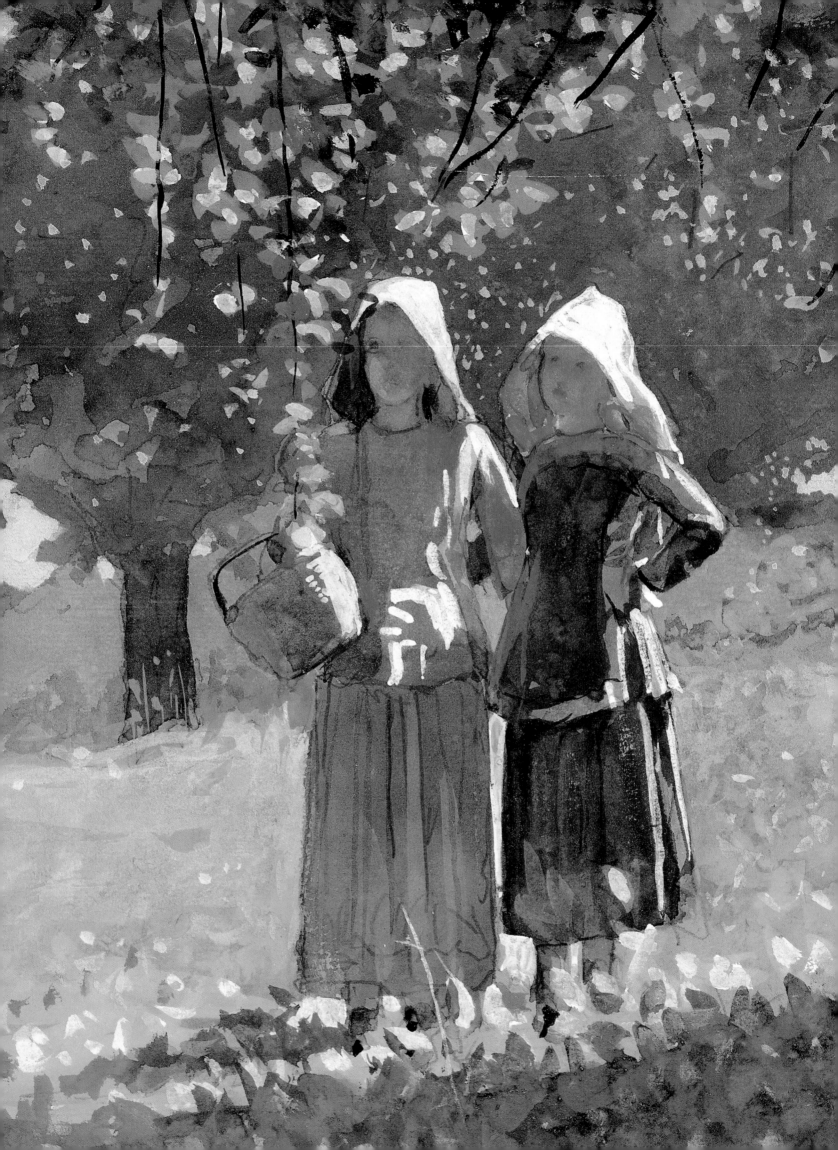

"Mr. Winslow Homer Is Wholly 'En Rapport' with American Life"

As AMERICAN ART GENERALLY ADOPTED MORE AND MORE INTERNATIONAL INFLUENCES, HOMER'S POSITION AS THE FOREmost national artist remained uncontested. In 1879, he presented work that again was hailed as forthrightly native even as he incorporated many of the newly popular European influences. Both his watercolors and oils this year visibly displayed his absorption of prevailing trends, most notably the impressionist and decorative aesthetics. While the American attributes discerned in Homer's work garnered unanimously positive reactions, his varied presentations of them again received mixed responses.

During the fall and winter of 1878–79, Homer concentrated on making art as he worked to reconcile the competing national and international influences. As a result, he exhibited rarely until the Watercolor Society's annual exhibition.[1] Much of his energy was devoted to drawing, which coincided with a growing interest in the medium as an art form itself.[2] Supporting this new impulse was the black-and-white exhibition at the Salmagundi Club in February 1879 to which Homer contributed "a frame of pencil memoranda," which appeared "clever" and indicated, according to the *Mail*, "a decided leaning towards the 'impressionists.'"[3] A fuller display of Homer's impressionist tendencies was simultaneously on view at the Watercolor Society.

The 1879 American Watercolor Society exhibition was widely reviewed. The critics almost unanimously agreed that the show was greatly improved over past years and that its fineness could be attributed to an overall higher quality of work rather than to a few specific outstanding pieces. A greater variety of both method and subject made the show appealing to many viewers and furnished acceptable work to critics of different persuasions, whether they favored European-trained or homebred artists or were liberal or conservative in attitude towards technique and theme.[4] More than one critic discovered originality on the exhibition's walls, and its appearance was welcomed as evidence of thinking, individuality, and Americanness, even in the face of considerable European imitation.[5]

As a wider range of watercolor methods became acceptable, writers cared more for what was being expressed than the mode of execution. The call for the expression of deeper thoughts was one articulation of this viewpoint. William Brownell of the *World* elaborated, stating "the important thing after all [is] always not how anything is done but what it is and how completely it is expressed."[6] As was true for oil painting, the interest in watercolors was now less on the technique employed and more on how it supported the thought being conveyed. Most important was that the idea being expressed be worth it. A single correct means of artistic treatment no longer existed. Variety and individuality were advocated in their own right.

J. Frank Currier
versus
Winslow Homer

———•———

Fig. 106. J. Frank Currier (American, 1843–1909), *Polling bei Weilheim, Bayern*, 1878.
Watercolor on paper, 11 x 15 ¾ in. (28 x 40 cm). Private collection

The main catalyst for the discussions of the 1879 watercolor show was the high percentage of works identified as impressionist. Their appearance raised such questions as what is impressionism? Is it a valid means of expression? How is it manifested? Corollary topics of discussion included the validity of the sketch, the question of what was appropriate for exhibition, and the definition of completeness. These issues surfaced in nearly every one of the twenty periodicals that covered the exhibition. Defining impressionism, however, was a thorny problem. The *Post*, for one, noted that it was not an entirely useful term because it had such broad applications. In fact, by 1879 certain critics, notably Charles DeKay, were sufficiently familiar with French Impressionism to incorporate some of its technical aspects into their use of the term. Still, impressionism was generally understood to include any artist "who neglects details for sentiment," and it acknowledged that such a result could be accomplished in many different ways.[7] Despite the blurred parameters of impressionism, all the critics agreed that the most aggressively impressionist aesthetic appeared in the group of sheets J. Frank Currier sent from Munich.

Currier, a Boston native, had gone to Munich in 1870 to study at the Royal Academy; he remained in Germany until 1898.[8] The images he sent to the Watercolor Society exhibition were landscapes, but the most extreme examples appeared to most viewers as diffuse, amoebic forms and layers of color.[9] To viewers in the 1870s, Currier's watercolors were virtually abstract. Created primarily by applying wet paint to wet paper, the Munich resident's sheets were the most technically radical work shown publicly during this era. Many soundly denounced them, and even the few positive commentaries included qualifications.[10]

The criticism of Currier's entries, which may have included works like *Polling bei Weilheim, Bayern* (fig. 106), focused on their seeming lack of comprehensible subject, composition, or design as well as on his extreme methods of handling. To William Laffan of the *Sun*, Currier's contributions appeared as "arbitrary and capricious blots of color rudely splashed about the paper with no direct or intelligible reference to any outline or design or arrangement of form." He continued that the watercolors went beyond the outer extreme of anything ever created by Whistler, who was generally acknowledged as the most radical American artist of the day, and in their technical and intellectual incompleteness, he found them analogous to a stack of building materials, rather than a completed edifice.[11]

The critics generally agreed that Currier's images were entirely indecipherable if viewed at close range. What happened when they were seen at a distance was debatable. Some art writers felt that at a distant vantage point they resolved into varying degrees of landscape images. For example, Charles DeKay, although bothered by what he believed to be affectation and undue European influence in the work, could not deny the power of the images when viewed at a distance. He marveled that the "strange blendings of apparently meaningless color resolve themselves into landscapes . . . of no mean excellence."[12] DeKay recognized that Currier's methods had allowed him to suggest the transient effects of light and air on the landscape. The writer for the *Herald* was less kind, noting that "if you stand off thirty feet, half close your eyes and try to think hard what he means you may get a glimmer, if your tastes are of the madly impressionist stamp." Yet, he gave Currier credit for them as "valuable memoranda, full of suggestion to himself and others" even as he felt "they are not the sort of material he should send to public exhibition."[13]

The majority of the writers enumerated Currier's faults. The *Mail* characterized his watercolors as "nightmare productions."[14] The *Post* raised the question of artistic completeness, both technical and conceptual. To this writer, likely George Sheldon, Currier's sheets were just paint on paper, and because they did not elicit an emotion—be it the beautiful, the poetic, or the pathetic—they were not works of art.[15] Yet, even those critics who did not like Currier's works could not help but appreciate some compelling aspects in them. Some critics recognized that reactions could differ depending on whether the works were considered as interesting studies or as appropriate for exhibition. Currier's watercolors received their most positive reviews when appreciated as studies.[16] For the critic who could accept the articulation of the transitory features of nature through the broad suggestion of its physical characteristics as a valid artistic endeavor, Currier's sheets were worthwhile.

In contrast to Currier's experimental landscapes were the twenty-nine sheets by Homer.[17] Homer's offerings received significantly more attention than Currier's, but the commentary often reflected, either directly or indirectly, the impact of the Munich resident's sheets. Trying to explain its grievances with Currier, the *Herald* suggested "nothing could point to our moral better than the landscapes by Winslow Homer."[18] Homer's work was now often held up as the proper remedy to what was wrong with Currier's and his extreme impressionist mode. Homer was considered by many to be worthy of the top honors.[19]

When Homer sent his portfolio of work to the Watercolor Society's hanging committee, it was reported that "so pleased were they with the contents that they resolved to hang all."[20] If Homer's absence at the Watercolor Society annual in 1878 had been the result of his annoyance with critics and patrons, his triumphant return in 1879 was considered by Charles DeKay as a very positive artistic consequence of that pique.[21] Earl Shinn proposed, rather, that the work was the product of intense concentration in hermitlike seclusion.[22] Even though Homer was surrounded by the Valentine family at Houghton Farm and was not truly reclusive in the summer of 1878, Shinn interpreted Homer's situation as one of being removed from the art world at large in a way that was different from his usual summer travels in the company of fellow artists.[23]

The images on view at the Watercolor Society exhibition, mostly born out of his recent visit to Houghton Farm, were primarily of children, often in the guise of shepherds and shepherdesses, enjoying outdoor country life.[24] These sheets were quite various in their method, ranging from the graphically articulate and transparent

washes of *Fresh Air* (fig. 107) to the thick, opaque gouaches of *In the Orchard* (now known as *Apple Picking*; fig. 108). As Jana Colacino has noted, Homer explored three quite different technical approaches in these sheets: one based on transparent washes, one in which an interest in light drove the rendering of figures in atmospheric conditions, and one reflecting experiments with arranging colors according to Michel Chevreul's color theory.[25] Whichever technique Homer employed, he combined it with a noticeably sophisticated sense of compositional design, of which a Japanese-inspired flattened perspective was often a component. This is true of the sheets without a horizon line, such as *Weary* (fig. 109) and *Scene at Houghton Farm* (fig. 110), and those composed of layered bands of color, such as *On the Stile* (fig. 111), *Boy and Girl on a Hillside* (fig. 112), and *Shepherdess Tending Sheep* (fig. 113).

Homer's contributions to the 1879 Watercolor Society show were met with great enthusiasm. Fifteen of the twenty reports on his work were complimentary and nearly half of them were extremely laudatory. As in years past when he exhibited large numbers of sheets, the remarks, though voluminous, primarily addressed the group as a whole and in terms of broader issues they suggested. Only *Fresh Air* and *In the Orchard* were repeatedly discussed individually. What was admired in Homer's watercolors varied from critic to critic, but they all shared an appreciation of what they perceived as his direct communion with nature. Many writers called this quality "naturalness" and tied it to Homer's individuality, his American subjects and style, and his use of light and color. Forward-thinking critics also saw it as a manifestation of impressionism, and one that improved on Currier's version of it. In this context, Homer's work held an important position in the discussion of acceptable levels of sketchiness and the appropriateness of exhibiting sketches. His watercolors this year seem to have served collectively as a catalyst for critics to coalesce their thinking on these issues.

The combination of subject matter, the properties of the watercolor medium itself, and freedom from outside influences secured the appellation of Homer's Houghton Farm images as wonderfully American. *Frank Leslie's Illustrated Newspaper*, always a champion of things American, found in the watercolor medium and native subjects all that was needed to create a truly national art. *Leslie's* felt that watercolor allowed for a greater "display of originality and a fairer chance for our American artists to show their individual force and strength than in oil" because the American landscape had "a peculiar lightness, brightness and clearness in our skies, a vivacious play of color and an intensity in our autumnal tints and sunset hues which lend themselves admirably to the purposes of the water-colorist," and the lives of her people "offer very distinct and original subjects of inspiration." For these reasons, the newspaper felt watercolor might be the medium in which that "American 'school' so much despaired of" could be established. Homer's sheets were the perfect embodiment of these ideas, and thus his impressionism was identified as the perfect antidote to Currier's European-infected mode.[26] Even for the newly published *Art Interchange*, which thoroughly supported Currier and other European-trained artists, Homer held a special place for the homegrown flavor of his works, which was seen as the key to their charm and beauty.[27]

DeKay of the *Times*, who was both open to the impressionist aesthetic and a seeker of a particularly American idiom for art, also applauded Homer as indigenous. Looking at *Fresh Air*, he remarked on the homebred quality of the image. He found its American characteristics were grounded in physical type, costume, and pose, as well as the fact that the figure was not prettified or idealized according to the European canon. DeKay especially found native qualities in Homer's style, the foundation of which was that he "hits straight at the mark and leaves the unimportant in a picture to take care of itself. This is being an Impressionist in the true and broad sense, not as limited by the exact forms of procedure used by certain artists in France." DeKay also understood that each of Homer's works investigated a particular artistic problem and that the energy of seeking the solution to that problem pervaded the image. Thus, Homer's impressionism, for DeKay, was rooted in his direct painting techniques that bespoke of an honesty and vitality which secured the works as both original and national.[28] Homer's methods

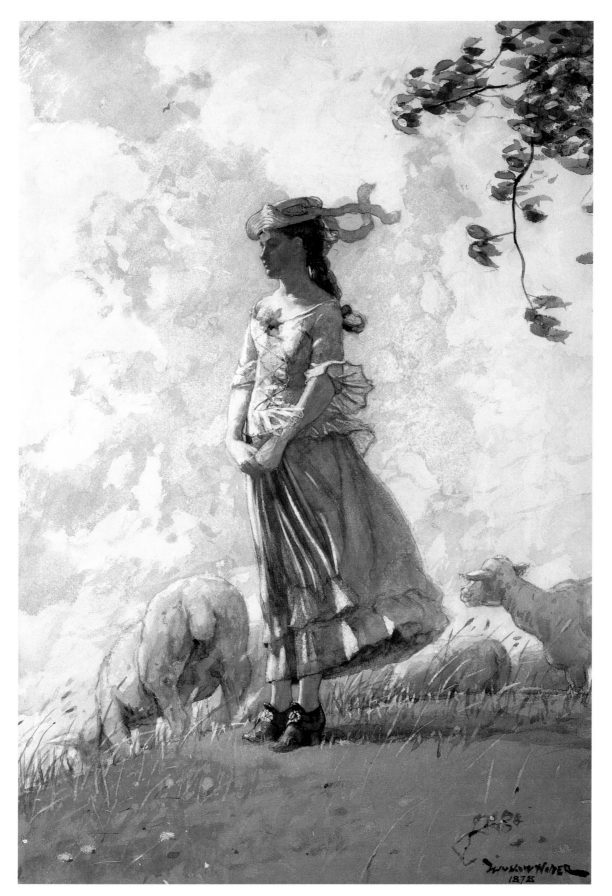

Fig. 107. *Fresh Air*, 1878. Watercolor over charcoal on paper, 20 ⅟₁₆ x 14 in. (51 x 35.6 cm).

Brooklyn Museum of Art. Dick S. Ramsay Fund

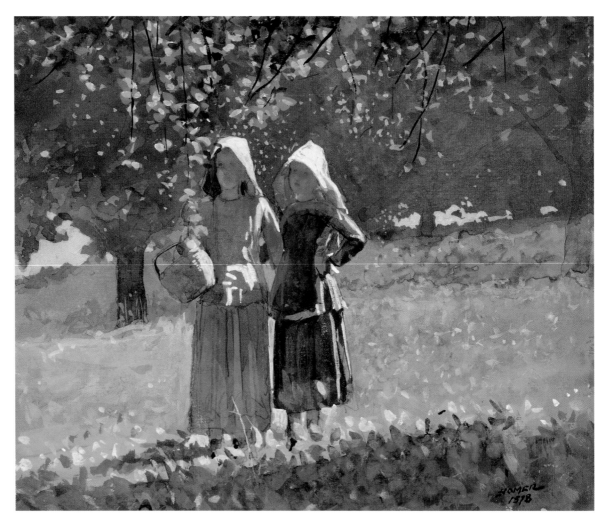

Fig. 108. *Apple Picking (In the Orchard)*, 1878. Watercolor and gouache on paper, 7 x 8 ⅜ in. (17.8 x 21.3 cm).
Terra Foundation for the Arts, Chicago. Daniel J. Terra Collection, 1992.7

perfectly supported his scenes of childhood, which remained a metaphor for young America. Whereas others were bothered by the sketchiness or unfinished quality of Homer's works, DeKay was charmed by what was left out. He found it not only appropriate for the watercolor medium, but also a defining characteristic of an American brand of impressionism. If DeKay found it unimaginable that Currier actually saw what he put down on paper, he believed that Homer captured his impressions freshly and purely. Whereas Currier's extreme mode appeared to most as only technical pyrotechnics, Homer found a middle ground that satisfied the desire for a recognizably American expression that was also poetic, artistic, and cosmopolitan.[29]

As Homer was touted as purely American by some critics, foreign models were nonetheless part of his artistic idiom. Both Earl Shinn and William Laffan recognized Homer's debt to European traditions and newer decorative interests, even as they applauded his work as native.[30] Laffan outlined in a lengthy homage to Homer the European and decorative modes that he saw operating in the work. Noting at the outset that Homer's watercolor entries "should be considered apart and by themselves, just as they themselves stand in American art," he wrote:

> *It is rather surprising that an American artist should come home to his studio at the approach*
> *of winter with a portfolio full of 'Little Bopeeps' . . . shepherdesses not only as real as sheep and*

Fig. 109. *Weary*, c. 1878. Watercolor and graphite on paper, 9 ½ x 12 ¼ in. (24.1 x 31.1 cm).
Terra Foundation for the Arts, Chicago. Daniel J. Terra Collection, 1992.41

crooks could make them, but possessed of all the daintiness of the true and original porcelain,
distinctive in their own way as the shepherdesses of Watteau were in theirs. . . . To Mr. Homer
belongs the distinction of having discovered the American shepherdess and introduced her to the
public in studies that are more essentially and distinctively pastoral than anything that any
American artist has yet attempted. . . . The impressions of those children . . . convey the idea of
wholesome, hearty and artless youngsters . . . yet full of that sense of dawning responsibility and
amenableness to reason that make the seriousness of childhood so wholly inscrutable. . . . All
these . . . [are] full of strong individuality of treatment, and pervaded by a sentiment and feeling
of rusticity and pastoral simplicity that are entirely fascinating.[31]

In his exaltation of the American qualities in Homer's work, Laffan not only acknowledged the shepherdess theme as rooted in French Rococo art of the eighteenth century, but he did so approvingly. For him, the key to Homer's success was his absorption of outside influence for his own use and particular expression. What the *Sun* critic saw as "happy naturalness" and "artlessness" gave the children the best characteristics to represent the qualities of American childhood that had been pictured in genre painting since the early 1840s. Yet here, instead of using a narrative format to present images of American childhood and, ultimately, of the promise of America, light,

Fig. 110. *Scene at Houghton Farm*, 1878. Watercolor and pencil on paper, 7 ¼ x 11 ¼ in. (18.4 x 28.6 cm).

Hirshhorn Museum and Sculpture Garden, Smithsonian Institution, Washington, D.C.

Gift of the Joseph H. Hirshhorn Foundation, 1966

Fig. 111. *On the Stile*, c. 1878. Watercolor over graphite on paper, 8 ¹¹⁄₁₆ x 11 ⅛ in. (22 x 28.3 cm).

National Gallery of Art, Washington, D.C. Collection of Mr. and Mrs. Paul Mellon

Fig. 112. *Boy and Girl on a Hillside,* 1878. Watercolor over graphite on paper, 8 ¹³⁄₁₆ x 11 ⁷⁄₁₆ in. (22.7 x 28.7 cm).
Museum of Fine Arts, Boston. Bequest of the Estate of Katharine Dexter McCormick, 68.568

color, and transparent washes–that is, all technical means–imbued the images with rich emotion, both national and poetic.

Homer's power of observation and his ability to grasp essential truths of nature through an amalgam of artistic strategies also provided the reasons for the *World*'s praise. Brownell thought highly of the sheets and noted, "some of the best drawings here, such as Mr. Winslow Homer's, are pricked out with body-color, the very mention of which is sufficient to shock a logical water-color painter. But the point we wish to indicate is that the general technique of the art necessitates a rapid, photographic, untrammelled and unsophisticated expression." This gave the work a crispness, freshness, and buoyancy that Brownell found natural to watercolor, qualities that were lost in too meticulously detailed work.[32] Although he did not mention any specific works, the positive qualities he noticed appear in multiple sheets created at the Valentine farm, including *In the Orchard* (fig. 108), *Scene at Houghton Farm* (fig. 110), and *Girl on a Garden Seat* (now known as *Woman on a Bench*; fig. 115). Having always found tedious the controversy over the use of body color or transparent wash, Brownell appreciated Homer's facility for capitalizing on the spontaneity and accidental inherent in the medium and again asserted that Homer's watercolors demonstrated that it was not labored or specific techniques that led to success.

Susan Nichols Carter in the *Art Journal* again lauded Homer for his technical applications, especially his use of color and light. She understood his aesthetic was the result of choices made in order to achieve the

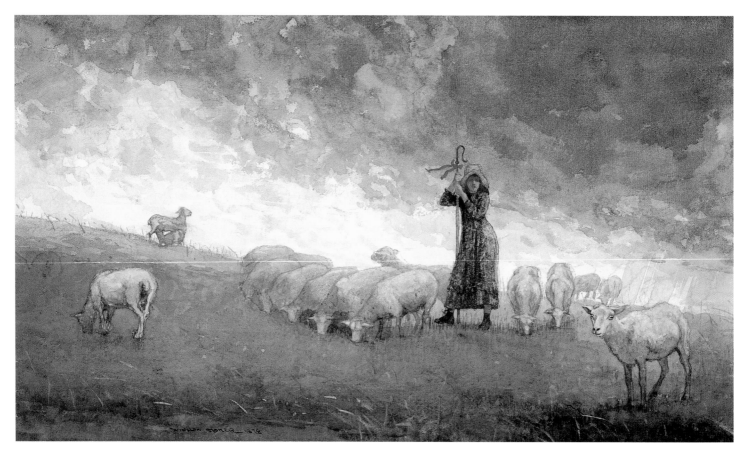

Fig. 115. *Shepherdess Tending Sheep*, 1878. Watercolor on paper, 11 ⁹⁄₁₆ x 19 ¾ in. (29.4 x 50.2 cm).
Brooklyn Museum of Art. Dick S. Ramsay Fund

representation of specific natural effects and expressions of feeling that grew out of his direct experience of nature. She devoted a large portion of her watercolor review to Homer and explained that his sheets were not simply artistic experiments, and she purposefully separated Homer from the pure art-for-art's-sake practitioners. She recognized that intentional artistic choices had long played an important role for Homer but that they served the deeper purpose of revealing truth and beauty. In *Fresh Air* (fig. 107), Carter particularly admired the animation of life suggested by the wind, indicated through the treatment of the leaves and the folds of the figure's clothing. In others, most notably *In the Orchard* (fig. 108), and *Girl on a Garden Seat* (fig. 115), she noted:

> *We have rarely seen anything more pure and gentle. . . . [I]t takes an artist as well informed as Mr. Homer to dare to contrast such a dark, clear shadow with the brilliant dash of sunshine which isolates the little shepherdess from the spectator, and throws her woody retreat into a poetical remoteness. . . . Mr. Homer charms us by the naturalness of his model and her dress, the action of her figure, and the vigorous color of the sketch.*

Carter saw Homer's treatment–especially his manipulation of light and shadow–supporting, even creating, the national identity and inherent poetry of his image. Knowing that Homer's color caused reservation among her peers "who care for melting golden or purple tones," she acknowledged that Homer's palette had a sharp edge when compared to the rest of the works in the exhibition. She advocated, however, that such boldness supported the robustness and healthiness of his subjects. For Carter, Homer achieved the blend of attention to subject and style that she required for successful art, without pandering to public taste or artistic theory.[33]

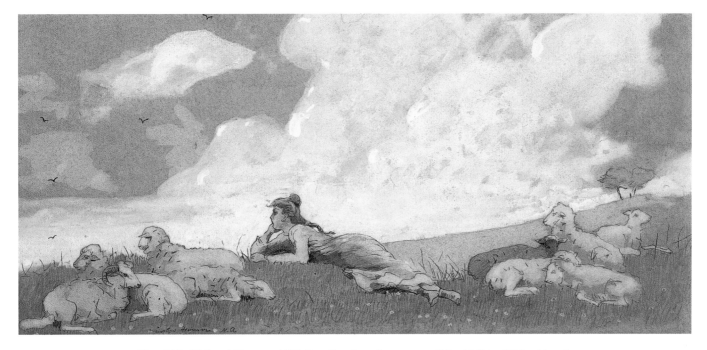

Fig. 114. *Girl and Sheep*, c. 1879. Pencil and wash on paper, 7 ⅝ x 16 ⅛ in. (19.4 x 41 cm).
Albright-Knox Art Gallery, Buffalo, New York. Bequest of Norman E. Boasberg, 1962

Earl Shinn of the *Nation* reacted variously to Homer's diverse techniques. Particularly attracted to the black-and-white section of the exhibition, Shinn was pleased by Homer's more monochromatic figure drawings, perhaps those similar to *Girl and Sheep* (fig. 114), for their austerity, conciseness, and naturalness of pose.[34] Shinn preferred Homer's manner over Currier's, which he felt included falsely added effects. The critic also appreciated a number of Homer's more colored sheets, described as "his circle of little rustic girl-studies, set in . . . hot dewy morning scenes." They drew his attention for "the splendor and luminousness of their frank daylight." *In the Orchard* (fig. 108), with its combination of opaque color and speckles of yellows sparkling across the sheet, may have inspired such a comment. However, with the more fully colored sheets, Shinn, who always preferred academic drawing, noted wistfully that only in a few of the works did Homer show himself "conspicuously the draughtsman."[35]

In the face of all these positive reactions to Homer's color-laden and free brush, the issue of finish in his work continued to preoccupy some critics. William Round of the *Independent* had reserved praise for Homer because completeness—both visual and conceptual—eluded him when looking at Homer's sheets. For Round, Homer's treatment, devoid of realistic specificity and often suggesting the transient, left his work in an unfinished state.[36] The disappointment in Homer's lack of finish here, however, was more tempered than it had been in the mid-1870s. Homer's entries now looked less extreme in their handling because of his American subjects and his accommodation of acceptable European traits, the growing general acceptance of looser painting styles, and the placement of Currier's more radical work hanging nearby.

Homer's color and finish incited Mariana Griswold van Rensselaer to write the only completely negative review of the watercolors. She complained:

> *Mr. Winslow Homer exhibited no less than twenty-nine numbers, in which the various yet cognate eccentricities of his brush were fully represented. His scale of colors varies exceedingly. . . .*

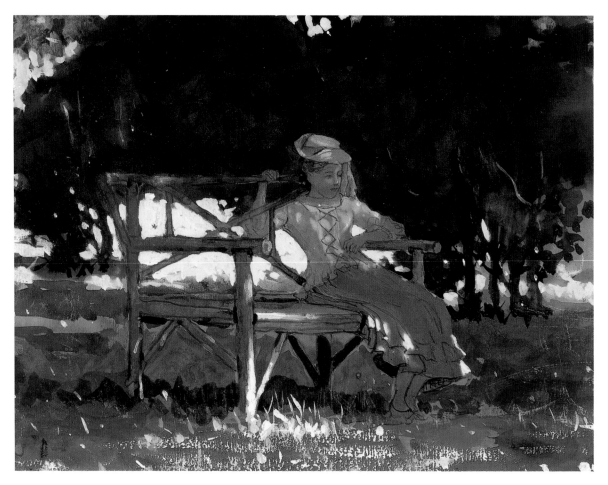

Fig. 115. *Woman on a Bench (Girl on a Garden Seat)*, c. 1878. Watercolor and gouache on paper, 6 ⅜ x 8 ¼ in. (16.2 x 21 cm). McNay Art Museum, San Antonio, Texas. Mary and Sylvan Lang Collection

> *He turns in preference to most unbeautiful figures of wooden outline and glaring diversity of tint. . . . Mr. Homer must have some idea of the indistinct crudeness of his own work both in out-line and in color, or he would not carefully label his pictures "Girl"; "Sheep and Basket"; "Girl on a Garden Seat" [fig. 115]; "Girl, Boat, and Boy"; "Girl with a Half Rake" [sic] [Girl with Hay Rake; fig. 116]; and so on.*[37]

Van Rensselaer labeled Homer's sheets eccentric and inpenetrable because of their varied palette of bright colors and untraditional modeling, which used outline and bright highlights rather than gradations of tone. She pre-ferred, instead, the Munich ways of Shirlaw, even if not entirely those of Currier.[38]

Clarence Cook's comments were double-edged. He wrote that "Mr. Winslow Homer is welcome back again, and we greet his bits of drawings poking their heads up everywhere like dandelions in a Spring meadow. Nothing here to make Mr. Homer known, if we did not know him; but plenty to remind us of the days when we first knew him. Every one of these drawings is good for something."[39] Like van Rensselaer, Cook did not elaborate on the cause for his response, but it appears his frustrations remained similar to those in the recent past, espe-cially with regard to inconsequential subject matter and lack of finish. At least there was enough good in the work for the *Tribune* critic's recent anger to subside for the moment.

Even though freedom of handling was no longer automatically considered careless or unfinished, the critic for the *Mail* was also disappointed that some of Homer's offerings appeared crude.[40] He asserted charges of sloppi-

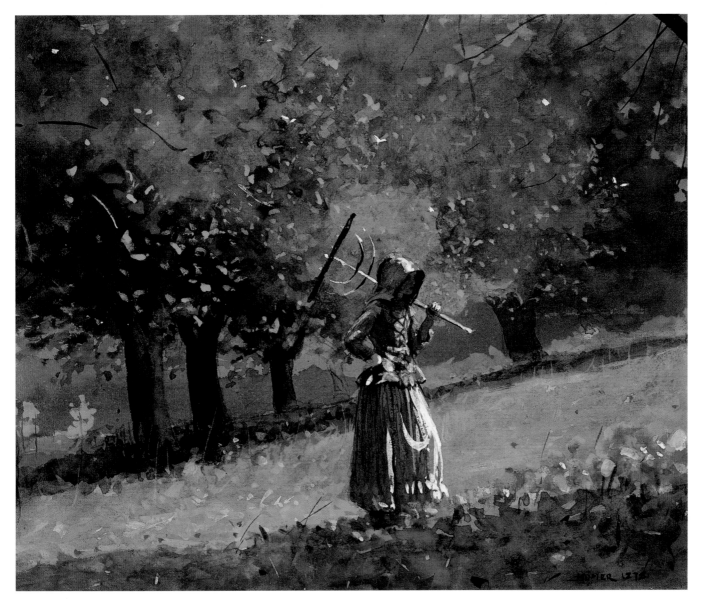

Fig. 116. *Girl with Hay Rake*, 1878. Watercolor on paper, 6 ¹⁵⁄₁₆ x 8 ⁷⁄₁₆ in. (17.6 x 21.4 cm). National Gallery of Art, Washington, D.C.

Gift of Ruth K. Henschel in memory of her husband, Charles R. Henschel

ness separately from praise of the appearance of controlled broadness of stroke. For this writer, however, Homer still crossed over the boundary lines of acceptability in some works. Unfortunately, the *Mail* did not devote any more space to this issue and left its readers hanging without a clue to the specific works with which it found fault.

The issue for George Sheldon of the *Post* was affectation. Although he warmly approved of Homer's insistence on painting nature forthrightly and appreciated his "style of a lusty and independent American," arising from his freedom from outside influences and from his technical proficiency, he felt Homer fell into the trap of self-consciousness.[41] To avoid this unpleasant effect, which he described as crude and coarse, Sheldon suggested Homer study examples by other artists to achieve a necessary refinement. Yet, he qualified his remarks by noting that his reactions were relevant only when regarding Homer's entries "as pictures."[42] With this last phrase, the writer raised the question of whether Homer's watercolors were simply studies or to be considered as completed works. For Sheldon, studies and pictures were two different art forms and thus different rules applied to their

consideration. As pictures–that is, as completed artistic statements–Homer's group suffered due to their self-conscious insistence on optical truth without idealization of any type. "But if, on the contrary," he continued, "they are intended to be only studies in the strictly studio sense of the term, mere memorandums of natural effects, which the artist jotted down for future use in finished pictures, then their excellences can be taken singly and independently; and this, perhaps, after all, is the way that Mr. Homer proposed and expected them to be taken when he sent his portfolio to the academy."[43] Sheldon was willing to give high praise to them if they were intended only as visual reminders and not finished conceptions, but the fact that they were exhibited and for sale left him doubtful that this was Homer's intention. This critic, as well as many others, had not yet made the leap that Homer seems to have: that what these critics identified as studies were, for Homer, acceptable in and of themselves as exhibitable and complete works of art.

Pondering these issues, Sheldon compared Homer and Currier. He found common ground in their business practices and artistic methods. Both artists offered their watercolor entries for sale and the critic felt the best of both men's work shared the primary defect of lacking any pictorial unity. He felt this was the case with *In the Orchard* (fig. 108), his favorite of Homer's work. He complained: "The moment you get near enough to see well Mr. Homer's two charming girls 'In the Orchard,' your attention is diverted to his fantastic treatment of the dresses they wear and the trees in the background."[44] The "fantastic treatment" here was the sameness of tint found in those two areas and the seeming lack of effect of the light on them. What Susan Nichols Carter had highly regarded in Homer's treatment of picturing certain daylight conditions, this writer condemned as destroying the pictorial unity. Both Homer's and Currier's images of momentary effects lacked the emotional content as well as certain artistic conventions that Sheldon expected in art, and thus they appeared simply as paint on paper.

Homer's 1879 watercolor entries placed him in a new position. With Currier's sheets nearby, Homer was no longer the most radical practitioner of the medium. Instead, he now provided for most of the critics an American brand of the nascent impressionism that offered a wonderful balance between the old and the new, the national and the cosmopolitan; that expressed physical reality and emotion through the suggestion of the ephemeral; and that combined the honest depiction of nature, individual self-expression, and emotional force in a unique and, therefore, American way. Homer's special facility with the watercolor medium imbued these works with not only a naturalness but a grace that appealed to nearly all. While the critics tended to lump the entries as a group, they represented a wide variety of techniques and approaches. In some, like *In the Orchard*, Homer was more extreme in his experiments with bright and opaque color. In others, like *Fresh Air* (fig. 107), he consolidated earlier efforts in combination with his more recent interests. The fully rendered shepherdess on the hill continued Homer's use of controlled washes as it displayed his absorption of French antecedents.[45] Now that the definitions of finish and appropriate levels of completion were changing away from the physical to the psychological or intellectual, Homer's watercolors, though still criticized by some for their sloppy brushwork, were seen as some of his most pleasing work to date.

Just as the watercolor show was closing and the National Academy was opening its annual exhibition, an assessment of Homer's art appeared in an article by Samuel Benjamin in *Harper's New Monthly Magazine*, in which the current state of American art was appraised. In his discussion of the "present tendencies" of American art, Benjamin wrote of Homer's situation some dozen years after his first European sojourn. The critic enumerated the elements of Homer's art that had succeeded and failed. Citing Homer's originality, subject choices, and design abilities as proof of the potential for an American art, Benjamin further boosted Homer by favorably comparing him–without the suggestion of influence–to Jules Breton, one of the French artists most highly regarded in the United States. Yet, Benjamin noted that what all the critics and perhaps Homer, too, wanted most–depth of thought or feeling in his art–still eluded him.[46]

Although Homer had devoted significant energy to watercolor and drawing in the second half of 1878, he did not neglect his work in oil entirely. He had three new paintings to show–*Upland Cotton* (fig. 119), *The Shepherdess of Houghton Farm* (now known as *The Shepherdess*; fig. 121), and *Sun-down* (location unknown)–at the Academy's 1879 annual exhibition, which, if it did not generate the excitement it had in 1877, overcame the malaise of 1878. Even though the Society of American Artists exhibition diluted the power of the Academy show, it was thoroughly reviewed and considered to be a success.[47] A number of writers remarked that the art displayed a higher quality in general, and found that good productions came from the hands of both the older and younger artists.[48] The attitudes toward the younger artists were more varied this year. Some critics felt they were not meeting the promise they had shown two years earlier.[49] Other writers felt that the young men continued to have a positive effect, one of which was to stimulate the older artists to produce better work.[50] Whatever critics felt about the younger artists, the contributions of the new generation of American artists were frequently judged in terms of a contest among the European-trained, especially pitting Munich against Paris influences. Shirlaw, Chase, and Duveneck were frequently compared with James Carroll Beckwith, J. Alden Weir, Wyatt Eaton, Edgar Ward, and the newcomer John Singer Sargent, who exhibited *Neapolitan Children Bathing* (fig. 117).[51]

Fig. 117. John Singer Sargent (American, 1856–1925), *Neapolitan Children Bathing*, 1879. Oil on canvas, 10 %₁₆ x 16 ³⁄₁₆ in. (26.8 x 41.1 cm). Sterling and Francine Clark Art Institute, Williamstown, Massachusetts, 1955.852

More than foreign training, the need for greater thought and completeness of ideas in American painting was the issue most prominently discussed. *Appleton's*, the *Tribune*, the *Times*, and *American Architect and Building News* offered the majority opinion that substantial meaning was lacking and that it was one of, if not the most, critical elements in art. In general, the critics looked for pictures whose technique supported ideas that stirred the heart, suggested the connection between man and the universe, or exuded a vital spirit.[52] The premium the younger artists placed on bravura technique drove these critics and others to plea for this deeper thought. Clarence Cook blamed America's bent towards the scientific and exacting for the inordinate concentration on technique.[53] No one questioned the importance of good technical methods, or even that, perhaps, they were best learned in a European, academic setting. Some worried, however, that the understanding that their chief usefulness as the means to an end–that is, to provide the vehicle for expressing substantive thought–had been lost.[54] Mariana Griswold van Rensselaer felt this way and explained that an artist's method needed not only to suit the subject but also to take its explication to a meaningful conclusion.[55] *Appleton's* blamed the Munich men as a group for causing this artistic state of affairs. It did not fault the foreign-trained students for trying to be unconventional, but it did not want unconventionality to take hold at the expense of "taste and sanity" nor interfere with the real aim of art–that is, truth. For the critic of *Appleton's*, art-for-art's-sake was a frightening concept.[56]

In the context of these general reactions to the exhibition, the critics' responses to artists other than Homer reveal the practical application of their philosophies. Although critics both praised and condemned the Munich-trained artists–mainly Shirlaw, Chase and Duveneck–along the lines of the past two years, they more

Fig. 118. George Fuller (American, 1822–1884), *And She Was a Witch*, 1877/83. Oil on canvas, 30 x 40 in. (76.2 x 101.6 cm). The Metropolitan Museum of Art, New York. Gift of George I. Seney, 1887 (87.8.7)

consistently praised the French-trained artists, especially James Beckwith, John Singer Sargent, and Wyatt Eaton. Earl Shinn (writing as Edward Strahan) concisely outlined the reasons. He explained that the Munich students were more showy and popular as a result of their technical flair, but he was not sure they were as good as the French-trained artists. He admitted that the Munich-inspired canvases were clever and those on the Academy walls were attractive, but to his mind and eye, they paid attention to the wrong qualities and were superficial as a consequence. For example, he thought the portraits by Munich students looked wooden. He believed the Munich artists lacked the understanding to produce the look of firm flesh, and therefore their portraits had little vitality. In contrast, he said the French system was "austere, thorough, and honorable . . . [an] ideal is to be planted on anatomical accuracy."[57] For Shinn as well as a number of his colleagues, the influence of Munich created an art of the surface–both of paint and thought–whereas he found the French methods deeper in artistic construction and thus a better conduit for ideas.

The artist who received the broadest praise in the discussions about the relationship of style and ideas in painting was George Fuller, who exhibited *The Romany Girl* (location unknown) and *And She Was a Witch* (fig. 118). Charles DeKay noted that Fuller's work blended both what the public liked–a story–and what artists liked–a singular key of color. Fuller's work also fulfilled DeKay's requirements for a national art: to show the beautiful, picturesque, or peculiar traits of a place and people. The *Times* critic accepted that American images would not all

be startlingly beautiful or picturesque since American modern life was not generally so.[58] In fact, a wide range of critics–from the most cosmopolitan to the most nationalistic–appreciated Fuller for his native subjects that were rendered with sympathy, drama, imagination, subjectivity, and a literary quality.[59] As Sarah Burns has noted, Fuller's success grew out of his ability to combine the local character so admired in Homer's art with the poetry found in the canvases of William Morris Hunt, a combination that pleased almost everyone.[60]

Although Fuller's work received the widest approval, Homer's three entries garnered much thoughtful consideration.[61] Homer himself must have highly approved of the canvases, for at $1,500 per painting, he was asking his highest prices to date.[62] While some critics made blanket statements concerning Homer's paintings, his three offerings were mainly treated separately in recognition that they were three very different excursions in paint, investigating diverse subjects and methods. The *World* noted that "[m]ore than any one painter possibly he tends this year to elevate the general character of the exhibition. The pictures are very different in motive, and besides indicating a higher average of thought and expression than many of Mr. Homer's pictures have done, show a marked versatility upon this higher level."[63]

"The Pictures Are Very Different in Motive"

Homer's subjects had similarities within their diversity. All three featured women. *Upland Cotton* (fig. 119) featured African-American women in the fields and was related to the earlier *The Cotton Pickers* (fig. 89). *The Shepherdess of Houghton Farm* (fig. 121) was derived from one of the pastoral watercolors shown in the winter. *Sundown* pictured a fashionable woman by the sea. The canvases also shared special interests in color and compositional design, but in each one Homer experimented with different approaches and emphases of concern. For these divergent endeavors, he received various responses, from high marks for *Upland Cotton* to a nearly unanimous condemnation of *Sundown*.

Upland Cotton, which today is significantly altered due to Homer's own changes in the 1890s and a subsequent early-twentieth-century restoration, was greeted with great enthusiasm.[64] The sky was the only element in the painting that was criticized at all. The *Telegram* could only describe its deficiencies as imperfect, and the *Herald* simply called it "incoherent."[65] In the *Times*, Charles DeKay thought the color relationships in the sky were flawed, but he also acknowledged the challenge Homer's color scheme presented, noting that a "finer sense of the relations of tones in the painting would possibly have lent it a severer character." DeKay understood that a variety of artistic elements had to be carefully balanced for the success of the completed canvas, and that a further shift in the key of color in *Upland Cotton* might have had an even greater adverse impact. Nonetheless, he felt Homer could have accomplished more by blending his marvelous design with greater harmony and feeling.[66] DeKay's suggestion indicates his desire, felt also by many other critics, that Homer's color needed to lose its acidic edge.

Upland Cotton was a success because it combined an especially American subject with the contemporary affinity for the decorative. Thus, the painting offered an avenue to thinking about serious issues within the format of the newer emphasis on beauty. While in subject and composition the image has many commonalities with Homer's 1876 *The Cotton Pickers*, *Upland Cotton*'s extreme vertical format, lower viewpoint, higher horizon, and patterning of cotton pods over the bottom half of the painting transform the basic elements of the earlier canvas from one of monumental, resonating figures into a much more decorative image. This strong decorative element was heartily praised by both conservative and forward-thinking critics alike, reflecting how widespread now was the acceptance of the decorative impulse as well as how successful Homer was in making a difficult topic palatable.[67]

As had *The Cotton Pickers*, *Upland Cotton* addressed political and social issues. If the statuesque figures in the earlier painting convey strength and defiance, the women in *Upland Cotton* likely were originally less

Fig. 119. *Upland Cotton*, 1879/95. Oil on canvas,
49 ½ x 30 in. (125.7 x 76.2 cm).
Weil Brothers, Montgomery, Alabama

grounded in their surroundings, thereby appearing less commanding and perhaps suggesting the less secure position African-Americans occupied in 1879 as their hopes for greater parity had evaporated with the failure of Reconstruction.[68] Mariana Griswold van Rensselaer commented not on *Upland Cotton* but on *A Visit from the Old Mistress* (fig. 97) and *Sunday Morning in Virginia* (fig. 98) when they were shown at the Boston Art Club coincident with the Academy show. She suggested the continued worthiness of picturing African-American life, even though she did not wholly approve of these paintings as artistic productions. She explained: "It is the fashion to admire the artist's studies of American life. So do we from a certain point of view. They will always be interesting, just as old prints, descriptive . . . of the epoch, are interesting. . . . Mr. Homer relies on a sagacious choice of incident, and therein lies the secret of his success."[69] For the critic for *Appleton's*, a writer who championed native productions above all and believed truth to be the aim of art, Homer's pictures represented the best of the present and signaled the promise of the future. After condemning the seemingly overwhelming emphasis on technique in the exhibition, he was relieved to note:

> *Fortunately, all our painters are not of one way of thinking. Mr. Winslow Homer is wholly* en rapport *with American life. He cares nothing for schools of painting; he is utterly free from foreign influences; and, being penetrated through and through with the spirit of the present, with the things and ideas that surround us, his work reflects them exclusively. . . . In three pictures this year there are more reach and fullness of purpose than in his recent works, and they indicate unmistakably, we think, that, when the conditions unite favorably, Mr. Homer will produce a truly great American painting.*

The writer further accepted that in *Upland Cotton* a particular artistic notion—that of the decorative—was being explored. Keeping that goal in mind, he felt that Homer had painted a "brilliant and unique" composition.[70] Couching his artistic interests in a uniquely American subject, Homer made some of his most cosmopolitan designs acceptable to even the most native-biased critics. This combination garnered for *Upland Cotton* more praise than had any other of Homer's oils in two years.

The conjoining of Americanness with modernity in *Upland Cotton* was noted repeatedly. Even though the *Times* criticized the painting of the sky, it applauded the canvas, calling it both "fresh and modern as well as

national in subject."[71] The *Daily Graphic* phrased its praise in terms of how Homer successfully blended the best of his established ways with new elements. The writer saw a greater completeness added to Homer's signature vigor and individuality and a decorative design and palette applied to an unmistakably American subject. Appreciating Homer's individuality, Americanness, and newly decorative approach, this writer also recognized the extent to which this home subject related to the emerging interests in exotic women as subjects, especially by Americans painting abroad.[72] For example, at the same time Homer was exhibiting *Upland Cotton*, John Singer Sargent was painting his alluring *Fumée d'ambre gris* (fig. 120), which features a draped Moroccan woman. Acknowledging that Homer's artistic treatment might arouse debate, the *Telegram* emphasized: "The theme has evidently been deeply studied and reproduced with a nice fidelity that is indeed rare. Against him the complaint cannot be urged that he does not choose modern and American subjects."[73] Not only had Homer chosen a national and contemporary subject of significance, but, finally, he had combined it with an acceptable level of artistry and technical completion. This union of subject and style may have softened opposition to what may have seemed to some as more extreme explorations into the decorative.

For the critics who thoroughly embraced the cult of the decorative, *Upland Cotton* was perfection in paint. Susan Nichols Carter stated most clearly the origins of Homer's decorative influence and how it was interwoven with the thoroughly American subject:

Fig. 120. John Singer Sargent (American, 1856–1925), *Fumée d'ambre gris*, 1880. Oil on canvas, 54 ¾ x 35 ¹¹/₁₆ in. (139.1 x 90.6 cm). Sterling and Francine Clark Art Institute, Williamstown, Massachusetts, 1955.15

"Upland Cotton," a scene on a Southern plantation, is a remarkable penetration of Japanese thought into American expression. The cotton-plants are straggling across a footpath, in which are two negro women, with their heavy, Oriental figures clad in strong, rich colours. One woman stands upright, with her turbaned head swung back, outlined against a thin, hot sky. The other woman is stooping over and gathering the cotton-pods, and her rounded back seems to bear the burden of all the toil of her race . . . in the variously developed cotton-pods . . . each pod is painted as if doing it was all the artist had ever cared for. The picture is a superb piece of decoration, with its deep, queer colours like the Japanese dull greens, dim reds, and strange neutral-blues and pinks. . . . [Japanese art's] peculiar and artistic subtlety has been assimilated precisely by Mr. Homer. This picture seems to us original and important as an example of new thought.[74]

Japonisme became increasingly prevalent in America in the late seventies, but Homer's appropriation of Japanese elements for a uniquely American subject distinguished his use of them from the methods of his peers.[75] The race-based subject imbued the painting with a potency to which the artist's decorative sensibility contributed a sheen of exoticism and beauty.

The overwhelming approval of *Upland Cotton* was offset by the severe criticism of *Sundown*. The canvas, the ultimate fate of which is unknown, portrayed a single female figure seated on a beach and holding a shell near her face, off of which sunset light was reflected. Only a single schooner sailing on the far horizon punctuated the marine background.[76] Homer's struggle to complete the canvas was recounted by Charles DeKay. He reported in the *Times* that at the exhibition's Varnishing Day, only a few artists took the opportunity to touch up their work in situ. DeKay noted there was

> *[T]he case of Mr. Winslow Homer, who finds that his young girl sitting on the sea-beach before a wall of surf, and holding up a shell, is quite out of harmony with everything about it. . . . Mr. Homer varnishes down his large canvas, and certainly improves it very much; but whether it can ever be improved up to a point worthy of his skill and reputation is quite another matter. . . . The picture is out of tune, in spite of that air of individuality which all Mr. Homer's work possesses and which raises him so far out of the crowd of mediocrities.*[77]

DeKay's response to *Sundown* was among the kindest. Some writers were unusually glib or sarcastic in their remarks. Mariana Griswold van Rensselaer called the painting "comical," while the *Independent* said "the joke is a poor one."[78] The rigidity of the water and the coloration, especially in the painting of reflected light, were the primary targets of the barbs. Earl Shinn, in the *Nation*, called Homer's *Sundown* "a painful paint-problem of vivisection, not pursued out of any sympathy with the heroine, but to show how the hot rays of sunset are cutting into the sclerotic coats of her eyes."[79] Whatever this painting looked like, it appears Homer went beyond the pale in exhibiting bold color experiments.

Not all writers resorted to poking fun at the canvas. It was treated seriously by some who endeavored to point out the cause of its problems. Interestingly, Earl Shinn, writing as Edward Strahan in *Art Amateur*, considered the painting with an earnestness missing from his sarcastic comments in the *Nation*.[80] In his more serious consideration of the painting, Shinn focused on Homer's particular brand of realism:

> *Mr. Winslow Homer is a realist of the realists, with a kind of haughty and half-grudged poetry breaking out from him against his will. . . . That he despises composition, and never idealizes anything is his peculiar form of artistic virtue. In "Sundown" . . . [f]ull of serious study and careful to apply the supposed conditions of the light to every part of the composition, it is yet so abrupt in its massive forms . . . that we think rather of mosaic-work than of painting—mosaic-work where the stony nature of the vehicle has got into the pictorial effect.*[81]

Shinn understood that Homer was trying to capture the effects of reflected light under particular sunset conditions. He saw the design of the canvas (or lack thereof) indicating Homer's insistence on an artistic program guided by picturing optical reality without idealization. In acknowledging Homer's unadulterated realism and in disputing his interest in composition, Shinn sounded remarkably like Henry James's writing in 1875 about *Milking Time*, yet Shinn found only massive, hard-edged forms and little pictorial quality here.

The color of *Sundown* was not its only obstacle to success. For some art writers, the problems of the palette were joined with an awkward figure, poorly rendered water, and an uninteresting subject. The *Telegram* enumerated the painting's faults and worried its appearance in the exhibition would cause irreparable damage to Homer's reputation.[82] Clarence Cook was the critic most frustrated by *Sundown*, and his temper flared again because, in his eyes, not only had Homer turned his back on a potentially successful picture, but the Academy had awarded him for it. Cook spewed:

But what to say of the audacity of Mr. Winslow Homer, who sends his picture "Sundown" into an assembly such as this is supposed to be; and what to say of the Academy that gives it a conspicuous place upon the line in the best room! . . . It is so unnatural, so ugly, so wanting in taste, in sentiment, in meaning of any sort, and–here's the rub–it might have been so pretty, or beautiful, or grand, according to the artist's mood or capacity, that we have no patience to discuss it.[83]

Homer's attempt here was, perhaps, to conjoin a decorative and more aestheticized image of woman, such as he had explored in *Autumn* of 1877 (fig. 96), with the picturing of certain transient effects of color and light. For Cook, however, *Sundown* was ruined by its combination of an insignificant subject and overpowering statement of the optical truth of color and light at a particular moment. Lacking any feeling, beauty, poetry, deep thought, or worthwhile artistic treatment, it was devoid of the *Tribune* critic's requirements for good art. Cook was so exasperated by *Sundown* that he ignored Homer's other two entries.

Where *Upland Cotton* had succeeded, especially in subject as well as in design, figures, and, to a lesser degree, color, *Sundown* seems to have failed. As she did frequently, Susan Nichols Carter came to Homer's defense. She noted that viewers would be struck by the "very great range in the scale of colour and light and shade" and the "violent effect of sunset." Unlike her peers, she found the light-catching elements throughout the composition transfiguring and real. She concluded: "This sudden and fierce glow has the splendour of the stage effect under calcium light, but it is, nevertheless, a true effect of one of the phases of Nature. Such a moment as this is that which Mr. Homer has caught and fixed upon his canvas."[84] For Carter, picturing momentary effects was a valid, even worthwhile, artistic pursuit, and as Homer stayed true to nature in feeling or in fact, his work deserved credit.

Standing apart from the other reviews of *Sundown*, the *Herald* gave the painting its only outright commendation. It called the canvas "one of the striking pictures of the display," and found "the sparkle of the reflections" and the suggestion of the seascape praiseworthy. The critic also found the overall sunset tone "admirable," the effect of sunlight "very real," and the rolling wave "very true."[85] The *Herald* critic embraced, as did Susan Nichols Carter, the idea that the transitory effects of nature, alone, were deserving of artistic treatment. He also unwaveringly supported any work that had color at the center of its artistic program.[86]

Homer's *The Shepherdess of Houghton Farm* (fig. 121) received less notice and more mixed reviews than his two other canvases. Those critics who remembered the watercolor from which it was derived found the oil to be less successful. The *Herald* asserted: "We agree with the Hanging Committee in their estimate of Winslow Homer's 'The Shepherdess of Houghton Farm,' which they have hung high. It seems a thin enlargement in oil of a watercolor study. The pose of the extremely robust figure of the girl is good, but the painting lacks solidity."[87] The solidity mentioned may have referred not only to artistic matters, but to thematic ones as well. The writer of the *Herald*'s comment suggests that perhaps he believed oil painting deserved more serious topics than those essayed in a watercolor and thereby, simply translating a pleasant and pleasing watercolor into oil was not appropriate. The *Daily Graphic* agreed, noting: "His shepherdess seems like an unsuccessful effort to elaborate one of the pastoral ideas exhibited in the watercolor collection. . . . The sentiment and refinement which is displayed in the landscape and sheep seems totally wanting in the figure of the girl, which is crude in color and wooden in pose."[88]

Other critics also believed Homer experienced particular difficulty in trying to translate one of his rococoesque figures into oil. Mariana Griswold van Rensselaer said the color of the girl's skin was most abhorrent and blamed Homer for failing intentionally. She lamented: "Mr. Winslow Homer abandons more and more entirely his better manner. The color in his *Shepherdess of Houghton Farm* is not bad by accident, it would seem, but by deliberate design. Especially may this be said of the raspberry-colored flesh."[89] The *Atlantic* simply called the girl

Fig. 121. *The Shepherdess (The Shepherdess of Houghton Farm)*, c. 1879. Oil on canvas,
24 ½ x 28 ⅛ in. (62.2 x 71.4 cm). Private collection

"frigid."[90] The *Independent* thoroughly criticized the entire artistic treatment of the painting. He admitted that it was "only not so bad as his 'Sundown,' for the simple reason that nothing else could be so bad; but which is incorrect in drawing, absurd in arrangement, and detestable in color."[91] Both the *Atlantic* and the *Independent* sought truth, beauty, and feeling as that found in the works of Fuller and La Farge as well as certain of Inness's canvases, where the poetry of nature was expressed.[92] In their eyes, Homer's painting possessed none of these qualities. Most similar in composition to *Over the Hills* (fig. 78), the figure in *The Shepherdess of Houghton Farm* appears right up against the picture's surface. This feature, again seen in concert with a low viewpoint and lighting from above, flattens the illusion of space and pushes the figure forward into the viewer's space.[93] Additionally, Homer painted the shepherdess's costume with short, forceful brush strokes of a widely varied palette. Thick dashes of blues, pinks, whites, and yellow give a richly textured surface to the girl's blouse, quite unlike anything he had ever painted.

Some critics could appreciate the canvas. The *World* and *Appleton's* found her a charming image abounding in pictorial unity and sentiment. The *World* wrote: "[N]othing [is] as charming in the union of blithe freshness and simple idyllic sweetness as the 'Shepherdess.'"[94] *Appleton's* concurred: "His 'Shepherdess of Houghton Farm' in the present exhibition is a charming idyl–a sort of modern Watteau–in which there is a fullness of sentiment and tenderness that he has not been accustomed to exhibit. The landscape is treated, moreover, in a manner that has a most delicate and subtle relation to the sentiment of the story."[95] As it had been able to accept the decorative impulse of *Upland Cotton*, *Appleton's* saw a loveliness in the shepherdess that was acceptable in its own right as long as it connected to some glimmer of a story. The *Post* framed its comments within a larger discussion of various approaches to art. Remarking that some artists grounded their work in "moral influence" and others focused on technical bravura, the writer also noted "there is a third class [of artists] that paint a subject merely and only 'because they loved it and found it so.'" Among this group, the writer found Homer preeminent in his shepherdess images.[96] The lovely image itself was sufficient. No moralizing narrative or artistic wizardry was necessary.

Overall, responses to Homer's three entries in the 1879 Academy exhibition ran the spectrum from positive to negative. These reactions came as Homer appropriated some of the most recent international trends. In a certain regard, he continued the experimentation at work in his entries to the 1879 watercolor show and elaborated on it at the Academy in the more highly regarded medium of oil painting and in a wider variety of subjects. Although some of the commentary was contradictory, the criticism that his three Academy pictures elicited outlined what was or was not successful in Homer's oil painting. American themes tied to substantive issues always won him his highest praise. His forays into the decorative were appreciated, but his experiments with unorthodox color and subjects were unsettling to most critics. While the responses Homer received likely aided him in honing his artistic vision, he fairly turned his back on the praise for particular themes and artistic elements. He never again painted another image of African-Americans, nor did he create as overtly decorative a canvas as large in scale as *Upland Cotton*. He also discontinued the shepherdess theme, and it would be 1890 before he attempted a beach scene with a woman anything like *Sundown*.

Between 1877 and 1879, Homer explored a number of the new modes surfacing on the American art scene. His oils and watercolors reflected the rising interests in decoration, Japanese design, and a variety of European styles and techniques. The beautiful and the poetic appeared more prominently in Homer's work as he acknowledged the concern of some critics that technique was overtaking substantive meaning as the purpose of art. As Homer experimented with various permutations of these influences and attitudes, he always understood how important a recognizable national identity was to the success of American art. To that end, Homer never wavered in his commitment to American subjects even as he dressed them in various layers of influences.

The reception of Homer's paintings in the last years of the 1870s was as varied as the work itself. The one constant was the perception of Homer's work as American in subject and style. The art press searched, as did Homer, for the appropriate resolution for American art in an international context. In 1879, Homer remained suspended between the old and new guard, and neither he nor the critics had arrived at any firm conclusions.

CHAPTER 8

1880–81 *Moving On*

AMONG THE MANY COMPETING INTERESTS VYING FOR SUPREMACY IN AMERICAN ART IN THE 1880S, THE MOST HIGHLY sought works were those deemed beautiful and poetically expressive. Homer capitalized on this situation when, in early 1880, he unveiled *Peach Blossoms* of 1878 (fig. 122), first in his studio and then at a Mathews Gallery sale. The critics rewarded him with high praise. With a pastel palette of pink, light blue, and green, *Peach Blossoms* was celebrated for its aesthetic qualities. The *Post*, considering the model "a peach blossom herself," suggested that Homer had at last successfully created a happy coincidence of man-made and natural beauty.[1] In this light-filled scene, the figure, fully modeled by light, color, and drawing, is set against a landscape background defined by bands of color indicating the fence, grass, and sky. Dots of pink punctuate the left side of the canvas to create a lovely spring image with a sophisticated design that suggests both the depth of the landscape and an abstract patterning of light and color. Clarence Cook, who had been so critical of *Sundown* at the 1879 Academy, wrote of the canvas approvingly. He especially praised the figure as well modeled. He also liked how the treatment of the field and sky complemented the girl, supporting the portrayal of her as in the springtime of her life.[2] Indeed, with its blend of a decorative impulse with a focus on outdoor light and its effect on color, *Peach Blossoms* fairly fulfilled Cook's prescription for art that conjoined beauty, life, and poetic truth to nature.

While the public presentation of *Peach Blossoms* was surely an effort on Homer's part to show (and sell) work with positive results, it was also indicative of something else. It is clear that Homer began to reduce his art inventory at the close of the 1870s.[3] Over a thirteen-month period, Homer placed a considerable number of works in club exhibitions and auctions, those venues where sales were most easily accomplished. At the monthly meeting of the Century Club in November of 1879, *Sundown* was shown again along with a special exhibition of forty-seven of Homer's watercolors.[4] In early January 1880, *A Visit from the Old Mistress* (fig. 97) and *Sunday Morning in Virginia* (fig. 98) reappeared at the Union League Club just a few weeks before *Peach Blossoms* appeared at Mathews.[5]

Homer's most obvious attempt to divest himself of his work came in early March 1880, when he offered seventy-two drawings and watercolors for sale at Mathews Gallery. The sale precluded Homer's showing at the 1880 Watercolor Society exhibition and some critics were annoyed by his choice of venues. *Scribner's* remarked: "Mr. Winslow Homer, who is always surprising his admirers, chose to stay away from the exhibition altogether this year, although he showed last year a greater number of pictures than any other painter. Instead of hazarding again his reputation as a water-colorist after the success of last year, he had the inspiration to doubt the fickle public and

"Always Surprising His Admirers"

———•———

Fig. 122. *Peach Blossoms*, 1878. Oil on canvas, 13 ¼ x 19 ⅜ in. (33.7 x 49 cm).
The Art Institute of Chicago. Gift of George B. Harrington, 1946.338

prefer a sale of his own, in which it is said good prices were obtained."[6] Even though he did not exhibit in the watercolor show, his name was often invoked in the reviews regarding two prominent aspects of other works in the exhibition—the greater use of transparent color and the decline in the use of body color—both of which were applauded.[7] While the watercolor exhibition was considered of high quality, many critics felt that it would have been greatly improved if a number of the missing artists, including Homer, had contributed.[8] Homer was especially missed not only because his work was exceptional and his membership in the society implied a certain duty to the show, but also because he had been so prominent in 1879.

The works at Mathews Gallery dated from the beginning of Homer's career to his most recent sheets, allowing the two substantial reports of the sale to summarize contemporary attitudes toward Homer's work on paper. George Sheldon of the *Post* attached a special significance to seeing this broad range of work because it demonstrated that Homer's ability with line, which had first made his reputation, was still visible and commendable, as was the national character of his art, which the critic described as "robust" and "healthy." In his extended remarks, Sheldon focused on the more recent sheets and, as he had when they were shown in 1879, he lauded the images of shepherdesses as being particularly American. He outlined their native qualities, noting:

> *Here are the American shepherdesses which only Mr. Homer paints—self-possessed, serious, inde-*
> *pendent; not French peasants who till the soil; not Swiss slaves who watch cows, knitting stock-*

Fig. 123. *Autumn, Mountainville, New York,* 1878. Watercolor on paper, 13 x 20 in. (33 x 50.8 cm). Private collection

ings meanwhile with eyes downcast; not German frauen, *who are drawers of water and shapeless, but free-born American women on free-soil farms, who have had a free-school education, who read newspapers, who have the sense of ownership, and whose bodies are symmetrically and generously proportioned. . . . Mr. Homer . . . here sings her praises; and the lyric is the most spirited, most comprehensive and most truthful poetry of the subject yet produced by art. This is Mr. Homer's triumph.*[9]

The strong national identity in these images was based in characteristics perceived in the physical bearing of the figures, especially the girls. As Sheldon pointed out, their American qualities were derived not only from their "symmetrically and generously proportioned bodies," but also from their physical attitudes, which suggested the activities they engage in, their costuming, and the settings of open air and light in which they were depicted.[10] Homer may have drawn on the European canon for his shepherdesses, but they were grounded in so American an idiom that they could satisfy cosmopolitan interests and still resonate as truly national. This combination gave the work the highly desired quality of "truthful poetry."

If Sheldon emphasized the Americanness of Homer's work, the writer for the *World* championed the watercolors' originality as an important characteristic in and of itself.[11] He was especially impressed with how Homer's uniqueness had endured, and he located individuality in both the slightest and most ambitious works.

In fact, the critic was at a loss to name another artist who could show seventy-two drawings of equal originality and variety. Homer not only displayed the technical skill that was currently de rigueur, but he used it to distinctive ends.[12] As a number of critics had pointed out in the last five years, many artists could master the mechanics of art. The defining characteristic of a true artist was how he employed his technique.

Homer's watercolors, however, did not escape criticism. Since the *World*'s critic still believed watercolor was inherently inferior to oil, he saw limitations in using watercolor to depict subjects representing substantial ideas. Using *October* (probably *Autumn, Mountainville, New York*; fig. 123) as an example of watercolor's failings, the writer explained, "it is so large a subject and treated in so large a way that the necessary shortcomings of the medium in which it is painted jar a trifle and that we should much prefer an 'October' from Mr. Homer in which the depth and richness of the month's color should be interpreted in oil." This particular sheet, however, was redeemed as "a fine thing" for "its freshness and breeziness, and indeed all its merits as a transcript of a stirring thing in nature are unmistakable."[13] While the writer longed for a more symbolic explication of the season, which he felt could only be expressed through the weightier medium of oil, he was captivated by the essence of autumn suggested through the view Homer pictured. In *Autumn, Mountainville, New York*, the sight, smell, and feel of the fall season are wonderfully created in a combination of the selected view, composition, and technique. The undulating hills of Homer's locale have a visual rhythm that is accentuated by the tight cropping and the head-on view. As the landscape rolls up and down, the sheet comes alive in a seasonal palette of golds, oranges, and greens set against the layered transparent washes of the sky that are patterned light and dark from left to right.

Although the Mathews Gallery sale profits of $1,037 were hailed a success, it is hard to measure if the sale met Homer's probable goal of divesting himself of property.[14] The appearance of *Upland Cotton* (fig. 119) at the Union League Club the following week, however, suggests further efforts to that end. As usual, the club showing met with little press coverage, but a remark in the *Times* offers an example of the contradictions Homer faced. Having given *Upland Cotton* a favorable review when it was seen at the Academy, the *Times* now regarded it with a certain disapproval. It noted that the painting had "its fine places and its crude" and that the figures were "ungraceful." The writer's biggest complaint was that the image, specifically the women, lacked good design. He continued that its other (although unnamed) admirable qualities demanded that the artist take this worthy basic idea and treat it in a manner beyond simply telling a story. Underlying his disappointment in the canvas was that it was Homer who had produced such a work, for the writer felt, "No one has a better foundation for such a progress in his art than Mr. Homer, for no one unites just his proportion of experience, industry, and originality.[15] Exactly a year before, the same newspaper had called *Upland Cotton* "a graceful tribute to the plant which has made so many fortunes."[16] For the writer in 1880, the design did not support its potentially deep, symbolic meaning, and such failure condemned the painting and again prevented Homer from meeting a critic's expectations.

After the sale at Mathews and the showing of *Upland Cotton*, Homer's work was next visible in a loan exhibition at the Metropolitan Museum of Art. The paintings on view, both European and American, were borrowed from private collections and included *Prisoners from the Front* (fig. 1), *Bright Side* (The Fine Arts Museums of San Francisco), and *A Fair Wind*, now called *Breezing Up* (fig. 76).[17] While the American canvases inspired little commentary, *Prisoners from the Front* continued to be acclaimed. Earl Shinn wrote: "Homer's 'Confederate Prisoners' is gaining in beauty year by year, and is richer in color, tone and air than any European out-of-doors group present."[18] Even Mariana Griswold van Rennselaer, who lately had been extremely critical of Homer, reminded the public that, in this venue, they could judge him by his very best, "which he has never excelled and, perhaps, never matched for strength combined with pictorial effect."[19] While Homer must have been pleased with the continued recognition for the 1866 canvas, he also must have been chilled by the perception, still shared by many, that in fourteen years, he had not created a painting that equaled or surpassed its success.

The National Academy of Design exhibition in 1880 was Homer's most prominent venue of the year. His entries indicated his engagement with current trends and the challenges they posed for him. They were evaluated in a show that was covered thoroughly, but no longer held the prominence it once had.[20] The Academy was frequently overshadowed in the comparisons between it and the Society of American Artists. The *Independent* noted specifically that the Academy had been harmed by the success of the new society and that the Watercolor Society and the Salmagundi Club shows were among the most interesting exhibitions in town.[21] It was also observed that the Academy was ineffectual as an institution and that the academicians were equally failing as artists. William Brownell, now writing for the *Nation*, said that the 1880 exhibition demonstrated the Academy's problems. He saw a show divided clearly into two camps–the academicians and the younger artists–with the younger artists offering the only hope of progress.[22] *Art Amateur* agreed

that the show was divided, with each sector eliciting its own reaction. It wrote that the exhibition "though clogged with dead material, incloses [*sic*] a group of healthy and vital works where life still beats."[23]

To the contrary, *Appleton's* suggested that an important symbiotic relationship existed between the Academy and the Society of American Artists. It found a healthy representation of the strengths (and pitfalls) of the current tendencies between the two groups, with the Academy generally exemplifying the conservative principles of the establishment and the Society of American Artists showcasing the most recent trends. *Appleton's* critic credited the Academy for recognizing the necessity of beauty in art, while he commended the new men for showing careful study in their works and not displaying

Fig. 124. Eastman Johnson (American, 1824–1906),

The Cranberry Harvest, Island of Nantucket, 1880.

Oil on canvas, 27 ⅜ x 54 ½ in. (69.5 x 138.4 cm).

Timken Museum of Art, San Diego. The Putman Foundation

artificiality.[24] No matter how one felt about the older or younger artists, foreign-trained or native-bred, one thing was clear to each of these critics: the art world had changed. By 1880, the younger artists were no longer a sensation. They were a generally accepted part of the fabric of American art.[25]

The 1880 Academy exhibition was deemed mediocre at best by most reviewers. Many agreed with Charles DeKay, who determined that, while great work was lacking, little of it was ridiculous. Such a showing saved embarrassment, but it warranted no great admiration for American art. The exhibition was perceived as compromised by the absence of a number of key younger artists, especially the Munich-trained trio of Chase, Shirlaw, and Currier, and the lack of entries by important older contributors, including Inness and Church. Thus, with the diminished representation of Society of American Artist members and no examples of Inness or Church, fewer extremes were visible than in the recent past.[26]

George Hows, writing as "Strix" in the *Express*, and Samuel Benjamin in *American Art Review* were more generous in their appraisals of the show. Not only did Hows appreciate the nonacademic and less conventional artistic expressions of the younger artists, he also saw cosmopolitan attitudes and strength of thought among the older generation. The *Express* critic also recognized that the split between the native and international contingents was not always clean, and that a number of artists made use of the variety of attitudes and artistic modes available.[27] Benjamin, who felt that an important duty of art was the interpretation of national traits, believed the show demonstrated that American art was in a healthy state, and praised the exhibition for its noticeable "native influences."[28]

Fig. 125. George Fuller (American, 1822–1884),

Quadroon, 1880. Oil on canvas,

50 ½ x 40 ½ in. (128.3 x 102.9 cm).

The Metropolitan Museum of Art, New York.

Gift of George A. Hearn, 1910 (10.64.3)

Certain canvases appeared at the top of nearly every critic's list, most notably Eastman Johnson's *The Cranberry Harvest, Island of Nantucket* (fig. 124) and George Fuller's *Quadroon* (fig. 125). Johnson's *The Cranberry Harvest* was considered the best of the older artists' work.[29] Even though disagreements arose about the cohesiveness of the composition and the merits of the figure groupings, the picture secured high praise for its light and color, which were pronounced exquisite. These features were also given as the reasons that "he has been for so many long years a young man," even though he lacked the individuality of Homer.[30] Throughout his career Johnson, like Homer, had brought together the old and the new. Here, the image of harvesting by hand evoked memories of a simpler past.[31] Yet, the vehicle for picturing the sunny moment of daily life was glittering bright light and color, which had a decidedly international flavor. Thus, Johnson combined elements that satisfied both those who needed the comfort of the older genre tradition and those who preferred the accomplished technique and approach of the Europeans.

Amid the praise for Johnson's ability to portray dazzling light and color, poetic sentiment and tonal palettes continued to rise in acceptance. Fuller's *Quadroon* received high marks for its combination of beauty and artistic harmony. The poignancy of the implied plight of the subject—a girl of mixed-race heritage—elicited a particularly sympathetic response. Some critics especially commended Fuller's low tones and beautiful drawing for giving the image a softness and purity that heightened the drama and humanity of the subject.[32]

"Little Oases in the Desert of Mediocrity"

————— • —————

Among this selection of paintings where images replete with poetry and sentiment were juxtaposed with visual investigations of outdoor light and color, Homer was represented by *A Visit from the Old Mistress* (fig. 97), *Sunday Morning in Virginia* (fig. 98), *Camp Fire* (fig. 126), and *Summer* (location unknown). The appearance of the two scenes of African-Americans was likely another attempt to sell them. *Camp Fire* also was several years old, having been painted mainly in 1877, but appeared in public for the first time in the 1880 Academy exhibition.[33] *Summer* may have been the most recent painting of the group. All together, these paintings did not attract the attention of many critics. Only six periodicals earnestly commented on them, although they were mentioned in passing in some half dozen more.

Multiple factors contributed to the press's diminished interest in Homer's entries. Some writers noted that *A Visit from the Old Mistress* and *Sunday Morning in Virginia* were so well known that they did not need further review.[34] More important, given the broad range of pictures on view, Homer's work may have been ignored because it neither fit comfortably into the unoffi-

cial categories for pictures–either impressionist or poetic–nor was it so striking as to command a niche of its own as it often had in the past. For example, there was no obvious place to discuss him in the reviews by the *Sun* and the *American Architect and Building News*. They were so focused on the younger generation that their comments on older artists were only reserved for condemning the very worst.[35] Yet, it is surprising that no mention of Homer appeared in either the *Commercial Advertiser*, which thoroughly discussed both the older and genre artists, or the *Tribune*, which, in praising Eastman Johnson, J. G. Brown, and Thomas Anschutz, seemed to have deliberately ignored Homer.[36] Johnson's *The Cranberry Harvest*, a striking new work by an older colleague, may have eclipsed the attention to Homer's entries.

A Visit from the Old Mistress and *Sunday Morning in Virginia*, nonetheless, still garnered a few lengthy notices. When they were shown at the Paris Exposition Universelle in 1878, these pictures prompted interest mainly for their national qualities. Now, two years later and on home turf, they were assessed for their emotional content. *Appleton's* succinctly stated what was now needed for artistic success: "Artists can not flourish except by their hold on human sympathies and susceptibilities, by their power to move the public heart."[37] The artist's sympathetic relationship between external nature and interior feeling was key to this power.

Judged by these new standards, Homer's paintings remained successful for their expression of sympathy through sincerity and truthfulness. Samuel Benjamin cogently recognized Homer's affinity for poetic sentiment and the means by which he achieved it. Comparing him to Fuller, Benjamin noted in the *American Art Review* that while the two artists investigated similar themes, Homer accessed his subjects through external rather than Fuller's more psychological avenues. He believed Homer's particular type of realistic depiction of certain kinds of narrative subjects opened the door to sentiment. In works like *A Visit from the Old Mistress*, he found Homer "sometimes . . . strikes a minor key. . . . Homely as it is in subject, the row of slave women rising to receive the stately lady of the plantation are rendered with a subtle felicity of position and expression that invests this composition with unusual importance."[38] The canvas told more than the simple story; its deeper meaning was recognized. *Art Amateur*, though somewhat disappointed that Homer was exhibiting old work, still found the canvases appealing for the power of the figures' dispositions. In *A Visit from the Old Mistress*, the writer saw the gulf between the situations of the white and African-American women through the differences of their poses. The rigidity of the former mistress spoke of her respectability, even in new, probably straitened, circumstances, while a perceived awkwardness in the former slaves suggested both resignation and expectancy. Explaining what made these images so compelling and descriptive of a time and place, he continued: "Mr. Homer shows an involuntary depth of observation and philosophy, making his canvases so many authentic documents. . . . The reason is, that he observed these manners with the enthusiasm of a historian and man of imagination."[39] Reminiscent of the praise for *Prisoners from the Front*, these words acknowledge Homer's successful blending of actual observation with a creative vision borne out of the larger underlying themes. Now, the issue of finish was never raised in the discussions of *A Visit from the Old Mistress* and *Sunday Morning in Virginia* as it had been in their earlier showings. A completeness of idea, gained through the combination of the entire subject and its articulation, especially the composition and poses of the figures, dispensed with concern for polished surface finish.

The other writers who noticed these two canvases generally agreed with those of *American Art Review* and *Art Amateur*. The combination of Homer's powers of observation with imagination placed him within the most modern camp of artists, who William Crary Brownell outlined as sweeping American artistic culture:

> *In painting, as well as in literature, one of the changes, wrought by what is so widely known*
> *and perhaps so little understood as "modern realism" consists in stimulating the imagination*
> *instead of in satisfying the sensibility. . . . [T]here is less expression and more suggestion; the*

Fig. 126. *Camp Fire*, 1877/80. Oil on canvas, 23 ¾ x 38 ⅛ in. (60.3 x 96.8 cm). The Metropolitan Museum of Art, New York.
Gift of Henry Keney Pomeroy, 1927 (27.181)

artist's effort is expended rather upon perfecting the ensemble, *noting relations, taking in a larger circle; a complexity of moral elements has taken the place of the old simplicity whose multifariousness was almost wholly pictorial.*[40]

Brownell especially appreciated Homer's African-American subjects. Noting that the theme had been too long neglected in American art, he found Homer's exploration of it "very clever, very real, and very sympathetic." As one who sought unity of thought and composition, he was particularly satisfied with how Homer's own artistic picturesqueness integrated remarkably well with the "almost aggressive picturesqueness of negro traits and aspect." Brownell found an exotic quality in the former slaves, which Homer's approach supported at the same time that it told the story of their plight.[41]

Hows, in the *Express*, concurred with Brownell on the strength of character depicted in Homer's African-American women. He noted that, unlike most depictions of African-Americans, Homer's were painted without exaggeration or caricature and were revealed as "genuine . . . each figure tells its story."[42] Now looking for substance of thought in painting, critics focused on the deeper story Homer suggested through his figural depictions. However, in contrast to Benjamin, Hows and Brownell both perceived the pose of the white woman as awkward rather than appropriately upright, therefore rendering her characterization shallow in comparison to the other figures.[43]

Whether Homer intentionally painted the old mistress in her stiff pose is unknown, but the response to her varied, perhaps due to an intentional ambiguity in the figure that mirrored the feelings of artist and critics themselves.

Charles DeKay played the devil's advocate in the *Times*. Although he found much to like in the two paintings, he suggested that Homer did not go far enough in his artistic exposition of the subjects. Similar to the way in which Clarence Cook formerly dogged Homer, DeKay alternately praised and damned the artist. In his eyes, Homer fairly saved the exhibition, which he thought was filled with "indifferent and inane canvases." As someone who advocated a discernible national identity through style as well as subject matter, DeKay championed Homer's African-American subjects, but he felt they were limited because they were only for "no higher art than genre painting." The *Times* critic had greater expectations for Homer, and he found his success only as relative to the greater failures of his colleagues. Compared to his peers, Homer ranked high, but in *A Visit from the Old Mistress*, DeKay found a formal presentation that did not support the deeper meaning of the subject. He complained that the scene lacked drama for he did not consider the "naturally awkward position of the former slaves" as sufficiently expressive, even though he assumed their poses indicated their changed status since the Civil War. He also criticized the face of the former mistress because it did not suggest any particular emotion. Concluding his remarks, he wondered, "Is it unreasonable to ask that a painter of Mr. Homer's ability should have made a little more of this interesting situation between former mistress and former chattels?"[44] DeKay truly acclaimed no works in the exhibition. However, in his criticism of Homer and others, he encouraged artists to strive for the emotional drama he saw in the painting style of artists such as William Morris Hunt. The external path that Homer used to achieve an expression of internal feeling remained too close to narrative genre for DeKay.

DeKay found, along with *A Visit from the Old Mistress* and *Sunday Morning in Virginia*, "two more pictures here, which, as usual, form little oases in the desert of mediocrity." The first was *Summer*, "a painting of a real and freckled country-girl in an orchard. The shadows over her face are pleasantly managed, and the scene reminds one of the water-colors for which Mr. Homer received so much praise two years ago."[45] If the canvases picturing African-American women were serious in content, *Summer*, which today is known only by written description, seems to have been centered in artistic concerns, especially the capturing of light and color in relation to a figure out-of-doors. Those who only looked for the expression of substantial thoughts ignored the picture. The few, like DeKay, who could admire interesting artistic treatment for its own sake, were impressed with its depiction of the outdoors and especially its simplicity. Samuel Benjamin thoroughly enjoyed the canvas for its naturalness, which he found achieved through a simplicity of composition and the suppression of details. Using these stylistic elements, Homer had created a marvelous suggestion of motion–both in the landscape and in the girl who was described as "descending down a rapid slope."[46] Like the best of the Houghton Farm watercolors, from which it may have been derived, *Summer* depicted a momentary impression of light, color, and action, which was achieved through paring down observations to essential elements.

Charles De Kay was also favorably impressed with *Camp Fire* (fig. 126), calling the canvas not only marvelously "natural," but also artistic. The *Times* writer most highly commended Homer's articulation of the sparks of the fire against their surroundings. He noticed that a key element in its success was the wall of darkness that serves as the background of the painting. He realized, too, that the effectiveness of that background depended on the arrangement of the protruding tree trunks and cut poles as well as such small, but important, details as the bits of red flowers at the far left. DeKay understood that this backdrop structure was necessary to create the striking natural phenomena of sparks shooting into the night air, the boldness of which he likened to Japanese drawings of lightning bursting out of a cloud.[47]

Over the past three years, Homer had increasingly experimented with the variety of ways in which light might be used as a vehicle of expression. In one of his few published interviews, the artist explained that painting

outdoors was a necessity for accurately painting the light depicted in *Camp Fire*. In the *Art Journal*, George Sheldon quoted Homer:

> *"I prefer every time," he says, "a picture composed and painted out-doors. . . . This making studies and then taking them home to use them is only half right. You get the composition, but you lose the freshness; you miss the subtle and, to the artist, the finer characteristics of the scene itself. . . . Out-doors you have the sky overhead giving one light; then the reflected light from whatever reflects; then the direct light of the sun: so that, in the blending and suffusing of these several luminations, there is no such thing as a line to be seen anywhere."*[48]

This quotation has frequently been cited to prove that Homer replicated in paint exactly what he saw in nature, but a careful reading of it reveals that his preoccupation was not with duplicating entire scenes intact but with studying and capturing effects of light and color outdoors.[49]

Sheldon, in fact, reported that Homer had painted the main components of the picture in the woods. However, the large tree on the left, which was needed to balance the overall design scheme, was not on the original site. To provide for its accurate insertion in the setting, Sheldon noted that Homer "found it elsewhere, built a fire in front of it, observed the effect, and transferred it to the canvas." The critic then stated that "no painter in this country, probably, has a profounder respect for such out-door work, a more lively apprehension of its value, or a sincerer and more serious aversion to manufactured and conventional studio-pictures."[50] Both Sheldon and DeKay understood that Homer's desire to capture natural phenomena, although based on a very concerted study of the actual outdoors, was always funneled through his sharp eyes and imagination, and that he was always selecting, rejecting, arranging, and changing what he saw to fit his aesthetic intentions.

The four canvases Homer exhibited at the 1880 Academy exhibition exemplified the crossroads at which the artist stood at this point in his career. The variety of the images suggests that Homer struggled to reconcile what interested him with the plurality of aesthetic modes currently competing in the American art world. The African-American themes represented his long-standing commitment to national subject matter. In them, he interwove a constellation of elements that drew on both his roots in the mid-nineteenth-century tradition of picturing daily life and his interest in the newer modes of poetic expression that explored the human condition. *Camp Fire* and *Summer* reflected Homer's growing interest in presenting natural phenomena in aesthetic terms. The task Homer set for himself seems to have been to find artistic solutions that would tell the essential stories of American life through compelling design and the depiction of natural phenomena.

Homer Desires to Work "in Private"

———•———

By the spring of 1880, Homer seems to have realized that in order to resolve these issues he needed to leave New York. At the end of March, he announced he was leaving the Tenth Street Studio Building to continue his work "in private."[51] While Homer's desire may have been to work without distraction, he did not entirely neglect the social aspect of his art-life. That Homer still cared about the Academy as an organization is suggested by his attendance at its 1880 annual meeting in mid-May. His presence was noteworthy due to the absence of many other important academicians.[52] At the beginning of the summer season, Homer left for Gloucester, embarking on his second extended stay at the seaside town. He lived an outdoors life once he arrived. He resided on Ten Pound Island, which, although in close vicinity to the mainland town, required him to row ashore for food and companionship.[53] While this isolation has been interpreted to suggest growing hermetic tendencies, Homer's intention seems to have been to concentrate fully on his work. On

Ten Pound Island, he immersed himself in the light, color, and atmosphere that were central to his current artistic interests. After his summer at Gloucester, Homer stopped at Boston and New York before spending most of September and October at Houghton Farm. Though he may have needed to create this work at a distance, Homer did not lose time in showing it as soon as he returned from his travels, and from the first glance, the fruits of his summer's labor were declared successful.[54] Forty-five new watercolors were on view at the November Century Club meeting. They were described as "vigorously washed effects of various aspects of nature" in the *American Art Review*, and the *Post* said that they had "real artistic quality and fine originality of conception and execution."[55] These comments were just the beginning of a flood tide of varied responses to these numerous new sheets.

Homer chose Boston as the venue for the first full-scale showing of his summer 1880 watercolors. In December about 125 sheets were on view at the Doll and Richards Gallery. The New York press, understandably, paid little attention to the occasion, although one Gotham critic expressed regret that Homer had selected his native city over his adopted hometown for the inaugural showing. Having seen a preview of the works (presumably at the Century or possibly at Homer's current rooms), he was especially peeved because he felt the watercolors demonstrated greater technical skill than ever seen from Homer's brush and that their designs attested to "the freshness and vigor of his intellectual methods."[56] The *Times* acknowledged the Boston exhibition by reprinting the review from the *Boston Daily Advertiser*. The report, which some editor of the *Times* must have found worthy, was highly critical of what it saw. Noting that a number of the sheets indicated a renewed interest in pure landscape, the Boston writer complained that there were no finished pictures in the group, and that they all only displayed "frank and hasty impressions of striking effects." After a description of *Gloucester Sunset* (fig. 134), Homer was severely condemned for trying to match in paint the hues of the extreme optical effects of an actual experience. The writer indicated that in art, tonal values must appear relative to each other and "much lower than the scale of nature."[57] For this critic, the unadulterated truth of nature sometimes needed to be adjusted to be artistic.

The contrast between the remarks of the *Post* and the *Boston Daily Advertiser* summarizes the debate the watercolors fostered when they appeared at the American Watercolor Society show. To some, these sheets—only a small number of which captured particularly spectacular effects of light—appeared to demonstrate superb skill, original thought, and fresh design, making them remarkable productions. Yet for others, even if they recognized them as truthful records of nature, Homer's watercolors were not adequate as works of art. In the reviews of the 1881 Watercolor Society exhibition, the successes and failures of Homer's most recent watercolors were hotly argued.

The American Watercolor Society's 1881 exhibition was its largest to date, with some eight hundred entries. The show was distinguished by its size, and also because there were few foreign works and no contributions in black and white.[58] Earl Shinn described the breadth of offerings: "The drawings range from the old-fashioned, highly-finished, carefully-stippled anecdote pictures of earlier schools to the most daring 'impressionism' of Munich, Italy, and Spain."[59] Clarence Cook also recognized the diversity of the watercolors. In it, he saw a significant gulf between the old and new guards comparable to the one found in English literature between Wordsworth and Keats, in which the two generations had little in common and the new sprang from sources other than home ones.[60] The wide variety in the sheets was matched by equally divergent opinions about them. The critical examination of the exhibition was comprehensive, but the great mass of the show made it hard to review in a cohesive way.[61] While half of the press corps found the watercolor show only vaguely satisfactory, the other half hailed it as a real success. *Art Interchange*, for one, had been prepared to be disappointed, but

"From the Old-Fashioned . . . to the Most Daring 'Impressionism'"

———— • ————

Fig. 127. *Sunset Fires*, 1880. Watercolor on paper, 9 ¾ x 13 ⅝ in. (24.8 x 34.6 cm). Collection of the Westmoreland Museum of American Art, Greensburg, Pennsylvania. Gift of the William A. Coulter Fund, 1964.36

instead found much to like.[62] The consensus was that the variety of styles and the disappearance of body color were the two most welcome aspects of the exhibition.[63] Central to and informing all of these remarks was a reaction to the sheets that displayed impressionist tendencies. The press now found the impressionist aesthetic visible not only in the productions of the Munich school and its chief practitioner, J. Frank Currier, but also in those influenced by the Spanish-Roman school, the French school, and even James Whistler. The *Tribune* not only recognized the multifarious influences that could be connected to impressionism, but also found improvements over the first Munich examples. Cook gave credit to Munich, which had "held the door," but for him, the best works in the show exhibited the influences of Fortuny, Whistler, or French Impressionism. For Cook and others, these contributions, especially the work of Fortuny-disciple Robert Blum, gave considerable hope for American art.[64] The critic from the *Independent* was the sole reviewer to completely shun the show's impressionist aesthetic.[65]

As the critics reacted to the most radically impressionistic sheets, they assessed the technical achievements and discussed the ends to which transparent color should be used. In this context, critics presented diverse opinions about the proper uses of watercolor and oil. The reviewers for the *World* and the *Post* especially applauded the transparency they saw, noting it as the key to successful watercolor art. The *World* declared: "Let it

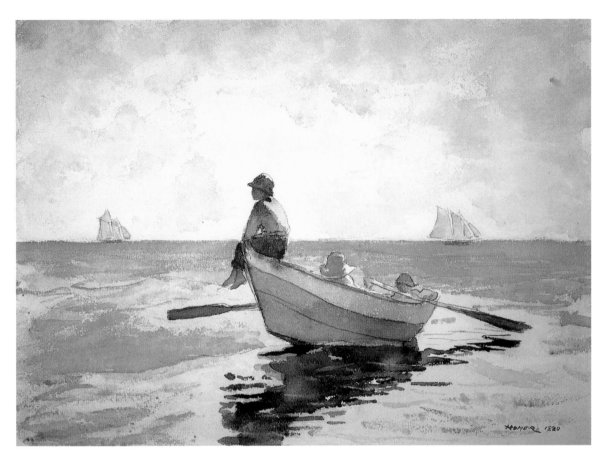

Fig. 128. *Boys in a Dory*, 1880. Watercolor on paper, 10 x 14 in. (25.4 x 35.6 cm).

Mr. and Mrs. R. Crosby Kemper

be remembered by all aquarellists that purity, brilliancy and transparency are the great things in water-color."[66] The *Post* framed its positive reaction to the show in the context of the history of watercolor art in America, noting that its two enduring, positive characteristics–going directly to nature to record "original impressions" and using transparent color–reigned supreme in this show.[67] These remarks shared an appreciation of transparency and direct methods and a desire to have nature suggested through simple, but filtered artistic expression, rather than through a mimetic recording of its outward physical appearance.

George Hows in the *Express* voiced an opposite opinion. Although not totally opposed to the impressionistic aesthetic, he was irritated by the numerous blatant expressions of it. As a result, Hows declared the show a great disappointment citing the "vague and distorted theories" worked out on paper.[68] He was most bothered by the artists' exclusive adoption of particular influences, preferring instead an eclectic blend of sources. Hows encouraged American artists to look at all schools of art, including the German and French, and to extract and recombine the best of each as suggested by Matthew Arnold's theories. He criticized Americans who studied abroad simply to achieve surface perfection and imitation of the masters. Whatever the technique employed, he hoped to see it applied to home subjects.[69]

With a huge array of works to survey, some reviewers resorted to brief descriptions of individual objects in itemized listings. The younger artists garnered the most notice and among their work, Robert Blum's *Venetian Bead Stringers* (location unknown) was the most celebrated individual sheet. However, the older artists were not ignored, and of the more established artists, Thomas Waterman Wood, president of the society, and Samuel Colman frequently captured the critics' attention. In both cursory and in-depth reviews, Homer and Currier

Fig. 129. *Gloucester Schooners and Sloop*, 1880. Graphite, watercolor, and gouache on paper, 13 ⅜ x 19 ⅜ in.
(34 x 49.2 cm). Philadelphia Museum of Art. Gift of Dr. and Mrs. George Woodward

received the most consistent attention. Even so, a number of papers inexplicably ignored them, including the *Daily Graphic, World, Commercial Advertiser,* and *Mail.*[70]

A visitor to the watercolor exhibition might have missed Homer's entries. Twenty-three of his sheets adorned the walls of the Academy, but a number of critics complained that they were difficult to see.[71] The *Tribune* explained that the problem was not that the hanging committee intentionally placed Homer's works in remote areas, but that the pictures arrived so late they were hung in the spaces remaining after the general installation.[72] The poor placement of Homer's entries did not prevent some writers from commenting on their superabundance, especially considering the complete absence of his work the previous year.[73] Others felt that such quantity displayed an unsavory immodesty.[74] The *Critic* was of the opinion that the small format of many of Homer's sheets contributed to their excessive numbers, and their size compromised the quality of the work. Furthermore, this writer blamed his colleagues for their decreased scale.[75] In previous years, Homer had been advised to focus his attention on fewer productions, but now the critical body was called to task for encouraging contradictory behavior. The singling out of Homer as an artist who the critic believed was responsive to the art press is one of few indications that Homer was known to be sensitive to critical remarks.

Homer's contributions to the Watercolor Society truly constituted a diverse group. Although most of the sheets were derived from his recent visit to Gloucester, they pictured such various subjects as interior genre

Fig. 130. *Gloucester Harbor and Dory*, 1880. Watercolor and gouache over graphite on paper, 13 $^{11}/_{16}$ x 19 $^5/_8$ in. (34.7 x 49.8 cm). Fogg Art Museum, Harvard University Art Museums, Cambridge, Massachusetts. Anonymous gift

scenes; solitary women outdoors, some on the shore and some in boats; boys on the beach and on the water; harbor scenes; and pure marine subjects. Within this variety of themes, a high percentage featured water not only as subject, but also as a crucial design element. Homer's marine focus intersected with a growing popularity of marine art that the *Independent* suggested was the result of both artists and the art-appreciating public having matured to a point where the challenges of sea painting were better handled, appreciated, and, therefore, more marketable.[76]

The ocean at Gloucester was the subject of Homer's first extended experiments in watercolor, and on this second visit he again explored it in a multitude of ways: through subject matter, technique, and compositional form. Images such as *Gloucester Sunset* (fig. 134) covered entire sheets in bold contrasting colors. Others, such as *Eastern Point Light* (fig. 138), were monochromatic. Some, including *Gloucester Schooners and Sloop* (fig. 129) and *Gloucester Harbor and Dory* (fig. 130), included the Gloucester waterfront. It was only when he pictured women, as in *The Garden Wall* (fig. 131) and *Girl on Beach* (fig. 132), that the sea was merely suggested or served as a background element. The sheets also varied in their use of graphite. Homer employed precise drawing and a multicolored palette to cover the entire sheet in *Sunset at Gloucester* (fig. 140), while he used mainly variations of

blue with sketchy outlines in pencil in *Boys in a Dory* (fig. 128). Consistent in all these outdoor images is Homer's keen interest in capturing light effects and in balancing the interplay between preserving the flatness of the water-color sheet and picturing illusionistic space.[77]

When Edward Hale saw the watercolors in Boston, he had observed: "Winslow Homer has some wildly impressionistic pictures at Doll's . . . how queer and how unexpected."[78] Seeing the pictures in New York, the critics were similarly surprised, and their comments often only discussed the most astonishing sheets. Responses varied from high regard to absolute horror. The individual critics' attitudes toward impressionist handling and Frank Currier's work informed, but did not unilaterally determine, their reactions to Homer's watercolors. The relationships of the responses to the two artists with the impressionist aesthetic were complex and perceived variously by individual critics.[79] Such commentary would give Homer much to ponder as he considered his next campaign of work.

Homer's 1880 watercolors received unabashedly negative reviews from some critics. Their disapproval was focused primarily on his figural images. George Hows sarcastically remarked about the sheet titled *Something Good About This?*: "The average spectator will be tempted to inquire, 'Where?' The picture represents an impossible woman, sitting on an equally impossible bank and looking out upon some equally impossible water, where some very chalky boats, with chalkier sails are to be seen. Remembering Mr. Homer's 'Prisoners at the Front' [*sic*] and the 'Sunny Side,' it seems almost impossible to believe he could have been guilty of this strange pictorial conundrum."[80] In a subsequent article, Hows condemned others of Homer's images of women, especially those pictured seated, noting, as he perhaps viewed *Girl on Beach* (fig. 132):

> *There is so much girl here that were it to arise from its sitting position . . . here would be a giant.*
> *. . . So long are the lower limbs of this peculiarity in black that were she to arise she would go*
> *clear out of the frame and pass through the muddy firmament Mr. Homer has painted above*
> *her. And to think there are no less than twenty-three similar caricatures by this artist in the pres-*
> *ent exhibition!*[81]

Hows's remarks revived the recurring question whether or not Homer possessed the ability to depict the female figure in proper proportion. Such long-legged women, seen also in *The Garden Wall* (fig. 131), continued the general composition of the seated women in interiors shown in 1877. However, their poses here–sitting slightly pivoted on a rock and on a wall, respectively–torqued their bodies, accentuating not only the curve down the hip to the thigh but also causing the fabrics of their dresses to gather at that same area. Homer did not idealize any features of his figures, and the sharpness of the outdoor light further heightened the angularity and the distortion that was inherent in their poses.

Such faults in Homer's female figures, though visible in only a few of the works on view, predisposed Hows to dislike Homer's other sheets. The preponderance of impressionism in the show added to the *Express* critic's displeasure on the whole and made him specifically detest Homer's *Sunset Fires* (fig. 127), about which he remarked:

> *No. 578 by Winslow Homer is called in the catalogue 'Sunset.' It is well to be told what things are,*
> *for, as Captain Corcoran parenthetically puts it, 'things are seldom what they seem.' This curious*
> *combination of red and black certainly looks as little like a sunset as Roscoe Conkling resembles*
> *the Apollo Belvedere. But as Roscoe probably believes he resembles the latter, on the same*
> *hypothesis Mr. Homer may be led to believe that this scene-painter's frenzy looks like a sunset.*[82]

Comparing Homer to Roscoe Conkling, the controversial and soon-to-be-deposed head of the Republican political machine in New York, Hows suggested not only that Homer was defrauding the public, but also that, due to

Fig. 131. *The Garden Wall (Girl on a Garden Wall)*, 1880. Watercolor on paper, 8 ¼ x 12 ¼ in. (21 x 31.1 cm).
Huntington Museum of Art, West Virginia. Gift of Mrs. Arthur S. Dayton

Fig. 132. *Girl on Beach*, 1880. Watercolor over chalk on paper, 8 ⅛ x 12 ³⁄₁₆ in. (20.6 x 31 cm).
The Nelson-Atkins Museum of Art, Kansas City, Missouri. Anonymous loan

Fig. 133. Drawing after George H. Smillie (American, 1840–1921), *Oaks Near Portland, Maine*, 1880.
Medium unknown; illustrated in *American Art Review* 2 (March 1881), 195

misguided assumptions, he was headed down a very wrong path.[83] For Hows, however, Currier's outdoor scenes, not Homer's, were the worst in the exhibition. They were "perhaps . . . the crowning atrocity of impressionism . . . [with a] . . . wild chaos of mud and bedraggled colors drawn across the paper as though the painter had dropped his palette upon it."[84] The critic, instead, designated George Smillie as the most successful landscapist. In Smillie's *Oaks Near Portland, Maine* (fig. 133), Hows found a positive eclecticism that mixed the vigor of Munich with the poetry and sentiment of the United States.[85] Believing that delineating the facts of nature and a certain reliance on academic drawing were the foundations of art, Hows condemned Homer for bad figure drawing and poor compositional design. He also added to Homer's faults the sin of not being true to nature, a rare criticism of the artist, but one which was raised in the discussions of the impressionist aesthetic and Homer's more radical sheets on view in 1881. To add insult to injury, Hows, as so many had over the past dozen years, resurrected *Prisoners from the Front* as the last real expression of Homer's talent.[86]

Charles DeKay of the *Times* responded to Homer's figures with a harshness equal to Hows's. He, too, complained about the poor drawing and the ungainly length of the girls' legs. The marines fared better with this critic, who liked impressionism and Currier. He appreciated the boldness of Homer's seascapes and noticed some of the artist's "old raciness and vigor" in them. Indeed, the decisive calligraphic strokes delineating the waves in sheets such as *Gloucester Sunset* (fig. 134) suggest a force in their gesture and color. While DeKay acknowledged that Homer's current work shared desired elements of earlier productions, he preferred Currier's "astounding breadth," and added, too, that the Munich-trained artist now supplanted Homer as the artist who had not yet met expectations.[87]

Of all the papers covering the 1881 Watercolor Society exhibition, the *Telegram* paid the most attention to figurative work. Generally unhappy with what he saw, the writer lamented that American artists failed to understand how to group or draw figures, contrast colors, manage light, and interpret textures. He suggested they study the Spanish-Roman school. From this point of view, the critic found nothing redeeming in Homer's work. He com-

Fig. 134. *Gloucester Sunset*, 1880. Watercolor on paper, 9 ½ x 13 ½ in. (24.1 x 34.3 cm). Mr. and Mrs. George M. Kaufman

plained that his figures were affected and unattractive and placed in nondescript surroundings. The lack of any notion of fashionable taste and material beauty, so prevalent in the Fortuny circle, made these works a failure for this writer.[88]

The *Telegram* critic was also disturbed by Homer's seascapes, but for other reasons. Possibly referring to *Gloucester Sunset*, he complained: "Again, what can Mr. Homer mean by contributing so tawdry and wretched a piece of work as 'Sunset?' This is not art. It is not even audacity; for when a painter who can do excellent things, deliberately chooses to represent himself by scratching in parallel lines of blue and red to tell the story of a sunset, his behavior is either stupid or culpably careless. It is a shame to see good powers wasted like this."[89] While this critic did not elaborate further, he implied that color was an insufficient vehicle to convey the scene and the emotions it elicited. Although he acknowledged that Homer went to nature (something he felt other artists did not do enough), he faulted him for what he did (or did not do) with that experience. And, yet again, when measured against his past endeavors, this new work failed miserably.[90]

More gentle in their censure of Homer were Samuel Benjamin, writing in the *American Art Review*, and William Laffan of the *Sun*. Both writers expressed sympathy for what the artist was trying to accomplish. Noticing only his most radical experiments, they seem to have understood that he was working through artistic problems and that these sheets were the results of that process. Even so, they found his contributions disappointing.

Fig. 135. Drawing by F. S. Church (American, 1842–1923/24) after J. Frank Currier (American, 1843–1909),

Landscape, 1881. Watercolor on paper; illustrated in *American Art Review* 2 (March 1881), 197

Benjamin identified Homer's coast scenes as unique and representative of the artist's alignment with the impressionist aesthetic; however, he felt that it was not successfully employed here. He concluded that Homer was overwhelmed by his own ideas, which the critic approvingly perceived as both poetic and artistic. By contrast, Benjamin accepted Currier's work as "[o]f course . . . only splashes of color . . . spilled at random over the paper." Yet, he found that if they were seen at a sufficient distance, they "resolve themselves into a certain method that really suggests nature with considerable power."[91] Currier's sheets like *Landscape* (fig. 135) may have been easier to read than Homer's *Sunset*, but Benjamin also seems to have held Homer and Currier to slightly different standards. While Currier's work could be considered within the bounds of its limitations, Benjamin seems to have expected greater accomplishments from Homer, and these watercolors left his hopes unfulfilled.

William Laffan had eagerly anticipated Homer's next productions during the artist's two-year hiatus between showings at the Watercolor Society. Yet, Homer's 1880 sheets left the *Sun* critic disillusioned because they lacked the marvelous expression of national identity he had applauded in the 1878–79 watercolors and were so radically different from the shepherdesses he had so admired previously. He felt that the contributions Homer sent to the exhibition were "almost as eccentric as those of Mr. Currier. . . . It is a disappointment, but he [Homer] is worth the waiting for."[92] Although Laffan's few words about Currier centered on how badly his entries were hung, he called his work "a tonic of great virtue" for the agitation it caused in the art community.[93] However, he looked to Homer for an expansion of–or at least a reprise of–his 1879 offerings, not necessarily in subject, but as genuine representations of the outdoors, expressed in original, natural, and unaffected forms–all key elements of Laffan's definition of Americanness. He also favored visual completeness, which, in his eyes, Homer's sheets lacked. Although Laffan was befuddled by both Homer's work and his behavior, he acknowledged that the artist's

best work was the result of accumulated experience and, thus, he was willing to wait for his next set of endeavors.[94] Homer's present offerings led Benjamin and Laffan, as had others, to muse on the artist's past and to reconsider his position as the hope for the future success of American art.

If Benjamin and Laffan were temperate in expressing their conflicted feelings about Homer's sheets in the exhibition and their expectations of him, Clarence Cook and Mariana van Rennselaer wrestled quite fervently and at length with the artist and his watercolors. Cook, as he had for two decades, grounded his remarks in his belief that truth in art was essential. From this viewpoint, he launched his discussion of both the show in general and of Homer in particular, while only mentioning Currier in passing. Cook's line of thinking allowed him to still praise Thomas Waterman Wood for his careful study and to appreciate him as an important survivor of the old school. It also brought him to condemn Samuel Colman's Venetian scene, *The Tower of St. Mark's* (fig. 136), because it did not depict the Venice of memory or imagination to anyone familiar with the locale despite its accomplished technique.[95] Cook brought impressionism into this discussion by noting that its rise was a result of the current demand that an artist "paint the thing as he himself really sees it, and not as he has been taught to see it and to paint it."[96]

Fig. 136. Drawing after Samuel Colman (American, 1832–1920), *The Tower of St. Mark's*, c. 1880. Watercolor on paper; illustrated in *American Art Review* 2 (March 1881), 194

Acknowledging his focus on truthful painting led Cook directly to Homer and, as had long been his practice, he both berated and commended the artist. In his first review, he noticed that "Winslow Homer, from not exhibiting at all, has taken to exhibiting very odd things in which nothing of himself, as we know him, remains."[97] Cook never easily adjusted to the first appearances of major changes in Homer's work, and the great visual differences in these sheets sent Cook on a tirade that alternated between attacking and grudgingly complimenting the artist. In it, the *Tribune* critic gave Homer credit because "[h]e has always looked at things about him with his own eyes and told what he has seen in his own language, clearly and truthfully.[98] However, he criticized the artist because he applied his excellence in conveying the truth only to topics of little importance, noting that Homer's few good subjects were arrived at only by accident. In addition to the necessity of truthfulness and substantive themes for good art, Cook also required "the pictorial or picture-making faculty," and of this quality Homer, too, was sorely wanting.[99] Cook chose *Winding the Clock* (fig. 137), the sheet in which Homer most closely revisited earlier genre traditions, to illustrate his opinion. He explained:

> *The girl is in difficulties . . . and, even if it were a prettier face, why take a subject that obliges the owner of the drawing to look at something disagreeable, when nothing is to be gained by it! As for the want of the picture-making faculty displayed in this drawing we suppose it hardly needs to be pointed out. An uncommonly tall girl standing on a chair beside a tall, old-fashioned eight-day*

700—DESIGN FOR A FAN—Brissot.

74—WINDING THE CLOCK—12 x 19—Winslow Homer.

511—A LUSCIOUS TRIO—9 x 17—J. Tuzo.

44—LIMOGES VASE—12 x 19—A. Cross.

196—EMBROIDERY—7 x 11—F. D. Millet.

531—UNDER GREEN APPLE BOUGHS—14 x 16—Theo. Robinson

Fig. 137. *Winding the Clock*, c. 1880. Medium unknown, 19 x 12 in. (48.3 x 30.5 cm). Illustrated in *American Water Color Society. Fourteenth Annual Exhibition*, exh. cat. (New York: American Water Color Society, 1881), n.p.

clock, is a subject that would tax any-body's skill to make into a picture.[100]

Cook's reaction to the pedantic subject is easily comprehended, but, with only the catalogue illustration of this sheet surviving, the reasons for his complaint about the artistic treatment can only be suggested. *Winding the Clock*'s apparently crowded composition and low viewpoint that exaggerated the elongation of the composition and its component parts seem to have been the sources of his disapproval. Whatever its artistic problems, Cook made it clear that subject matter still ultimately determined the success of a painting and thus a poor subject determined that a work of art fail.

In the face of this critique, Cook admitted he had chosen to focus on an oddity among Homer's contributions and recognized that picturing effects of light was what was really of interest to the artist. After again degrading Homer in his typical style, Cook finally declared that the most radical marine sheets were most worthy of his approval for their inherent truth and handling of light.[101] These images best answered Cook's call for truthful observation in a personal artistic language in support of a worthy subject. In Homer's boldly painted seascapes, Cook perceived the essential nature of the ocean that would become the foundation of Homer's art for years to come.

Mariana Griswold van Rennselaer also struggled in her assessment of Homer. Her review, which focused almost entirely on Currier and Homer, admitted that Homer's works were powerful and original. In fact, she called them "the strongest thing in the collection."[102] Yet, as she focused on *Sunset Fires* (fig. 127) and *Eastern Point Light* (fig. 138), she realized that she ultimately found these sheets repellent because they afforded none of the pleasure she felt works of art must provide. Although she understood intellectually that Homer was presenting his personal observations of nature and could even accept that viewpoint as artistic because it was unique and genuine, van Rennselaer felt cheated by Homer's pictures because they lacked any "ideal charm." Nonetheless, she was repeatedly drawn to his sheets on account of their strength.[103] The dilemma for van Rennselaer was reconciling the fact that she found Homer's images visually and emotionally compelling at the same time that they appeared in complete opposition to her requirements for art, which depended on a combination of truth and beauty. She intuitively believed the works to be artistic as well as honest, but she had difficulty connecting

Fig. 138. *Eastern Point Light*, 1880. Watercolor on paper, 9 ⅝ x 13 ⅜ in. (24.4 x 34 cm).
The Art Museum, Princeton University. Gift of Alastair B. Martin, Class of 1938

Homer's images to actual nature and experience. Idealization was the missing element, preventing access to the images and causing them to appear brutal instead of lovely.

Van Rennselaer understood both Homer and Currier were presenting impressions of nature.[104] Currier's nature was, however, comprehensible, benign, rooted in its charming aspects, and evoked lyrically. Thus, Currier's work delighted her because it was both pleasant to look at and exuded an excitement inherent in the open landscape.[105] In Homer's work, the critic admired the intensity and awesome power of nature conveyed in sheets such as *Sunset Fires*, but *Eastern Point Light* stymied her, and on the whole, Homer's contributions were somewhat bewildering.[106] Even so, van Rennselaer had revised her opinion of Homer's watercolors from 1879, when she could not abide his display at the Watercolor Society exhibition. In this very different set of sheets, which was antithetical to the previous group of charming shepherdesses, she better understood what Homer was trying to do and acknowledged the importance and strength of his expressions of natural phenomena, even if she could not enjoy them.

The *Atlantic* printed van Rensselaer's final thoughts on the exhibition at the end of the summer. She concluded that Homer's entries had shown him "at his very best, and when at that best must always be recognized as strong, and individual, and intensely local. Whether or not one personally likes his kind of strength and his sort of individuality is another matter."[107] Van Rensselaer's approval of the Gloucester marines increased over the next two years. The sunset image she had approached cautiously in 1881 was praised in 1883 for its boldly pared-down image and deeply keyed colors "insisting upon and emphasizing a theme which another artist would have thought

Fig. 139. Drawing after Roswell Shurtleff (American, 1838–1915), *Basin Harbor, Lake Champlain,* c. 1880.
Watercolor on paper; illustrated in *American Art Review* 2 (March 1881), 197

already too pronounced and too emphatic for artistic use. That he could do this and keep the balance of his work is a patent proof of his artistic power."[108] Van Rennselaer now understood the source of Homer's images and the direction of his vision, and, therefore, was able to find these sheets legitimate works of art.

Amid the predominantly negative reviews of Homer's 1880 watercolors appeared notices that offered considerable, if not completely unconditional, approval. Interestingly, they came from writers quite varied in their feelings about impressionist technique. The *Independent* could not tolerate Currier's art nor the art of those who ascribed to similar notions of impressionism. However, it found the proper expression of it in the work of Homer. The writer explained:

> *What the "impressionists" try to do and fail Winslow Homer, and [a few others], try to do and succeed. . . . Winslow Homer is always true to himself; and in being true to himself, he is always true to art, since he has the truest instincts of an artist–a deep love of Nature and a clear vision to see her aright in her varying moods of expression.*[109]

The elements that combined in this writer's mind to make Currier a failure and Homer a success included careful observation. He found a similar alertness in the works of the more conservative artists such as Roswell M. Shurtleff (*Basin Harbor, Lake Champlain*; fig. 139) and Henry Farrer. Yet, he did not require that careful observation be made manifest only through detail, but accepted individual–that is, personal and unique–means of expression that conveyed what was experienced in a comprehensible way. Clarity of color was another requirement for this

critic, and, therefore, Currier's mixing of tints was as reprehensible as Homer's laying pure color side by side was acceptable.[110] In Homer's sheets, the *Independent* observed a sufficient explication of subject and design, offered in the name of truth, that others like Cook had found lacking.

Scribner's also applauded Homer for his personal means of expression. Asserting that good art went beyond technical prowess, it announced that the all-important feature of a watercolor, as in an oil painting, was the artist's individual statement. "[W]hat tells," noted the writer for *Scribner's*, "is his own taste, his own sense of beauty, his own view of nature and power of presenting that view, his own intellectual force."[111] From this viewpoint, the reviewer was attracted to numerous works that had "the air of being born from the same sketchbook." He noted they were, "Direct, simple, crude sometimes—never 'pretty'—they caught the eye by an unmistakable look of nature. They were Mr. Winslow Homer's contributions, virile, and frank, as everything that comes from this artist is."[112]

The favorable opinions of William Crary Brownell and Earl Shinn came from different perspectives than those of the writers for the *Independent* and *Scribner's*. Brownell and Shinn represented the leading edge in art criticism, and while they approached Homer's work from somewhat different perspectives, their commendations of his watercolors jointly outlined future trends in American art. As far as Brownell was concerned, the chance to see Homer's watercolors was the only reason to visit the exhibition. While he was pleased with the indications of progress in the show, he found that the majority of works fell short due to their "essential aimlessness" in the use of the medium. His position was embedded in his belief that the capacities of watercolor and oil were very different. In watercolor, he looked for "[a] quick impression, a really genuine effect," but such impressions were "as rare as the memorandum-like treatment which a true water-color subject demands."[113] Brownell found just enough of this quality in Currier's work to call him "clever," even though it was "ugly."[114] It was Homer, however, who, according to Brownell, demonstrated the best use of watercolor. He believed Homer captured the requisite "dignified impressions" by grounding each of his works in a fleeting effect found in the landscape.[115] The critic, therefore, appreciated the variety of nature's characteristics seen in Homer's sheets. For example, he enjoyed *Eastern Point Light* for its depiction of foggy atmospheric conditions and other sheets, perhaps *Sunset at Gloucester* (fig. 140), for their beautiful softness, a characteristic Brownell rarely found in Homer's work.[116] In his wide range of marine subjects, Homer fulfilled Brownell's dictum that watercolor suggest the momentary in a personal and pictorial manner. Contrary to Cook, who demanded that all art, including watercolors, express large ideas, Brownell said that perfectly picturing the small effect was not narrow or limiting, but could be considered dignified and serious. For Brownell, Currier had only the veneer of truth in his memoranda, while Homer depicted deep-seated honesty.[117]

One aspect of Homer's sheets, however, Brownell found disturbing. Almost all of them lacked elegance. The critic found such artistic practice dangerous, even though he realized it granted Homer's work much of its strength and originality.[118] Accepting this contradiction, which Brownell saw most prominently in *Gloucester Sunset* and *Sunset Fires*, he more fully embraced Homer's overall vision than Cook or van Rennselaer. In his appreciation of a depiction of momentary atmospheric effects as a valid, exhibitable work, Brownell remained one of America's most forward-thinking critics and one of the greatest champions of Homer's watercolors. Nonetheless, the absence of refinement in them truly bothered this critic, and it led him to wonder how this shortcoming might be reconciled without compromising the strength of the work. Such questioning, as it had for Cook, Laffan, and Benjamin, led Brownell to look ahead to what might come next in Homer's oeuvre.[119]

Earl Shinn shared the status of vanguard critic with Brownell. Exceeding his colleague's open-mindedness, Shinn fully appreciated the examples of both Currier and Homer. His review in *Art Amateur* was one of the few to compare the two artists directly. He began with the Munich resident, noting his mysterious sheets set the audacious

Fig. 140. *Sunset at Gloucester*, 1880. Watercolor and pencil on paper, 13 x 23 ¾ in. (33 x 60.3 cm).
Addison Gallery of American Art, Phillips Academy, Andover, Massachusetts. Gift of anonymous donor, 1930.11

tone of the whole show. He believed Currier's work conveyed "the full passion and delight of a color impression derived straight from Nature, with no time allowed for the cooling off of the sentiment into definition and calculation, these drawings, warm and loyal as strains of music, tell their story as musical notes do, in vibrations and sympathies."[120] Shinn accepted Currier's use of color as the primary vehicle of artistic expression because of its special capacity to evoke emotion without being filtered through the intellect. Unlike any of his fellow critics, Shinn imagined Currier's sheets could be appreciated regardless of their directional orientation because rather than being connected to any particular topic, they were wonderfully rich in sensation no matter what their specific subject.[121] Shinn nearly admitted that if the beautiful, decorative, and poetic could ultimately be understood in a painting, identifiable subject matter might be dispensable. Nonetheless, his admiration for Currier had a caveat. He faulted him for not making drawing the foundation of his art's design.[122]

After his remarks on Currier, Shinn compared his work with Homer's. If Currier was admired for his passionate expression of nature, Homer was praised for his sincerity and directness. Shinn's vocabulary reflected the aggressive character of Homer's most boldly painted sheets in his discussion of the sunset images. He described *Gloucester Sunset* (fig. 134): "quickly moving water, sails, and fiery sky: the whole breadth of the running tide is interlaced and lashed with snaky lines of blackness alternating with strong color, conveying in marvellous [*sic*] degree the feeling of luminous moving water tortured with whips of advancing night."[123] To Shinn, Homer succeeded to an even greater degree than Currier because the pervading spirit of his image was expressed not only by color but also with line, light effects, and design. Indeed, in the sunset watercolors, Homer employed, as he often had through the 1870s, bands of alternating light and dark colors, painted edge to edge on the paper. This basic structure provided the foundation of the marine view as well as the backdrop against which the atmospheric

drama could unfold through line, form, and light. For Shinn, such strategies sufficiently created an impression of nature that rang true and complete.

Truthfulness had always garnered the highest praise for Homer's art since the beginning of his career. Now, the means for its expression had multiple acceptable forms, and critics with as varied viewpoints as Earl Shinn and the conservative writer for the *Independent* could find truth in the Gloucester watercolors. Yet, there were those critics who could find no truth in these sheets, and Homer, once again, came away from a presentation of defiantly new work with mixed acclaim. The disapproving reviews must have been disheartening, but Homer also must have found it encouraging that even a few critics understood his attempts to capture the essential qualities of nature.

As Homer encountered the clashing reactions to his newest watercolors, it is likely he had already chosen England as his next destination. His decision coincided with the post-centennial surge of American interest in British culture, which appeared not only in the form of influence on a variety of the arts, but in press coverage as well.[124] Articles on English art and reviews of new British art publications increased noticeably as did the recognition of the growing American presence in London.[125] Among the Americans showing in London at this time were George Boughton, William Hennessey, Jervis McEntee, J. G. Brown, and Arthur Parton.[126] In addition, Edwin Austin Abbey had resided there since 1878, and William Trost Richards had lived on the coast of England from August 1878 to September of 1880.[127] All of these men were artists with whom Homer had shared experiences in the exhibitions and the studio and club life of New York.

The Search for New Material

——————•——————

That Homer might turn his thoughts to Europe and specifically to England seemed logical. Perhaps, for him, the most significant aspect of the contemporary Anglophilia was that British watercolor was held in the highest esteem and that the quality of J.M.W. Turner's watercolors was yet the standard to be met.[128] *Scribner's*, for example, used the occasion of watercolor exhibitions in London as a platform to praise the thought, technique, and ideals of British practitioners of the medium, and to point out how such creativity and accomplishment in watercolor was not yet in evidence in America.[129] As Homer sought a useful locale to work out his next artistic step, it is only natural that he would be attracted to a place where many of his colleagues had connections, and watercolor was a specialty. As was typical, however, Homer pursued an independent path, selecting not London, but the more remote Cullercoats, as his destination.

Homer relentlessly pursued his own personal artistic journey in the 1870s, but that pursuit always remained within the boundaries of the New York art world. The last published notices of Homer at the time of his sailing abroad were of his serving on a committee of artists giving a reception for Frederick Bridgman prior to his return to Europe.[130] While Homer may have done no more than lend his name to this event, to do so was to take part in celebrating one of the fastest rising new men.[131] Even as he was heading into a period of separation, Homer remained engaged with the leading edge of American art.

When Homer left New York for England, observers accepted his departure as typical of American artists' experience.[132] In the *Post*, his trip abroad was simply reported along with the listings of other artists' travels.[133] When Mariana Griswold van Rensselaer wrote in 1883 about Homer's English trip, she noted that his recent travels and the changes in his art were part of the changes breeding generally in American art, especially its more cosmopolitan outlook.[134] Other writers in the following half century, too, noticed that Homer's 1880 trip to Gloucester and the one to England the following year marked a shift in Homer's lifestyle and art, but they understood them to be an extension of his peripatetic ways of the 1870s as he searched for artistic material.[135]

CHAPTER 9 *"What Shall We Say about Winslow Homer?"*

"ART['S] . . . PURPOSE IS . . . TO INTERPRET THE GREAT TRUTHS OF LIFE AND NATURE; NOT MERELY TO PLEASE THE OPTIC nerve, but to elevate the soul."[1] When the critic Samuel Benjamin wrote these words in 1881 he could have had the art of Winslow Homer in mind. From the close of the Civil War onward, Homer searched for subjects and modes of formal expression that would provide a level of seriousness comparable to his paintings that had chronicled the national conflict. Throughout the 1870s, that quest was repeatedly demonstrated through his unflagging independence, his diverse explorations of technique, and his commitment to creating meaningful images derived from daily experience and the natural world around him. Homer's last works from this period, the 1880 Gloucester seascapes, were a radical, but logical conclusion to his art of the 1870s. As he approached the midpoint of his career, these sunset watercolors anticipated the sheets painted in Cullercoats, England, and ultimately led to his images of the sea and the woods in the 1890s.

The reviews of Homer's art published between 1868 and 1881 outline his pursuit of appropriate subjects and methods. They not only delineate the relative success or failure of the many combinations of subject and style with which he experimented, but more important, they also illuminate how tightly interwoven his art was with the pressing artistic issues of the day and the role his work played in the development of the New York art press. In addition, these reports, by providing at least a sketch of his activities within the art community, aid us in understanding how Homer negotiated the art world at large.

Homer's experience as an artist in the 1870s was grounded in his success in the late 1860s with *Prisoners from the Front* (fig. 1). The high praise it garnered marked Homer as America's young artist of promise. His designation as the quintessential American artist and a hope for the future remained constant throughout the decade and created a certain notion of what his art should be—especially original and national. As a result, high, even unrealistic, expectations that intersected with the growing demand for America to have an identifiable national art plagued him, and often placed him at the center of controversy as well as praise.

The new paintings Homer exhibited upon his reentry into the New York art world in 1868 demonstrated both subjects and artistic approaches he would further investigate over the next dozen years. Works such as *Rocky Coast and Gulls* (fig. 6) and *Low Tide* (fig. 10) foreshadow the images of the sea and child-life that he would return to again and again throughout the decade. They also reveal some of the lessons he had learned from outside influences, such as contemporary French painting, that would continually feed his art. The responses to these works addressed issues that would dominate discussions of his work through the 1870s—its distinctiveness, his use of home subjects, and his lack of finish—while at the same time raised the larger concerns for American art

in which his painting would play a key role: questions of honesty and truth in art, the nature of originality, and how to define a national art.

It was clear by 1870 that Homer sought a position from which he could challenge the accepted construct of art without being entirely dismissed. This proved to be a delicate balancing act. When he showed works such as *Eagle Head* (fig. 16) and the group of eight sketches including *Lobster Cove* (fig. 19) at the 1870 Academy exhibition, they were labeled "unique" and "original" as well as "defiant" and "unconventional." At a time when subject matter often determined the value of art, Homer's contemporary, native themes were praised at the same time that they were condemned for bordering on the inappropriate. Similarly, his artistic practices, particularly the lack of conventional perspective in combination with a loose painting style, captivated some reviewers at the same time that they were rejected by others. With *The Country School* (fig. 24), Homer learned how subject and style might be finessed. From this point on, he recognized that using an especially national subject could gain him considerable stylistic freedom or, conversely, that using a more traditional technique could gain him latitude with his subject matter. Slowly, too, the critics came to be more accepting of his vigorous painting style.

As Homer found a niche for his art, he also experimented with his personal relationship with the art world. During 1873–74, Homer's service on various committees of the National Academy of Design gave him the opportunity to experience firsthand the politics of American art. His activities coincided with the conflicts that eventually divided the Academy between young and old, progressive and status quo. Homer was never clearly aligned with one camp or the other throughout the 1870s, and he seems to have quickly become uncomfortable in a role which he likely feared might threaten his personal and artistic independence. This commitment to independence would not only help to identify his art as undeniably American, but also enable him to take part in and make use of the many possibilities available in an art world undergoing dramatic changes.

Turning to watercolor, Homer found a medium for which he had a special affinity. Even though his watercolors would at times provoke the same extremes of critical reactions as his oils, they also gained for him a greater measure of artistic freedom since the acceptable boundaries of the medium were more elastic. In turn, Homer's watercolors forced the critics to come to terms with the medium and eventually accept it as valid in its own right. In the end, it was watercolor that enabled Homer to break free of the many competing aesthetic interests of the late 1870s to find both subjects and means that again were uniquely his.

As the New York art world of the mid-1870s entered a period of rapid change, Homer's work underwent its own transformation. The exhibition of *The Course of True Love* (location unknown) and *Milking Time* (fig. 66) in 1875 marked the end of his use of traditional story-narrative and the expansion of his reliance on pictorial design and artistic treatment, especially the use of light and color. The following year, the appearance of *A Fair Wind* (fig. 76) and *Cattle Piece* (fig. 77) reinforced Homer's contradictory position as the leading artist who fulfilled the requirements for a national art at the same time that he continued to challenge his viewers. Even as he remained rooted in tradition, in nearly every work he would, in some way, break with orthodox art practice. If the subject of *A Fair Wind* celebrated the joys and vitality of American life, that of *Cattle Piece* made everyone somewhat uncomfortable. The two canvases' different artistic dispositions similarly pleased and chafed his audiences. Such work caused many critics to agree with the opinion of the *Art Journal* in 1876 when it argued: "It is impossible to deny Homer's genius; it is equally impossible to be always satisfied with what he puts on canvas."[2]

After the centennial celebrations of 1876, Homer's art was most ostensibly engaged with the variety of new trends made popular by the influx of European paintings and American artists trained in Munich or Paris. In the last years of the decade, his images of fashionable women and young shepherds and shepherdesses and his appropriation of decorative and Japanese aesthetics especially played into the contemporary cosmopolitanism. Yet, once the Munich-trained artists appeared on the New York art scene, Homer's place as the most radical, unconventional,

and sketchy painter was eclipsed. Instead, because Homer's images were always perceived, first and foremost, as native, they offered his viewers an avenue for the acceptance of European influence without compromising their status as American. Thus, as the decade wore on, Homer's watercolors and oils were simultaneously appreciated for embracing European influence while remaining thoroughly national. *Answering the Horn* (fig. 93) and the watercolors he exhibited in 1879, for instance, demonstrated his ability to nationalize artistic strategies, even when they were clearly derived from European sources.

As American art was seeking parity with its European counterparts at the end of the 1870s, many artists and critics turned towards the consideration of the larger purpose of art, and Homer worked hard to reconcile the call for a national art with the prevailing preference for internationally based styles. In this atmosphere, he also weighed the benefits of the two rising aesthetics: one that derived from interests in the beautiful and poetic and one that used the outward appearance of things as the catalyst for both subject and style. As was his habit, Homer explored both avenues, creating such different canvases as *Upland Cotton* (fig. 119) and *Camp Fire* (fig. 126). Having experimented with many of the available artistic modes, he endeavored to merge components of these various, seemingly incompatible, approaches in his last summer's work at Gloucester. In the end, his paintings again took an increasingly independent path that intersected yet remained distinct from the work of his peers.

What, then, shall we say about Winslow Homer in the 1870s? Through his work, the reactions to it, and the little we know about his activities, he appears to have been a man who very consciously constructed a professional career fully integrated with the art world at the same time that he strove to express his own personal vision and concerns. No doubt, Homer always sought acceptance for his art, but his determined independence continually pressed against the edges of art society's limits. There is the sense that Homer carefully calculated how far he could exceed its boundaries without completely alienating his audience. Sometimes he was successful in his calculations, at other times he failed miserably. He was held to such a high level of expectation that, while he earned very high marks in those rare cases where he satisfied, any misstep on his part was interpreted as a failure of American art.

Pursuing a variety of artistic paths, Homer had to contend with critical reactions that were often widely divergent and even inconsistent. Amid the critical controversies, Homer's art frequently tugged at the hearts and minds of many critics, thus fulfilling a primary requirement for art. Yet, aspects of his experiments in technique and style caused even his most ardent admirers to waver in their appreciation of him. Indeed, Homer's unorthodox means of pursuing his personal vision alternately inspired and antagonized the press as they grappled with their own shifting definitions of art. Nearly every bit of high praise for Homer during the 1870s was offset by stinging rebukes. On the one hand, he was celebrated as the best and most American artist of the day, for his art fulfilled the requirement that to be American was to be independent and original. On the other hand, Homer was most often criticized when he pushed independence and originality beyond acceptable limits. Thus, when he appeared too independent and he did not meet the critics' expectations, his success was transformed into failure. His originality was repeatedly both his downfall and saving grace.

By the close of the 1870s, Homer had achieved a prominence reserved for few artists, but he also increasingly baffled many critics. American art changed significantly between 1870 and 1880 as it became engaged in the wider international arena. Together and separately, Homer and his critics struggled to come to terms with these changes. By 1880, all parties stood at an important crossroads as they determined, individually and collectively, how to shape a national identity for American art.

Homer's decision to leave New York, first for Gloucester, then England, and finally choosing to settle in Maine, has often been attributed to personal difficulties, but it is much more likely that he chose to leave because of professional dissatisfaction. Suffering from a failed romance has frequently been cited as the underlying cause

of his withdrawal from New York.[5] We may never know the true story of Homer's personal situation, but the cacophony of responses to his art in the 1870s suggests that perhaps his greatest challenge was desire of another sort–to create art that pleased both himself and his audience, most notably the critics. Surely the repeated derision by the art press, even if it was occasionally relieved by pockets of high praise, must have worn him down. Homer spent the 1870s experimenting with subject matter, artistic treatment, and his own place in the art world. By the end of the decade, he seems to have exhausted the subjects and styles available in New York and the nearby environs in which he traveled. In fact, A. B. Adamson, a Cullercoats neighbor, remembering Homer many years later, reported that the artist had tired of American subjects.[4] By 1880, Homer was clearly searching for something new. It seems that Homer realized that he needed a change of venue, as he had regularly over the past dozen years, to break out of the confines in which he had existed since the success of *Prisoners from the Front*. No doubt, Homer wanted to retain, even enhance, his role as the quintessential American artist. To achieve this goal, however, he had to create his next body of work sequestered from the aesthetic and cultural turmoil of the New York art world.

NEW YORK NATIONAL ACADEMY OF DESIGN—AT THE HEAD OF THE STAIRCASE.—[See Page 317.]

New York National Academy of Design–At the Head of the Staircase, wood engraving,

Harper's Weekly 14 (14 May 1870), 316

Leading Art Critics, Writers, and Editors, 1868–81

Samuel Greene Wheeler Benjamin (1837–1914): painter, writer, and critic; son of a missionary father, grew up in Greece; 1859: graduates Williams College; 1870: in Boston studying as a marine painter; 1876–1880s: writes for *Atlantic*, *Harper's*, *Art Journal*, and *American Art Review*, and authors a number of books on European and American art; 1878–82: exhibits marine paintings at the National Academy of Design; 1883–85: serves as first American minister to Persia.

Samuel Greene Wheeler Benjamin, *The Life and Adventures of A Free Lance* (Burlington, Vt.: Free Press, Co., 1914); *National Academy of Design Record*; *Dictionary of American Biography*.

Eugene Benson (1839–1908): used pseudonyms "Proteus" and "Sordello"; painter, critic, and writer; born in Hyde Park, N.Y.; 1856: studies at National Academy of Design; 1861–66, 1869–71, 1874, 1877–78: exhibits at the National Academy of Design; 1862: elected associate of the National Academy of Design; mid-1860s: writes for *Post*; 1868–73: in New Haven; writes for *Appleton's*, *Galaxy*, *Atlantic*, and *Putnam's*; by 1873: expatriates to Europe, mainly Italy, and resumes life primarily as a painter and writer.

H. W. French, *Art and Artists in Connecticut* (1879; reprint, New York: Da Capo, 1970); *National Academy of Design Record*; Robert Scholnick, "Between Realism and Romanticism: The Curious Career of Eugene Benson," *American Literary Realism* 14 (1981): 242–50; Meixner, *French Realist Painting and the Critique of American Society*; *Dictionary of American Biography*.

Richard Rogers Bowker (1848–1933): editor and publisher; born in Salem, Mass.; 1868: graduates Free Academy (City College of New York); 1869–75: first literary editor of *Mail*; 1875: literary editor of *Tribune*; 1879–1933: owner-editor of *Publisher's Weekly*.

Wingate, *Views and Interviews*; *Dictionary of American Biography*; Richard Rogers Bowker Papers, Manuscript Division, New York Public Library.

William Crary Brownell (1851–1928): critic; born in New York City; 1871: graduates Amherst College; 1871–79: on staff of *World*; 1871: as reporter; 1872–79: as city editor; 1878–80: writes for *Scribner's*; 1879–81: writes for *Nation*; from 1881: best known as literary critic; 1881–84: in Europe.

Haskell, *The Nation*; Russell Sturgis, "William Crary Brownell as Critic on Fine Art," *International Monthly* 5 (April 1903): 448–67; Gertrude Hall Brownell, *William Crary Brownell, An Anthology of His Writings* (New York: Scribner's, 1923); Edith Wharton, "William C. Brownell," *Scribner's* 84 (November 1928): 596–602; Frank Fletcher, "The Critical Values of William Crary Brownell" (Ph.D. diss., University of Michigan, 1951); Frank Fletcher, "Bibliography of William Crary Brownell," *Bulletin of Bibliography* 20 (1953): 242–44; *Dictionary of Literary Biography*; *Dictionary of American Biography*; William Crary Brownell Papers, Amherst College, Amherst, Massachusetts.

Oliver Bell Bunce (1828–1890): editor and writer; 1872–81: editor of *Appleton's*; writes "Editor's Table"; plays prominent role in New York publishing world; famous for Sunday evening salons attended by artists and writers, including Winslow Homer; instrumental in publication of *Picturesque America* and related volumes.

Obituary, *New York Times*, 16 May 1890, 5; William H. Rideing, *Many Celebrities and A Few Others* (New York: Doubleday, Page and Co., 1912); Sue Rainey, *Creating "Picturesque America": Monument to the National and Cultural Landscape* (Nashville, Tenn.: Vanderbilt University Press, 1996); *Dictionary of American Biography*.

Susan Nichols Carter (1835–1896): painter, critic, writer, and art teacher-administrator; born in Cambridge, Mass.; student of William Morris Hunt; 1871–77: primary art writer for *Appleton's*; 1873–96: head of the Women's Art School of Cooper Union Institute; 1875–76, 1878, 1885–87, 1889: exhibits at National Academy of Design; from 1877: writes for *Art Journal*; ?–1879: married to Robert Carter, editor of *Appleton's*.

National Academy of Design Record; *Appleton's Cyclopedia of American Biography*, 1877, "Robert Carter" entry; Obituary, *New York Times*, 11 August 1896, 5; Archives, Library of the Cooper Union Institute for the Advancement of Science and Art, New York.

Samuel Stillman Conant (1831–?1885): critic, writer, and editor; born in Waterville, Maine; 1858–60: studies abroad after attending college at Hamilton, N.Y.; from 1869: various posts with a number of periodicals, including *Times*, *Express*, *Galaxy*, *Harper's Weekly*, and *Harper's New Monthly Magazine*; 1885: disappears.

"The Lotos Reception," *New York Evening Mail*, 8 April 1872, 2; Matthew Hale Smith, *Sunshine and Shadow in New York* (Hartford, Conn.: J. B. Burr and Co., 1869); *Appleton's Cyclopedia of American Biography*, 1887; William B. Cushing, *Initials and Pseudonyms: A Dictionary of Literary Disguises* (New York: Thomas Y. Crowell, 1885).

Clarence Cook (1828–1900): critic, editor, and publisher; grew up in Boston and New York; 1849: graduates Harvard College; 1853–63: writes poetry, magazine and newspaper articles, and teaches; 1863: a founder of Society for the Advancement of Truth in Art; 1863–64: editor of *New Path*; 1864–82: art critic for *Tribune*; 1868: writes for *Galaxy*; 1872–75: writes for *Atlantic*; 1875–81: writes for *Scribner's*; 1881–84: writes for *Art Amateur*; 1884–93: publisher of *The Studio*.

John P. Simoni, "Art Critics and Criticism in Nineteenth-Century America" (Ph.D. diss., Ohio State University, 1952); Weiss, "Clarence Cook: The Critical Writings"; Ferber and Gerdts, *The New Path*.

David Goodman Croly (1829–1889): writer and editor; best known as husband of the journalist Jane "Jennie June" Croly and father of progressive reformer Herbert Croly; Irish born, but came to the United States as a young boy; grew up in New York City; 1855–73: various posts with a number of New York newspapers, including *Post, Herald,* and *World*; 1873–78: editor of *Daily Graphic*; very active in reform issues.

Wingate, *Views and Interviews; Dictionary of American Biography*.

Charles DeKay (1848–1935): used pseudonym "Henry Eckford" late in life; poet, critic, and editor; born in Washington, D.C.; brother of artist Helena DeKay; educated in Dresden, Germany, and Newburgh, N.Y.; 1868: graduates Yale University; 1868–70: in Europe; 1876–94: art and literary critic for *Times*; 1894–97: serves as United States Consul-General at Berlin; 1892: a founder of National Sculpture Society; 1898: a founder of National Arts Club; 1907: art editor of *Post*; 1915–17: editor of *Art World*.

"Charles DeKay, 86, Poet, Critic, Dead," *New York Times*, 24 May 1935, 21; Lisa N. Peters, "Charles DeKay: Art Critic for the People,"

(unpublished paper, William H. Gerdts American Art Library, 1985).

Richard Watson Gilder (1844–1909): editor and writer; 1872: marries artist Helena DeKay; 1870–81: editor of *Scribner's*; 1870–78: writes "Old Cabinet" column; 1879–80: in Europe; 1881–1909: editor of *Century*.

Cushing, *Initials and Pseudonyms*; Rosamund Gilder, ed., *The Letters of Richard Watson Gilder* (Boston: Houghton Mifflin Co., 1936); Arthur John, *The Best Years of the "Century": Richard Watson Gilder, Scribner's Monthly, and the Century Magazine, 1870–1909* (Urbana: University of Illinois Press, 1981); *Dictionary of American Biography*; Richard Watson Gilder Papers, Manuscripts Division, New York Public Library; Century Magazine Papers, Manuscripts Division, Columbia University.

Parke Godwin (1816–1904): writer, critic, and editor; wrote on art, science, and literature; 1853–57 and 1868–70: editor of *Putnam's*; 1860–81: editor and partial owner of *Post*; 1878: assumes position of editor-in-chief at *Post* after father-in-law William Cullen Bryant's death; 1881–1900: editor of *Commercial Advertiser*.

Eugene Benson, "New York Journalists. II. Parke Godwin, of the *Evening Post*," *Galaxy* 7 (February 1869): 230–36; Smith, *Sunshine and Shadow*; Wingate, *Views and Interviews*; "Parke Godwin Dead," *New York Times*, 8 January 1904, 7; Allan Nevins, *The Evening Post: A Century of Journalism*, 1922 reprint (New York: Russell and Russell, 1968); *Dictionary of Literary Biography*; Parke Godwin Papers, Princeton University; Bryant-Godwin Papers, Manuscripts Division, New York Public Library.

Theodore C. Grannis (1831–1878): painter and critic; born in Schenectady, N.Y.; Brooklyn resident during years as artist and critic; prior to artist-critic career: works as a tradesman; 1868–78: art critic for *Commercial Advertiser*; occasional contributor to *Art Journal, Aldine,* and *Brooklyn Eagle*, and possibly *Post*; member of the Palette Club and Brooklyn Art Association; 1868–71: exhibits at the National Academy of Design.

"Art Matters," *New York Evening Express*, 2 December 1868, 2; "Death of Theodore C. Grannis," *New York Commercial Advertiser*, 26 January 1878, 1; "Theodore C. Grannis, Journalist," *New York Times*, 27 January 1878, 6;

Obituary, *Aldine* 9, no. 4 (1878?): 141–42; *National Academy of Design Record.*

Lucy Hamilton Hooper (1835–1893): poet and critic; born in Philadelphia; 1868: on editorial staff of *Lippincott's*; 1874–93: to Paris; continues as foreign correspondent to *Lippincott's* and *Art Journal*, as well as to Philadelphia, Baltimore, and St. Louis newspapers.

Dictionary of American Biography.

George W. Hows (dates unknown): used pseudonym "Strix"; critic for *Express*.

New York Evening Mail, 8 April 1872, 2; Francis Gerry Fairfield, *The Clubs of New York* (New York: Henry Hinton, 1873); Cushing, *Initials and Pseudonyms.*

William Hurlbert (1827–1895): critic, writer, and editor; born in Charleston, S.C.; 1847: graduates Harvard College; 1849: graduates Harvard Divinity School; 1849–51: in Europe; 1855: on staff of *Putnam's*; drama critic for *Albion*; 1857–62: on staff of *Times*; 1862–83: on staff of *World*, and from 1876 was editor-in-chief; after 1883: mainly in Europe.

Eugene Benson, "New York Journalists. W. H. Hurlbert," *Galaxy* 7 (January 1869): 30–34; "William Henry Hurlbert Dead," *New York Times*, 7 September 1895, 5; George T. McJimsey, *Genteel Partisan: Manton Marble* (Ames: Iowa University Press, 1971); William John Thorn, "Montgomery Schuyler: The Newspaper Architectural Articles of a Protomodern Critic, 1868–1907" (Ph.D. diss., University of Minnesota, 1976); *Dictionary of American Biography.*

James Jackson Jarves (1818–1888): critic, writer, and collector; born in Boston; 1837: to Hawaii for health; 1851: to Europe; from 1852: settles in Florence; forms collection of Italian art; 1855: publishes *Art Hints*, first of many books on art, and begins contributions to numerous papers and magazines; 1871 and 1884: sales of Jarves Collection.

Francis Steegmuller, *The Two Lives of James Jackson Jarves* (New Haven, Conn.: Yale University Press, 1951); *Dictionary of American Biography.*

Sylvester Rosa Koehler (1837–1900): critic, editor, and curator; born in

Germany; 1868: to Boston; 1868–78: technical manager for Louis Prang's lithographic company; 1879–81: editor and critic for *American Art Review*; c. 1881–1900: graphic arts curator, first in Washington at the United States National Museum and then at the Museum of Fine Arts, Boston.

Dictionary of American Biography.

William Mackay Laffan (1848–1909): critic, editor, publisher, and art advisor; born in Dublin; educated at Trinity College, Dublin; to the United States after medical studies in Ireland; on newspaper staffs in San Francisco and then in Baltimore; interlude working for railroads; 1877–81: on staff of *Sun*; 1881–84: art editor for Harper Brothers publishers and London agent for them; 1884: returns to *Sun* and named publisher; owner after 1900; also advisor on Chinese ceramics; trustee of Metropolitan Museum of Art.

"W. M. Laffan Dead of Appendicitis," *New York Times*, 20 November 1909, 11; Frank M. O'Brien, *The Story of the Sun*, reprint (New York: Greenwood Press, 1968).

Charles Eliot Norton (1827–1908): writer, editor, professor; born in Boston; 1846: graduates Harvard College; 1855–57: in Europe; 1857: begins association with a variety of magazines, especially the *Atlantic* and *North American Review*; 1865–1908: founder and editor-writer for *Nation*; 1868–73: in Europe; 1875–97: teaches art history at Harvard.

Haskell, *Nation*; Kermit Vanderbilt, *Charles Eliot Norton: Apostle of Culture in a Democracy* (Cambridge, Mass.: Belknap Press, 1959); *Dictionary of American Biography*; *Dictionary of Literary Biography*.

George E. Pond (1837–1899): used pseudonym "Philip Quilibet"; writer and editor; born in Boston; 1858: graduates Harvard College; 1862–64: serves in Civil War; 1864–68: associate editor of *Army and Navy Journal*; 1868–70: on editorial staff of *Times*; 1868–78: writes "Drift-Wood" column for *Galaxy*; 1870–77: in Philadelphia; editor-in-chief of Philadelphia *Record*; 1877–c. 1880: resumes connection with *Army and Navy Journal*; 1880–99: on editorial staff of *Sun*.

"Death List of a Day. George Edward Pond," *New York Times*, 23 September 1899, 7; Obituary, *New York Sun*, 23 September 1899, 7; *Dictionary of American Biography*.

George W. Sheldon (1843–1914): critic and writer; born in South Carolina; 1863 and 1866: graduates with B.A. and M.A. from Princeton University; 1865–73: teaches at Princeton and at Union Theological Seminary; c. 1873–at least 1879: critic for *Post*; from 1875: contributes to *Art Journal, Harper's New Monthly*, and authors a number of volumes on American art; 1890–1900: literary advisor to D. Appleton & Co., London.

"Art Notes," *New York Commercial Advertiser*, 26 March 1879, 1; *Who Was Who In America*.

Earl Shinn (1838–1886): used pseudonyms "Edward Strahan," "Sigma," "L'Enfant Perdu"; painter and critic; born in Philadelphia; 1859–64: studies at the Pennsylvania Academy of the Fine Arts; 1866–67: in France; studies at Ecole des Beaux-Arts under Jean-Léon Gérôme; 1868–70: on staff of Philadelphia *Evening Bulletin*; 1870: to New York; 1870–81: writes for *Nation*, primary art critic from 1874–79; occasional writer for *Post*; 1872: writes for *Lippincott's*; 1879: writes for *Scribner's*; 1879–81: writes for *Art Amateur*.

Obituary, *Art Amateur*, 16 (16 December 1886), 5; William Walton, *Earl Shinn, A Sketch* (Philadelphia: George Barrie, [1887]), courtesy William H. Gerdts American Art Library; Haskell, *Nation*; William M. Armstrong, ed., *The Gilded Age Letters of E. L. Godkin* (Albany: State University of New York Press, 1974); David Sellin, *Americans in Brittany and Normandy*, exh. cat. (Phoenix: Phoenix Art Museum, 1982); Earl Shinn Papers, Archives of American Art.

Russell Sturgis (1836–1909): architect and critic; born in Baltimore; raised in New York; 1856: graduates Free Academy (City College of New York); 1863–68: practices architecture with Peter Wight; 1868–c. 1880: in private practice; 1863: a founder of Society for the Advancement of Truth in Art; 1863–65: writes for *New Path*; from 1865: contributes to *Nation*; 1897–1909: writes "Field of Art" column in *Scribner's*; author and coauthor of numerous books on art and architecture.

"Russel Sturgis, Architect, Dead," *New York Times*, 12 February 1909, 11; Haskell, *Nation*; Ferber and Gerdts, *The New Path*; *Dictionary of American Biography*.

D. O'C. Townley (1831–1872): used pseudonym "Alderman Rooney"; editor, writer, and critic; born in Dublin; briefly studied painting in Dublin; 1869: to United States; 1869–72: city editor and art critic for *Mail*; active in Palette Club; writes occasionally for magazines, including *Aldine, Scribner's*, and *Old and New*; 1872: manager at Grand Opera House, New York City.

New York Evening Mail, 8 April 1872, 2; "Funeral of D. O'C. Townley," *New York Evening Mail*, 31 December 1872, 2; "Obituary. D. O'C. Townley, Journalist," *New York Times*, 29 December 1872, 5.

Mariana Griswold van Rennselaer (1851–1934): poet and critic; born in New York City; 1868–73: to Germany with family; 1873: marries Schuyler van Rennselaer; resides in New Brunswick, N.J. until husband's death in 1884; 1876: begins publishing poems; 1877: to Europe for most of the year; on return, begins soliciting writing assignments; first writings appear in *Lippincott's, American Architect and Building News*, and *American Art Review*; 1884–1934: resides in New York City.

Lois Dinnerstein, "Opulence and Ocular Delight, Splendor and Squalor: Critical Writings in Art and Architecture by Mariana Griswold van Rennselaer" (Ph.D. diss., City University of New York Graduate Center, 1979); *Dictionary of American Biography*.

Andrew C. Wheeler (1835–1903): used pseudonyms "Trinculo," "Nym Crinkle," "J.P.M.," and "J. P. Mowbray"; writer and critic; born in New York City; 1857: joins staff of *Times*; 1858–c. 1862: in West and Midwest including Milwaukee and Chicago; c. 1863–64: returns to New York; drama critic for *New York Leader*; 1870–c. 1897: drama and sometimes art critic for *World* and *Sun*.

"Death of Andrew C. Wheeler," *New York Times*, 11 March 1903, 9; Cushing, *Initials and Pseudonyms*; McJimsey, *Genteel Partisan*; Thorn, "Montgomery Schuyler"; *Dictionary of American Biography*.

Checklist of the Exhibition

Cernay la Ville–French Farm, 1867
Oil on panel
10 ⁹⁄₁₆ x 18 ¹⁄₁₆ in. (26.8 x 45.9 cm)
Krannert Art Museum, University
of Illinois, Urbana-Champaign.
Trees Collection

The Studio, 1867
Oil on canvas
18 x 15 in. (45.7 x 38.1 cm)
The Metropolitan Museum of Art,
New York. Samuel D. Lee Fund, 1939
(39.14)

*The Bridle Path, White Mountains
(The White Mountains)*, 1868
Oil on canvas
24 ⅛ x 38 in. (61.3 x 96.5 cm)
Sterling and Francine Clark Art Institute,
Williamstown, Massachusetts, 1955.2
KANSAS CITY AND ATLANTA ONLY

*Lobster Cove, Manchester,
Massachusetts*, 1869
Oil on wood panel
12 ³⁄₁₆ x 21 ¼ in. (31.3 x 54 cm)
Cooper-Hewitt, National Design
Museum, Smithsonian Institution,
New York. Gift of Charles Savage
Homer, Jr., 1915-17-1

Long Branch, New Jersey, 1869
Oil on canvas
16 x 21 ¾ in. (40.6 x 55.2 cm)
Museum of Fine Arts, Boston.
The Hayden Collection, 41.631
KANSAS CITY ONLY

*On the Beach (On the Beach, Long
Branch, New Jersey)*, c. 1869
Oil on canvas
16 x 22 ½ in. (40.6 x 57.2 cm)
Canajoharie Library and Art
Gallery, New York

Rocky Coast and Gulls, 1869
Oil on canvas
16 ¼ x 28 ⅛ in. (41.3 x 71.4 cm)
Museum of Fine Arts, Boston.
Bequest of Grenville H. Norcross,
37.486

White Mountain Wagon, c. 1869
Oil on wood panel
11 ¾ x 15 ¹³⁄₁₆ in. (29.8 x 40.2 cm)
Cooper-Hewitt, National Design
Museum, Smithsonian Institution,
New York. Gift of Mrs. Charles Savage
Homer, Jr., 1918-20-9

An Adirondack Lake, 1870
Oil on canvas
24 ¼ x 38 ¼ in. (61.6 x 97.2 cm)
Henry Art Gallery, University of
Washington, Seattle.
Horace C. Henry Collection

*Eagle Head, Manchester, Massachusetts
(High Tide)*, 1870
Oil on canvas
26 x 38 in. (66 x 96.5 cm)
The Metropolitan Museum of Art,
New York. Gift of Mrs. William F.
Milton, 1923 (23.77.2)

The Country School, 1871
Oil on canvas
21 ⅜ x 38 ⅜ in. (54.3 x 97.5 cm)
The Saint Louis Art Museum.
Purchase

The Country Store, 1872
Oil on wood panel
11 ⅞ x 18 ⅛ in. (30.2 x 46.1 cm)
Hirshhorn Museum and Sculpture
Garden, Smithsonian Institution,
Washington, D.C. Gift of
Joseph H. Hirshhorn, 1966

Crossing the Pasture, 1872
Oil on canvas
26 ¼ x 38 ⅛ in. (66.7 x 96.8 cm)
Amon Carter Museum, Fort Worth,
Texas, 1976.37
KANSAS CITY ONLY

Girl Reading on a Stone Porch, 1872
Oil on panel
6 x 8 ½ in. (15.2 x 21.6 cm)
Private collection

*Looking Out to Sea (Female Figure
in Black near a Window)*, 1872
Oil on canvas
15 ½ x 22 ½ in. (39.4 x 57.2 cm)
Private collection. Courtesy
Berry-Hill Galleries, New York
KANSAS CITY AND LOS ANGELES ONLY

Snap the Whip, 1872
Oil on canvas
22 x 36 in. (55.9 x 91.4 cm)
The Butler Institute of American
Art, Youngstown, Ohio.
Museum Purchase, 1919
KANSAS CITY AND LOS ANGELES ONLY

Sunlight and Shadow, c. 1872
Oil on canvas
15 ¹³⁄₁₆ x 22 ¹¹⁄₁₆ in. (40.2 x 57.6 cm)
Cooper-Hewitt, National Design
Museum, Smithsonian Institution,
New York. Gift of Charles Savage
Homer, Jr., 1917-14-7

Waiting for an Answer, 1872
Oil on canvas
12 x 17 in. (30.5 x 43.2 cm)
Peabody Collection, Courtesy of the
Maryland Commission on Artistic
Property of the Maryland State Archives

Boy on the Rocks, 1873
Watercolor on paper
8 ½ x 13 ¼ in. (21.6 x 33.7 cm)
Canajoharie Library and Art
Gallery, New York
LOS ANGELES AND ATLANTA ONLY

Breezing Up (A Fair Wind), 1873–76
Oil on canvas
24 ³⁄₁₆ x 38 ³⁄₁₆ in. (61.5 x 97 cm)
National Gallery of Art, Washington,
D.C. Gift of the W. L. and May T. Mellon
Foundation

A Clam-Bake, 1873
Watercolor, gouache, and graphite
on paper
7 ⅝ x 13 ⅝ in. (19.7 x 34.6 cm)
The Cleveland Museum of Art.
Gift of Mrs. Homer H. Johnson, 1945.229
ATLANTA ONLY

*Girls with Lobster (A Fisherman's
Daughter)*, 1873
Watercolor and gouache over graphite
on paper
9 ½ x 12 ¹³⁄₁₆ in. (24.2 x 32.9 cm)
The Cleveland Museum of Art. Purchase
from the J. H. Wade Fund, 1943.660
KANSAS CITY AND LOS ANGELES ONLY

Gloucester Harbor, 1873
Oil on canvas
15 ½ x 22 ½ in. (39.4 x 57.2 cm)
The Nelson-Atkins Museum of Art,
Kansas City, Missouri. Gift of the
Enid and Crosby Kemper Foundation

How Many Eggs?, 1873
Watercolor on paper
13 ⅛ x 9 ⅜ in. (33.3 x 24.4 cm)
Private collection. Courtesy of James
Graham & Sons Gallery, New York

In Charge of Baby, 1873
Watercolor on paper
8 ½ x 13 ½ in. (21.6 x 34.3 cm)
Mr. A. Alfred Taubman
KANSAS CITY ONLY

Waiting for Dad (Longing), 1873
Watercolor and gouache on paper
9 ¾ x 13 ¾ in. (24.8 x 34.9 cm)
Mills College Art Museum,
Oakland, California.
Gift of Jane C. Tolman

Children on a Fence, 1874
Watercolor over pencil on paper
7 ³⁄₁₆ x 11 ⅞ in. (18.3 x 30.2 cm)
Williams College Museum of Art,
Williamstown, Massachusetts. Museum
purchase with funds provided by the
Assyrian Relief Exchange, 41.2
KANSAS CITY ONLY

Man in a Punt, Fishing, 1874
Watercolor over graphite on paper
9 ¾ x 13 ½ in. (24.8 x 34.3 cm)
Private collection
KANSAS CITY AND LOS ANGELES ONLY

A Temperance Meeting, 1874
Oil on canvas
20 ⅜ x 30 ⅛ in. (51.8 x 76.5 cm)
Philadelphia Museum of Art.
Purchased with the John Howard
McFadden, Jr. Fund

*Waiting for a Bite (Why Don't the
Suckers Bite?)*, c. 1874
Watercolor and graphite on paper
7 ³⁄₁₆ x 13 ³⁄₁₆ in. (18.6 x 33.8 cm)
Addison Gallery of American Art,
Phillips Academy, Andover,
Massachusetts. Gift of Mary D. and
Arthur L. Williston, 1948.28
KANSAS CITY AND ATLANTA ONLY

The Busy Bee, 1875
Watercolor and gouache on paper
10 ⅛ x 9 ½ in. (25.7 x 24.1 cm)
Private collection
LOS ANGELES ONLY

Contraband, 1875
Watercolor on paper
8 ¾ x 7 ⅞ in. (22.2 x 20 cm)
Canajoharie Library and Art Gallery,
New York

Furling the Jib, 1875
Pencil and Chinese white on paper
8 ⅜ x 12 ¼ in. (21.3 x 31.1 cm)
Private collection

Milking Time, 1875
Oil on canvas
24 x 38 ¼ in. (61 x 97.2 cm)
Delaware Art Museum, Wilmington.
Gift of the Friends of Art
and other donors

*Taking Sunflower to Teacher (A Flower
for the Teacher)*, 1875
Watercolor on paper
7 ⅝ x 6 ³⁄₁₆ in. (19.4 x 15.7 cm)
Georgia Museum of Art, University
of Georgia, Athens. Eva Underhill
Holbrook Memorial Collection of
American Art. Gift of Alfred H. Holbrook,
GMOA 45.50
KANSAS CITY AND ATLANTA ONLY

Three Boys in a Dory with Lobster Pots,
1875
Watercolor and gouache over graphite
on paper
13 ⁹⁄₁₆ x 20 ½ in. (34.4 x 52.1 cm)
The Nelson-Atkins Museum of Art,
Kansas City, Missouri.
Purchase: Nelson Trust

The Trysting Place, 1875
Watercolor on paper
12 x 8 ¹⁄₁₆ in. (30.5 x 20.5 cm)
Princeton University Library, Depart-
ment of Rare Books and Special
Collections. Gift of the Estate of
Laurence Hutton in 1913; on long-
term loan to The Art Museum,
Princeton University, New Jersey
KANSAS CITY ONLY

Uncle Ned at Home, 1875
Oil on canvas
14 x 22 in. (35.6 x 55.9 cm)
Private collection. Courtesy of The
Caldwell Gallery, Manlius, New York
KANSAS CITY ONLY

Unruly Calf (Cattle Piece), 1875
Oil on canvas
24 ¼ x 38 ½ in. (61.6 x 97.8 cm)
Private collection, Chicago

Answering the Horn (The Home Signal),
1876
Oil on canvas
38 ¼ x 24 ¼ in. (97.2 x 61.6 cm)
Muskegon Museum of Art, Michigan.
Hackley Picture Fund

The Cotton Pickers, 1876
Oil on canvas
24 ¹⁄₁₆ x 38 ⅛ in. (61.1 x 96.8 cm)
Los Angeles County Museum of Art.
Acquisition made possible through
Museum Trustees: Robert O. Anderson,
R. Stanton Avery, B. Gerald Cantor,
Edward W. Carter, Justin Dart,
Charles E. Ducommun, Camilla
Chandler Frost, Julian Ganz, Jr.,
Dr. Armand Hammer, Harry Lenart,
Dr. Franklin D. Murphy, Mrs. Joan
Palevsky, Richard E. Sherwood,
Maynard J. Toll, and Hal B. Wallis,
M.77.68

Shall I Tell Your Fortune?, 1876
Oil on canvas
24 x 27 in. (61 x 68.6 cm)
Fayez Sarofim Collection

Song of the Lark (In the Field), 1876
Oil on canvas
38 ⅜ x 24 ¼ in. (98.1 x 61.5 cm)
Chrysler Museum of Art, Norfolk,
Virginia. Gift of Walter P. Chrysler, Jr.,
in honor of Dr. T. Lane Stokes, 83.590

*Twilight at Leeds, New York
(Landscape)*, 1876
Oil on canvas mounted on fiberboard
24 ⅛ x 28 in. (61.3 x 71.1 cm)
Museum of Fine Arts, Boston. Bequest
of David P. Kimball in memory of his
wife Clara Bertram Kimball, 23.521

A Visit from the Old Mistress, 1876
Oil on canvas
18 x 24 ⅛ in. (45.7 x 61.3 cm)
Smithsonian American Art Museum,
Washington, D.C. Gift of William T. Evans

The Watermelon Boys, 1876
Oil on canvas
24 ⅛ x 38 ⅛ in. (61.3 x 96.8 cm)
Cooper-Hewitt, National Design
Museum, Smithsonian Institution,
New York. Gift of Charles Savage
Homer, Jr., 1917-14-6

Backgammon, 1877
Watercolor over charcoal on paper
17 ¾ x 22 ¼ in. (45.2 x 56.4 cm)
Fine Arts Museums of San Francisco.
Achenbach Foundation for Graphic Arts.
Gift of Mr. and Mrs. John D. Rockefeller,
3ʳᵈ, 1993.35.15

Blackboard, 1877
Watercolor on paper
19 ⁷⁄₁₆ x 12 ³⁄₁₆ in. (49.4 x 31 cm)
National Gallery of Art, Washington, D.C.
Gift (partial and promised) of Jo Ann
and Julian Ganz, Jr., in honor of the
fiftieth anniversary of the National
Gallery of Art
KANSAS CITY ONLY

Camp Fire, 1877/80
Oil on canvas
23 ¾ x 38 ⅛ in. (60.3 x 96.8 cm)
The Metropolitan Museum of Art,
New York. Gift of Henry Keney Pomeroy,
1927 (27.181)

Sunday Morning in Virginia, 1877
Oil on canvas
18 x 24 in. (45.7 x 61 cm)
Cincinnati Art Museum.
John J. Emery Fund

Two Guides, 1877
Oil on canvas
24 ¼ x 38 ¼ in. (61.5 x 97.2 cm)
Sterling and Francine Clark Art Institute,
Williamstown, Massachusetts, 1955.3
KANSAS CITY AND ATLANTA ONLY

Woman and Elephant, c. 1877
Watercolor on paper on linen
11 ¾ x 8 ¾ in. (29.8 x 22.2 cm)
Albright-Knox Art Gallery,
Buffalo, New York.
Gift of Mrs. John W. Ames, 1959

Apple Picking (In the Orchard), 1878
Watercolor and gouache on paper
7 x 8 ⅜ in. (17.8 x 21.3 cm)
Terra Foundation for the Arts, Chicago.
Daniel J. Terra Collection, 1992.7
KANSAS CITY ONLY

Boy and Girl on a Hillside, 1878
Watercolor over graphite on paper
8 ¹³⁄₁₆ x 11 ³⁄₁₆ in. (22.7 x 28.7 cm)
Museum of Fine Arts, Boston.
Bequest of the Estate of Katharine
Dexter McCormick, 68.568
LOS ANGELES AND ATLANTA ONLY

Fresh Air, 1878
Watercolor over charcoal on paper
20 ¹⁄₁₆ x 14 in. (51 x 35.6 cm)
Brooklyn Museum of Art.
Dick S. Ramsay Fund
KANSAS CITY ONLY

Girl with Hay Rake, 1878
Watercolor on paper
6 ¹³⁄₁₆ x 8 ⁷⁄₁₆ in. (17.6 x 21.4 cm)
National Gallery of Art, Washington, D.C.
Gift of Ruth K. Henschel in memory of
her husband, Charles R. Henschel
KANSAS CITY AND LOS ANGELES ONLY

Peach Blossoms, 1878
Oil on canvas
13 ¼ x 19 ⅜ in. (33.7 x 49 cm)
The Art Institute of Chicago. Gift of
George B. Harrington, 1946.338

Scene at Houghton Farm, 1878
Watercolor and pencil on paper
7 ¼ x 11 ⅛ in. (18.4 x 28.6 cm)
Hirshhorn Museum and Sculpture
Garden, Smithsonian Institution,
Washington, D.C. Gift of the Joseph H.
Hirshhorn Foundation, 1966
KANSAS CITY AND ATLANTA ONLY

Shepherdess, 1878
Ceramic tile
7 ¾ x 7 ¾ in. (19.7 x 19.7 cm)
Lyman Allyn Museum of Art at
Connecticut College, New London

Shepherdess Tending Sheep, 1878
Watercolor on paper
11 ⁹⁄₁₆ x 19 ¾ in. (29.4 x 50.2 cm)
Brooklyn Museum of Art.
Dick S. Ramsay Fund
LOS ANGELES AND ATLANTA ONLY

Weary, c. 1878
Watercolor and graphite on paper
9 ½ x 12 ¼ in. (24.1 x 31.1 cm)
Terra Foundation for the Arts, Chicago.
Daniel J. Terra Collection, 1992.41
ATLANTA ONLY

Woman on a Bench (Girl on a Garden Seat), c. 1878
Watercolor and gouache on paper
6 ⅜ x 8 ¼ in. (16.2 x 21 cm)
McNay Art Museum, San Antonio, Texas.
Mary and Sylvan Lang Collection
KANSAS CITY AND LOS ANGELES ONLY

Woman Sewing, 1878-79
Watercolor over pencil on paper
9 ¾ x 7 ¾ in. (24.8 x 19.7 cm)
The Corcoran Gallery of Art,
Washington, D.C. Bequest of
James Parmelee, 41.15

Girl and Sheep, c. 1879
Pencil and wash on paper
7 ⅝ x 16 ⅛ in. (19.4 x 41 cm)
Albright-Knox Art Gallery,
Buffalo, New York. Bequest of
Norman E. Boasberg, 1962

Boys in a Dory, 1880
Watercolor on paper
10 x 14 in. (25.4 x 35.6 cm)
Mr. and Mrs. R. Crosby Kemper
KANSAS CITY ONLY

The Garden Wall (Girl on a Garden Wall), 1880
Watercolor on paper
8 ¼ x 12 ¼ in. (21 x 31.1 cm)
Huntington Museum of Art, West
Virginia. Gift of Mrs. Arthur S. Dayton

Girl on Beach, 1880
Watercolor over chalk on paper
8 ⅛ x 12 ³⁄₁₆ in. (20.6 x 31 cm)
The Nelson-Atkins Museum of Art,
Kansas City, Missouri. Anonymous loan

Gloucester Harbor and Dory, 1880
Watercolor and gouache over graphite
on paper
13 ¹¹⁄₁₆ x 19 ⅝ in. (34.7 x 49.8 cm)
Fogg Art Museum, Harvard University
Art Museums, Cambridge, Massachu-
setts. Anonymous gift
KANSAS CITY AND LOS ANGELES ONLY

Gloucester Schooners and Sloop, 1880
Graphite, watercolor, and gouache
on paper
13 ⅜ x 19 ⅜ in. (34 x 49.2 cm)
Philadelphia Museum of Art. Gift of
Dr. and Mrs. George Woodward
LOS ANGELES AND ATLANTA ONLY

Gloucester Sunset, 1880
Watercolor on paper
9 ½ x 13 ½ in. (24.1 x 34.3 cm)
Mr. and Mrs. George M. Kaufman
LOS ANGELES ONLY

Sunset at Gloucester, 1880
Watercolor and pencil on paper
13 x 23 ¾ in. (33 x 60.3 cm)
Addison Gallery of American Art,
Phillips Academy, Andover,
Massachusetts. Gift of anonymous
donor, 1930.11
KANSAS CITY AND ATLANTA ONLY

Sunset Fires, 1880
Watercolor on paper
9 ¾ x 13 ⅝ in. (24.8 x 34.6 cm)
Collection of the Westmoreland
Museum of American Art,
Greensburg, Pennsylvania. Gift of the
William A. Coulter Fund, 1964.36
KANSAS CITY AND ATLANTA ONLY

Notes

Notes to the Introduction

1. Arthur Hoeber, "Art and Artists," *New York Globe and Commercial Advertiser*, 7 February 1911, 8.

2. This project is built on more than seventy years of Homer studies, many of which are listed in the bibliography. No writer on Homer can ignore the tremendous debt owed to Lloyd Goodrich for the foundation he laid for modern studies of the artist, including our understanding of his 1870s images. The more recent and most useful writings that incorporate examinations of Homer's career before 1880 include: Lucretia Giese, "Winslow Homer: Painter of the Civil War" (Ph.D. diss., Harvard University, 1986); Marc Simpson et al., *Winslow Homer: Paintings of the Civil War*, exh. cat. (San Francisco: Fine Arts Museums of San Francisco, 1988); Peter H. Wood and Karen C. C. Dalton, *Winslow Homer's Images of Blacks: The Civil War and Reconstruction Years*, exh. cat. (Austin: University of Texas Press, 1988); Henry Adams, "Winslow Homer's 'Impressionism' and Its Relation to His Trip to France," *Studies in the History of Art* 26 (1990): 61–89; John Wilmerding and Linda Ayres, *Winslow Homer in the 1870s*, exh. cat. (Princeton, N.J.: Princeton University Press, 1990); and David Tatham, *Winslow Homer in the Adirondacks* (Syracuse, N.Y.: Syracuse University Press, 1996). Nicolai Cikovsky, Jr. and Franklin Kelly, *Winslow Homer*, exh. cat. (Washington, D.C.: National Gallery of Art, 1995) is a notable exception to the retrospective literature in that it treated Homer's pre-1883 career thoroughly.

3. With the exception of Cikovsky and Kelly, *Winslow Homer*, the same narrow set of contemporary critical responses have been repeated in the studies that have included Homer's 1870s paintings.

4. New York increasingly usurped Boston's position as the seat of popular magazine publishing through the 1870s. Thomas Bender, *New York Intellect* (New York: Alfred Knopf, 1987), 168.

5. For a useful overview of the New York art world at this time, see Linda Henefield Skalet, "The Market for American Painting in New York, 1870–1915" (Ph.D. diss., Johns Hopkins University, 1980), 9ff.

6. There is still much research to be conducted on the early history of American dealers, but a brief overview of this period may be found in Gerald Bolas, "The Early Years of the American Art Association, 1879–1900" (Ph.D. diss., City University of New York, 1998).

7. On the history and challenges of the reconstruction period, see Eric Foner, *Reconstruction: America's Unfinished Revolution, 1863–1877* (New York: Harper and Row, 1988); Allan Nevins, *The Emergence of Modern America, 1865–1878* (New York: Macmillan, 1927); Edward Chase Kirkland, *Dream and Thought in the Business Community, 1860–1900* (Ithaca, N.Y.: Cornell University Press, 1956); Thomas J. Schlereth, *Victorian America: Transformations in Everyday Life, 1876–1915* (New York: Harper Collins, 1991); and Alan Trachtenberg, *The Incorporation of America: Culture and Society in the Gilded Age* (New York: Hill and Wang, 1982).

8. On the rise and fall of the Hudson River School, see John K. Howat et al., *American Paradise: The World of the Hudson River School*, exh. cat. (New York: Metropolitan Museum of Art, 1987).

9. On American art in an international context see, especially, Peter Bermingham, *American Art in the Barbizon Mood*, exh. cat. (Washington, D.C.: Smithsonian Institution Press, 1975); Doreen Bolger Burke et al., *In Pursuit of Beauty: Americans and the Aesthetic Movement*, exh. cat. (New York: Rizzoli, 1986); Susan P. Casteras, *English Pre-Raphaelitism and Its Reception in America in the Nineteenth Century* (Cranbury, N.J.: Associated University Presses, 1990); Linda Ferber and William H. Gerdts, *The New Path: Ruskin and the American Pre-Raphaelites*, exh. cat. (Brooklyn: The Brooklyn Museum, 1985); Laura L. Meixner, *French Realist Painting and the Critique of American Society, 1865–1900* (New York: Cambridge University Press, 1995); Michael Quick and Eberhard Ruhmer, *Munich and American Realism in the Nineteenth Century*, exh. cat. (Sacramento: E. B. Crocker Art Gallery, 1978); Hollister Sturges, *Jules Breton and the French Rural Tradition*, exh. cat. (Omaha: Joslyn Art Museum, 1982); Edward J. Sullivan, *Fortuny: 1838–1874* (Barcelona: Fundació Caixa de Pensions, 1989); and H. Barbara Weinberg, *The Lure of Paris* (New York: Abbeville Press, 1991).

10. For the history of the Academy during the 1870s, see Eliot Clark, *History of the National Academy of Design, 1825–1953* (New York: Columbia University Press, 1954), 84–106, and Lois Marie Fink and Joshua C. Taylor, *Academy: The Academic Tradition in American Art*, exh. cat. (Washington, D.C.: Smithsonian Institution Press, 1975), 50–89.

11. That Homer struggled with his art in the 1870s has long been noted in scholarship. The most recent discussion of it appeared in Nicolai Cikovsky, Jr., "Reconstruction," in Cikovsky and Kelly, *Winslow Homer*, 102–4.

12. Homer created over 800 drawings, watercolors, and oil paintings as well as a small number of ceramic tiles between 1868 and 1881. Although they are dis-

cussed in passing, Homer's drawings for prints have not been included in this accounting. I am grateful to Abigail Booth Gerdts, director of the Graduate School and University Center of the City University of New York/The Lloyd Goodrich and Edith Havens Goodrich/Whitney Museum of American Art Record of Works by Winslow Homer (hereafter cited as CUNY/Goodrich/Whitney Homer Record), for supplying me with these numbers. I have also benefited tremendously from Ms. Gerdts's extensive factual knowledge and wealth of understanding of Homer's work during the period under study.

13. Charles F. Wingate, ed., *Views and Interviews on Journalism* (New York: F. B. Patterson, 1875), 7.

14. The newspapers studied include: the *Commercial Advertiser, Evening Express, Evening Mail, Evening Post, Evening Telegram, New York Daily Tribune, New York Herald, New York Times, New York World*, and *Sun*. Three of these papers had only begun publication after 1860. The *World* was established in 1861; the *Mail* and *Telegram* did not appear until 1867. The *Independent* was a weekly, and although it was published in 1868–69, it did not include art articles until 1870. The *Daily Graphic* joined the group at its founding in 1873. (Hereafter, the papers will be mentioned by their common short names such as the *Post, Times*, etc.) Papers such as the *New York Ledger* and *Daily News* had very minimal art coverage and so have been included only at those specific moments when they published art-related topics. The *New York Leader* ceased publication in 1871. Brooklyn papers have not been included except where they impart specific information related to Winslow Homer, since at this time Brooklyn and its papers were yet a separate entity from those in Manhattan. On Brooklyn's separation from Manhattan, see Linda Ferber, "A Taste Awakened: The American Watercolor Movement in Brooklyn," in Linda Ferber and Barbara Dayer Gallati, *Masters of Light and Color: Homer, Sargent and the American Watercolor Movement*, exh. cat. (Washington, D.C.: Smithsonian Institution Press, 1998), 1–39. For a thorough overview of the art press in New York during the 1870s, see Margaret C. Conrads, chap. 1 in "Winslow Homer and His Critics in the 1870s" (Ph.D. diss., City University of New York, 1999).

15. Greeley's death particularly facilitated this change. Frederic Hudson, *Journalism in the United States from 1690–1872* (New York: Harper Bros., 1873), 778.

16. Frank Luther Mott, *American Journalism, A History: 1690–1960*, 3d ed. (New York: Macmillan, 1962), 385.

17. Ibid., 412.

18. Although Clarence Cook had served in the continuous capacity as art critic for the *Tribune* since 1864, his role in the Civil War years was somewhat an anomaly. Not until between 1868 and 1873 did the *Post, World*, and *Commercial Advertiser* begin to assign regular art reporting responsibilities to specific individuals. The *Sun* does not seem to have had a designated art writer/critic until 1877. In the case of the *Times*, while covering art may have been the purview of one individual on the staff before 1875, it was not until that year that art articles of substance appeared consistently.

19. The general magazines include: *Appleton's Journal, Atlantic Monthly, Galaxy, Harper's New Monthly Magazine, Harper's Weekly, Nation, Putnam's Monthly*, and *Scribner's Monthly*.

20. In the 1820s, early general magazines such as the *New York Mirror, Knickerbocker*, and *New York Magazine and Democratic Review* had contained occasional art articles. While none of these periodicals survived into the 1870s, their mission was furthered in later but still pre–Civil War publications, such as *Harper's New Monthly Magazine* and *Harper's Weekly*, both first published in 1850, and *Atlantic Monthly*, begun in 1857, all of which continued into the period of this study. *Appleton's* first appeared in 1869, *Galaxy* in 1866, *Nation* in 1865, *Putnam's* in 1868 (but ceased in 1870), and *Scribner's* in 1870. On early art writings, see William H. Gerdts, "The American 'Discourses': A Survey of Lectures and Writings on American Art, 1770–1858," *American Art Journal* 15 (summer 1983): 61–79; William H. Gerdts, "American Landscape Painting; Critical Judgments, 1730–1845," *American Art Journal* 17 (winter 1985): 28–59; and Barbara Novak O'Doherty, "Some American Words: Basic Aesthetic Guidelines, 1825–1870," *American Art Journal* 1 (spring 1969): 78–91.

21. Frank Luther Mott, *The History of American Magazines*, vol. 2 (Cambridge, Mass.: Harvard University Press, 1967), 506–7.

22. There had been a small group of earlier magazines dedicated to art, the most important of which were the short-lived *Crayon* (1856–61) and *New Path* (1863–65). On the *Crayon*, see Janice Simon, "*The Crayon*, 1855–61: The Voice of Nature in Criticism, Poetry, and the Fine Arts" (Ph.D. diss., University of Michigan, 1990). On the *New Path*, see Ferber and Gerdts, *The New Path*. Bridging the period of this study, *Watson's Art Journal*, devoted to both music and art, first appeared in 1864 and lasted until 1875.

23. "What Is Art Criticism?" *Nation* 2 (19 April 1866): 504–6. See also, for example, Christopher P. Cranch, "Art Criticism Reviewed," *Galaxy* 4 (May 1867): 77–81.

24. "Fine Arts. The Landscape at the Academy," *New York Daily Tribune*, 30 April 1870, 5.

NOTES TO CHAPTER 1

1. Much has been written on *Prisoners from the Front*. See, especially, Nicolai Cikovsky, Jr., "Winslow Homer's *Prisoner's from the Front*," *Metropolitan Museum of Art Journal* 12 (1977): 155–72; Simpson et al., *Winslow Homer: Paintings of the Civil War*; and Giese, "Winslow Homer: Painter of the Civil War."

2. On the Paris Exposition, see Carol Troyen, "Innocents Abroad: American Painters at the 1867 Exposition Universelle, Paris," *American Art Journal* 16 (autumn 1984): 2–29.

3. The debate on America's cultural shortcoming grew after mid-century. See Ann Farmer Meservey, "The Role of Art in American Life: Critics' Views on Native Art and Literature, 1830–65," *American Art Journal* 10 (May 1978): 73–89.

4. For the most comprehensive overview of the reaction to *Prisoners from the Front*, see Marc Simpson, "20. *Prisoners from the Front*," in Simpson et al., *Winslow Homer: Paintings of the Civil War*, 247–59.

5. [George William Curtis], "Editor's Easy Chair," *Harper's New Monthly Magazine* 33 (June 1866): 118. For another example where Barlow is identified, see "Fine Arts. The Forty-First Exhibition of the National Academy of Design. [First Notice]," *Nation* 2 (11 May 1866): 605.

6. Sordello [Eugene Benson, pseud.], "National Academy of Design. Forty-First Annual Exhibition. First Article," *New York Evening Post*, 28 April 1866, 1.

7. Lucretia H. Giese, "*Prisoners from the Front*: An American History Painting?" in Simpson et al., *Winslow Homer: Paintings of the Civil War*, 67–69.

8. *New York Evening Post*, 28 April 1866, 1. For more on *Prisoners from the Front* as a history painting see Giese, "*Prisoners from the Front*," 65–81, and Patricia M. Burnham and Lucretia Hoover Giese, eds., *Redefining American History Painting* (New York: Cambridge University Press, 1995).

9. See, for example, "National Academy of Design. Forty-First Annual Exhibition," *New York Leader*, 12 May 1866, 1; "National Academy of Design. West Room," *American Art Journal* 5 (14 June 1866): 116; E. B. [Eugene Benson], "Art. About 'Figure Pictures' At the Academy," *The Round Table* 3 (12 May 1866): 295; and Masquerade [pseud.], "Pictures at the Academy of Design. Third Article," *New York Commercial Advertiser*, 7 May 1866, 2.

10. *New York Evening Post*, 28 April 1866, 1, and *Nation*, 11 May 1866, 603.

11. "Fine Arts. National Academy of Design. II," *New York Albion*, 12 May 1866, 225, and *American Art Journal* 5 (14 June 1866): 116.

12. Frederic Church's *Rainy Day in the Tropics* (Fine Arts Museums of San Francisco) and Eastman Johnson's *Negro Life at the South* (The New-York Historical Society) were the other two canvases most highly lauded. Despite the front-and-center attention that Homer's *Prisoners from the Front* received, his other canvas in the exhibition, *Bright Side* (Fine Arts Museums of San Francisco), received no such notice. It is important to note that throughout this period, while some of Homer's works received extensive amounts of praise, others, shown simultaneously, were sometimes ignored entirely. In these cases, lack of response might be read as a kind of negative commentary, for it suggests the work did not even deserve mention.

13. "Art Matters," *New York Evening Mail*, 13 January 1868, 1, and "The Exhibition of the National Academy of Design," *New York Evening Post*, 13 January 1868, 2.

14. *New York Evening Mail*, 13 January 1868, 1.

15. *New York Evening Post*, 13 January 1868, 2.

16. While there is no documentation to definitively secure the identity of *Cernay la Ville* as *Picardie, France*, it is the only work known that fits the generalized descriptions of the contemporary press.

17. It should be noted that financial need forced Homer to work frequently as an illustrator in 1868. He made at least twenty-six images for four magazines (*Harper's Weekly, Galaxy, Our Young Folks,* and *Harper's Bazaar*) and four book projects (*Good Stories, Part III* [Boston: Ticknor and Fields, 1868]; John Esten Cooke, *Mohun* [New York: F. J. Huntington and Co., 1869]; Cousin Virginia [Virginia Wales Johnson], *The Christmas Stocking* [New York: William Rockwell, 1869]; and William Barnes, *Rural Poems* [Boston:

Roberts Brothers, 1869]). For a listing of all Homer's book illustrations, see David Tatham, *Winslow Homer and the Illustrated Book* (Syracuse, N.Y.: Syracuse University Press, 1992), 297–300. Only rarely, however, were illustrations remarked on in a critical forum, and so their consideration does not figure here except in passing.

18. "The National Academy of Design. Forty-Third Annual Exhibition," *New York Daily Tribune*, 4 May 1868, 2.

19. In the context of the 1868 Academy annual, the debate around European versus American art focused on the superiority of European (especially French) figure painting and the best way for American art to absorb its technical excellencies without giving itself over to its perceived immorality or insubstantiality. This portion of the debate does not intersect with the critical reactions to Homer here but will become important later on. For the 1868 views see, for example, "The National Academy. The Reception," *New York Evening Mail*, 15 April 1868, 3; *New York Daily Tribune*, 4 May 1868, 2; and "National Academy of Design. Second Article," *New York Commercial Advertiser*, 28 April 1868, 1. The larger issue was investigated by Eugene Benson in "Democratic Deities," *Galaxy* 6 (November 1868): 661–65.

20. "The Academy of Design. Private View of the Forty-Third Annual Exhibition," *New York Daily Tribune*, 15 April 1868, 4; *New York Commercial Advertiser*, 28 April 1868, 1; and S.S.C. [Samuel Stillman Conant], "Literature and Art. Art and Artists. The Spring Exhibition of the National Academy of Design," *Galaxy* 5 (May 1868): 657–58.

21. "Notes on Art," *New York Herald*, 20 April 1868, 7, and *New York Evening Mail*, 15 April 1868, 3.

22. "Fine Arts. Forty-Third Exhibition of the National Academy of Design. First Notice," *Nation* 6 (30 April 1868): 356.

23. "Fine Arts," *Putnam's* 1 (June 1868): 772.

24. *New York Daily Tribune*, 4 May 1868, 2.

25. "Art in New York. Past and Present," *New York World*, 2 January 1868, 2.

26. Troyen, "Innocents Abroad," 13–22 passim.

27. This hope was held by critics of all schools of thought. See, for example, *New York Evening Mail*, 15 April 1868, 3, and "National Academy of Design," *New York Commercial Advertiser*, 18 May 1868, 1.

28. "Fine Arts. Forty-Third Exhibition of the National Academy of Design," *Nation* 6 (7

May 1868): 377. For a similar reaction, see *New York Daily Tribune*, 15 April 1868, 4.

29. Such was also the case in "National Academy of Design. Fourth Article," *New York Commercial Advertiser*, 12 May 1868, 1.

30. "Fine Arts. National Academy of Design–Forty-Third Annual Exhibition," *New York Daily Tribune*, 21 May 1868, 2.

31. He counseled all artists at this time: "If he will wisely determine to call no man master, but to try earnestly whenever he paints . . . he will in the end find himself developing an individual system, which will contain the truth of Nature as it appears to him." Ibid.

32. Comparisons of Homer's work to French art in the late 1860s have often been made in passing. The topic has received its fullest consideration in Adams, "Winslow Homer's 'Impressionism'," *Studies in the History of Art* 26 (1990), 61–89.

33. *New York Commercial Advertiser*, 12 May 1868, 1.

34. On the criticism of *The Briarwood Pipe*, see Cikovsky and Kelly, *Winslow Homer*, 42–43, and Marc Simpson, "8. *The Brierwood Pipe*," in Simpson et al., *Winslow Homer: Paintings of the Civil War*, 171–72.

35. On the expectations of genre painting, see Lesley Carol Wright, "Men Making Meaning in Nineteenth-Century American Genre Painting, 1860–1900" (Ph.D. diss., Stanford University, 1993), 7–17.

36. "Fine Arts. National Academy of Design. Fourth Article," *New York Daily Tribune*, 18 June 1868, 2. On the painting's French connections, see Natalie Spassky, *American Paintings in The Metropolitan Museum of Art*, vol. 2 (New York: Metropolitan Museum of Art, 1985), 445–48.

37. Homer provided at least nineteen magazine illustrations for *Harper's Bazaar*, *Harper's Weekly, Appleton's* (new in 1869), and the *Galaxy*. He also drew an illustration for John Greenleaf Whittier's *Ballads of New England*. (Tatham, *Winslow Homer and the Illustrated Book*, 299.) That Homer could not pay rent on what was probably an ancillary studio space at the Mendelssohn Glee Club in March suggests his financial situation. He offered to draw a group portrait of the club members for the $57 he owed, but his offer was declined. (Allan Robinson, *The Mendelssohn Glee Club* [New York: privately printed, 1930], unpaginated.) John Davis, Smith College, kindly brought this incident to my attention, and Abigail Gerdts suggested that the room at the club was in addition to

Homer's primary studio.

38. The identification of Homer's summer travels are drawn from newspaper reports, painting titles, and illustration titles. See, for example, "Art Matters," *New York Evening Express*, 2 September 1868, 2.

39. His most significant canvas from 1868, *The Bridle Path, White Mountains* (fig. 15), was shown at the Brooklyn Art Association in March 1869. The New York City press did not review the show; a few papers merely mentioned its occurrence. See "Art in Brooklyn," *New York Evening Mail*, 16 March 1869, 4; "Brooklyn Art Association–Spring Exhibition," *New York Evening Post*, 16 March 1869, 2; and "Art Association," *New York Commercial Advertiser*, 16 March 1869, 3. *The Bridle Path* received its full due when it was shown the next year at the Academy. See chap. 2.

40. "National Academy of Design," *New York World*, 14 April 1869, 5.

41. Some form of praise for the exhibition exceeded blatant criticism by a 2:1 margin in the reviews. The mediocrity of the show was commented on especially in the serials with critics who had the broadest art knowledge: "The Fine Arts. The National Academy of Design Forty-Fourth Annual Exhibition," *New York Daily Tribune*, 13 May 1869, 2; "Fine Arts. The National Academy of Design," *New York Times*, 19 April 1869, 5; and "Fine Arts. The National Academy of Design," *Putnam's* 3 (June 1869): 746–48.

42. The success of the younger artists is mentioned specifically in "The Academy of Design. The Forty-Fourth Exhibition," *New York Evening Post*, 27 April 1869, 1; "Fine Arts. The National Academy of Design," *New York Albion*, 1 May 1869, 243–44; and "National Academy of Design," *New York Commercial Advertiser*, 14 April 1869, 2.

43. For examples of the discussion of these matters, see *New York Daily Tribune*, 13 May 1869, 2; "Fine Arts. Sixth Notice of the Spring Exhibition of the National Academy of Design," *New York Evening Mail*, 12 May 1869, 1; "Fine Arts. Changes In The National Academy of Design," *New York Times*, 11 June 1869, 4; "Reforms In The National Academy of Design," *New York Evening Post*, 28 September 1869, 2; and "Fine Arts," *Putnam's* 4 (October 1869): 507–10.

44. The absence of these artists was especially noted in: "National Academy of Design," *New York Herald*, 14 April 1869, 9; "Fine Arts. The Forty-Fourth Annual Exhibition of the National Academy of Design," *New York Evening Mail*, 14 April, 1869, 1; *New York Commercial Advertiser*, 14 April

1869, 2; and *New York Evening Post*, 27 April 1869, 1.

45. "Fine Arts. Forty-Fifth Exhibition of the National Academy of Design," *Nation* 8 (29 April 1869): 341.

46. "Fine Arts. The National Academy of Design," *New York Times*, 19 April 1869, 5, and "Fine Arts. The National Academy of Design," *New York Times*, 30 April 1869, 4. *Putnam's* critic also preferred Colman's work and was bothered by the sketchy drawing and "handling by no means masterly" of Homer's painting, yet he praised *Manchester Coast*'s "fine qualities of color." *Putnam's*, June 1869, 748.

47. "Fine Arts. Forty-Fourth Annual Exhibition of the Academy of Design," *New York Herald*, 26 April 1869, 7.

48. What French art could be seen in New York in the late 1860s is outlined in Lois Marie Fink, "French Art in the United States, 1850–70: Three Dealers and Collectors," *Gazette des Beaux-Arts* 92 (September 1978): 87–100. My understanding of the commonalities between Homer's and Monet's painting has greatly benefited from looking at the work of both artists with Jim Wright, Eyk and Rose-Marie van Otterloo, Conservator of Paintings, Museum of Fine Arts, Boston.

49. Grannis's inclusion as an artist is mentioned in "Art Matters. National Academy of Design," *New York Evening Express*, 22 May 1869, 2. His 1869 entry was *Rocks at Low Tide* (location unknown), presumably a marine. He exhibited at the annuals of 1868–71, and his entries are listed in Maria Naylor, ed., *The National Academy of Design Exhibition Record, 1861–1900*, vol. 1 (New York: Kennedy Galleries, 1973), 354. The topic of artist-critics is a fascinating one that this study only mentions.

50. "National Academy of Design. Third Article," *New York Commercial Advertiser*, 12 May 1869, 1.

51. Grannis praised especially the work of Alfred Thompson Bricher and Maurice Frederick De Haas. (Ibid.) The only descriptive reference to Grannis's canvas is found in *New York Evening Express*, 22 May 1869, 2, where it was called "delicately painted."

52. [Clarence Cook], "The Fine Arts. The National Academy of Design. Forty-Fourth Annual Exhibition," *New York Daily Tribune*, 22 May 1869, 1.

53. Ibid.

54. Ibid.

55. Laura L. Meixner has outlined the different camps of critics circa 1865–70 in a similar way, but with regard to the American response to French art, in *French Realist Painting and the Critique of American Society*, 142.

56. *New York Daily Tribune*, 22 May 1869, 1.

57. *Nation*, 29 April 1869, 340.

58. On the discussion surrounding Johnson at the 1869 annual, see John Davis, "Children in the Parlor: Eastman Johnson's *Brown Family* and the Post–Civil War Luxury Interior," *American Art* 10 (summer 1996): 61–65.

59. "Art Matters. Third Winter Exhibition of the Academy of Design. First Article," *New York Evening Express*, 13 November 1869, 1.

60. Only eight newspapers and two magazines covered this particular exhibition. The inclusion of foreign canvases and the fact that many of the American works had been previously exhibited drew varied responses, but the overall assessment of the show was nearly unanimous. For general commentary on the show, see "National Academy of Design. Annual Winter Exhibition," *New York Daily Tribune*, 4 November 1869, 4; S.S.C. [Samuel Stillman Conant], "Literature and Art," *Galaxy* 8 (December 1869): 858–59; and "Fine Arts. National Academy of Design," *New York Evening Post*, 24 November 1869, 1.

61. *Catalogue of the Third Winter Exhibition of the National Academy of Design (1869–70) Including the Third Annual Collection of the American Society of Painters in Water Color* (New York: E. Wells Sackett, 1870), indicates that *Low Tide* was withdrawn by the time this version of the catalogue was printed. The impetus for this 1870 printing was the extension of the show to run concurrent with the American Watercolor Society's annual exhibition early in the new year. It should be noted that sometimes works were withdrawn from extended exhibitions simply because of the duration of the venue.

62. The identification of *Long Branch* is problematic because a work entitled *Long Branch Ladies Bathing* was shown at the Century Club on December 4, 1869, which also matches the description of the Boston painting. "Fine Arts," *New York Evening Post*, 9 December 1869, 2.

63. "National Academy of Design. Third Winter Exhibition," *New York World*, 6 November 1869, 12.

64. "Fine Arts. The Winter Exhibition of the

National Academy of Design," *New York Evening Mail*, 6 November 1869. Franklin Kelly, National Gallery of Art, kindly supplied me with a transcription of the original article.

65. Ibid.

66. William Milton was told *Low Tide* was painted over when he tried to purchase the canvas from the artist a year or two after its initial showing. (Cikovsky and Kelly, *Winslow Homer*, 81–83.) Cutting, however, was the actuality. Today, *On the Beach* does not show any evidence of repainting or multiple campaigns of painting related to the present image. Interestingly, X-rays reveal that a figure, totally unrelated to *Low Tide*, was Homer's initial foray on the canvas. (I am grateful to Michael Heslip, Williamstown Art Conservation Laboratory, for sharing his examination report and thoughts about the painting's physical history.) Similarly, *Beach Scene*, which has been examined with infrared reflectography but not X-rayed, shows minimal changes in the current image but also has indications of an unrelated paint structure, likely originating from a different composition underneath. (Emil Bosshard, Thyssen-Bornemisza Foundation, to James Crawford, Canajoharie Library and Art Gallery, 14 February 2000.)

67. Cikosvky and Kelly, *Winslow Homer*, 83.

68. *New York Evening Post*, 24 November 1869, 1.

69. "Art Matters. Third Winter Exhibition of the National Academy of Design. Second Article," *New York Evening Express*, 24 November 1869, 1.

70. [Clarence Cook], "Fine Arts. Third Winter Exhibition At The Academy. Third Article," *Tribune*, 4 December 1869, 3.

NOTES TO CHAPTER 2

1. The increase in Homer's output in oil began in the second half of 1869. Most of the nineteen oils dated 1869, the result of that summer's travels, were exhibited in 1870. Sixteen works dated 1870 are known. Illustration, however, was still Homer's main source of income, and in 1870 he had fifteen commissions for magazine illustrations: one each to the *Galaxy* and *Appleton's*, two to *Harper's Bazaar*, five to *Every Saturday*, and six to *Harper's Weekly*.

2. The present locations of the latter six are unknown.

3. Of the major dailies, only the *Sun* and the *Commercial Advertiser* did not publish extensive reviews. In an era when magazines paid less attention to exhibitions, only the *Nation* and *Harper's Weekly*, both weeklies, and *Putnam's* covered the show.

4. The ratio of favorable versus negative responses was 3:1. "Fine Arts," *New York Times*, 17 April 1870, 3, simply praised the show in general. Those that focused on progress included "National Academy of Design. Reception and Private View–The Forty-Fifth Annual Exhibition," *New York World*, 15 April 1870, 5; "The Spring Exhibition. Forty-Fifth Annual Exhibition of the N.A.D.," *New York Evening Mail*, 18 April 1870, 1; and "The Exhibition At The Academy Of Design," *New York Albion*, 21 May 1870, 328–29.

5. James Jackson Jarves, *Art Thoughts* (New York: Hurd and Houghton, 1869), 291–99.

6. See, for example, "Fine Arts. The Landscapes of the Academy," *New York Daily Tribune*, 30 April 1870, 5; *New York Albion*, 21 May 1870, 328–29; and "Art Gossip. The True Test of a Good Academy Exhibition," *New York Evening Mail*, 29 April 1870, 1. The purely negative remarks about the show also were based on assessments of progress. See "Fine Arts. National Academy of Design–Critical Review of a Portion of the Pictures on Exhibition," *New York Evening Telegram*, 23 April 1870, 2, and Eugene Benson, "The Annual Exhibition of the Academy," *Putnam's* 5 (June 1870): 708.

7. Only the *World* felt otherwise, suggesting more than usual care and thought could be seen in the show, especially in the landscapes. *New York World*, 15 April 1870, 5.

8. "National Academy of Design," *New York Daily Tribune*, 30 April 1864, 3, quoted in Jo Ann W. Weiss, "Clarence Cook: His Critical Writings" (Ph.D. diss., Johns Hopkins University, 1977), 44.

9. *New York Evening Telegram*, 23 April 1870, 2.

10. "Art Notes. National Academy of Design," *New York Herald*, 24 April 1870, 10, and John Jones, A. M., "The National Academy of Design," *Harper's Weekly* 14 (14 May 1870): 307.

11. James Jackson Jarves, *Art Hints* (New York: Harper and Brothers, 1855), 310.

12. This was the case for the writers of "Fine Arts. Forty-Fifth Exhibition of the National Academy of Design. Second Notice," *Nation* 10 (2 June 1870): 357; "Art Culture," *New York Evening Post*, 13 October 1869, 2; and "National Academy of Design. Third Notice," *New York Evening Post*, 10 June 1870, 1.

13. On the high esteem in which landscape was held see, for example, *New York World*, 15 April 1870, 5; *New York Herald*, 24 April 1870, 10; and "Art Notes. The Academy of Design," *New York Albion*, 23 April 1870, 267.

14. Ila Weiss, *Poetic Landscape: The Art and Experience of Sanford R. Gifford* (Newark: University of Delaware Press, 1987), 328, lists *San Giorgio* as formerly in the collection of Richard Butler.

15. Only the *Mail* complained that the painting was too showy. "Art Gossip," *New York Evening Mail*, 20 April 1870, 1.

16. "National Academy of Design. First Notice," *New York Evening Post*, 27 April 1870, 1, and "Academy of Design. Second Article," *New York World*, 8 May 1870, 5.

17. Such complaints were aired in *New York Evening Mail*, 20 April 1870, 1; "Art Notes. National Academy of Design," *New York Herald*, 8 May 1870, 3; and *New York Albion*, 23 April 1870, 267. Even those who found some pleasing aspects in Bierstadt's canvas had to admit, like the *Times* writer: "Fine as this picture is . . . it is not nature." *New York Times*, 17 April 1870, 3.

18. *New York Albion*, 21 May 1870, 328–29; "National Academy of Design. Forty-Fifth Annual Exhibition," *New York World*, 24 April 1870, 3; "Art Matters. National Academy of Design (Third Article)," *New York Evening Express*, 7 May 1870, 2; *New York World*, 8 May 1870, 5; and "National Academy of Design. Second Notice," *New York Evening Post*, 9 May 1870, 1.

19. "Fine Arts. The Exhibition of Paintings at the National Academy of Design," *New York Evening Telegram*, 28 April 1870, 2; *New York Times*, 17 April 1870, 3; "Fine Arts. The Spring Exhibition of the Academy of Design–Second Notice," *New York Times*, 24 April 1870, 3; and *New York Evening Mail*, 18 April 1870, 1, were most laudatory. The *Albion* agreed that *The After Glow* was Church's best picture to date, but it considered the foreground too detailed. *New York Albion*, 23 April 1870, 267.

20. "National Academy of Design. Third Notice," *New York Evening Post*, 10 June 1870, 1, and "Art Notes. National Academy of Design–South Room Continued," *New York Herald*, 18 May 1870, 4. The *New York World*, 8 May 1870, 5, presented a similar point of view.

21. Of the newspapers reviewing the exhibition, only the *Telegram* ignored him.

22. "The Academy of Design. The Opening of the Season," *New York Daily Tribune*, 15 April 1870, 4, and *New York Daily Tribune*, 30 April 1870, 5. A similar viewpoint appeared in Jones, *Harper's Weekly*, 14 May 1870, 307.

23. Benson, *Putnam's*, June 1870, 702.

24. *New York Daily Tribune*, 30 April 1870, 5.

25. *New York World*, 24 April 1870, 3. The problem of the critic not having the language to articulate his reaction suggests not only the radical nature of Homer's work but also the immaturity of American art criticism. In fact, as will become evident below, it was only from their reactions to Courbet, first formed in the late 1860s, that critics began to have a vocabulary with which to discuss Homer. On how American critics responded to Courbet, see Meixner, *French Realist Painting*, 152–56.

26. Ralph Waldo Emerson, "Quotation and Originality," *North American Review* 106 (April 1868): 555.

27. Thomas W. Higginson, "Americanism in Literature," *Atlantic Monthly* 25 (January 1870): 57, 63.

28. On American literature's relationship with nationalism, see Benjamin Townley Spencer, *The Quest for Nationality: An American Campaign* (Syracuse, N.Y.: Syracuse University Press, 1957).

29. *New York Daily Tribune*, 30 April 1870, 5.

30. Although *Manners and Customs* is unlocated, its treatment by the critics relative to the Clark and Metropolitan canvases suggests it was of a similar scale.

31. *New York Evening Post*, 27 April 1870, 1.

32. The response to the subject of *The Bridle Path* was softer than the more virulent reactions to the beach scenes. For example, the *Mail* acknowledged that *The Bridle Path* did "less violence to good taste" than *Eagle Head*, yet it suggested the White Mountain scene was more appropriate for travel book illustration than for a work of art. ("Art Gossip. The Forty-Fifth Annual Exhibition of the N.A.D.," *New York Evening Mail*, 4 May 1870, 1.) On the subject of *The Bridle Path*, see David Tatham, "Winslow Homer in the Mountains," *Appalachia* 36 (15 June 1966): 73, and Catherine Campbell et al., *The White Mountains: Place and Perceptions*, exh. cat. (Hanover, N.H.: University Presses of New England, 1980), passim. On the history of beach resorts and seabathing, see Lena Lenček and Gideon Bosker, *The Beach: The History of Paradise on Earth* (New York: Viking, 1998).

33. *New York Evening Post*, 27 April 1870, 1.

34. *New York Evening Mail*, 4 May 1870, 1. John Jones cast his reservations more mildly, finding the subject "not quite refined." Jones, *Harper's Weekly*, 14 May 1870, 307.

35. "Art Gossip. The Forty-Fifth Annual Exhibition of the N.A.D.," *New York Evening Mail*, 27 June 1870, 1.

36. *New York Herald*, 8 May 1870, 3.

37. Lenček and Bosker, *The Beach*, 152.

38. Ibid., 189.

39. Benson, *Putnam's*, June 1870, 702–3.

40. A comparable distinctiveness in Homer's Civil War paintings was noted in Nicolai Cikovsky, Jr., "The School of War," in Cikovsky and Kelly, *Winslow Homer*, 24–26.

41. For descriptions of Guy's *Little Stranger* and Perry's *Huldy*, see Jones, *Harper's Weekly*, 14 May 1870, 307, and *New York Herald*, 8 May 1870, 3, respectively.

42. Perry's work received special praise for its subject, exquisite detail, drawing, overall conception, and beauty, from the conservative John Jones to the forward-thinking Eugene Benson. For their praise of Perry and responses to his peers, see Jones, *Harper's Weekly*, 14 May 1870, 307, and Benson, *Putnam's*, June 1870, 701, 706–8.

43. Benson, *Putnam's*, June 1870, 702–3.

44. Sordello [Eugene Benson], "The New Art-Life in France. Gustave Courbet and P. J. Proudhon [*sic*]," *New York Evening Post*, 14 August 1867, 1. Laura Meixner has noted in passing the similarity of Benson's reactions to Courbet and Homer in *French Realist Painting*, 154 and 288, note 32. The friendship between Benson and Homer is outlined in Cikovsky, "School of War," in Cikovsky and Kelly, *Winslow Homer*, 28–34.

45. Benson, *Putnam's*, June 1870, 703.

46. Among those who characterized the pictures as powerful were: *New York Evening Post*, 27 April 1870, 1; "Art Matters. National Academy of Design–Second Article," *New York Evening Express*, 30 April 1870, 2; and *New York World*, 24 April 1870, 3.

47. *New York Daily Tribune*, 15 April 1870, 4.

48. *New York Daily Tribune*, 30 April 1870, 5.

49. *New York Evening Express*, 30 April 1870, 2.

50. *New York Evening Mail*, 4 May 1870, 1.

51. *New York World*, 24 April 1870, 3. A similar reaction appeared in *New York Evening Post*, 27 April 1870, 1.

52. *New York Times*, 17 April 1870, 3.

53. *New York World*, 24 April 1870, 3.

54. Lenček and Bosker, *The Beach*, 200–201.

55. *New York Evening Mail*, 4 May 1870, 1. *New York Evening Post*, 27 April 1870, 1, agreed.

56. Homer was not the only artist with a large selection of work in this exhibition. Kruseman Van Elten and William Hart exhibited nine and ten works respectively, and contributions from each artist were noticed to be of the study/sketch variety. See, for example, *New York Times*, 24 April 1870, 3, and *New York World*, 24 April 1870, 3. The group of sketches was expressly noticed in "Fine Arts. Forty-Fifth Exhibition of the National Academy of Design," *Nation* 10 (28 April 1870): 278; *New York Daily Tribune*, 30 April 1870, 5; *New York Herald*, 24 April 1870, 10; and *New York Evening Post*, 10 June 1870, 1.

57. *Nation*, 28 April 1870, 278.

58. There remained, however, critics, such as the writer for the *Herald*, who held tightly to the belief that careful and literal description were of paramount importance. *New York Herald*, 24 April 1870, 10.

59. Such attitudes were expressed in *New York Daily Tribune*, 30 April 1870, 5; *New York Times*, 24 April 1870, 3; and *New York World*, 8 May 1870, 5.

60. Eleanor Jones Harvey has explored the issues surrounding the exhibited oil sketches of the premier landscape painters during the period 1830–80 in *The Painted Sketch: American Impressions From Nature, 1830–80*, exh. cat. (Dallas: Dallas Museum of Art, 1998), especially chap. 3: "The Oil Sketch on Display," 63–69.

61. Jones, *Harper's Weekly*, 14 May 1870, 307.

62. *New York World*, 24 April 1870, 3.

63. Eleanor Harvey contends that a greater acceptance of sketches as exhibitable works of art at the Academy was in evidence from the late 1860s. (Harvey, *The Painted Sketch*, 64–68.) This assertion holds true for the 1870s in general and was

the case by 1870 for the group of artists she examined in particular. However, the specific example of the critical reactions to the sketches at the 1870 Academy annual, particularly Homer's points out that, at this moment, there was a body of work on view that was not considered appropriate for public display, and suggests how still very unresolved the issue of the "exhibitable" sketch was in 1870.

64. *New York Daily Tribune*, 30 April 1870, 5.

65. *Nation*, 28 April 1870, 278.

66. *New York World*, 24 April 1870, 3.

67. *New York World*, 8 May 1870, 5.

68. David B. Lawall, *Asher B. Durand: A Documentary Catalogue of the Narrative and Landscape Paintings* (New York: Garland Publishing, 1978), 193–95.

69. Harvey, *The Painted Sketch*, 64–65.

70. Both *White Mountain Wagon* and *Lobster Cove* are painted on wood board, three-eighths of an inch thick and with circular saw marks evident on both sides. These panels have a pattern of holes along the edges, suggesting the wood had an earlier use such as the makings of a crate. Abigail Gerdts has pointed out that Homer often bought large lots of goods–from clothing to canned goods–and that it would not have been out of character for Homer to have bought an odd lot of wood. (Conversations with the author, October and November 1999.) There are other works on similar panels, such as *Beach, Late Afternoon* (Metropolitan Museum of Art). I am grateful to Quentin Rankin, Smithsonian American Art Museum, and Konstanze Bachmann, Cooper-Hewitt Museum, for their observations of the technique in *Lobster Cove* and *White Mountain Wagon*.

71. In Homer's illustration, "The Picnic Excursion," the wagon and its passengers appear delineated by light and shade, but have the added definition of outline and some detail. "The Picnic Excursion–By Winslow Homer," *Appleton's Journal*, 14 August 1869, 624.

72. *New York World*, 24 April 1870, 3.

73. Benson, *Putnam's*, June 1870, 703.

74. See, for example, *New York Daily Tribune*, 30 April 1870, 5, and *New York Evening Post*, 27 April 1870, 1.

75. Homer drew seven illustrations for *Every Saturday* in 1871, most of them related to his Adirondack and Long Branch

sojourns of the previous summer. Although he had nine additional drawings published in two books of poetry, these drawing were actually contracted for and created in 1870. Tatham, *Winslow Homer and the Illustrated Book*, 299.

76. Homer exhibited eight paintings at six of the eight monthly meetings: seaside images in January and February; Civil War images in February and October; Adirondack images in April and May; and rural life images in November. The Century Club often served as the place where Homer could get informal and informed reactions in a friendly environment. The *Post* suggested the importance of the Century's exhibitions: "At these exhibitions the members have been favored with the first view of nearly all of the important works which have been produced by our leading painters. . . . That these exhibitions . . . are of importance, is shown by the fact that the kindly criticism which the occasion evokes is always listened to with attention and its purport heeded." ("Art at the Century," *New York Evening Post*, 11 October 1871, 1.) It also cannot be ignored that the club was among the best venues for sales. I am indebted to Jonathan Harding, The Century Association, for the list of Homer's contributions to club exhibitions from the Century Association Archives.

77. "Art Notes. The Palette Club," *New York Herald*, 20 February 1871, 3, and "Art Notes. The National Academy of Design," *New York Herald*, 7 March 1871, 10. His paintings also appeared at the premier auction houses. "Important Sale of American and Foreign Oil Paintings," *New York Evening Post*, 9 May 1871, 4, and Eli Perkins, "Somerville Gallery," *New York Commercial Advertiser*, 13 December 1871, 1. Determining whether or not Homer was responsible for placing his works at auction is often difficult. However, it is noteworthy that his work was available to be seen in these other venues.

78. "The Century," *New York Evening Mail*, 6 February 1871, 1.

79. Ibid.

80. Ibid.

81. Daniel E. Sutherland, *The Expansion of Everyday Life, 1860–1876* (New York: Harper and Row, 1989), 178–80.

82. *New York Evening Mail*, 6 February 1871, 1.

83. John Jones, A. M., "The Academy Exhibition," *Harper's Weekly* 15 (27 May 1871): 475, and "Art Notes," *New York Herald*, 13 February 1871, 6. Mary Lynn Stevens

Heininger et al., *Century of Childhood*, exh. cat. (Rochester, N.Y.: Margaret Woodbury Strong Museum, 1984), provides a succinct outline of the attitudes towards youth in the nineteenth century.

84. The positive responses to Johnson's work came from every quarter, not only at its Century Club viewing, but the following week at the Union League Club and in the spring at the National Academy exhibition. See, for example, *New York Herald*, 13 February 1871, 6; "The Academy of Design. The Forty-Sixth Annual Exhibition," *New York World*, 23 April 1871, 2; "Fine Arts. Private View of the Exhibition of the Academy of Design," *New York Daily Tribune*, 14 April 1871, 4; and Susan Nichols Carter, "The Spring Exhibition At The Academy of Design," *Appleton's Journal* 5 (27 May 1871): 619–20.

85. Both paintings are inscribed 1870 and it is impossible to know definitively which of the two canvases was shown. While the Colby painting was likely painted second, it immediately went into the possession of Lawson Valentine (David Tatham, *Winslow Homer in the Adirondacks* [Syracuse, N.Y.: Syracuse University Press, 1996], 26–27). The Henry Art Gallery version was said to have been selected by the critic Russell Sturgis for its first owner Joseph H. Scranton, who we only know owned the painting prior to his death in 1872. (CUNY/Goodrich/Whitney Homer Record) The Century Club would have been a likely venue for Sturgis to have seen the painting.

86. "Art Gossip. The April Exhibition at the Century Club," *New York Evening Mail*, 3 April 1871, 1.

87. "Art Notes," *New York Evening Post*, 7 June 1871, 1.

88. Annette Blaugrund, "The Tenth Street Studio Building (New York)" (Ph.D. diss., Columbia University, 1987), is a comprehensive study of life at the studio building in the nineteenth century.

89. All of these artists except Wood, who joined the building in 1874, were already in residence when Homer arrived. On the genre painters in the Tenth Street Studio Building, see Blaugrund, "Tenth Street Studio Building," 122–99.

90. *Old Mill* and *The Country School*, for example, had appeared at the Century (November 1871) and the Union League Club (March 1872 and February 1872, respectively). Another, and surely important, result of Homer's exhibiting at the Century was the sale of pictures. Three out of these five paintings–*A Rainy Day in Camp; The Country Store; and The Country*

School–were already sold when they appeared at the Academy. Among the effects of what seems to have been improved sales was that Homer's illustration work clearly was being pushed further into the background. In 1872, he drew only three magazine illustrations, all for *Harper's Weekly*, and participated in only one book project, James Russell Lowell's *The Courtin'*. See Tatham, *Winslow Homer and the Illustrated Book*, 300.

91. For example, while the *World*, *Tribune*, and *Mail* printed a minimum of three reviews each, two or more of them were only short references rather than the extensive multiple reviews that had appeared in 1870.

92. For a brief overview of these events, see Richard Brandon Morris, ed., *Encyclopedia of American History* (New York: Harper, 1953), 250–51.

93. "Art Gossip," *New York Evening Mail*, 23 March 1872, 1, noted the competition in general. Mentions of these events were made in, among others, *New York Evening Mail*, 23 March 1872, 1; "Fine Arts. Exhibition of the National Academy of Design–Picture Sales, &c.," *New York Times*, 14 April 1872, 2; and "Art Matters. The Lockwood Collection," *New York Evening Express*, 13 April 1872, 2. The abundance of sales was one indication of how the commerce of art was rapidly changing in this era. A topic requiring further, in-depth study, it has been covered generally in Skalet, "The Market for American Painting in New York." A more recent overview of it can be found in Bolas, "The Early Years of the American Art Association," 12–98 passim.

94. Offering this viewpoint were, for example, "The Spring Exhibition of the Academy of Design," *New York Herald*, 14 April 1872, 5; "The Realm of Art. Exhibition of Pictures at the Academy of Design," *New York Evening Telegram*, 13 April 1872, 3; "Fine Arts. Opening of the Spring Exhibition," *New York Daily Tribune*, 12 April 1872, 5; and "Art Receptions. The National Academy Spring Exhibition," *New York Evening Mail*, 12 April 1872, 2.

95. The *Post* was positive in its first review, but a harsher criticism appeared in a later review. ("City Intelligence. National Academy of Design," *New York Evening Post*, 17 April 1872, 4; "Fine Arts. Close of the National Academy of Design," *New York Evening Post*, 6 July 1872, 1.) This contradictory response could have been the result of extended study or different writers. A general displeasure with the exhibition was expressed in *New York Times*, 14 April 1872, 2.

96. This was remarked on in *New York Daily Tribune*, 12 April 1872, 5; *New York Evening Mail*, 12 April 1872, 2; and "Art Matters. The Academy Exhibition. First Article," *New York Evening Express*, 13 April 1872, 2.

97. This sentiment was put forth not only in *New York Evening Express*, 13 April 1872, 2, but also in *New York Herald*, 14 April 1872, 5.

98. *New York Daily Tribune*, 12 April 1872, 3, and *New York Herald*, 14 April 1872, 5.

99. See, for example, "The Academy Exhibition," *New York World*, 12 April 1872, 1; *New York Times*, 14 April 1872, 2; "The Spring Exhibition of the National Academy," *Appleton's Journal* 7 (25 May 1872): 578–80; and *New York Evening Mail*, 12 April 1872, 2.

100. Clarence Cook severely chastised Church in *New York Daily Tribune*, 12 April 1872, 5. Eleanor Harvey has noted that Church never exhibited his "Great Pictures" at the Academy. (Harvey, *The Painted Sketch*, 67.) The other single painting that received considerable attention outside the Academy walls was Thomas Moran's *Grand Canyon of the Yellowstone* (1872; Smithsonian American Art Museum). Lengthy reviews of the Moran painting can be found in "On The Easel," *New York Evening Mail*, 25 March 1872, 1; "Art. Grand Canyon of the Yellowstone River," *New York Independent*, 23 May 1872, 2; "Culture and Progress," *Scribner's* 4 (June 1872): 251–52; and "Art," *Atlantic* 30 (August 1872): 246–47.

101. The number of landscape subjects decreased and figure/genre subjects increased, each by ten percent, between 1867 and 1874. (Theodore E. Stebbins, Jr., "Luminism in Context: A New View," in John Wilmerding, ed., *American Light: The Luminist Movement, 1850–75: Paintings, Drawings, Photographs*, exh. cat. [Washington, D.C.: National Gallery of Art, 1980], 215.) Stebbins's estimate was based on titles and thus not authoritatively accurate, but the numbers give a reasonable idea of the shift. Why the shift occurred is still to be studied, though scholars have suggested several possible reasons. As to the decrease in landscape art, Nicolai Cikovsky has suggested that the destruction of so much land during the Civil War damaged the concept of the landscape as the location for national beliefs, (Cikovsky, "School of War," in Cikovsky and Kelly, *Winslow Homer*, 72). On the side of genre, Sarah Burns (*Pastoral Inventions*, 6) has argued that genre became an increasingly appropriate vehicle for exploring the issues of the day. The increased interaction of populations

fostered human interaction as a worthy subject.

102. The serials that reviewed the show included the *Herald*, *Post*, *Express*, *Telegram*, *World*, *Tribune*, *Appleton's Journal*, *Independent*, *Times*, *Scribner's Monthly*, and *Mail*. The last three ignored Homer. The *Mail* reviews seem to have been interrupted, possibly due to a change in circumstances for their regular critic D. O'C. Townley, who died at the end of 1872. On Townley, see Appendix.

103. See, for example, *New York World*, 12 April 1872, 1; *New York Herald*, 14 April 1872, 5. Most effusive was the comment in *New York Evening Post*, 6 July 1872, 1, that stated, in a show full of faults, Homer's work was one of the few redeeming features.

104. The descriptions were both factual as well as interpretive. Factual descriptions appeared in, for example, "Art Matters. The Academy Exhibition. Second Article," *New York Evening Express*, 18 April 1872, 2, and "Art. National Academy of Design," *New York Independent*, 25 April 1872, 2. More interpretive descriptions were made in "The Realm of Art. Some Notes on the Academy Spring Exhibition," *New York Evening Telegram*, 20 April 1872, 2; and "Fine Arts. Exhibition of the Academy of Design," *New York Daily Tribune*, 17 April 1872, 6.

105. *New York Evening Express*, 18 April 1872, 2.

106. Additionally, many considered a free public education, available to all, imperative in a democratic society. See "Two Dangers Threatening Our Schools," *Nation* 15 (15 August 1872): 103–4; Cikovsky and Kelly, *Winslow Homer*, 88; and John Davis, entry on Eastman Johnson's *The Early Scholar* in Franklin Kelly et al., *American Paintings of the Nineteenth Century*, pt. 1, (Washington, D.C.: National Gallery of Art), 373–74.

107. *New York Evening Express*, 18 April 1872, 2.

108. *New York Evening Telegram*, 20 April 1872, 2, noted "visitors . . . one and all, cultured and uncultured" delighted in this work. A similar sentiment was expressed in *New York Daily Tribune*, 17 April 1872, 6, and *Appleton's Journal*, 25 May 1872, 578.

109. Sarah Burns has recently written about *The Old Stagecoach* as an important reference point for Homer's *Snap the Whip* in "In Whose Shadow? Eastman Johnson in the Postwar Decades," in Teresa A. Carbone and Patricia Hills, *Eastman Johnson:*

Painting America, exh. cat. (Brooklyn: Brooklyn Museum of Art, 1999), 192–93. Nicolai Cikovsky has discussed the layers of issues found in the school images in "Winslow Homer's *School Time*: 'A Picture Thoroughly National,'" in *Essays in Honor of Paul Mellon* (Washington, D.C.: National Gallery of Art, 1986), 47–69. See also Cikovsky and Kelly, *Winslow Homer*, 64, 88.

110. "School-Children," *Aldine* 5 (October 1872): 198.

111. "The National Education Bill," *Nation* 14 (29 February 1872): 133.

112. Cikovsky first noted the teacher's modernity. (Cikovsky, "Winslow Homer's *School Time*," 53–54, and Cikovsky and Kelly, *Winslow Homer*, 64, 88.) For the statistic, see Sutherland, *Expansion of Everyday Life*, 97.

113. See, for example, *New York Independent*, 25 April 1872, 2; *New York Evening Telegram*, 20 April 1872, 2, and *New York Daily Tribune*, 17 April 1872, 6.

114. *New York Evening Telegram*, 20 April 1872, 2.

115. *New York Daily Tribune*, 17 April 1872, 6.

116. *New York Evening Express*, 18 April 1872, 2.

117. The concept of the book of nature in landscape painting in the mid-nineteenth century has been investigated in Francis Murphy, *The Book of Nature: American Painters and the Natural Sublime*, exh. cat. (Yonkers, N.Y.: Hudson River Museum, 1983).

118. *New York Evening Telegram*, 20 April 1872, 2, and *New York Independent*, 25 April 1872, 2, shared this view.

119. Judith Walsh has noted the significance of the cherry blossom in the context of the language of flowers familiar to nineteenth-century Americans in "The Language of Flowers and Other Floral Symbolism Used by Winslow Homer," *Antiques* 156 (November 1999): 713.

120. *New York Evening Express*, 18 April 1872, 2; *New York Daily Tribune*, 17 April 1872, 6; and A.C.W. [Andrew C. Wheeler], "Gossip in a Gallery. A Visit to the Academy of Design," *New York World*, 21 April 1872, 2.

121. It is interesting to note that if the version of *The Country School* shown at the Academy is the same canvas (rather than its near twin [Addison Gallery of American Art]) exhibited at the Union League Club in February 1872, either Homer worked significantly on the painting or the critics substantially changed their opinions about it. At the club venue, *The Country School* was criticized for Homer's usual sin of unfinish. As the writer for the *Times* noted, it had problems that "by very little care, might have been avoided." "Fine Arts. Art Reception at the Union League Club," *New York Times*, 11 February 1872, 3. Similar complaints appeared in "Union League Club," *New York Evening Mail*, 10 February 1872, 4.

122. It had "the soul of suggestion" in its "veracious outlines." A.C.W. [Andrew C. Wheeler], *New York World*, 21 April 1872, 2.

123. "The style of painting is sketchy and unelaborate, yet masterly. . . . The very thinness of the execution harmonizes singularly with this bare, unadorned rustic life," noted the *Independent*, which also suggested that it was perhaps easier to accept a less elaborate style for a rural subject than for those in which a certain refinement was expected. *New York Independent*, 25 April 1872, 2.

124. *New York Evening Telegram*, 20 April 1872, 2.

125. Cikovsky, "Winslow Homer's *School Time*," 64–67.

126. *New York Evening Post*, 6 July 1872, 1.

127. The influence of Couture on Homer is another interesting topic for consideration, but not here. On Couture and his American students, see Albert Boime, *Thomas Couture and the Eclectic Vision* (New Haven, Conn.: Yale University Press, 1980), 557–612.

128. The critics who commended the painting noted their approval without explaining their responses. See, for example, *New York Evening Telegram*, 13 April 1872, 3, and *New York Daily Tribune*, 12 April 1872, 5. Those less pleased with it criticized its tired Civil War subject and weak execution. *Appleton's Journal*, 25 May 1872, 579, and *Scribner's*, June 1872, 252–53.

129. *New York Evening Telegram*, 20 April 1872, 2; *New York Daily Tribune*, 17 April 1872, 6; and *Appleton's Journal* 7 (25 May 1872): 579. Similar comments befell the work of John Beaufain Irving. *New York Evening Express*, 18 April 1872, 2; *New York Evening Telegram*, 20 April 1872, 2; and *New York Daily Tribune*, 17 April 1872, 6.

130. A.C.W. [Andrew C. Wheeler], *New York World*, 21 April 1872, 2.

131. "The Realm of Art. Landscape Paintings in the Spring Exhibition," *New York Evening Telegram*, 4 May 1872, 2, clearly stated: "In painting it is not only hand work but brain work we want." A similar view was expressed in "Art," *Atlantic* 29 (March 1872): 372.

132. *New York Evening Telegram*, 20 April 1872, 2; *New York Evening Express*, 18 April 1872, 2; and *New York Daily Tribune*, 12 April 1872, 5.

133. *New York Evening Telegram*, 20 April 1872, 2, and A.C.W. [Andrew C. Wheeler], *New York World*, 21 April 1872, 2. For a recent and very perceptive interpretation of the painting, see Nicolai Cikovsky, Jr., "Winslow Homer's (So-called) *Morning Bell*," *American Art Journal* 29 (1998): 5–17.

134. *New York Evening Telegram*, 4 May 1872, 2, and *New York Evening Post*, 6 July 1872, 1.

135. "The Realm of Art. Some Notes on Genre Pictures and Beauties of the Academy Exhibition," *New York Evening Telegram*, 27 April 1872, 2; A.C.W. [Andrew C. Wheeler], *New York World*, 21 April 1872, 2; and James Jackson Jarves, "Art. The Needs of a Young Artist," *New York Independent*, 2 May 1872, 4.

136. The story of Homer using city street children as models has often been told. The genesis of the story can be found in the description of Homer working on the painting in "The Realm of Art. Gossip Among the Brushes, Maulsticks and Easels," *New York Evening Telegram*, 8 June 1872, 2. It should be noted that there are two versions of this painting. While the Butler canvas (fig. 31; originally owned by John Sherwood) retains its mountain backdrop, the painting in the Metropolitan Museum of Art's collection has had similar scenery painted out. The order in which these two paintings were created and when this alteration of the Met's canvas occurred is unknown. See Cikovsky and Kelly, *Winslow Homer*, 90–91. On the Metropolitan's version, see Spassky, *American Paintings in The Metropolitan Museum of Art*, 457–61.

137. The reports of Homer's travels and traveling companion can be found in "Art Notes," *New York Evening Post*, 8 July 1872, 1, and "Art Notes," *New York Evening Mail*, 18 October 1872, 2.

138. Because the painting was never exhibited at the Academy, it never received full treatment by the critics. See the discussion of the 1873 Academy exhibition in chap. 3.

139. Clarence Cook referred to *The Country School* as the companion to *Snap the Whip*

in "Fine Arts. The Sherwood Collection," *New York Daily Tribune*, 23 April 1873, 4. The painting's nostalgic and contemporary qualities were noticed in *New York Evening Telegram*, 8 June 1872, 2, and "The Return of the Artists," *New York Herald*, 19 October 1872, 6.

140. These shortcomings were mentioned by *New York Herald*, 19 October 1872, 6; "Art Notes," *New York Herald*, 27 November 1872, 4; "Art Matters," *New York Commercial Advertiser*, 10 December 1872, 1, and "Fine Arts. Reception at the Union League Club–New Pictures," *New York Times*, 16 December 1872, 3.

141. This was the case in the comments that appeared in "Art Matters. Recent Pictures," *New York World*, 17 November 1872, 6; "Art," *New York Evening Mail*, 26 April 1873, 2; and "Fine Arts. Reception at the Union League Club–New Pictures," *New York Times*, 16 December 1872, 3.

Notes to Chapter 5

1. On the impact of the depression see Foner, *Reconstruction: America's Unfinished Revolution*, 511–59. The radical nature of the vast changes in New York is suggested even in Homer's work for magazines. While the number of Homer's illustrations remained constant in 1874, his assignments included urban subjects touching on problems of the day. Subjects such as "Station-House Lodgers" (*Harper's Weekly* 18 [7 February 1874], 132) and "The Chinese in New York–Scene in a Baxter Street Club House" (*Harper's Weekly* 18 [7 March 1874], 212) illustrated the growing concerns about increased immigration, crime, and drug abuse in New York City.

2. La Farge was elected to the Academy in 1869 and served on a number of committees. Clark, *History of the National Academy of Design*, 96–97.

3. Homer exhibited at five of the eight monthly exhibitions at the Century. Sales in which Homer's work could be found included the Archibald Johnston Sale ("Art," *New York Evening Mail*, 5 March 1873, 2); the Sherwood Sale ("Fine Arts. Mr. John H. Sherwood's Collection," *New York World*, 23 April 1873, 5); the Avery Sale (*Catalogue of Samuel P. Avery's Collection of Paintings* [New York: privately printed, 1873], no. 93); the Somerville Sale of May 1873 ("The Fine Arts. The American Collection in the Somerville Gallery," *New York Times*, 3 May 1873, 4); at the American and Foreign Art Agency ("Art Matters. The American and Foreign Art Agency," *New York Herald*, 22 September 1873, 4); Thom's

Gallery ("Art Notes," *New York World*, 29 September 1873, 5); and Snedecor's Gallery ("Fine Arts. What Snedecor Has to Show this Season," *New York Evening Mail*, 31 December 1873, 1). Homer also opened his studio on at least two occasions, as was noted in "Art Reception," *New York World*, 24 January 1873, 5, and "Artists' Reception," *New York World*, 28 March 1873, 5.

4. *Girl in a Hammock* could possibly have been *In the Hammock* (private collection). Two other pictures known only as *Study*, shown in March and November, respectively, may have also been figure works. The only work Homer exhibited at the Union League Club this year was described as a figure picture. See "Art at the Union League," *New York Evening Post*, 14 February 1873, 2.

5. At the Somerville Gallery, there was, in addition to *Waiting for an Answer*, another canvas by Homer called *Waiting for a Partner* (location unknown), which also may have implied romance. *New York Times*, 3 May 1873, 4.

6. The rise of specifically ideal female subjects, one that Homer did not explore, would appear by the middle of the decade. See Leila Bailey Van Hook, "The Ideal Women in American Art, 1875–1910" (Ph.D. diss., City University of New York, 1988).

7. "Art at the Century," *New York Evening Post*, 3 February 1873, 2, and "Art at the Century," *New York Evening Post*, 4 March 1873, 2.

8. Judith Walsh kindly supplied the information on geraniums. See also Walsh, "The Language of Flowers," 708–17.

9. "Art Notes," *New York Daily Graphic*, 2 May 1873, 6, and "Art," *New York Evening Mail*, 2 May 1873, 2. At Thom's Gallery, the light in *Waiting for an Answer* was again mentioned in "Art Notes. Artists in Town–Vacation Work–The Coming Season," *New York World*, 29 September 1873, 5.

10. It is interesting to note that Homer reworked this painting, probably not long after it was first completed. There exist two signatures, one on top of the other, in the lower left. All of Homer's changes can be considered adjustments or refinements to heighten the activity of the paint surface. He slightly changed the profile of the trees against the sky and added additional dashes of color in the foreground. Shelley Svaboda, Baltimore Museum of Art, was most helpful in the examination of this painting.

11. Worthington Whittredge and W. O. Stone were the other two artists elected to

the committee. The election was noted in "The National Academy of Design," *New York Daily Tribune*, 10 May 1872, 8; "The National Academy of Design," *New York Times*, 10 May 1872, 3; "Art Notes," *Watson's Art Journal* 17 (1 June 1872): 55; and "Art Matters," *New York Herald*, 12 May 1872, 10. I am grateful to David Dearinger, Chief Curator, National Academy of Design, for clarifying the precise role of the hanging committee.

12. *New York World*, 23 April 1873, 5.

13. I am grateful to Abigail Gerdts and David Dearinger for sharing their thoughts with me on this matter.

14. The paintings were *Apple Blossoms* (location unknown); *Coming through the Rye* (private collection); *Crossing the Bridge* (probably Lauren Rogers Museum of Art, Laurel, Mississippi); *Haying Time* (location unknown); *Siesta* (location unknown); and *Waiting for a Partner* (location unknown). Of these, *Haying Time* was said to be large. *New York Times*, 3 May 1873, 4.

15. "National Academy of Design," *New York Evening Post*, 15 May 1873, 1; "Art. Annual Exhibition of N. A. of Design," *Aldine* 6 (June 1873): 127; and "Fine Arts. The Academy Exhibition," *Nation* 16 (22 May 1873): 358–59.

16. For condemnation of the show, see, for example, "National Academy of Design," *New York Daily Graphic*, 21 April 1873, 2; "Art, Music and Drama. Fine Arts. The National Academy of Design–Forty-Eighth Annual Exhibition. Second Notice," *New York Daily Tribune*, 25 April 1873, 5; *Aldine*, June 1873, 127; and Angelo, "Correspondence. The National Academy of Design," *Watson's Art Journal* 18 (26 April 1873): 309. For specific criticism of the hanging committee see "Fine Arts. The Spring Exhibition at the Academy," *New York Evening Mail*, 15 April 1873, 1, and "Art. The Spring Exhibition at the Academy of Design," *New York Independent*, 1 May 1873, 550–51.

17. The election was noted in "Art," *New York Evening Mail*, 15 May 1873, 2, and "New Officers of the Academy of Design," *New York World*, 15 May 1873, 5, among others.

18. Cikovsky and Kelly, *Winslow Homer*, 394.

19. Homer was reported as still in the country on the evening of the November meeting at the Century, even though he had pictures on view and the *Mail* had reported seeing Homer's new work in his studio the week before. A logical explanation for this course of events is that Homer

came into town, dropped off his work, and then left again within a few days. "Art at the Century," *New York Evening Post*, 3 November 1873, 2, and "Fine Arts. A Visit to the Tenth Street Studio," *New York Evening Mail*, 28 October 1873, 1.

20. The main text on the watercolor movement in America, to whom anyone working on watercolor in this period is indebted, is Foster, "Makers of the American Watercolor Movement." A recent, welcome addition to the literature on the American Watercolor Society and its effect on exhibition watercolors is Barbara Dayer Gallati, "The Exhibition Watercolor in America," in Ferber and Gallati, *Masters of Color and Light*, 41–68.

21. On the response to this exhibition, see Susan P. Casteras, "The 1857–58 Exhibition of English Art in America: Critical Responses to Pre-Raphaelitism," in Ferber and Gerdts, *The New Path*, 109–33.

22. The American Pre-Raphaelites, as the American devotees of Ruskin were known, included William Trost Richards, Henry and Thomas Farrer, Charles Moore, and John Henry and John William Hill. On the watercolors of the American Pre-Raphaelites, see Kathleen A. Foster, "The Pre-Raphaelite Medium: Ruskin, Turner, and American Watercolor," in Ferber and Gerdts, *The New Path*, 79–108.

23. Foster, "Makers of the American Watercolor Movement," 30, 54.

24. For an overview of Fortuny's influence on America, see Edward J. Sullivan, "Fortuny in America: His Collectors and Disciples," in *Fortuny: 1838–1874*, 102–16. Fortuny's loosely defined group of followers received its name from the fact that, although the members hailed from a number of nations, they generally congregated to paint in Italy, most often Rome. Of others often associated with the Roman School, José Villegas was Spanish; Attilio Simonetti was Italian; and Jean Georges Vibert was French. See W. R. Johnston, "Fortuny and His Circle," *Walters Art Gallery Bulletin*, supplement no. 2 (April 1970), n. p.

25. "The Fine Arts. The American Society of Painters in Water-Colors–Seventh Annual Exhibition," *New York Daily Tribune*, 29 January 1874, 4. See, for example, "The Water-Color Exhibition. The Progress of the Society. Some of the Pictures. Second Article," *New York Evening Post*, 17 February 1874, 1, and "Fine Arts. The Exhibition of the Society of Water-Color Painters," *New York Evening Mail*, 29 January 1874, 1.

26. See, for example, "The Water-Color Exhibition," *New York Times*, 29 January 1874, 8, and "Art Matters. The Water-Color Exhibition," *New York Evening Express*, 29 January 1874, 2.

27. *New York Times*, 29 January 1874, 8, offered general support of European art. The three artists were praised at the expense of others in *New York Daily Tribune*, 29 January 1874, 4; "Art Matters. American Society of Painters in Water Colors–Seventh Annual Exhibition," *New York Herald*, 29 January 1874, 7; "The Water-Color Exhibition. Last Evening at the Academy of Design," *New York Daily Graphic*, 29 January 1874, 600; and "Culture and Progress. American Water Colors," *Scribner's* 7 (April 1874): 760–61.

28. "Art Matters. The Water Color Exhibition," *New York Herald*, 28 January 1874, 4, and "The Water Color Exhibition," *New York World*, 5 February 1874, 4–5.

29. Foster, "Makers of the American Watercolor Movement," 48.

30. As it did for many of his peers, the 1873 watercolor show may have inspired Homer to investigate the medium at this moment. See Foster, "Makers of the American Watercolor Movement," 49–53. More recently, Jana Colacino has suggested Homer's attraction to watercolor was directly related to his engagement with the color theories of Michel Eugène Chevreul. (Jana Therese Colacino, "Winslow Homer Watercolors and the Color Theories of M. E. Chevreul," master's thesis, Syracuse University, 1994, 26–27.) Homer had shown a watercolor of a garden scene with a figure at the Century in November 1873. Perhaps positive responses in that forum encouraged him to bring the work to a larger audience. "Art at the Century," *New York Evening Post*, 3 November 1873, 2.

31. *Catalogue of the Seventh Annual Exhibition of the American Society of Painters in Water Colors*, exh. cat. (New York: privately printed, 1874), nos. 34, 40, 41, 45, 46. As each entry was titled in the plural, it suggests that multiple sheets were framed together for each one. "Fine Arts. The Water Color Exhibition," *New York Daily Tribune*, 14 February 1874, 7, indicated that ten sketches were on view.

32. "Art. The Water-Color Exhibition," *Aldine* 7 (May 1874): 107, remarked that all the subjects were of child-life, whereas *New York World*, 5 February 1874, 4–5, described the image of boys with a kitten.

33. "Fine Arts. Why the Exhibition of Water-Colors is Succeeding," *New York Evening Mail*, 18 February 1874, 1, and "Fine Arts and Music. National Academy of Design–The Forty-Ninth Annual Exhibition. Third Article," *New York Daily Tribune*, 13 April 1874, 7.

34. *New York Evening Mail*, 18 February 1874, 1. Also approving were "American Society of Painters in Water Colors. Seventh Annual Exhibition," *New York Evening Post*, 28 January 1874, 3; [Earl Shinn], "Notes," *Nation* 18 (12 March 1874): 172; *New York World*, 5 February 1874, 4–5; and *New York Daily Tribune*, 14 February 1874, 7. Even when criticized for being too realistic and for "violent contrasts of light and shadow," the watercolors were called remarkable. "Water-Color Paintings. Some of the Pictures Now on Exhibition at the Academy of Design," *New York Daily Graphic*, 7 February 1874, 663. "Vigor," "life," and "strength" were used, for example, in *New York World*, 5 February 1874, 4–5, and *New York Evening Mail*, 29 January 1874, 1. The use of adjectives associated with masculinity was pervasive in the responses to Homer's art in the seventies, as in other periods of his oeuvre.

35. *New York Evening Mail*, 18 February 1874, 1.

36. *New York Daily Tribune*, 14 February 1874, 7. [Shinn], *Nation*, 12 March 1874, 172, generally agreed with Cook, although he did wish for more finished pieces.

37. *New York Evening Mail*, 29 January 1874, 1.

38. Foster, "Makers of the American Watercolor Movement," 118–26. There were four Atlantic City marine subjects by Richards in the 1874 exhibition, all owned by George Whitney. Although its provenance is not known with absolute certainty, *A High Tide at Atlantic City* may well have been one of those sheets. The serenity of Richards's work was favorably compared to that found in the poems of William Cullen Bryant in "Art. The Water-Color Collection. Second Article," *Appleton's Journal* 11 (28 February 1874): 283–84, and "Fine Arts–Drama–Music. Fine Arts. The Water-Color Exhibition," *New York Daily Tribune*, 23 February 1874, 7.

39. For typical reactions to Bellows's work, see *New York Evening Post*, 17 February 1874, 1, and *New York Evening Mail*, 18 February 1874, 1. On the acceptance of delicateness in art, see "Art," *Atlantic* 32 (April 1874): 502–4.

40. The assigner of the title to Homer's sheets is unknown, but if Homer intentionally named them *Leaves from a Sketch Book*, it may have been as a way to emphasize their connection to the sketch genre, to which watercolor was most closely aligned and in which incompleteness was more easily accepted. Such a positioning of the work by Homer would indicate a particular cunning on the artist's part.

41. The energy and time that the work in watercolor must have taken between the summer of 1873 and early 1874 surely affected Homer's activity in oil. In some years, such as 1874, 1878, and 1879, concerted efforts in watercolor seem to have been responsible for a decrease in his production of oils. For example, he had created twenty-nine canvases in 1873, but only nineteen came from his hand in 1874.

42. See "The Academy of Design," *New York Times*, 9 April 1874, 4; "Fine Arts–Music–Drama. Fine Arts. National Academy of Design–Private View–Forty-Ninth Annual Exhibition," *New York Daily Tribune*, 9 April 1874, 4; and "The Spring Exhibition of the Academy of Design," *New York Herald*, 7 April 1874, 8. Homer's participation on the council is recorded in his attendance at the meetings of 23 March, 30 March, 6 April, 20 April, and 27 April, in the Minutes of the National Academy of Design Council, National Academy of Design Archives.

43. *School Time* measures 12 ½ x 19 ¼ inches. *Dad's Coming* measures 9 x 13 ¾ inches. *Girl in a Hammock*, described in "Fine Arts. The Academy Exhibition," *New York Times*, 6 April 1874, 2, as "a girl in leafy Summertime reading in a hammock swung among the trees," is most likely the Cooper-Hewitt's canvas entitled *Sunlight and Shadow*, which measures 15 ¹³⁄₁₆ x 22 ¹¹⁄₁₆ inches and is therefore the largest of the three works. It is harder to precisely identify *Sunday Morning*. It could be the painting known today as *In the Hammock* (private collection), which measures 13 ¼ x 19 ¾ inches.

44. *A Temperance Meeting*, at 20 ⅛ x 30 ⅛ inches, was significantly larger than the works Homer sent to the Academy. It is not known whether the painting sold. The collection at Leavitt's was the inventory of dealer Rufus Moore. "City Intelligence. Leavitt Art Rooms. Paintings by American Artists," *New York Evening Post*, 6 March 1874, 1.

45. See, for example, "Cabinet Pictures at Leavitt's," *New York World*, 6 March 1874, 5. Later in the year, *Gloucester Harbor* did sell for sixty-two dollars, the highest price listed in the report from the auction at Mathews Art Gallery. "The Sale of Paintings," *New York Evening Mail*, 19 December 1874, 4.

46. The exhibition was covered by at least ten newspapers and six magazines. It is not known if the *Express* reviewed the show, since microfilm reels available lacked the months during which the exhibition was held. Such positive notices appeared for example, in "National Academy of Design. Reception and Private View To-Night," *New York Evening Post*, 8 April 1874, 2; "Art at the Academy," *New York Evening Telegram*, 11 April 1874, 1; "The Academy Exhibition," *New York World*, 9 April 1874, 4; and *New York Times*, 6 April 1874, 2. In no review was there a truly dissenting voice.

47. The *Mail* was the only paper that truly disliked the painting, although others were critical of particular aspects. "Fine Arts. The Exhibition at the Academy of Design," *New York Evening Mail*, 25 April 1874, 1. Clarence Cook questioned the canvas's placement, not because he did not like the painting, but because he preferred some of the American pictures. "Fine Arts. National Academy of Design. Forty-Ninth Annual Exhibition. Second Article," *New York Daily Tribune*, 11 April 1874, 7. For the *Herald*, the central installation of *Lost* was praised because it did not pander to either the Academy's or the public's opinion, and was hung there simply as the best picture in the most honored place regardless of its country of origin. "The Academy of Design. Some of the Gems of the Present Exhibition," *New York Herald*, 20 April 1874, 3.

48. The hanging committee was composed of artists for whom careful drawing and execution in paint were important aspects of their own work. Both Irving and Brandt had studied in Düsseldorf. *New York Daily Tribune*, 9 April 1874, 4; "Culture and Progress. The Academy Exhibition," *Scribner's* 8 (June 1874): 245; "Art. The Academy Exhibition," *Appleton's Journal* 11 (25 April 1874): 540; and *New York Times*, 9 April 1874, 4.

49. "Fine Arts. Annual Exhibition of the National Academy of Design," *New York Daily Graphic*, 9 April 1874, 290; *New York Times*, 9 April 1874, 4; and "The New Departure at the National Academy," *New York Evening Mail*, 9 April 1874, 2.

50. See, for example, "Fine Arts-Music. Fine Arts. National Academy of Design–Forty-Ninth Annual Exhibition. Fifth Article," *New York Daily Tribune*, 24 April 1874, 5; "Art. Composition Pictures at the Academy," *Appleton's Journal* 11 (16 May 1874): 636; and "National Academy of Design," *New York Evening Post*, 4 May 1874, 1.

51. *New York Daily Graphic*, 9 April 1874, 290; "Art Matters. The Spring Exhibition at the Academy of Design," *New York Herald*, 9 April 1874, 6; *New York Daily Tribune*, 11 April 1874, 7.

52. "Fine Arts. The Academy of Design," *New York Times*, 13 April 1874, 5; *New York Herald*, 20 April 1874, 3; *New York Evening Post*, 8 April 1874, 2; *New York Evening Mail*, 9 April 1974, 2; and *New York Evening Telegram*, 11 April 1874, 1. John Davis discusses the responses to the painting in relation to its location in Church's career in *Landscape of Belief: Encountering the Holy Land in Nineteenth Century American Art and Culture* (Princeton, N.J.: Princeton University Press, 1996), 194–96.

53. "Fine Arts. The Exhibition at the Academy of Design," *New York Sun*, 15 April 1874, 2; [Earl Shinn], "Fine Arts. The National Academy Exhibition. II," *Nation* 18 (14 May 1874): 320–22; and "National Academy of Design. Second Article. Forty-Ninth Annual Exhibition," *New York World*, 27 April 1874, 5.

54. *New York Evening Post*, 4 May 1874, 1; "Fine Arts–Music–Drama. Fine Arts. National Academy of Design Forty-Ninth Annual Exhibition. Fourth Article," *New York Daily Tribune*, 18 April 1874, 6; "Fine Arts. The Academy Exhibition. Second Notice," *New York Times*, 19 April 1874, 4; and "Fine Arts. The Exhibition at the National Academy," *New York Evening Mail*, 17 April 1874, 1. "The Exhibition. Some of the Notable Pictures," *New York Evening Mail*, 10 April 1874, 1, and *New York Evening Mail*, 17 April 1874, 1, praised Guy's canvas as the ultimate in novel conception and talent in execution. The most critical reactions can be found in *New York Daily Tribune*, 18 April 1874, 6, and "National Academy of Design. [First Article.] Forty-Ninth Annual Exhibition," *New York World*, 19 April 1874, 2.

55. Eastman Johnson also exhibited what were considered less significant works, but his *Prisoner of State* (location unknown), *Bo-Peep* (private collection), and *Tea Party* (private collection) received considerably more attention than did Homer's work.

56. "Exhibition of the National Academy of Design. IV," *Watson's Art Journal* 21 (13 June 1874): 1.

57. *New York Evening Post*, 4 May 1874, 1, and *New York World*, 19 April 1874, 2.

58. *New York Daily Tribune*, 13 April 1874, 7.

59. *New York Times*, 6 April 1874, 2.

60. *New York Times*, 19 April 1874, 4. A similarly positive response to *Sunday Morning* appeared in [Shinn], "Fine Arts. The National Academy Exhibition. I," *Nation* 18 (7 May 1874): 304–5.

61. Linda Ayres, "Lawson Valentine, Houghton Farm, and Winslow Homer," in Wilmerding and Ayres, *Winslow Homer in the 1870s*, 19.

62. Homer was reported back from the Adirondacks in "Art Notes," *New York Daily Graphic*, 19 June 1874, 835. See also

Tatham, *Winslow Homer in the Adirondacks*, 49.

63. An October 1874 photograph pictures all four men, along with others. Tatham, *Winslow Homer in the Adirondacks*, 60.

64. The reports of Homer's stay on Long Island can be found in "Art Notes," *New York Evening Post*, 25 July 1874, 2, and "Movements of Artists," *Watson's Art Journal* 21 (1 August 1874): 142.

65. *New York Evening Post*, 25 July 1874, 2, and "Art Matters. Studio Gossip," *New York Evening Express*, 31 October 1874, 1.

NOTES TO CHAPTER 4

1. Nicolai Cikovsky, Jr., "Reconstruction," in Cikvosky and Kelly, *Winslow Homer*, 98.

2. On the upheavals as Reconstruction policies shifted from hopeful solutions to actual disasters, see Foner, *Reconstruction*, especially chaps. 8–11, 346–559.

3. John Ferguson Weir recollected that Homer, when employed by *Harper's Weekly*, "struggled to get out of it to take up more important work." Theodore Sizer, ed., *The Recollections of John Ferguson Weir* (New Haven, Conn.: Yale University Press, 1957), 46. Over the next decade Homer created images that were published as illustrations, but they were only occasional excursions. See Tatham, *Winslow Homer and the Illustrated Book*, 300–301. See also Cikovsky, "Reconstruction," in Cikvosky and Kelly, *Winslow Homer*, 97–98. While the possibility for financial gain has been suggested as an impetus for Homer's interest in watercolor and as a reason for his quitting illustration work in 1875, it was only a possibility and not a fact at this stage in his career. As a writer noted that year: "Even now water-color pictures are far from being appreciated as they deserve." ("The Fine Arts. Exhibition of the American Society of Painters in Water Colors," *New York Times*, 31 January 1875, 7.)

4. The works shown included entries titled: *A Pot Fisherman*; *A Fisherman's Daughter* (now known as *Girls with Lobster*; fig. 59); *On the Fence* (possibly fig. 51); *Fly Fishing*; *A Clam-Bake* (fig. 48); *Why Don't the Suckers Bite?* (now known as *Waiting for a Bite*; fig. 49); *Pull Him In!*; *Cow Boys*; *The Bazaar Book of Decorum*; *Good Morning*; *A Farm Wagon* (private collection); *Green Apples*; *On the Sands*; *Riding at Anchor* (possibly *Boy with Anchor*; The Cleveland Museum of Art); *What Is It?* (private collection); *The Changing Basket*; *Another Girl*; *The Thaddeus of Warsaw*; *Skirting the Wheat*; *A Lazy Day*; *The City of Gloucester*; *An Oil Prince*; *Adirondack Guides*; *In Charge of Baby* (fig. 50); *A Basket of Clams* (fig. 57); *How Many Eggs?* (fig. 58); *The Sick Chicken* (fig. 56); *Idle Hours*; and seven sheets, each titled *Sketch–In Black and White*. The whereabouts of those listed without locations are unknown.

5. Eight of the eleven newspapers that reviewed the exhibition published series of three or more articles. The *Commercial Advertiser* was the only major daily paper that did not cover the show. Even magazines, notably the *Nation* and *Appleton's*, had multiple reviews. The appearance of the New York edition of the *Art Journal* brought not only another voice to the exhibition reviews, but an influx of many monographic and well-illustrated art articles of American and European artists.

6. See, for example, "The Water-Color Exhibition. Progress of the Society–Some of the Pictures. Second Article," *New York Evening Post*, 10 February 1875, 1; "American Water Colors," *New York Times*, 21 February 1875, 6; and "Fine Arts," *New York Independent*, 4 February 1875, 6. The single dissenting voice came from William Brownell in the *World*, whose criticism of the show centered on the fact that it was an exhibit not strictly of the members of the Watercolor Society, and that artist-members had contributed only a small percentage of the works. Brownell was angry also because works from private collections and, especially, foreign works were included. These concerns seem to arise from his sympathy with those trying to survive as artists in New York City, many of whom were friends. His complaints about the show are peppered throughout the series of reviews. See "The Water-Color Exhibition. First Notice," *New York World*, 8 February 1875, 5; "The Water-Color Exhibition. Second Notice," *New York World*, 15 February 1875, 5; and "A Last Word with The Water-Colorists," *New York World*, 27 February 1875, 5–6.

7. These factors were mentioned in "Art and Artists. The Progress Made in Painting in Water Colors. The Water Color Exhibition at the Academy," *New York Evening Telegram*, 1 February 1875, 4; "Fine Arts. Close of the Exhibition of the American Water Color Society," *New York Daily Tribune*, 1 March 1875, 7; and "Water Color Exhibitions," *New York Herald*, 14 February 1875, 8. "The Fine Arts. The Water-Color Exhibition–Concluding Notice," *New York Times*, 14 February 1875, 5, and "Art Matters. The Water-Color Exhibition. First Article," *New York Evening Express*, 6 February 1875, 1, noted that watercolor could no longer be ignored.

8. "Fine Arts. The Water-Color Exhibition," *New York Evening Mail*, 16 February 1875, 1, identified figure painting as the key to the show's success. Welcoming the new watercolorists were: *New York Evening Post*, 10 February 1875, 1; "The Fine Arts. American Society of Painters in Water Colors. The Eighth Annual Exhibition at the Academy of Design–Notices of the Principal Works," *New York Times*, 7 February 1875, 9; and "The Arts. The Water-Color Exhibition," *Appleton's Journal* 13 (13 February 1875): 216.

9. "American Society of Painters in Water-Colours," *Art Journal* 1 (March 1875): 91–92.

10. *New York World*, 8 February 1875, 5, and "Fine Arts," *New York Independent*, 11 February 1875, 6–7.

11. "Fine Arts. American Society of Painters in Water Colors–Eighth Annual Exhibition–Private View," *New York Daily Tribune*, 1 February 1875, 7; *Art Journal* 1 (March 1875), 91–92; "The Water-Color Exhibition," *New York Evening Post*, 23 February 1875, 1.

12. *New York Evening Post*, 10 February 1875, 1; "The Water Color Exhibition," *New York Herald*, 10 February 1875, 6; and "The Arts. The Water-Color Exhibition. Second Paper," *Appleton's Journal* 13 (20 February 1875): 247–48. Only the group of American landscapes were seen as good enough to compete with or surpass the Europeans. "Culture and Progress. Eighth Exhibition of the Water-Color Society," *Scribner's* 9 (April 1875): 762–64, saw the American landscapes as the best work overall; [Earl Shinn], "Fine Arts. The Water-Color Exhibition–Loan Exhibition of the Union League," *Nation* 20 (4 February 1875): 84; *Art Journal* 1 (March 1875): 91-92; and *New York Evening Post*, 10 February 1875, 1, picked out the landscape work as the strongest competition for the Europeans.

13. Gouache, most often called body color in the nineteenth century, mixed pigment with white as well as water, making the medium opaque. Transparency in watercolor is achieved by adding only water to pure pigments. Linda and Peter Murray, *A Dictionary of Art and Artists* (Baltimore: Penguin Books, 1968), 50, 437–38.

14. Such qualities were admired by, among others, "Fine Arts. The Opening of the Water-Color Exhibition," *New York Evening Mail*, 30 January 1875, 1; and *New York Times*, 31 January 1875, 7; "Painter in Water-Colors," *New York Evening Express*, 1 February 1875, 4; *New York Evening Telegram*, 1 February 1875, 4; and *Appleton's Journal*, 20 February 1875, 247–48. In

a number of cases, the preference for transparency was expressed as the condemnation of bodycolor or praise for its absence. Such was the case in *New York Herald*, 10 February 1875, 6; "Fine Arts. The Water-Color Exhibition," *New York Sun*, 10 February 1875, 2; and *New York Evening Mail*, 30 January 1875, 1.

15. Henry James, Jr., "On Some Pictures Lately Exhibited," *Galaxy* 20 (July 1875): 91–92. The watercolors of the Spanish-Italian artists James used as his reference point were not only those in the Watercolor Society show, but also ones that were on view simultaneously at Goupil's Gallery.

16. "Fine Arts. The American Society of Painters in Water Colors–Eighth Annual Exhibition," *New York Daily Tribune*, 22 February 1875, 5. A similar viewpoint was expressed in *New York World*, 15 February 1875, 5, and *New York World*, 27 February 1875, 5–6.

17. "Art," *Atlantic* 35 (April 1875): 508–9. The interest in conjoining beauty and truth followed the underlying philosophy of Matthew Arnold's writings, which were becoming increasingly popular at this time. On Matthew Arnold in America, see John Henry Raleigh, *Matthew Arnold and American Culture* (Berkeley: University of California Press, 1957). For succinct statements of Arnold's philosophy, see especially pp. 23 and 31. Influencing, too, the *Atlantic*'s viewpoint may have been the desire in the 1870s for assimilation on multiple fronts in American culture and society. See John Higham, *Strangers in the Land: Patterns of American Nativism, 1860–1925* (New Brunswick, N.J.: Rutgers University Press, 1955), 19–21.

18. "Art Notes," *New York Herald*, 15 February 1875, 5; Erastus South, "Fine Arts. The Water Colors at the Academy–The Lotus Club Monthly Art Reception," *New York Daily Graphic*, 2 February 1875, 672; *New York World*, 15 February 1875, 5; *New York Evening Telegram*, 1 February 1875, 4; and *Scribner's*, April 1875, 764.

19. *New York Daily Tribune*, 22 February 1875, 5.

20. Ibid.

21. Ibid. *New York World*, 15 February 1875, 5, and "Fine Arts. The Water-Color Exhibition," *New York Evening Mail*, 22 February 1875, 1, generally agreed with Cook.

22. Ibid. The watercolor is described quite fully in *New York Evening Post*, 10 February 1875, and it matches in reverse Scott's illustration in "Turkey Shooting," *Harper's Weekly* 18 (17 January 1874): 60

(see fig. 53). It seems to have resembled a colored drawing and did not make use of transparent washes as the vehicle of description.

23. *New York Daily Tribune*, 22 February 1875, 5.

24. *New York Evening Express*, 6 February 1875, 1.

25. See, for example, *New York Sun*, 10 February 1875, 2, and James, *Galaxy*, July 1875, 91.

26. *Appleton's Journal*, 13 February 1875, 216; *New York Times*, 7 February 1875, 9; and *New York Times*, 14 February 1875, 5. As Lesley Wright has pointed out, the positive reactions the works elicited were, in part, likely due to the warm sentiment such scenes conjured for the artist, patron, and critic alike. Wright has discussed how such images were tied to a construct of beliefs and values shared by those most likely to come in contact with Homer's work. Wright, "Men Making Meaning," 17–18 and passim.

27. *Art Journal*, March 1875, 92. A similar viewpoint is expressed in *New York Independent*, 11 February 1875, 6–7.

28. [Earl Shinn], "Fine Arts. The Water-Color Society's Exhibition. II," *Nation* 20 (18 February 1875): 119. A similar viewpoint is found in *Atlantic*, April 1875, 508. It is worthwhile noting that Lucy Hooper commented similarly about the work of Edouard Manet in the Paris Salon. She noted that his figures looked "cut out of sheet-tin." Lucy Hooper, "Fine Arts. The Salon of 1874," *Appleton's Journal* 11 (20 June 1874): 796.

29. "Fine Arts. The Water-Color Exhibition," *New York Evening Mail*, 10 February 1875, 1.

30. Such reasons for praise were offered, for example, in "National Academy of Design. Opening of the Fiftieth Annual Exhibition," *New York Evening Post*, 7 April 1875, 2; "The Academy Exhibition," *New York Daily Graphic*, 10 April 1875, 303; [Earl Shinn], "Fine Arts. Fiftieth Annual Exhibition of the Academy of Design. I," *Nation* 20 (15 April 1875): 264–65; and "The National Academy of Design," *Art Journal* 1 (May 1875): 155–58. The *Times* was the only paper truly dissatisfied with the entire show. "The Fine Arts. Exhibition of the Academy of Design," *New York Times*, 10 April 1875, 3. Some writers chose to remain noncommittal, and instead focused their remarks on individual artists or aspects of the exhibition. See, for example, "The Arts," *Appleton's Journal* 13 (24 April 1875): 534–36; and C.L.N., "Fine

Art. The National Academy at New York," *Old and New* 11 (May 1875): 617–19.

31. "Art Matters. Academy of Design–The Fiftieth Annual Exhibition," *New York Evening Express*, 8 April 1875, 2; "Academy of Design. Opening of the Fiftieth Annual Exhibition," *New York Herald*, 8 April 1875, 12; and "The Fine Arts. The Exhibition at the Academy of Design. Second Notice," *New York Times*, 17 April 1875, 3. Some complained that the rule was not evenly applied. In fact, Homer's entry *Uncle Ned* had been exhibited at the Century in January 1874. A listing of some of the works already shown appeared in "The Academy and the Clubs," *New York Daily Tribune*, 10 April 1875, 2. "Fine Arts. The National Academy of Design–Fiftieth Annual Exhibition–Private View," *New York Daily Tribune*, 9 April 1875, 7, was clear that it was the Academy that was in a rut and not the whole of American art, which it felt was not adequately represented, due, in part, to the rule.

32. "Fine Arts. Private Views of the Academy of Design," *New York Sun*, 9 April 1875, 2.

33. "Fine Arts. The National Academy of Design. Fiftieth Annual Exhibition. Third Notice," *New York Daily Tribune*, 29 April 1875, 7.

34. The younger men were praised as a group in "The Spring Exhibition. Varnishing Day at the Academy of Design," *New York World*, 7 April 1875, 2; *New York Herald*, 8 April 1875, 12; [Earl Shinn], "Fine Arts. Fiftieth Exhibition of the Academy of Design. II," *Nation* 20 (22 April 1875): 281–82; "Culture and Progress. The Academy of Design," *Scribner's* 10 (June 1875): 251–52; *New York Daily Tribune*, 9 April 1875, 7; "The National Academy of Design," *New York Evening Express*, 28 May 1875, 1; and *New York World*, 15 May 1875, 4–5. Only *Appleton's* pointed out the need to respect the older artists, reminding its readers that the older generation should not be spoken of lightly and that they deserved gratitude for their accomplishments. *Appleton's Journal*, 24 April 1875, 534–35.

35. Homer, in fact, was singled out by the *Daily Graphic* as an example of how critics treated artists of reputation unfairly. The incident to which it referred was the cruel treatment he received from the critic of the *World*, but it was used as indicative of a larger issue–the lack of critical standards for art. "Fine Arts. A Word for the Painters," *New York Daily Graphic*, 15 May 1875, 571, and "The National Academy of Design. Second Notice," *New York World*, 15 May 1875, 4–5.

36. [Shinn], *Nation*, 22 April 1875, 281–82. Among those concurring were *New York Herald*, 8 April 1875, 12, and "Fine Arts," *New York Independent*, 29 April 1875, 6.

37. S.N.C. [Susan Nichols Carter], "The Academy Exhibition. I. The Portraits and Fancy Heads," *New York Evening Post*, 17 April 1875, 1, and *New York Daily Tribune*, 29 April 1875, 7. The *Tribune* critic, believing that American art should represent national cultural accomplishment, also was bothered that those trained abroad were noticed to the exclusion of home artists. *New York Daily Tribune*, 9 April 1874, 7. *Art Journal*, May 1875, 158, had nothing good to say about the Munich students.

38. James, *Galaxy*, July 1875, 94–95.

39. S.N.C. [Susan Nichols Carter], *New York Evening Post*, 17 April 1875, 1.

40. *New York Evening Express*, 8 April 1875, 2; *New York Herald*, 8 April 1875, 12; S.N.C. [Susan Nichols Carter], *New York Evening Post*, 17 April 1875, 1; *New York World*, 15 May 1875, 4–5; and "The Fine Arts. New Pictures and Where They May Be Seen. The Academy Exhibitions," *New York Times*, 25 April 1875, 10.

41. On Americans in Munich, see Quick and Ruhmer, *Munich and American Realism in the Nineteenth Century*, and Katharina Bott and Gerhard Bott, eds., *ViceVersa: deutsche Maler in Amerika, amerkanische Maler in Deutschland, 1813–1913*, exh. cat. (Munich: Hirmer Verlag, 1996).

42. *Art Journal*, May 1875, 157; [Shinn], *Nation*, 22 April 1875, 281–82; "Fine Arts. A Glimpse of the Pictures at the Academy of Design. Second Article," *New York Daily Graphic*, 16 April 1875, 347; and *New York Times*, 10 April 1875, 3.

43. [Shinn], *Nation*, 22 April 1875, 282.

44. *Art Journal*, May 1875, 156; *New York Times*, 10 April 1875, 3; and *New York Daily Graphic*, 16 April 1875, 347.

45. *New York Daily Tribune*, 29 April 1875, 7.

46. *New York Evening Express*, 28 May 1875, 1.

47. *The Course of True Love* is unlocated today. At the time of the 1875 Academy show it was owned by John H. Sherman.

48. Twelve of the sixteen reviewing serials commented on his work. Although a high percentage of the reviewing periodicals gave him in-depth coverage, the most glaring omission, and perhaps most devastat-ing to the artist, was the lack of a single utterance from the usually expansive *Tribune*. Four sequential reviews in that paper cover the show quite thoroughly and include most of the important home and genre painters. See *New York Daily Tribune*, 9 April 1875, 7; "Fine Arts. National Academy of Design. Fiftieth Annual Exhibition. Second Notice," *New York Daily Tribune*, 26 April 1875, 7; *New York Daily Tribune*, 29 April 1875, 7; and "Fine Arts. National Academy of Design–Fiftieth Annual Exhibition. Fourth Notice," *New York Daily Tribune*, 1 May 1875, 2.

49. [Shinn], *Nation*, 15 April 1875, 265.

50. "The Arts," *Appleton's Journal* 13 (8 May 1875): 599; James, *Galaxy*, July 1875, 90; and *Scribner's*, June 1875, 251.

51. "Studio Notes," *New York World*, 22 March 1875, 5, described *Landscape* as: "[a]nother farm-yard scene, with green grass, a haystack and horse, and boys on the grass with sunlight lying about them."

52. The most complete description of the painting is found in *Appleton's Journal*, 8 May 1875, 599–600. *New York Daily Graphic*, 16 April 1875, 347, described the woman in *The Course of True Love* as the same one in *Milking Time*.

53. *Appleton's Journal*, 8 May 1875, 599.

54. Lesley Wright has investigated how such subjects, which created "paragraph pictures" and conjoined nostalgia, contemporary life issues, and basic human sentiment, connected to their viewers. See Wright, "Men Making Meaning," 8, 78, 110–28. More recently, Roger Stein has surveyed some of the meanings of New England settings in "After the War: Constructing a Rural Past," in William H. Truettner and Roger B. Stein, eds., *Picturing Old New England: Image and Memory*, exh. cat. (Washington, D.C.: National Museum of American Art, 1999), 15–41.

55. See, for example, "Changes in Population," *Harper's New Monthly Magazine* 38 (February 1869): 386–92, and "The Decay of New England," *Nation* 8 (27 May 1869): 410–11. For a recent overview of the shifts New England experienced right after the Civil War, see Dona Brown and Stephen Nissenbaum, "Changing New England," in *Picturing Old New England*, 1–13.

56. An additional factor noted as contributing to this state of affairs was that young women increasingly preferred to make the shift from the custody of their parents to their husband without a loss of social or financial status. See, for example, "Why Is Single Life Becoming More General?"

Nation 6 (5 March 1868): 190–91. The *Galaxy* was particularly focused on marriage and women's issues. See, for example, Albert Rhodes, "The Coming Marriage," *Galaxy* 16 (September 1873): 293–304, which included all kinds of American marriage statistics and the effects of marriage on American life, and Albert Rhodes, "The Marriage Question," *Galaxy* 20 (December 1875): 756–67. Over several years, Junius Henri Browne published a series about women, exploring their qualities, rights, and place in American society. Perhaps most germane to *The Course of True Love* was "Women as Tacticians," *Galaxy* 16 (November 1873): 662–70.

57. On this topic in general, see Sarah Burns, *Pastoral Inventions*, 216–22 and passim.

58. As with *The Country School*, descriptions of *The Course of True Love* were injected with varying degrees of humor and romance, depending on the writer. See, for example, "The National Academy of Design. A Half-Century of American Painting," *New York Sun*, 21 April 1875, 2; [Shinn], *Nation*, 15 April 1875, 265; *New York Times*, 10 April 1875, 3; *New York Times*, 25 April 1875, 10; and *Appleton's Journal*, 8 May 1875, 599. "Art Notes," *New York Evening Mail*, 5 November 1874, 1, reviewed the work in Homer's studio.

59. "Topics of the Time. About an American School of Art," *Scribner's* 10 (July 1875): 380. A similar viewpoint appeared in S.N.C. [Susan Nichols Carter], "The Academy Exhibition. III. Genre and Fancy Pictures," *New York Evening Post*, 1 May 1875, 1.

60. *New York Daily Tribune*, 29 April 1875, 7, for example, concurred with S.N.C. [Susan Nichols Carter], *New York Evening Post*, 1 May 1875, 1, in this regard.

61. James, *Galaxy*, July 1875, 93–94.

62. See Viola Hopkins Winner, *Henry James and the Visual Arts* (Charlottesville: University Press of Virginia, 1970), 22–30. A similar aim for art was outlined by the *Independent*: "It is the special aim of all art to excite the passions, rather than to convince the reason. Art is emotional not logical. Its chief aim is to fasten upon the human sympathies by a direct appeal to the senses, and not to fetter or captivate the reason by an argument." "Fine Arts," *New York Independent*, 13 May 1875, 5.

63. [Shinn], *Nation*, 15 April 1875, 265. Shinn saw in Homer's figure a young rustic akin to James Russell Lowell's Hosea Biglow of *The Biglow Papers*, a representative of "homely common sense" and driven by his conscience. On Hosea Biglow, see Richmond Croom Beatty, *James Russell*

Lowell (Nashville: Vanderbilt University Press, 1942), 75–76. Others praising *The Course of True Love*'s treatment were *New York Daily Graphic*, 10 April 1875, 303, and *Appleton's Journal*, 8 May 1875, 599.

64. [Shinn], "Fine Arts. Fiftieth Exhibition of the Academy of Design. IV," *Nation* 20 (20 May 1875): 352.

65. *Scribner's*, June 1875, 252, and *New York World*, 15 May 1875, 4–5.

66. *New York World*, 15 May 1875, 4–5.

67. *New York Times*, 25 April 1875, 10.

68. *New York Sun*, 21 April 1875, 2.

69. [Shinn], *Nation*, 15 April 1875, 265.

70. James, *Galaxy*, July 1875, 93–94.

71. Ibid.

72. [Shinn], *Nation*, 22 April 1875, 282, and James, *Galaxy*, July 1875, 90–91. Similar remarks were made in *New York Times*, 10 April 1875, 3, and *New York Daily Graphic*, 16 April 1875, 347.

73. *New York Evening Express*, 28 May 1875, 1.

74. *Milking Time* has undergone a number of restoration treatments over the years, some of which have somewhat compromised the surface of the painting. Thus, it is difficult today to fully assess the original visual impact of the sky and light.

75. *Appleton's Journal*, 8 May 1875, 599. *New York Evening Mail*, 5 November 1874, 1, expressed a similar reaction.

76. *New York World*, 15 May 1875, 4–5.

77. *Scribner's*, June 1875, 251–52.

78. *Art Journal*, May 1875, 155–58.

79. *New York Sun*, 21 April 1875, 2.

80. "The Century Club," *New York Evening Post*, 12 January 1874, 4, and [Shinn], *Nation*, 15 April 1875, 265.

81. *Landscape* was not discussed beyond a cursory mention of its existence. The only qualitative remark came from the *Daily Graphic*, which noted it had few of the excellent points usually found in Homer's painting. *New York Daily Graphic*, 16 April 1875, 347.

1. "Fine Arts," *New York Independent*, 6 January 1876, 8.

2. Morris, *Encyclopedia of American History*, 252

3. See, for example, "The Fine Arts. Private View of the Exhibition of the Society of Painters in Water Colors," *New York Times*, 30 January 1876, 6; "Fine Arts. Ninth Annual Exhibition of the Water-Color Society–Private View," *New York Daily Tribune*, 31 January 1876, 5; and Waterloo, "Art Notes. The Ninth Annual Exhibition of the American Society in Water Colors at the Academy of Design," *New York Evening Express*, 31 January 1876, 1.

4. This viewpoint was especially apparent in "A Glance into the Water Color Exhibition," *New York Evening Mail*, 31 January 1876, 2; *New York Times*, 30 January 1876, 6; "Art Matters. The American Society of Painters in Watercolor," *New York Evening Telegram*, 3 February 1876, 3; and "The Water-Color Exhibition," *New York Daily Tribune*, 19 February 1876, 7. Only the *Independent*, which, like its peers, praised the progress of American watercolor, found the comparison of foreign to American work coming down on the side of the Europeans. "Fine Arts. Exhibition of Paintings in Water Colors," *New York Independent*, 10 February 1876, 7.

5. Notable for its dissent on this topic was *Scribner's*, which found Fortuny and his followers too imitative of each other and suffering from a "secret sterility of the imagination." "Culture and Progress. Ninth Exhibition of the Water Color Society," *Scribner's* 11 (April 1876): 902.

6. "The Fine Arts. Exhibition of Water Colors. Second Notice of the Collection at the Academy of Design," *New York Times*, 13 February 1876, 10. See also, "Art Notes. The American Society of Painters in Water Colors," *New York Evening Express*, 17 February 1876, 1.

7. On Reconstruction, especially its failure in 1877, see Foner, *Reconstruction*, esp. chaps. 3, 4, 8, 10–12, and epilogue.

8. *New York Evening Telegram*, 3 February 1876, 3.

9. They were: *After the Bath*; *The Busy Bee* (fig. 70); *A Chimney Corner*; *Contraband* (fig. 71); *Fiction* (fig. 68); *A Fish Story* (private collection); *A Flower for the Teacher* (fig. 73); *Furling the Jib* (fig. 69); *The Gardener's Daughter*; *A Glimpse from a Railroad Train*; *A Penny for Your Thoughts*; *Poor Luck*; *Study*; and *Too Thoughtful for Her Years*. The whereabouts of those not

illustrated or listed without locations are unknown.

10. "Fine Arts. The Exhibition of the American Society of Painters in Water Colors," *New York Evening Mail*, 24 February 1876, 1.

11. The subjects of *After the Bath*; *A Chimney Corner*; *A Penny for Your Thoughts*; *Study*; and *Poor Luck* are unknown.

12. Some of the watercolors in this show had garnered notice as soon as Homer had returned from his 1875 summer travels. On a studio visit in early November, the *Herald* noted that Homer had made many watercolor studies and described *A Flower for the Teacher* as well as one of a "young lady standing in a grove." (*New York Herald*, 6 November 1875, 5.) In other advance notices, *The Gardener's Daughter* was especially singled out as an important work. "Studio Notes," *New York World*, 18 January 1876, 5, and "Art Matters. Studio News and Gossip," *New York Evening Express*, 24 January 1876, 1.

13. The *Tribune* noted that watercolors were appearing in much larger scale and scope than ever imaginable ten years earlier. "Fine Arts. The Water-Color Exhibition," *New York Daily Tribune*, 12 February 1876, 6–7.

14. Abbey, a newcomer on the watercolor scene, was represented by *The Stage Office* (location unknown), a scene in an old-fashioned stage office waiting room where a woman was being eyed by a man at the far end of the room. The watercolor is described in *New York Evening Telegram*, 3 February 1876, 3. Alfred Bellows and William Magrath also continued to be popular for their picturesque scenes, while James Craig Nicoll and Alfred T. Bricher received positive notice for their marines– all works with a considerable degree of surface finish. For example, see "The Fine Arts. Exhibition of Water Colors," *New York Times*, 6 February 1876, 10; "The Water-Colour Exhibition, New York," *The Art Journal* 2 (March 1876): 92–93; "Fine Arts. The Exhibition of Water Colors. Third Notice," *New York Evening Mail*, 11 February 1876, 1; and "The American Society of Painters in Water Colors," *New York Evening Post*, 29 January 1876, 4.

15. [Earl Shinn], "Fine Arts. Ninth Exhibition of the Water-Color Society," *Nation* 22 (17 February 1876): 120.

16. Ibid.

17. Ibid.

18. *New York Times*, 13 February 1876, 10;

New York Times, 6 February 1876, 10; and Erastus South, "The Water-Color Exhibition. A Glance at the Work of our Prominent Artists," *New York Daily Graphic*, 3 February 1876, 734.

19. *Art Journal*, March 1876, 92–93.

20. South, *New York Daily Graphic*, 3 February 1876, 734.

21. *New York Daily Tribune*, 31 January 1876, 5.

22. *New York Daily Tribune*, 19 February 1876, 7.

23. "Fine Art. The Ninth Exhibition of the Water Color Society," *New York Evening Mail*, 7 February 1876, 1.

24. Ibid.

25. *New York Daily Tribune*, 19 February 1876, 7.

26. It should be noted that Cook thought that the subject of *A Glimpse from a Railroad Train*–white boys swimming in a pond–was equally as bad. However, his criticism of that sheet had no derogatory overtones. Weiss, "Clarence Cook," 104, touches on this issue.

27. Among those praising his choice of African-American subjects were [Shinn], *Nation*, 17 February 1876, 120; "The Arts. The Water-Color Exhibition. Second Notice," *Appleton's Journal* 15 (19 February 1876): 251; South, *New York Daily Graphic*, 3 February 1876, 734; and *New York Times*, 13 February 1876, 10.

28. While it has been suggested, a trip to the South by Homer in 1875 has never been proven. For an overview of the scholarly treatment of this question, see Wood and Dalton, *Winslow Homer's Images of Blacks*, 66–67, 119. Homer's subjects were likely found in the Catskills or Long Island, where he had spent parts of the previous two summers. Both Mary Ann Calo and Abigail Booth Gerdts have outlined the possibilities of location for these works in Mary Ann Calo, "Winslow Homer's Visits to Virginia During Reconstruction," *American Art Journal* 12 (winter 1980): especially 10–20, and [Abigail Gerdts], entry for *Uncle Ned at Home* in *Important American Paintings, Drawings and Sculpture of the Nineteenth and Twentieth Centuries*, Christie's, 26 May 1993, lot 19.

29. Patricia Hills has recently explored the impact of incorporating freed slaves into society on Eastman Johnson's art in the late 1860s in "Painting Race: Eastman Johnson's Pictures of Slaves, Ex-Slaves and

Freedmen," in Carbone and Hills, *Eastman Johnson*, 1999, 121–27.

30. See, for example, *Art Journal*, March 1876, 93, and *Appleton's Journal*, 19 February 1876, 250–52. Peter Wood and Karen Dalton have outlined the serious issues at large in Homer's watercolors of African-American youth. See Wood and Dalton, *Winslow Homer's Images of Blacks*, 72–82.

31. [Shinn], *Nation*, 17 February 1876, 120.

32. Although the importance of the oil canvas was well remembered, the *Independent* mistakenly titled it *Prisoners to the Rear*. *New York Independent*, 10 February 1876, 7.

33. The most noticeable absence was a review from the *World*. That paper's art coverage was less frequent than usual in the spring of 1876, and what did appear was frequently from correspondents outside of New York. It is not known if William Brownell was absent from New York or not writing for some other reason (such as illness), but the lack of art articles suggests this could have been the case.

34. Those praising the exhibition and the higher ratio of younger artists included "The National Academy of Design. First Notice," *Art Journal* 2 (May 1876): 157; "Fine Arts. The Fifty-First Academy Exhibition," *New York Evening Mail*, 30 March 1876, 1; and "The Art Exhibition. The Annual Display of the National Academy," *New York Daily Graphic*, 29 March 1876, 229. "Academy of Design. The Fifty-First Annual Exhibition–Private View and Reception," *New York Times*, 28 March 1876, 8, however, decried the smaller proportion of older artists' work.

35. "Fine Arts–Music–The Drama. Fine Arts. Fifty-First Annual Exhibition of the National Academy of Design," *New York Daily Tribune*, 28 March 1876, 4.

36. On the role of children, see Heininger, *A Century of Childhood*.

37. Linda Jones Docherty, "A Search for Identity: American Art Criticism and the Concept of the 'Native School,' 1876–1893" (Ph.D. diss., University of North Carolina, Chapel Hill, 1985), 67.

38. "Fine Arts. National Academy of Design. Fifty-First Annual Exhibition," *New York Daily Tribune*, 1 April 1876, 7, and "Art," *Atlantic* 37 (June 1876): 758.

39. "Art Matters. A Hasty Glance at the Academy Exhibition," *New York Evening Express*, 6 May 1876, 1.

40. See, for example, *New York Times*,

28 March 1876, 8; "The Arts. Representative Pictures at the Academy," *Appleton's Journal* 15 (15 April 1876): 508–10; and "Fifty-First Exhibition of the National Academy," *New York Sun*, 28 March 1876, 2.

41. *Art Journal*, 2 May 1876, 158. The *Commercial Advertiser* responded similarly, but with a more positive cast to its remarks. It suggested that the collection was not so good as to be distinguished, but that one could find many works that either pleased or instructed. "National Academy of Design. Views of a Visitor," *New York Commericial Advertiser*, 13 April 1876, 3.

42. *New York Times*, 28 March 1876, 8, and *Art Journal*, May 1876, 157–58, missed great individual works. *Appleton's Journal*, 15 April 1876, 508.

43. *Cattle Piece* was described in the *Tribune* as "a calf leading a negro boy by a string," and in *Appleton's* as "a calf is pulling a colored boy." *New York Daily Tribune*, 1 April 1876, 7, and "The Arts. The Academy Exhibition," *Appleton's Journal* 15 (22 April 1876): 539.

44. Of the papers reviewing the show, neither the *Daily Graphic* nor the *Independent* discussed Homer's work. See *New York Daily Graphic*, 29 March 1876, 299; "The National Academy Exhibition. Some Landscapes," *New York Daily Graphic*, 1 April 1876, 263; "National Academy Exhibition. Some Landscapes and Marines," *New York Daily Graphic*, 10 April 1876, 325; and "The Fine Arts," *New York Independent*, 6 April 1876, 8. The *Herald* and the *World*, which did not review the show, had even noticed these works in process. See, for example, "Art Notes. Gossip Among the Studios," *New York Herald*, 6 November 1875, 5, and "Art Notes," *New York World*, 25 October 1875, 5.

45. Such feelings were articulated in "Art Matters. A Hasty Glance at the Academy Exhibition," *New York Evening Express*, 20 April 1876, 4, and [Earl Shinn], "Fine Arts. The National Academy Exhibition. II," *Nation* 22 (20 April 1876): 268. A thorough overview of the painting by Nicolai Cikovsky, Jr., appears in Kelly et al., *American Paintings of the Nineteenth Century*, pt. 1, 312–18.

46. *New York Daily Tribune*, 28 March 1876, 4.

47. *New York Daily Tribune*, 1 April 1876, 7.

48. Ibid.

49. "Academy of Design. Fifty-First Annual Exhibition. Second Notice," *New York Daily*

Tribune, 8 April 1876, 2.

50. Nicolai Cikovsky has suggested that *A Fair Wind* was a "symbolic embodiment" of centennial year hope and encouragement for the future in Cikovsky and Kelly, *Winslow Homer*, 144.

51. "The National Academy of Design," *New York Sun*, 30 April 1876, 2.

52. Ibid; *Appleton's Journal*, 22 April 1876, 539, felt similarly.

53. [Shinn], *Nation*, 20 April 1876, 268.

54. "The Fine Arts. Exhibition of the National Academy," *New York Times*, 8 April 1876, 6.

55. "The National Academy of Design. Second Notice," *Art Journal* 2 (June 1876): 190.

56. Cikovsky in Kelly et al., *American Paintings of the Nineteenth Century*, 312, 315–16.

57. This was the case in *Appleton's Journal*, 22 April 1876, 539, and *New York Sun*, 30 April 1876, 2.

58. *New York Daily Tribune*, 8 April 1876, 2.

59. *Atlantic*, June 1876, 759–60.

60. *Atlantic*, June 1876, 760, and Burns, *Pastoral Inventions*, 224.

61. When the painting was seen in Homer's studio during the winter, positive responses appeared in: *New York Herald*, 6 November 1875, 5; "Fine Arts," *New York Evening Post*, 5 January 1876, 1; and *Appleton's Journal*, 6 November 1875, 602–3. That it did not receive such support at the Academy could have been the result of the differences between viewing the work in process in the studio, as opposed to its appearing as a completed canvas in the formal Academy setting amid the broad array of offerings.

62. *New York Daily Tribune*, 8 April 1876, 2.

63. *Art Journal*, May 1876, 159.

64. A recent technical examination of the canvas has determined that the dog was an addition to the painting, albeit within the next three years when it was noticed, dog intact, in the collection of Charles Stewart Smith. (Edward Strahan [Earl Shinn], *The Art Treasures of America*, 1879; reprint [New York: Garland Publishing, 1977], 92.) That the dog was not painted until after the Academy showing is corroborated by the fact that the landscape continues uninter-rupted underneath his image. That this was the case and not one of Homer changing his mind as he first finished the work is further supported by the fact that no critic mentioned the animal's very commanding presence in any of the reviews. It is notable, too, that the painting has suffered damage, likely from water, especially along its right side. Early twentieth-century reports of its being cut down, however are not able to be substantiated by visible evidence. The canvas's present size of 24 x 38 (37 ⅞) inches matches a standard size Homer often used. I am grateful for the thorough examination provided by Cynthia Stow, Cumberland Conservation Laboratory, Nashville, Tennessee.

65. [Earl Shinn], *Nation*, 20 April 1876, 268.

66. [Earl Shinn], "Fine Arts. Exhibition of the National Academy of Design," *Nation* 22 (6 April 1876): 234. Among those who also praised Johnson's canvas in this way were *Art Journal*, May 1876, 159; *New York Daily Graphic*, 29 March 1876, 229; and *Appleton's Journal*, 15 April 1876, 508–9.

67. *New York Daily Tribune*, 1 April 1876, 7. The compositions of both *Over the Hills* and *Milking Time* rely on such Japanese print design conventions as strategic cropping and high viewpoints. The impact of Japanese art, especially prints, on Homer is briefly mentioned in Cikovsky and Kelly, *Winslow Homer*, 99, 143–44. A broader investigation is found in Albert Ten Eyck Gardner, *Winslow Homer, American Artist: His World and His Art* (New York: Clarkson Potter, 1961), especially 106–18.

68. Shinn's only criticism of the painting was that its "treatment bespeaks of Europe." [Shinn], *Nation*, 20 April 1876, 268. Cook's remarks appear in *New York Daily Tribune*, 1 April 1876, 7. *Atlantic*, June 1876, 760, also greatly admired La Farge's canvas for its simplicity and spiritual dimension.

69. *New York Times*, 8 April 1876, 6–7.

70. "Artistic Criticism," *American Architect and Building News* 1 (22 April 1876): 130–31, outlined the situation, as did "Art," *Atlantic* 38 (December 1876): 754–59.

71. On the centennial fair in general, see John Maass, *That Glorious Enterprise: The Centennial Exhibition of 1876 and H. J. Schwarzmann, Architect-in-Chief* (Watkins Glen, N.Y.: American Life Foundation, 1973).

72. "Art in America," *New York Times*, 22 November 1875, 2, and Maass, *Glorious Enterprise*, 72–75.

73. With the centennial, the interest in British art rose significantly through the end of the decade. It is worthy to note this fact in light of Homer's choice of England as his European destination in 1881. Among those who praised the British contributions were: "The Fine Arts at the Centennial. II," *American Architect and Building News* 1 (8 July 1876): 221; S.N.C. [Susan Nichols Carter], "Paintings at the Centennial Exhibition," *Art Journal* 2 (September 1876): 283–85; William M. F. Round, "Art at the Exposition," *New York Independent*, 8 June 1876, 12; and "The Century—Its Fruits and Its Festivals. X–Art," *Lippincott's Magazine* 18 (October 1876): 393–414.

74. Susan Hobbs, *American Art at the Centennial*, exh. cat. (Washington, D.C.: National Collection of Fine Arts, 1976), 8.

75. The American collection had been selected by a committee headed by the Philadelphia artist John Sartain, who was the chief of the bureau of art. The process of choosing and hanging the American entries was contentious throughout. The mechanics of the selection process and the issue of including American artists working abroad were heavily politicized. Maass, *Glorious Enterprise*, 72.

76. "The New World's Fair. Department of Fine Arts" *New York Daily Tribune*, 10 May 1876, 5.

77. S.N.C. [Susan Nichols Carter], "Art at the Exhibition," *Appleton's Journal* 15 (3 June 1876): 726.

78. The fact that the majority of the pictures had been seen previously and thoroughly commented upon at the time of their showings, in contrast to the European works being seen afresh, surely contributed to the approach taken in the reviews. Too, the huge size of the show lent itself to generalized commentary.

79. For negative responses to the painting, see, for example, "The Art of America. Its Exhibit at Philadelphia," *New York Times*, 13 June 1876, 1–2; "Studio Notes. Glimpses of the Exhibition," *New York Herald*, 6 August 1876, 3; and E.A.C., "Fine Arts at the Centennial. III," *New York Evening Mail*, 10 August 1876, 1. The one dissenting voice was that of Charles Briggs, who felt that the painting should not be judged simply by its subject. Charles F. Briggs, "Centennial Paintings. The American Department," *New York Independent*, 13 July 1876, 3.

80. On nationalism in America in general, see Higham, *Strangers in the Land*.

81. Taine first used this terminology in his *History of English Literature*, published in

1864. (Hippolyte Taine, *Histoire de la Lit-térature Anglaise*, [Paris: L. Hachette et vie, 1863–64].) For Taine, *race* pertained to the biological inheritance of a nation; *milieu* was defined as the physical environment and prevailing social institutions; and *moment* referred to the acquired momentum of social institutions carried over from the past. Taine was not always clear in his definitions of these terms nor was he consistent in their use, but they served as a framework for assessing the national character of art. See Martha Wolfenstein, "The Social Background of Taine's Philosophy of Art," in Peter Kivy, ed., *Essays on the History of Aesthetics* (Rochester, N.Y.: University of Rochester Press, 1992), 332, 340, and Thomas H. Goetz, *Taine and the Fine Arts* (Madrid: Playor, 1973), 70.

82. Docherty, "A Search for Identity," 59–69 passim. In the context of the American art at Philadelphia, "Alexis" in the *Mail*, for example, questioned whether or not art could possess distinctive national characteristics since the world was becoming smaller due to better transportation, communication, and increased interaction. For him, the art of the United States was a "pot-pourri," with the only national aspect being native subjects. Alexis, "Art at the Centennial. II," *New York Evening Mail*, 23 June 1876, 1.

83. See, for example, "The Fine Arts at the Centennial. VIII. The American Paintings," *American Architect and Building News* 1 (19 August 1876): 269–70, and E.A.C., *New York Evening Mail*, 10 August 1876, 1.

84. S.N.C. [Susan Nichols Carter], *Art Journal*, September 1876, 284–85. Using the English exhibition as an example, the *American Architect and Building News* agreed, noting selection, directness, and powerful expression as three important criteria for excellence in art. The author then praised London as the place to study art. It was considered not the place to begin training nor to learn drawing, but as the environment in which to conclude studies, when an artist is at the picture-making stage, because London offered great classes, good models, and great art to look at–both ancient and modern. *American Architect and Building News*, 8 July 1876, 221.

85. Edward Strahan [Earl Shinn], *Masterpieces of the International Exposition*, v. 1 (1876; reprint, New York: Garland Publishing, 1977), 193.

86. Ibid., 272.

87. When *The American Type* was shown at the Century Club in December 1876, it was described as "a spirited picture of a young farmer boy seated on the shady side of a haystack, with a pretty girl at his side.

The couple have had a dispute and are now mediating over the difficulty." "Art at the 'Century,'" *New York Commericial Advertiser*, 4 December 1876, 3.

88. E.A.C., *New York Evening Mail*, 10 August 1876, 1.

89. Gar, "The Art of America. Some Paintings to be Proud Of," *New York Times*, 11 June 1876, 1.

90. Ibid.; S.N.C. [Susan Nichols Carter], *Art Journal*, September 1876, 283–85; and John Weir, "Painting and Sculpture at the Centennial. VI," *American Architect and Building News* 3 (6 April 1878): 121–22.

91. "Fine Arts," *New York Herald*, 19 June 1876, 9.

92. "Studio Notes," *New York Herald*, 18 June 1876, 14.

93. "Fine Arts," *New York Evening Post*, 20 July 1876, 1, and *Boston Daily Evening Transcript*, 30 July 1876, courtesy William H. Gerdts American Art Library.

94. Ayres, *Winslow Homer in the 1870s*, 21–22.

95. He was noted as one of the latest arrivals in "Fine Arts," *New York Evening Post*, 14 November 1876, 1.

96. "The Johnston Picture Sale," *New York Evening Telegram*, 18 December 1876, 2. During the summer, *Prisoners from the Front* had also appeared in the Centennial Loan Exhibition in New York, where it received similar treatment. See, "Fine Arts. New-York Centennial Loan Exhibition," *New York Daily Tribune*, 23 June 1876, 3–4.

97. See, for example, "Painters and Buyers," *New York Times*, 30 September 1876, 4, and "Fine Arts," *New York Evening Mail*, 13 November 1876, 4.

98. "A Ramble among the Studios," *New York Daily Tribune*, 25 November 1876, 2. Critics' visits to Homer's studio occurred with some regularity during the 1870s and new works were often first seen in this setting. See, for example, the discussions of *Snap the Whip* in chap. 2, *Milking Time* and *Unruly Calf* in this chapter, and *A Visit from the Old Mistress* and *Sunday Morning in Virginia* in chap. 6.

NOTES TO CHAPTER 6

1. The painter James Fairman wrote a letter to the editor of the *Tribune* in January remarking, "The question What shall we

do for art? seems to come from an almost universal instinct since the late Philadelphia Exhibition." James Fairman, "Art Education in America," *New York Daily Tribune*, 13 January 1877, 3.

2. "American Art Progress," *New York Herald*, 7 May 1877, 6.

3. The exact phrase appeared in "New York Interest in Art Academy," *American Architect and Building News* 2 (29 September 1877): 310.

4. Most notable of the published commentaries is, perhaps, G. W. Sheldon, "A New Departure in American Art," *Harper's New Monthly Magazine* 56 (April 1878): 764–68.

5. On the impact of the Centennial Exposition in this regard, see Sylvia L. Yount, "'Give the People What They Want': The American Aesthetic Movement, Art Worlds, and Consumer Culture, 1876–1890" (Ph.D. diss., University of Pennsylvania, 1995).

6. "Fine Arts," *New York Independent*, 5 April 1877, 7.

7. See, for example, a series of letters to the editor and the responses in Omar (pseud.), "Art and Art Critics," *New York Daily Tribune*, 10 March 1877, 3; "Artists and Art Critics," *New York Daily Tribune*, 10 March 1877, 6; "Letters from the People. 'Art and Art Critics'," *New York Daily Tribune*, 12 March 1877, 5; and "Art and Art Critics," *New York Daily Tribune*, 13 March 1877, 5. See also J. F. Weir, "Relations and Points of Contact Between the Arts," *American Architect and Building News* 2 (10 March 1877): 76–78.

8. The former work was a new canvas, described as a "middle age cavalcade" ("Mr. Schenck's Art Gallery," *New York Commercial Advertiser*, 6 February 1877, 4). The latter canvas could have been an older work ("More Pictures for St. Louis," *New York Herald*, 27 August 1877, 3). Homer's 1877 Century Club contributions particularly reflect this wide range of subject interests. Exhibited in January, February, March, June, October, November, and December, they included the familiar farm scene of *Song of the Lark* (fig. 104); the African-American subjects of *The Cotton Pickers* (fig. 89), *Dressing for the Carnival* (Metropolitan Museum of Art), *A Visit from the Old Mistress* (fig. 97), and *Sunday Morning in Virginia* (fig. 98); the young women of *Backgammon* (fig. 85); *Reading* (*The New Novel*; fig. 86); and *Fortune Telling* (*Shall I Tell Your Fortune?*; fig. 102); the Adirondacks in *Night in Camp* (*Camp Fire*; fig. 126); and the historical *Reception of the French Ambassador* (location unknown). Cikovsky and Kelly, *Winslow Homer*, 409.

9. Homer's high level of activity in paint was matched by many appearances of his work in a variety of venues including the newly formed Art Students League. His Art Students League showings are mentioned in "Art Matters. Monthly Reunion of the Art Students League–Notes of Exhibitions," *New York Daily Graphic*, 10 January 1877, 479, and "City and Suburban News–New York," *New York Times*, 5 December 1877, 8. He attended the April Art Students League meeting as well. "The Art Students League. A Creditable Display of Work at Last Evening's Reception," *New York Daily Graphic*, 12 April 1877, 298. Reports of his contributing to an album of art to benefit St. Ann's Roman Catholic Church and his attending the opening reception of the Artists Fund Society this year are other indications of his participation in the art world. "Art Notes. Album of Art," *New York Evening Express*, 17 March 1877, 2.

10. In particular, the *World*, *Tribune*, *Herald*, and *Mail* offered substantially less coverage. The *Commercial Advertiser*'s coverage was exceptional; it published a series of six articles devoted to the exhibition. Even magazines, such as the *Nation*, curtailed their reviews.

11. For a brief overview of the Tilden-Hayes election, see Morris, *Encyclopedia of American History*, 252–53.

12. "Art Matters. Goupil's Water-Color Collection," *New York Herald*, 30 January 1877, 3, and "Water-Colors at the Kurtz Gallery," *New York Daily Tribune*, 3 February 1877, 7.

13. For an example of a short commendation, see "The Water-Color Exhibition," *New York Daily Tribune*, 20 January 1877, 4. For a long one, see Sidney Grey, "Paintings in Water Colors," *Aldine* 8 (March 1877): 327. The only unkind words appeared in [Earl Shinn], "Fine Arts," *Nation* 24 (15 February 1877): 108; "The Painters in Water Colors. The Tenth Annual Exhibition of the American Society–The Pictures by Foreign Artists. First Paper," *New York Evening Post*, 3 February 1877, 1; and "The Painters in Water Colors. Pictures by American Artists in the Exhibition. Second Paper," *New York Evening Post*, 13 February 1877, 1.

14. See, for example, *New York Evening Post*, 3 February 1877, 1; "Pictures at the Academy. The Exhibition of the American Society of Painters in Water Colors," *New York Daily Graphic*, 22 January 1877, 3; and "Tenth Exhibition of the Water-Color Society," *New York Daily Tribune*, 22 January 1877, 4.

15. For examples of the first instance, see "Fine Arts," *New York Independent*, 1 March 1877, 6, and Grey, *Aldine*, March 1877, 327; and for the latter, see *New York Daily Tribune*, 22 January 1877, 4, and "The Water-Color Exhibition," *Harper's Weekly* 21 (24 February 1877): 150.

16. Dissenting opinions about watercolor as a legitimate medium appeared in *New York Independent*, 1 March 1877, 6; "Display of Water-Colors At the Academy of Design," *New York Times*, 28 January 1877, 7; and "Water Colors. Tenth Exhibition of the American Society," *New York Times*, 21 January 1877, 7. An offshoot of the question surrounding the validity of watercolor was the recognition and concern that watercolor was a marketable commodity. *Harper's Weekly* noted: "It pays to paint in water-colors, and that, it must be allowed, is a powerful incentive even to the most idealistic of artists." (*Harper's Weekly* 21 [24 February 1877], 150.) In this context, the *Independent* suggested the better oil men were painting in watercolor simply to be fashionable or to experiment. (*New York Independent*, 1 March 1877, 6.) Worse, in the eyes of some critics, was that certain artists were creating watercolors in quantity specifically for the market. (Grey, *Aldine*, March 1877, 327.) Tiffany and Colman were specifically criticized in this regard in "The Fine Arts. Exhibition of Water-Color," *New York Times*, 22 January 1877, 4–5.

17. For a sampling of the variety of opinions, see *New York Evening Post*, 3 February 1877, 1; *New York Evening Post*, 13 February 1877, 1; "The Painters in Water Colors. The Tenth Annual Exhibition in the National Academy of Design. Last Paper," *New York Evening Post*, 27 February 1877, 1; S.N.C. [Susan Nichols Carter], "The Tenth New York Water-Colour Exhibition," *Art Journal* 3 (March 1877): 95–96; *New York Daily Graphic*, 22 January 1877, 3; *New York Times*, 22 January 1877, 4; and [Shinn], *Nation*, 15 February 1877, 108.

18. S.N.C. [Susan Nichols Carter], *Art Journal*, March 1877, 95–96, and "Water Colors. The Exhibition at the Academy of Design," *New York Commercial Advertiser*, 1 February 1877, 1.

19. "Our Water Color Painters. The Tenth Annual Exhibition of the American Society," *New York Commercial Advertiser*, 20 January 1877, 3; *New York Daily Tribune*, 20 January 1877, 4; *Harper's Weekly*, 24 February 1877, 150; and *New York Daily Graphic*, 22 January 1877, 3, specifically defined them as such.

20. See, for example, *New York Daily Graphic*, 3 February 1876, 734. In 1877 only the *Nation* complained of Homer's being careless. [Shinn], *Nation*, 15 February 1877, 108.

21. Such qualities were specifically attrib-

uted to his work in *New York Evening Post*, 13 February 1877, 1 and *New York Daily Graphic*, 22 January 1877, 3.

22. *New York Evening Post*, 13 February 1877, 1.

23. "The Old Cabinet," *Scribner's* 13 (April 1877): 866.

24. See Docherty, "A Search for Identity," 72–76.

25. *New York Times*, 28 January 1877, 7.

26. Docherty, "A Search for Identity," 66. David Huntington discussed the rising importance of the artist as individual maker in *The Quest for Unity: American Art Between World's Fairs 1876–1893*, exh. cat. (Detroit: Detroit Institute of Arts, 1983), 20–21.

27. See, for example, *New York Commercial Advertiser*, 20 January 1877, 3.

28. S.N.C. [Susan Nichols Carter], *Art Journal*, March 1877, 95.

29. On the issue of drawing in schools, see "Fine Arts," *New York Independent*, 4 January 1877, 6. On *Blackboard*'s modernity, see Cikovsky, "Winslow Homer's *School Time*," 46–49.

30. *New York Times*, 22 January 1877, 5.

31. Ibid.; *New York Evening Post*, 13 February 1877, 1; and *Scribner's*, April 1877, 866.

32. For examples of each kind of reaction, see *New York Evening Post*, 13 February 1877, 1; *New York Times*, 22 January 1877, 5; "Water Colors. Success of the Exhibition–Review of Some of the Pictures," *New York Commercial Advertiser*, 21 February 1877, 1; and *New York Daily Graphic*, 22 January 1877, 3.

33. *New York Evening Post*, 13 February 1877, 1. A similar viewpoint was expressed in *Scribner's*, April 1877, 866. The appearance of the objectionable green tints can possibly be tied to Homer's experimentation with the theories of M. E. Chevreul. See Colacino, "Winslow Homer Watercolors," 47–51.

34. This is the case in *New York Times*, 22 January 1877, 5; "Art Matters. The Water Color Exhibition," *New York Evening Express*, 22 January 1877, 1; and *New York Daily Graphic*, 22 January 1877, 3.

35. S.N.C. [Susan Nichols Carter], *Art Journal*, March 1877, 95.

36. Comparisons of these works with those

by the European painters have been made in Helen A. Cooper, *Winslow Homer Watercolors*, exh. cat. (Washington, D.C.: National Gallery of Art, 1986), 116; Foster, "Makers of the American Watercolor Movement," 78; and Cikovsky and Kelly, *Winslow Homer*, 100.

37. *New York Times*, 22 January 1877, 4.

38. The Aesthetic Movement's principal tenets were most completely embodied this year in Whistler's Peacock Room. On the Peacock Room, see "Editor's Table," *Appleton's Journal* 2 (May 1877): 473, and *New York Independent*, 5 April 1877, 7. On the roots and context of the Aesthetic Movement in America, see Roger Stein, "Artifact as Ideology: The Aesthetic Movement in Its American Cultural Context," in Burke et al., *In Pursuit of Beauty*, 23–51.

39. *Scribner's*, April 1877, 866–67, and [Shinn], *Nation*, 15 February 1877, 108.

40. *New York Times*, 28 January 1877, 7. A similar response without the connection to Japanese influence can be found in *New York Evening Express*, 22 January 1877, 1.

41. *New York Commercial Advertiser*, 21 February 1877, 1; *Scribner's*, April 1877, 866; and *New York Evening Express*, 22 January 1877, 1.

42. *New York Times*, 22 January 1877, 5.

43. Waterloo, "Art Matters. American Paintings," *New York Evening Express*, 1 March 1877, 2.

44. "Fine Arts. American Pictures on Exhibition," *New York World*, 1 March 1877, 5. It is interesting to note that *A Fair Wind*, praiseworthy as it was, did not find a purchaser at this sale.

45. Docherty, "A Search for Identity," 88, points out the importance of style as a means of defining American art at this time.

46. "Winslow Homer's 'Cotton Pickers'," *New York Evening Post*, 30 March 1877, 2.

47. On the painting's European connections, see Michael Quick, "Homer in Virginia," *Los Angeles County Museum of Art Bulletin* 24 (1978): 60–81.

48. The painting sold out of the Century showing to a London collector; it never appeared in another New York exhibition during Homer's lifetime.

49. For an in-depth description of the events surrounding this show, see Jennifer A. Martin Bienenstock, "The Formation and Early Years of the Society of American Artists, 1877–1884" (Ph.D. diss., City University of New York, 1983), 1–57.

50. That was the feeling, for example, in "The Academy Exhibition. I," *New York World*, 10 April 1877, 4; "The Academy of Design. The Pictures and Sculpture in the Fifty-Second Annual Exhibition. First Paper," *New York Evening Post*, 10 April 1877, 1; and "Pictures in the Spring Exhibition," *New York Daily Graphic*, 6 April 1877, 255. Charles H. Miller, Thomas LeClear, and Wordsworth Thompson served as the hanging committee.

51. The phrase "new departure" was specifically used by *New York World*, 10 April 1877, 4, and "American Art. The Academy of Design. A Second View of the Exhibition," *New York Times*, 8 April 1877, 4; and articulated by description or suggestion in "At the Academy. II," *New York Daily Tribune*, 7 April 1877, 5; "Fine Arts. The Academy Exhibition. I," *New York Evening Mail*, 16 April 1877, 1; "The Academy Exhibition," *Art Journal* 3 (May 1877), 157; and "Culture and Progress. The National Academy Exhibition," *Scribner's* 14 (June 1877): 263.

52. The *Art Journal* noticed that what some saw as a sudden change was just a reaction to surface differences, but in fact, changes had been in progress for some time. *Art Journal*, May 1877, 157. Clarence Cook, it will be remembered, had remarked in 1875 that an art revolution was already ongoing.

53. *New York World*, 10 April 1877, 4.

54. Ibid.

55. Editorials on the topic included *New York Herald*, 7 May 1877, 6, and "Protection in Art," *New York Times*, 17 June 1877, 6. There were articles, such as "The Progress of Painting in America," *North American Review* 124 (May 1877): 451–64, and "Art Progress in America," *New York Daily Graphic*, 23 August 1877, 1, which focused on American art progress.

56. "National Academy of Design. The Annual Exhibition," *New York Daily Tribune*, 3 April 1877, 4; "National Academy of Design. The Fifty-Second Exhibition," *New York Sun*, 15 April 1877, 3; [Earl Shinn], "Fifty-Second Exhibition of the Academy of Design," *Nation* 24 (5 April 1877): 207; and "Home Subjects for American Art," *Frank Leslie's Illustrated Newspaper*, 4 August 1877, 2.

57. *New York Daily Tribune*, 3 April 1877, 4. *New York Evening Mail*, 16 April 1877, 1, agreed.

58. *New York Times*, 8 April 1877, 4.

59. "The Academy Exhibition. II," *New York World*, 14 April 1877, 4–5, most heartily championed the Munich artists. For an example of a critic concerned with the practical application of Munich painting theory, see "The Academy of Design. Fifty-Second Annual Exhibition–A First View," *New York Times*, 3 April 1877, 5.

60. See, for example, *New York Daily Tribune*, 7 April 1877, 5, and "Paintings. The Exhibition of the National Academy of Design," *New York Commercial Advertiser*, 2 April 1877, 3.

61. "Editor's Table," *Appleton's Journal* 2 (June 1877): 569–70; *Scribner's*, June 1877, 263–64; *New York Commercial Advertiser*, 2 April 1877, 3; "National Academy of Design. Proposed Amendment to the By-Laws–Some of the Pictures in the Exhibition. Second Article," *New York Commercial Advertiser*, 19 April 1877, 1; "Fine Arts," *New York Independent*, 29 March 1877, 6; and "Fine Arts," *New York Independent*, 12 April 1877, 7.

62. Homer originally painted a horn that was held straight back from the man's proper left hand. That Homer deleted it and repainted a significant portion of the sky prior to showing the picture for the first time seems evident because no reviews mention the horn, and the multiple changes in the extended hand and the sky are integrated with original paint layers, an indication that they occurred within close proximity of time. An X-ray showing the horn as well as a full conservation treatment report is on deposit in the registrar's file at the Muskegon Museum of Art. I am very grateful to David Marquis, Upper Midwest Conservation Association, for his thorough technical analysis and sensitive conservation treatment of the painting.

63. It is difficult to know exactly how the bottom half of the canvas originally appeared because the flat green-brown middle ground we see today is the result of a considerably later campaign of painting by the artist. David Marquis to the author, 23 March 2000.

64. This was the case in "Academy of Design," *New York Times*, 15 April 1877, 6; "Academy of Design. III. Genre Pictures," *New York Daily Tribune*, 16 April 1877, 5; and "Fine Arts. The Academy Exhibition. II," *New York Evening Mail*, 23 April 1877, 1.

65. *New York Evening Mail*, 23 April 1877, 1. *New York Daily Tribune*, 16 April 1877, 5, asked similar questions.

66. *New York Daily Tribune*, 16 April 1877, 5.

67. Agreeing with Cook were *New York Evening Mail*, 23 April 1877, 1, and *Art Journal*, May 1877, 159–60. This definition of the American man has been tied to feelings about immigration, agrarian ideals, nostalgia for pre–Civil War simplicity, and anxiety over increased industrialization. See Wright, "Men Making Meaning," 38–44, and Burns, *Pastoral Inventions*, 37–88 passim.

68. Ibid. All of these remarks about the girl tie into the larger discussion of the American woman as natural. Sarah Burns explored this topic with other Homer paintings in the lecture "Winslow Homer and the Natural Woman," presented at the Isabella Stewart Gardner Museum, Boston, in 1999.

69. Mrs. Launt Thompson, "What is an American?" *Atlantic* 35 (May 1877): 561–67.

70. Not all critics thought this was possible. For the *Sun* critic, American life and scenery were simply not as picturesque as their European counterparts. He believed this situation would cause a problem for the younger artists after they returned home because he wanted them to paint home subjects. The crux of the problem was "how to do so truthfully and effectively, and with due regard to local surroundings." *New York Sun*, 15 April 1877, 3.

71. *New York Evening Mail*, 23 April 1877, 1.

72. *New York Daily Tribune*, 16 April 1877, 5.

73. "The Academy of Design. Genre Painting in the Fifty-Second Annual Exhibition. Fifth Paper," *New York Evening Post*, 12 May 1877, 1.

74. "The Academy Exhibition. IV," *New York World*, 23 April 1877, 5. *New York Daily Graphic*, 6 April 1877, 255, too, found Homer's painting peculiar though very good.

75. *Art Journal*, May 1877, 159. [Shinn], *Nation*, 5 April 1877, 208, agreed.

76. Sarah Burns also believed the criticisms of *Answering the Horn* were due to its being not "peasant enough" according to French canons. Burns, *Pastoral Inventions*, 216.

77. Kathleen Pyne, "Answering the Horn," in Huntington and Pyne, *Quest for Unity*, 55–56.

78. On the reading of genre paintings as democratic see Elizabeth Johns, *American Genre Painting: The Politics of Everyday Life* (New Haven, Conn.: Yale University Press, 1991).

79. *New York World*, 23 April 1877, 5; *New York Evening Mail*, 23 April 1877, 1; *Art Journal*, May 1877, 157–60; and *New York Times*, 15 April 1877, 6. Only the writer of *New York Commercial Advertiser*, 2 April 1877, 3, criticized the figures, saying that the odd proportion of the man made him seem "ten cubits high."

80. *New York Daily Tribune*, 16 April 1877, 5.

81. *New York World*, 23 April 1877, 5.

82. *New York Evening Post*, 12 May 1877, 1.

83. *Art Journal*, May 1877, 159, and *New York Evening Mail*, 23 April 1877, 1. The *Daily Graphic* simply complained about his colors generally. *New York Daily Graphic*, 6 April 1877, 255.

84. Illustrated in "Nemo," *Academy Sketches* (New York: George Putnam Sons, 1877), 46, and listed therein with the wider dimensions, the painting was originally much more horizontal. This more horizontal format accentuated the mirror-image effect of the design.

85. *New York Times*, 8 April 1877, 4, and *Scribner's*, June 1877, 264.

86. "The Academy Exhibition. VI," *New York World*, 7 May 1877, 5.

87. "Academy of Design. IV. Landscapes," *New York Daily Tribune*, 21 April 1877, 7.

88. *New York Sun*, 15 April 1877, 3.

89. Ibid.

90. "Art Announcements," *New York Evening Post*, 31 May 1877, 2.

91. Tatham, *Winslow Homer in the Adirondacks*, 65–80.

92. Homer's return to New York is noted in "Studio Notes," *New York Herald*, 24 September 1877, 3. Homer had switched the location of his studio in the Tenth Street Studio Building after returning from Virginia. It was noted that in June he had taken the space left vacant by the death of John Beaufain Irving. "Personal," *New York Evening Post*, 19 June 1877, 2.

93. Homer exhibited at the Century only in March, April, June, and November in 1878, with his only contribution in June being a single tile. His work that appeared in sales ranged from one to ten years old, and in many cases private collectors or dealers may have been the consignors.

94. There is at least one mention of him every month of the year except July, when he and most artists were out of town. Included in these mentions was his participation in artistic activities through the year, of which his membership in the Tile Club is probably the best-known example. On the Tile Club, see Ronald G. Pisano, *The Tile Club and the Aesthetic Movement in America* (New York: Harry N. Abrams, Inc., 1999).

95. Nicolai Cikovsky has rightly noted that these two paintings show Homer working in the stylish mode of his European peers Alfred Stevens, James Tissot, and Giovanni Boldini. Cikovsky and Kelly, *Winslow Homer*, 159.

96. "The Annual Sale of American Paintings. A Brilliant Display in the Leavitt Art Rooms," *New York Evening Post*, 25 January 1878, 3.

97. "Gossip of Local Art Circles. Something About the Associations in New York," *New York Daily Graphic*, 10 January 1878, 458.

98. George Sheldon put forth such bold statements as "the sole end of art is the expression of beauty" in Sheldon, *Harper's New Monthly Magazine*, April 1878, 767. David Huntington, in *Quest for Unity*, 13, discussed this change in the broader context.

99. For example, "Fine Arts. Studio Jottings," *New York Herald*, 3 February 1878, 6, and "Art Notes," *New York Daily Graphic*, 8 February 1878, 658.

100. "Pictures for the Paris Exhibition," *New York Evening Post*, 26 January 1878, 2.

101. On the serious issues Homer's images raised and the timeliness of their appearance, see Wood and Dalton, *Winslow Homer's Images of Blacks*, 84–95, and Elizabeth O'Leary, *At Beck and Call: The Representation of Domestic Servants in Nineteenth-Century American Painting* (Washington, D.C.: Smithsonian Institution Press, 1996), 156–61. On the state of America in 1877, see Foner, *Reconstruction*, 565–85.

102. Popular magazines were the primary venue for such images. Sol Eytinge's "Blackville Sketches," for example, was a popular series built on the humor found in placing the members of an African-American family in situations generally associated as reserved for whites only. The series began in "Blackville Sketches," *Harper's Weekly* 22 (12 January 1878): 32.

103. *New York Evening Post*, 26 January 1878, 2, recognized this aspect of the painting.

104. Those artists noted as missing

included Homer, J. G. Brown, Enoch Wood Perry, William Hart, and Homer Dodge Martin. See, for example, "Fine Arts. The Water-Color Society. I," *New York Independent*, 14 February 1878, 7, and "The Water-Color Exhibition," *New York Times*, 10 February 1878, 6.

105. The question of why a number of artists were absent was not answered directly, but an obvious reason may have been that they, like Homer, were preparing their contributions for the Paris Exposition.

106. The *Post* lauded him as "a most genuine and original painter in water colors." ("American Art in Water Colors. The Eleventh Annual Exhibition of the Water-Color Society in the Rooms of the Academy of Design," *New York Evening Post*, 20 February 1878, 1.) The *World* called him "by far the best and most logical water-color painter in America to our mind." ("The Water-Color Exhibition," *New York World*, 11 February 1878, 4.) The *Times* noted that Homer's artistic interests and treatment were extremely well suited to the medium, showing "a just appreciation of the scope of watercolors." (*New York Times*, 10 February 1878, 6.) Agreeing with the writers, too, was Earl Shinn in "Fine Arts. Eleventh Exhibition of the American Water-Color Society. I," *Nation* 26 (14 February 1878): 120–21. These writers, in the main, were among the more open-minded.

107. *New York Evening Post*, 20 February 1878, 1.

108. [Shinn], *Nation*, 14 February 1878, 120.

109. Clark, *History of the National Academy of Design*, 98–99, 105.

110. Twenty of the initial members were academicians, or were soon to be. (Clark, *History of the National Academy of Design*, 105). Homer neither exhibited with nor was a member of the group, although he was sometimes mistakenly identified as both; the confusion was likely caused by Homer Martin's connections with the Society. See, for example, "The Society of American Artists," *New York Daily Graphic*, 5 March 1878, 27.

111. Bienenstock, "Society of American Artists," 1–8.

112. Ibid., 36.

113. "Pictures and Critics," *New York Evening Telegram*, 9 April 1878, 2.

114. M.G.v.R. [Mariana Griswold van Rensselaer], "National Academy of Design, New York. Fifty-Third Annual Exhibition," *American Architect and Building News* 3

(27 April 1878): 149–50.

115. See, for example, "Hard Times and Art Culture," *New York Evening Mail*, 13 February 1878, 2, for an enumeration of the positive and negative effects of the depression.

116. See "Art Notes. The National Academy of Design Reception Last Evening," *New York Commercial Advertiser*, 2 April 1878, 1; "Art Notes. The Paintings at the National Academy of Design," *New York Commercial Advertiser*, 5 April 1878, 1; and "Art Notes. The National Academy of Design," *New York Commercial Advertiser*, 20 April 1878, 1.

117. The *Daily Graphic* and *Mail* praised the show as an advance and favorable in comparison to past efforts, but their notices of individual work remained brief. The *Daily Graphic* liked artists as varied as Enoch Wood Perry and William M. Chase. ("The National Academy of Design," *New York Daily Graphic*, 1 April 1878, 218.) The *Mail*, after praising the show in general, was mainly critical of individual works. ("National Academy of Design," *New York Evening Mail*, 4 April 1878, 3.) The *Independent* was more specific about what it found pleasing. It ranked the portraits first, the best of which were by either Munich- or Paris-trained artists. It then mentioned the works that expressed poetry and imagination, such as those by La Farge and Fuller, as worthy of close study. ("Fine Arts. The Academy Exhibition. The Portraits," *New York Independent*, 11 April 1878, 7, and "Fine Arts. In the Academy Exhibit. II," *New York Independent*, 18 April 1878, 9.)

118. "The Academy Exhibition. I," *New York World*, 14 April 1878, 3. Clarence Cook, too, found the show tame, although he gave the members of the Academy credit for trying hard. Nonetheless, he had to confess, he liked the Society of American Artists show better. Considering Cook's pivotal role in the formation and support of the group, it would have been strange for him to have any other response. "Art at the Academy. The Fifty-Third Annual Exhibition," *New York Daily Tribune*, 2 April 1878, 5.

119. [Earl Shinn], "Fine Arts. The Fifty-Third Exhibition of the Academy of Design," *Nation* 26 (18 April 1878): 265–66; "The Academy of Design. Opening of the Fifty-Third Annual Exhibition," *New York Evening Post*, 30 March 1878, 4; "The Academy Exhibition. Portraits," *New York Times*, 7 April 1878, 6–7; and "The National Academy of Design. I," *New York Sun*, 7 April 1878, 2.

120. The description of the painting when shown in Brooklyn indicated that a farmer was pictured at the background fence.

("Paintings. Thirty-Third Reception of the Art Association," *Brooklyn Union*, 5 December 1876, 3). The farmer did appear in an illustration of the painting in G. W. Sheldon, "American Painters–Winslow Homer and F. A. Bridgman," *Art Journal* 4 (August 1878): 226, but that image was drawn on the block in February. (See "Art Notes," *New York Evening Post*, 14 February 1878, 2.) That the farmer was gone by the time of the Academy show seems fairly certain since the *Nation*'s description only infers the farmer's presence as part of a suggested scenario. ([Earl Shinn], "Fine Arts. The National Academy Exhibition. Final Notice," *Nation* 26 [30 May 1878]: 363–64.) Wood and Dalton, *Winslow Homer's Images of Blacks*, 83–84, assert the farmer was never in the painting, but, although no eradicated figure is evident in an X-ray, infrared reflectography reveals a section of canvas clearly scraped down, possibly even sanded, at the place where the farmer stands in the illustration. Pentimenti of other changes made by the artist are visible. For example, there existed another boy to the right of the present figure group. I am grateful to Quentin Rankin, paintings conservator, Smithsonian American Art Museum, for his careful examination of and thoughtful comments about the canvas.

121. On the growing popularity of wilderness excursions at this time, see Tatham, *Winslow Homer in the Adirondacks*.

122. On the rise of the decorative movement and the production of artistic tiles, see Doreen Bolger Burke, "Painters and Sculptors in a Decorative Age," in Burke et al., *In Pursuit of Beauty*, 295–97. See also Pisano, *The Tile Club*, 11–67.

123. The *World*, *Tribune*, *Nation*, *Art Journal*, *Independent*, and *Sun* spent the most time with Homer's contributions.

124. "The National Academy of Design. II," *New York Sun*, 14 April 1878, 4. The *Tribune* also remarked on the unusual placement of the works, but rather thought Homer's selections deserved the sideline treatment. *New York Daily Tribune*, 2 April 1878, 5.

125. George William Sheldon was in London during this period, and who was writing for the *Post* is unknown. *New York Evening Post*, 30 March 1878, 4; "National Academy of Design. Some of the More Notable of the Paintings Exhibited," *New York Daily Graphic*, 3 April 1878, 234; "The Academy Exhibition. Critics on the Fence," *New York Times*, 10 April 1878, 2; and "Fine Arts. National Academy of Design–Seventh and Concluding Notice," *New York Herald*, 6 May 1878, 5.

126. "Fine Arts. National Academy of Design," *New York Evening Mail*, 1 April 1878, 4, and M.G.v.R. [Mariana Griswold van Rensselaer], *American Architect and Building News*, 27 April 1878, 149.

127. [Shinn], *Nation*, 30 May 1878, 363.

128. Ibid.

129. *New York Sun*, 14 April 1878, 3.

130. *New York Independent*, 18 April 1878, 9. The writer felt similarly about *Fresh Morning*. Mariana Griswold van Rensselaer agreed in M.G.v.R., *American Architect and Building News*, 27 April 1878, 149.

131. C. C. [Clarence Cook], "Fine Arts. National Academy of Design. Fifty-Third Annual Exhibition. V," *New York Daily Tribune*, 11 May 1878, 6.

132. All three of these paintings have suffered from overcleaning, but there is no doubt their original states were already very thin. Conversations with Michael Heslip, Williamstown Art Conservation Laboratory, and Quentin Rankin, Smithsonian American Art Museum, were very helpful in the assessment of the conditions of these paintings.

133. Susan Nichols Carter, "The Academy Exhibition," *Art Journal* 4 (May 1878): 159.

134. The definition of Impressionism went through some sizable changes from 1878 to the early 1880s. On this topic, see William H. Gerdts, *American Impressionism* (New York: Abbeville Press, 1984), 29, 31–32.

135. Carter, *Art Journal*, May 1878, 158.

136. *New York Sun*, 14 April 1878, 3.

137. "National Academy of Design," *New York Daily Graphic*, 10 April 1878, 287.

138. James Jackson Jarves, "Fine Arts. The American School of Painting. Elihu Vedder and John La Farge," *New York Independent*, 3 October 1878, 7.

139. *New York Independent*, 18 April 1878, 9.

140. "Editor's Table," *Appleton's Journal* 4 (February 1878): 193.

141. For Shinn, a subject that suggested a poetic narrative obtained such feeling. ([Shinn], "Notes," *Nation* 26 (4 April 1878): 229, and [Shinn], *Nation* 18 April 1878, 265–66.) For William Brownell, the poetic was now a function of artistic treatment, and he sought a completeness of thought that touched the soul through pictorial means. (*New York World*, 14 April 1878, 3; "The Academy Exhibition. II," *New York World*, 7 May 1878, 6; and "The Academy Exhibition. IV," *New York World*, 19 May 1878, 4.)

142. [Shinn], *Nation*, 30 May 1878, 363. "The Academy Exhibition. III," *New York World*, 18 May 1878, 6, expressed a similar viewpoint.

143. *New York Daily Tribune*, 11 May 1878, 6.

144. *New York Sun*, 14 April 1878, 3.

145. *New York Daily Tribune*, 11 May 1878, 6.

146. *New York Daily Tribune*, 2 April 1878, 5, and *New York Daily Tribune*, 11 May 1878, 6.

147. *New York Daily Tribune*, 11 May 1878, 6.

148. Ibid.

149. Cook feuded with other artists in this same period in addition to difficulties he had with his editor Whitelaw Reid. For example, there was an exchange with George Inness, part of which appeared in the *Tribune*. See, for example, "A Poem and a Statue. Mr. Inness Explains His Poem," *New York Daily Tribune*, 11 April 1878, 6. Jervis McEntee remarked in his diary on Cook and his relationship with Reid in an entry dated 18 March 1878. Jervis McEntee Diary, Jervis McEntee Papers, Archives of American Art.

150. M.G.v.R. [Mariana Griswold van Rensselaer], *American Architect and Building News*, 27 April 1878, 149. Clarence Cook also grouped Homer with the older artists. *New York Daily Tribune*, 2 April 1878, 5.

151. "The Coming Exhibition. Academy of Design Paintings," *New York Times*, 1 April 1878, 5; *New York Times*, 7 April 1878, 6–7; and *New York Times*, 10 April 1878, 2.

152. Sheldon, *Harper's New Monthly Magazine*, April 1878, 767.

153. The tiles pictured sea monsters and ladies on the beach. "Fine Arts. The Tile Club," *New York Herald*, 1 May 1878, 6, and *New York Herald*, 6 May 1878, 5.

154. "Brush and Pencil. Notes from the Studios," *New York Daily Tribune*, 22 June 1878, 5.

155. "The Salmagundi's Exhibition," *New York World*, 4 May 1878, 5, only briefly mentions the show and Homer as included in it. What Homer exhibited at the Salmagundi is unknown.

156. "Book and Art Notes. The National Academy of Design's Annual Meeting," *New York Commercial Advertiser*, 9 May 1878, 1, and "Academy of Design Meeting," *New York Evening Mail*, 9 May 1878, 4.

157. "Art and Artists," *New York Evening Mail*, 7 May 1878, 4.

158. *Boston Daily Evening Transcript*, 28 May 1878, quoted in Cikovsky and Kelly, *Winslow Homer*, 395.

159. At the end of 1878 John La Farge would have a similar sale in Boston before leaving for Europe. See, for example, the report in "Fine Arts. Studio and Other Art Notes," *New York Herald*, 15 December 1878, 12.

160. Bienenstock, "Society of American Artists," 91.

161. The selection process is outlined in United States Secretary of State, *Reports of the Commissioners to the Paris Universal Exposition* v. 1, (Washington, D.C.: Government Printing Office, 1880), 10–11. I am grateful to Gerald Bolas for sharing his extensive research on the 1878 Paris Exposition. On how the Paris committee operated, see David Maitland Armstrong, *Day Before Yesterday: Reminiscences of a Varied Life* (New York: Charles Scribner's Sons, 1920), 268.

162. "Pictures for Paris. List of American Artists To Be Represented," *New York Evening Telegram*, 16 March 1878, 3, and "Our Art at Paris," *New York Herald*, 16 March 1878, 6.

163. *Sunday Morning in Virginia* and *A Visit from the Old Mistress* came from Homer's studio; all the other paintings came from the collection of selection committee-member John Sherwood.

164. "Art Notes," *New York Commercial Advertiser*, 16 March 1878, 1.

165. "American Art at the Exposition," *New York Times*, 16 June 1878, 6.

166. Among the subjects Hooper expected to see were American girlhood, American daily life, the Civil War, and illustrations of American history or literature. (Lucy H. Hooper, "The Pictures at the Paris Exhibition. IV. The American Pictures," *Art Journal* 4 [November 1878]: 548–49.) The critic for the London *Academy* agreed. That writer's comments were reprinted in "Fine Arts," *New York Evening Post*, 23 July 1878, 2. See, also, Kate Field, "Kate Field in Switzerland. American Paintings of the Exposition," *New York Daily Graphic*, 31 August 1878, 422, and "Pictures at the Expo-

sition," *Atlantic* 42 (December 1878): 716.

167. W.J.S. [William James Stillman], "The Paris Exposition. IX. American Painting," *Nation* 26 (3 October 1878): 211.

168. D.M.A. [David Maitland Armstrong], "Art at the Paris Exposition," *Scribner's* 17 (December 1878): 281. Maitland's initials appeared only in the table of contents, whereas on the article itself, it is authored by "A Painter."

169. R. S. [Russell Sturgis], "The Paris Exposition–XV. The United States Fine Art Exhibit," *Nation* 26 (28 November 1878): 332.

170. The primary European responses that appeared in the American press included: [Paul Lefort], "American Artists at Paris. A Foreign Critics Opinion," *New York Daily Tribune*, 25 December 1878, 2; [Charles Tardieu], "Some Foreign Notions about the Fine Arts in America," *New York Sun*, 25 December 1878, 2; "Fine Arts. L'Art on American Artists," *New York Herald*, 23 December 1878, 9; "The Paris Exposition. English Opinion of American Pictures and Artists," *New York Herald*, 3 June 1878, 4; and [Victor Cherbuliez], "Cherbuliez on American Painting," *New York World*, 28 August 1878, 4–5.

171. *New York Daily Tribune*, 25 December 1878, 2. Homer's other African-American subject, *The Bright Side*, was only mentioned in listings of the exhibition's contents.

172. Outremer, "Art Talks from Abroad," *Aldine* 9 (1878): 201. It is unclear whether "Outremer" was distinguishing between the works which Homer sent himself and those which came from Sherwood's collection. With no other comments on this topic from this critic, it seems Homer may have been condemned for at least some circumstances beyond his control.

173. W.J.S. [William James Stillman], *Nation*, 3 October 1878, 211.

174. Hooper, *Art Journal*, November 1878, 349.

175. Gar, "American Genre Painters," *New York Times*, 25 August 1878, 10. [Field], *New York Daily Graphic*, 31 August 1878, 422, and Sheldon, *Art Journal*, August 1878, 227, agreed.

176. "Editor's Table. About Finish in Pictures," *Appleton's Journal* 5 (August 1878): 185, outlined the issues of the debate.

177. Homer had left the city by 24 June and was back by 31 October. ("Fine Arts," *New York Herald*, 24 June 1878, 4; and "Fine Arts," *New York Herald*, 31 October 1878, 7.) Probably due to his departure for Houghton Farm, it was reported that Homer was unable to join the Tile Club on their Long Island sketching sojourn ("Long Island Sketches," *New York Evening Post*, 28 June 1878, 2).

178. "The Brooklyn Art Association and The Art Students League," *New York Sun*, 8 December 1878, 3.

179. "Fine Arts," *New York Herald*, 11 November 1878, 5, and "Studio," *Art Interchange*, 11 December 1878, 51. Another positive notice of these sheets appeared in "Art Notes," *New York Evening Post*, 11 November 1878, 2.

180. Sheldon, *Art Journal*, August 1878, 227.

NOTES TO CHAPTER 7

1. Homer exhibited at the Century this year only in January, November, and December, rather than his usual six to eight times. His work was also much less available at sale, with only six instances known. See, for example, "Rooms for the Exhibition and Sale of American Pictures," *New York Evening Post*, 6 May 1879, 3; "Art Notes. Paintings at No. 817 Broadway (the Leavitt Gallery), The Barker and Matthew's Galleries, &c.," *New York Commercial Advertiser*, 14 May 1879, 1; and "Picture Sale," *New York Evening Express*, 22 December 1879, 3.

2. While the number of his oils remained stable, at thirteen, from the previous year, his watercolor production dropped from sixty-two to twenty-two, while his drawing production skyrocketed from thirty to seventy works.

3. Notice of this exhibition and its importance appeared in "Culture and Progress," *Scribner's* 18 (June 1879): 311. See, also: "Fine Arts. The Black and White Exhibition at the Kurtz Gallery," *New York Daily Graphic*, 13 February 1879, 707; "Fine Arts. The Black and White Exhibition of the Salmagundi Sketch Club–First Notice," *New York Herald*, 12 February 1879, 6; and "Fine Arts. The Salmagundi Exhibition," *New York Evening Mail*, 14 February 1879, 4.

4. This quality of the show was especially pointed out in "The Water-Color Society Exhibition," *New York Sun*, 1 February 1879, 2; "Editor's Table. Water-Colors," *Appleton's Journal* 6 (March 1879): 281, and "Fine Arts. Twelfth Annual Exhibition of the Water Color Society," *New York Herald*, 1 February 1879, 6. The quality of the show was something that, for example, both the open-minded Charles DeKay of the *Times* and the conservative writer for the *Aldine* could agree on despite their divergent opinions about individual pieces. "The Water-Color Society. A Brilliant Show at the Twelfth Exhibition," *New York Times*, 1 February 1879, 5, and "The Water-Color Exhibition," *Aldine* 9 (August 1879): 269–70.

5. *New York Sun*, 1 February 1879, 2, and "The Water-Color Exhibition," *Frank Leslie's Illustrated Newspaper*, 22 February 1879, 1–2. "American Art in Water-Colors. The Twelfth Annual Exhibition of the Water Color Society at the National Academy of Design. I," *New York Evening Post*, 11 February 1879, 1, and "The Water Color Exhibition," *New York Daily Graphic*, 7 February 1879, 663, offered mildly dissenting opinions.

6. "The Water-Color Exhibition. II," *New York World*, 10 February 1879, 4. *New York Daily Graphic*, 7 February 1879, 663; and C. C. [Clarence Cook], "The Water Color Society. Twelfth Annual Exhibition," *New York Daily Tribune*, 15 February 1879, 5, felt similarly.

7. *New York Evening Post*, 11 February 1879, 1.

8. *J. Frank Currier (1843–1909), A Solitary Vision*, exh. cat. (New York: Babcock Galleries, 1994), chronology.

9. As William Gerdts has noted, it is nearly impossible to positively identify Currier's nine entries which bore the titles: *Pines*; *Brook Scene*; *Willows and Water*; *Beechwood: Interior*; *Trees*; *Sunset* (2); *Sunset among the Willows*; and *Road-Side Scene*. William H. Gerdts, "The Overlooked Artist: J. Frank Currier," unpublished manuscript, 21–26; courtesy of William H. Gerdts. A shortened version of this insightful essay appeared in Bott and Bott, eds., *ViceVersa*, 114–26, see especially 118–20.

10. Six critics wrote negatively of Currier's work, four made no comment, and three found some good in it. As an example of the negative, see "The Water Color Exhibition," *New York Sun*, 23 February 1879, 2. The *World*, *Appleton's*, *Telegram*, and *Harper's Weekly* made no reference to Currier at all. For a positive remark, see *New York Daily Graphic*, 7 February 1879, 663.

11. "The Water Color Exhibition," *New York Sun*, 2 February 1879, 3. [Earl Shinn], "Fine Arts. The Growing School of American Water-Color Art," *Nation* 28 (6 March 1879): 172, made a similar comparison to Whistler.

12. *New York Times*, 1 February 1879, 5. Mariana Griswold van Rensselaer, "Recent Pictures in New York," *American Architect and Building News* 5 (22 March 1879): 94, agreed.

13. *New York Herald*, 1 February 1879, 6, and "Fine Arts. Water Color Exhibition–Fifth and Concluding Notice–The Corridor and Black and White Room," *New York Herald*, 24 February 1879, 5.

14. "Art Students League," *New York Evening Mail*, 6 March 1879, 4.

15. *New York Evening Post*, 11 February 1879, 1.

16. *New York Daily Graphic*, 7 February 1879, 663.

17. He exhibited *Husking*; *Fresh Air* (fig. 107); *Oak Trees with Girl*; *Chestnut Tree*; *Sketch*; *Girl in a Wind*; *Watching Sheep*; *Sketch from Nature*; *Girl on a Garden Seat* (now known as *Woman on a Bench*; fig. 115); *The Strawberry Field*; *Girl and Boy*; *Old House*; *A Rainy Day*; *October* (possibly *Autumn, Mountainville, New York*; fig. 123); *Oak Trees*; *Corn*; *Girl, Sheep, and Basket*; *Girl and Boat*; *Willows*; *Girl, Boat, and Boy*; *Black and White* (2); *The School Girl*; *Sketch*; *Girl on a Bank*; *Girl with Half a Rake* (*Girl with Hay Rake*; fig. 116); *In the Orchard* (now known as *Apple Picking*; fig. 108); *On the Fence* (National Gallery of Art); *On the Hill* (now known as *The Green Hill*; National Gallery of Art). Trying to precisely identify the watercolors with generic titles without exact descriptions is difficult. The whereabouts of those works listed without locations are not positively known.

18. *New York Herald*, 24 February 1879, 5.

19. See, for example, *New York Times*, 1 February 1879, 5, and *Scribner's*, June 1879, 310.

20. *New York Evening Post*, 11 February 1879, 1. This story was corroborated in [Shinn], *Nation*, 6 March 1879, 171. Some of these works may have been familiar from sightings at the Century Club and Art Students League in the late fall and early winter.

21. *New York Times*, 1 February 1879, 5.

22. [Shinn], *Nation*, 6 March 1879, 171.

23. This is not to suggest that the atmosphere at Houghton Farm was less than stimulating, but rather that it was different from being with his fellow artists. It should be remembered as well that Homer's time at the Valentine farm allowed for the artist to receive immediate response to his artistic endeavors from an important patron.

24. Clarence Cook suggested that some of the entries were the result of a trip to Long Island with other artists (he may have thought Homer had joined the Tile Club the previous June), but the images known today from the 1879 showing all seem to be from Houghton Farm. Cook's remarks appear in "The Water-Color Society. Twelfth Annual Exhibition," *New York Daily Tribune*, 1 March 1879, 5.

25. Colacino, "Winslow Homer's Watercolors," 62.

26. *Frank Leslie's Illustrated Newspaper*, 22 February 1879, 1–2.

27. "The Studio. Water Color Exhibition," *Art Interchange* 3 (19 February 1879): 26.

28. *New York Times*, 1 February 1879, 5.

29. Foster, "Makers of the American Watercolor Movement," 90.

30. [Earl Shinn], "Fine Arts. The American Water-Color Society's Exhibition," *Nation* 28 (6 February 1879): 107.

31. *New York Sun*, 2 February 1879, 3, and "The Water Color Exhibition," *New York Sun*, 16 February 1879, 3.

32. *New York World*, 5 February 1879, 4.

33. Susan Nichols Carter, "The Water-Color Exhibition," *Art Journal* 5 (March 1879): 93–95.

34. [Shinn], *Nation*, 6 March 1879, 171.

35. Ibid.

36. William M. F. Round, "Fine Arts. The Water Color Society," *New York Independent*, 6 March 1879, 9.

37. van Rensselaer, *American Architect and Building News*, 22 March 1879, 93–94.

38. Ibid. Aside from Shirlaw, there was not another artist she particularly liked; she was highly critical of many.

39. C. C. [Clarence Cook], "The American Water Color Society. Twelfth Annual Exhibition," *New York Daily Tribune*, 1 February 1879, 5.

40. "Water Color Exhibition," *New York Evening Mail*, 1 February 1879, 1.

41. *New York Evening Post*, 11 February 1879, 1.

42. Ibid.

43. Ibid.

44. Ibid.

45. See Colacino, "Winslow Homer's Watercolors," 61, and Foster, "Makers of the American Watercolor Movement," 87–89.

46. S.G.W.B. [Samuel Greene Wheeler Benjamin], "Present Tendencies of American Art," *Harper's New Monthly Magazine* 58 (March 1879): 491–92.

47. Twenty-one magazines and newspapers covered the show. Of them, the *Times* and the *Herald* devoted the greatest number of articles to it–eight each, although not all were long. In addition to these two papers, the *Tribune*, *World*, *Telegram*, and *Sun*, as well as the *Art Journal*, *Appleton's*, *Art Amateur* (new on the scene), and the *Nation* gave it especially full attention.

48. *Scribner's*, June 1879, 312–13; "The Academy Exhibition. A Creditable Display of the Work of American Artists," *New York Daily Graphic*, 29 March 1879, 207; and "The Academy Exhibition," *New York Evening Mail*, 1 April 1879, 4.

49. "Fine Arts. National Academy," *New York Independent*, 10 April 1879, 12, and "The Academy Exhibition. First Impression and a Hasty Tour of the Galleries," *New York Evening Post*, 30 March 1879, 4.

50. This viewpoint was expressed in "Art Matters. The Academy Exhibition. First Article," *New York Evening Express*, 9 April 1879, 3; "Fine Arts. Fifty-Fourth Annual Exhibition of the Academy of Design–Important Pictures–First Notice," *New York Herald*, 30 March 1879, 8; *Scribner's*, June 1879, 312–13; and "The Studio. The Spring Exhibition–National Academy of Design. Second Notice," *Art Interchange* 2 (16 April 1879): 58.

51. An especially cogent discussion outlining the differences can be found in Edward Strahan [Earl Shinn], "The Art Gallery. The National Academy of Design. First Notice," *Art Amateur* 1 (June 1879): 4–5.

52. "Editor's Table. The Academy Exhibition," *Appleton's Journal* 6 (May 1879): 471; "America in Pictures," *New York Times*, 16 April 1879, 4; and "Academy of Design. Fifty-Fourth Annual Exhibition. Fourth Article," *New York Daily Tribune*, 26 April 1879, 5.

53. *New York Daily Tribune*, 26 April 1879, 5.

54. This was particularly the concern expressed in Susan Nichols Carter, "The Academy Exhibition," *Art Journal* 5 (May 1879): 158.

55. Mariana Griswold van Rensselaer, "The Spring Exhibition in New York. The National Academy of Design–The Society of American Artists, Etc.," *American Architect and Building News* 5 (10 May 1879): 148.

56. *Appleton's Journal*, May 1879, 470–71.

57. Edward Strahan [Earl Shinn, pseud.], "The National Academy of Design. Concluding Notice," *Art Amateur* 1 (June 1879): 28.

58. "Preparing the Pictures. The Artist's Varnishing Day. Annual Exhibition of the Academy of Design," *New York Times*, 30 March 1879, 6, and *New York Times*, 16 April 1879, 4.

59. Praise for Fuller appeared in *New York Daily Tribune*, 26 April 1879, 5; "The Academy Exhibition. III," *New York World*, 27 April 1879, 3; *New York Evening Post*, 30 March 1879, 4; "Fine Arts. Exhibition of the Academy of Design. II," *Nation* 28 (22 May 1879): 359; *Scribner's*, June 1879, 313; "The National Academy," *New York Sun*, 20 April 1879, 2; Carter, *Art Journal*, May 1879, 158; "Fine Arts. Fifty-Fourth Annual Exhibition of the National Academy of Design–Fourth Notice–The South Gallery," *New York Herald*, 7 April 1879, 8; and *Art Interchange*, 16 April 1879, 58. Only *Appleton's* disagreed with its peers. It found Fuller too heavily dependent on execution and too derivative of the old masters. *Appleton's Journal*, May 1879, 470.

60. Burns, *Pastoral Inventions*, 222.

61. Eighteen of the twenty-one reviewing publications discussed Homer's work. Of the three abstaining serials, the *Commercial Advertiser* did not discuss individual artists and *Harper's Weekly* mentioned only a small number of artists, mainly landscapists and those conservative in practice. Why the *Express* ignored Homer is hard to discern, since it had positive reactions to a wide variety of home artists from J. G. Brown to George Inness. "Art Notes. The Coming Exhibition at the Academy," *New York Commercial Advertiser*, 25 March 1879, 1; "Art Notes. The Exhibition of Paintings at the National Academy Last Night–A Noteworthy Display," *New York Commercial Advertiser*, 1 April 1879, 1; "Art Notes," *New York Commercial Advertiser*, 4 April 1879, 1; "The National Academy," *Harper's Weekly* 23 (19 April 1879): 312–13; "The Academy," *Harper's Weekly* 23 (3 May 1879): 353; "The Academy," *Harper's Weekly* 23 (10 May 1879): 364; and *New York Evening Express*, 9 April 1879, 3.

62. Homer's asking prices for these paintings are listed in *The National Academy of Design Exhibition Record, 1861–1900*, 452.

63. *New York World*, 27 April 1879, 3.

64. A modern restorer repainted much of the canvas after Homer, himself, painted out a significant portion of the picture late in his career. CUNY/Goodrich/Whitney Record of Works by Winslow Homer.

65. "The Academy Paintings. A Better Display Than Has Been Seen for Years," *New York Evening Telegram*, 31 March 1879, 1, and *New York Herald*, 30 March 1879, 8.

66. *New York Times*, 30 March 1879, 6.

67. On the growth of the decorative arts, see Mariana Griswold van Rensselaer, "Decorative Art and Its Dogmas. Two Papers, I," *Lippincott's Magazine* 25 (February 1880): 215–20.

68. Wood and Dalton, *Winslow Homer's Images of Blacks*, 97–98. Due to the changes wrought on the canvas, the meaning of the figures can only be conjecture.

69. [Mariana Griswold van Rensselaer], "The Exhibition of Contemporary Art in Boston. II," *American Architect and Building News* 5 (17 May 1879): 157.

70. *Appleton's Journal*, May 1879, 471.

71. *New York Times*, 30 March 1879, 6.

72. *New York Daily Graphic*, 29 March 1879, 207–9.

73. *New York Evening Telegram*, 31 March 1879, 1.

74. Carter, *Art Journal*, May 1879, 158. [Earl Shinn], "Fine Arts. The Fifty-Fourth Exhibition of the Academy of Design," *Nation* 28 (15 May 1879): 341, also applauded the decorative qualities of the canvas.

75. On the influence of Japanese art on that of America in general see Clay Lancaster, *The Japanese Influence in America* (New York: Abbeville Press, 1983). On its availability in America, see Christine Wallace Laidlaw, "The American Reaction to Japanese Art, 1853–1876" (Ph.D. diss., Rutgers University, 1996).

76. It seems quite plausible that the harsh criticism caused Homer to destroy the painting at some point. The canvas seems to have had a certain resemblance to *Promenade on the Beach* (1880; Museum of Fine Arts, Springfield, Massachusetts). The paintings shared an overall singular tone of color; the image of a fashionable woman; the exploration of the effects of particular kinds of light; water presented in a stripe of color; and a boat on the horizon. The Springfield painting is derived from an ear-

lier drawing, and perhaps that was the case for *Sundown*. On the origins of *Promenade*, see Cikovsky and Kelly, *Winslow Homer*, 195–96. See also Lloyd Goodrich and Abigail Booth Gerdts, *Winslow Homer in Monochrome*, exh. cat. (New York: M. Knoedler and Co., 1986), 38, and Gordon Hendricks, *The Life and Work of Winslow Homer* (New York: H. N. Abrams, 1979), 128, 131, 139.

77. *New York Times*, 30 March 1879, 6.

78. van Rensselaer, *American Architect and Building News*, 10 May 1879, 149, and *New York Independent*, 10 April 1879, 13.

79. [Shinn], *Nation*, 15 May 1879, 341. A very sarcastic response to the painting appeared in "An Amateur in the Academy," *New York Daily Graphic*, 3 May 1879, 451.

80. Shinn has been identified as the writer of the *Nation* review in Daniel C. Haskell, *The Nation: Index of Titles and Contributors* (New York: New York Public Library, 1953), 445.

81. Strahan, *Art Amateur*, June 1879, 4.

82. "The Academy Pictures," *New York Evening Telegram*, 22 April 1879, 3.

83. *New York Daily Tribune*, 26 April 1879, 5. *New York Evening Mail*, 1 April 1879, 4, felt similarly, especially about the figure's lack of grace.

84. Carter, *Art Journal*, May 1879, 159.

85. *New York Herald*, 30 March 1879, 8. *Art Interchange* also had some very positive remarks. The writer found the figure especially well drawn, but the "cold blue of the wave" ruined the painting. "The Spring Exhibition. National Academy of Design. First Notice," *Art Interchange* 3 (2 April 1879): iii.

86. *New York Herald*, 30 March 1879, 8, and *New York Herald*, 7 April 1879, 8.

87. "Fine Arts. Fifty-Fourth Annual Exhibition of the National Academy of Design–Seventh Notice–The West and Northwest Galleries," *New York Herald*, 28 April 1879, 5.

88. *New York Daily Graphic*, 29 March 1879, 207.

89. van Rensselaer, *American Architect and Building News*, 10 May 1879, 149.

90. "The Two New York Exhibitions. II," *Atlantic* 43 (June 1879): 785.

91. *New York Independent*, 10 April 1879, 13.

92. *Atlantic*, June 1879, 782–87; *New York Independent*, 10 April 1879, 12–13; and "Fine Arts. The Academy Exhibition–The Landscapes," *New York Independent*, 8 May 1879, 6.

93. At a later date, Homer considerably repainted portions of the landscape, most noticeably on the right side.

94. *New York World*, 27 April 1879, 3.

95. *Appleton's Journal*, May 1879, 471.

96. "The Academy Painters. Features of the Annual Exhibition at Fourth Avenue and Twenty-Third Street," *New York Evening Post*, 24 May 1879, 1.

NOTES TO CHAPTER 8

1. "Fine Arts," *New York Evening Post*, 26 January 1880, 2. At Mathews Gallery, the *Post* called *Peach Blossoms* the principal attraction. "Art Sales," *New York Evening Post*, 2 February 1880, 2.

2. "Brush and Pencil," *New York Daily Tribune*, 26 January 1880, 5.

3. We know little about Homer's comings and goings in the summer of 1879, although it is believed he went both to Massachusetts and Houghton Farm. (Cikovsky and Kelly, *Winslow Homer*, 395.) Wherever he went, it was not public knowledge. In May *Art Interchange* reported: "Winslow Homer does not as yet care to tell his summer resort." ("Studio Notes. Tenth Street Studio," *Art Interchange* 2 [14 May 1879]: 79.) *Art Amateur*, for one, resented not knowing Homer's plans. It quipped: "Of Mr. Winslow Homer's movements in summer-time no person however intimate is ever supposed to have the secret, and the present season is not made an exception." ("Summer Haunts of Artists," *Art Amateur* 1 [August 1879]: 50.) Yet Homer's return to the city was reported as usual in the *World*, which noted he had been " 'all around' " during the summer. ("Bits of Art Gossip About Artists," *New York World*, 9 October 1879, 5.)

4. "Exhibitions and Sales," *American Art Review* 1(December 1879): 84.

5. *A Visit from the Old Mistress* and *Sunday Morning in Virginia* were briefly noted as on view in "Fine Arts," *New York Evening Post*, 9 January 1880, 2; "Fine Arts. Pictures at the Union League," *New York Herald*, 9 January 1880, 6; and "Fine Arts. Art Reception at the Union League," *New York Evening Mail*, 9 January 1880, 4.

6. "The Water-Colors," *Scribner's* 20 (June 1880): 313. See also, "The Water-Colors Again," *New York Times*, 1 February 1880, 2.

7. See, for example, "The Water-Color Exhibition," *New York World*, 7 February 1880, 4.

8. "Fine Arts. Thirteenth Annual Exhibition of the American Water Color Society–Fourth Article," *New York Herald*, 16 February 1880, 8. For similar remarks, see also Mariana Griswold van Rensselaer, "The Water-Color Exhibition, New York," *American Architect and Building News* 7 (28 February 1880): 80–82.

9. "Fine Arts," *New York Evening Post*, 3 March 1880, 2.

10. That the American girl was a distinctive type is corroborated in an article titled "The American Girl," by William Crary Brownell, who, though discussing her in the context of the American novel, defines the American girl as the *Post* and Homer did. Among her most distinctive qualities, according to Brownell, was that she was the product of personal independence and education, "two of the things we prize most." Self-consciousness was also one of her attributes, as were good sense and integrity. See [William Crary Brownell], "The American Girl," *Nation* 30 (8 April 1880): 265–66. Brownell is identified as the author of the article in Haskell, *The Nation* 61.

11. The notion of the artist as individual maker or "genius" surfacing here expands in the 1880s and 1890s to be the distinguishing mark of an artist at the turn of the century. Docherty, "A Search for Identity," 66.

12. "Water-Colors by Winslow Homer," *New York World*, 4 March 1880, 2. While it is known that William Crary Brownell was writing for the *Nation* at this time, it is not known whether he continued in any capacity at the *World* after he relinquished his art critic's position there in 1879. See appendix.

13. Ibid.

14. "Art In The Cities," *Art Journal* 6 (May 1880): 159. The sale results reported in "Winslow Homer's Water-Colors," *New York Times*, 5 March 1880, 8, and "Exhibitions and Sales," *American Art Review* 1 (1880): 269, indicate that the prices for watercolors ranged between nineteen and fifty dollars, while those for drawings ranged between five and fifteen. While the *Times* listed twenty-five watercolors as sold, it is unclear how many drawings were also sold as well as what was the ratio of drawings to watercolors in the sale.

15. "The Union League Club," *New York Times*, 12 March 1880, 5.

16. *New York Times*, 30 March 1879, 6. While the differences between the first and second reviews may reflect a change of opinion, we cannot discount that this discrepancy of responses may also be due to the fact that they were written by different individuals.

17. "Fine Arts. Metropolitan Museum of Art–Some of the Pictures for the Loan Collection–Details of the Approaching Opening," *New York Herald*, 23 March 1880, 13, and "New York's Art Museum," *New York Herald*, 29 March 1880, 3.

18. Edward Strahan [Earl Shinn], "The Art Gallery. The Metropolitan Museum of Art," *Art Amateur* 2 (May 1880): 116.

19. [Mariana Griswold van Rensselaer], "The Metropolitan Museum of Art, New York. The Loan Collections. I," *American Architect and Building News* 8 (17 July 1880): 27.

20. Fewer extended series of reviews appeared, especially in the newspapers. Most papers printed one or two reviews of the show. Only the *Express* and *Herald* published extensive reviews; they each printed seven installments. The June 1880 political conventions may have been another factor that contributed to the reduced number of Academy reviews.

21. "Fine Arts. National Academy of Design. Fifty-Fifth Annual Exhibition," *New York Independent*, 6 May 1880, 7.

22. [William Crary Brownell], "Fine Arts. National Academy of Design–Fifty-Fifth Annual Exhibition, I," *Nation* 30 (15 April 1880): 295. Similar feelings were expressed in the "National Academy of Design. Fifty-Fifth Annual Exhibition," *New York Daily Tribune*, 27 March 1880, 5, and Mariana Griswold van Rensselaer, "Spring Exhibition and Picture Sales In New York, I," *American Architect and Building News* 7 (1 May 1880): 190.

23. "Exhibition of the Academy of Design," *Art Amateur* 2 (May 1880): 112.

24. "Editor's Table. The Spring Exhibitions," *Appleton's Journal* 8 (May 1880): 471–72.

25. William Crary Brownell, "The Younger Painters of America. First Paper," *Scribner's* 20 (May 1880): 3, stated this fact most emphatically.

26. "The Academy Exhibition. The Press View of the Spring Collection," *New York Times*, 27 March 1880, 5. Among those who concurred was "The National Academy," *New York Sun*, 28 March 1880, 5, which pronounced the showing dull. Along the same lines, see "Fine Arts. Fifty-Fifth Annual Exhibition of the National Academy of Design–

Private View–First Article," *New York Herald*, 27 March 1880, 5; "Art at the Academy. Private View of the Fifty-Fifth Annual Exhibition," *New York Evening Telegram*, 27 March 1880, 2; "Fine Arts. Exhibition of the Academy of Design," *New York Evening Mail*, 27 March 1880, 1; and "National Academy of Design. Second Notice," *Art Interchange* 8 (14 April 1880): 63.

27. Strix [George Hows], "Our Feuilleton. Thirty Minutes at the Academy," *New York Evening Express*, 27 March 1880, 1, and Strix [George Hows], "Our Feuilleton. The Academy Exhibition. First Article," *New York Evening Express*, 3 April 1880, 1. Theodore Grannis's unidentified successor at the *Commercial Advertiser* also found the show of greater quality than in years past, applauding the more conservative artists as was its habit, but also now more accepting of French influence, especially for the use of color. "National Academy of Design. Private Press View of the Spring Collection," *New York Commercial Advertiser*, 27 March 1880, 1.

28. Samuel Greene Wheeler Benjamin, "The Exhibitions. V–National Academy of Design. Fifty-Fifth Exhibition. First Notice," *American Art Review* 1 (May 1880): 306–7.

29. For a thorough study of Johnson's *The Cranberry Harvest*, see Marc Simpson, Sally Mills, and Patricia Hills, *Eastman Johnson: The Cranberry Harvest, Island of Nantucket*, exh. cat. (San Diego: Timken Art Gallery, 1990).

30. *Art Amateur*, May 1880, 112. Similar sentiments were expressed in Benjamin, *American Art Review*, May 1880, 309; Strix [George Hows], "Our Feuilleton. The Academy Exhibition. Fourth Article," *New York Evening Express*, 8 May 1880, 1; *New York Evening Telegram*, 27 March 1880, 2; and *New York Herald*, 27 March 1880, 5.

31. Sarah Burns has made this point with other harvesting images. Burns, *Pastoral Inventions*, 36–38.

32. Benjamin, *American Art Review*, May 1880, 308; Samuel Greene Wheeler Benjamin, "The Exhibitions. V–National Academy of Design. Fifty-Fifth Exhibition. Second and Concluding Notice," *American Art Review* 1 (June 1880): 348; "The New York Spring Exhibitions. I. The National Academy Exhibition," *Art Journal* 6 (May 1880): 153; Strix [George Hows], "Our Feuilleton. The Academy Exhibition. Concluding Article," *New York Evening Express*, 15 May 1880, 1; and Brownell, *Scribner's*, May 1880, 15.

33. *Camp Fire* was noted in the press as a completed or nearly completed work in

"Fine Arts. Studio Jottings," *New York Herald*, 1 October 1877, 5, and "Reopening the Studios. New Pictures," *New York Daily Tribune*, 13 October 1877, 2. Although significant reworking of the painting is not obvious, Homer may have added enough "finishing touches" prior to the Academy to justify dating and presenting it as a new picture.

34. See, for example, *New York Evening Mail*, 27 March 1880, 1, and "Fine Arts. Fifty-Fifth Annual Exhibition of the National Academy of Design–Fifth Notice," *New York Herald*, 19 April 1880, 6.

35. *New York Sun*, 28 March 1880, 5; van Rensselaer, *American Architect and Building News*, 1 May 1880, 190–91; and Mariana Griswold van Rensselaer, "Spring Exhibitions and Pictures–Sales in New York. II," *American Architect and Building News* 7 (8 May 1880): 201–2.

36. *New York Commercial Advertiser*, 27 March 1880, 1; *New York Daily Tribune*, 27 March 1880, 5; and "Fine Arts. National Academy of Design. Fifty-Fifth Annual Exhibition. [Second Article]," *New York Daily Tribune*, 4 April 1880, 7.

37. *Appleton's Journal*, May 1880, 471.

38. Benjamin, *American Art Review*, May 1880, 308–9.

39. *Art Amateur*, May 1880, 112.

40. William Crary Brownell, "The Younger Painters of America. Second Paper," *Scribner's* 20 (July 1880): 326.

41. [Brownell], *Nation*, 15 April 1880, 295.

42. Strix [George Hows], "Our Feuilleton. The Academy Exhibition. Third Article," *New York Evening Express*, 24 April 1880, 1.

43. Ibid., and [Brownell], *Nation*, 15 April 1880, 295.

44. "Artists and Their Work. Pictures in the Academy," *New York Times*, 9 April 1880, 5.

45. Ibid.

46. Benjamin, *American Art Review*, May 1880, 309. *New York Evening Post*, 26 January 1880, 2, also noted the painting's simplicity.

47. *New York Times*, 9 April 1880, 5.

48. G.W.S. [George William Sheldon], "Sketches and Studies. II. From the Portfolios of A. H. Thayer, William M. Chase, Winslow Homer, and Peter Moran," *Art Journal* 6 (April 1880): 107.

49. For an expanded discussion of *Camp Fire*, see Tatham, *Homer in the Adirondacks*, 75–80.

50. [Sheldon], *Art Journal*, April 1880, 107.

51. "Winslow Homer designs relinquishing his studio at a date not far distant, and continuing his work in private," reported *Andrew's American Queen* on March 20, 1880. Quoted in Cikosvky and Kelly, *Winslow Homer*, 395. By mid-June, Gilbert Gaul had taken over Homer's former rooms. "Artist's Calendar," *New York Evening Post*, 15 June 1880, 2.

52. "Fine Arts. Annual Meeting of the National Academy of Design," *New York Herald*, 13 May 1880, 6, remarked on the low turnout. Homer is listed in attendance in "The Academy of Design," *New York Evening Post*, 13 May 1880, 4.

53. J. Eastman Chase, "Some Recollections of Winslow Homer," *Harper's Weekly* 54 (22 October 1910): 13.

54. "Fine Arts. Home Notes," *New York Herald*, 6 September 1880, 6, and Greta, "Boston Correspondence," *Art Amateur* 3 (October 1880): 95.

55. "Exhibitions and Sales," *American Art Review* 2 (December 1880): 84, and "Fine Arts," *New York Evening Post*, 11 November 1880, 2.

56. "Fine Arts," *New York Evening Post*, 4 November 1880, 3.

57. "Artists And Their Work," *New York Times*, 13 December 1880, 2. Homer's sensitivity to the cutting words from Boston was suggested in the *Art Interchange*'s last issue of the year. Commenting on Homer's drawing *Bossy*, the writer condemned the image's design and he reprimanded Homer for recent behavior. The writer snipped: "[H]e is 'posé' in the extreme, and affects eccentricities of manner that border upon gross rudeness. To visit him in his studio, is literally bearding a lion in his den; for Mr. Homer's strength as an artist is only equaled by his roughness when he does not happen to be just in the humor of being approached." "The Studio. Art Interchange Artists," *Art Interchange* 5 (22 December 1880): 130.

58. The exclusion of work in black-and-white was a result of the success of the Salmagundi black-and-white exhibitions in 1879.

59. Edward Strahan [Earl Shinn], "Exhibition of the American Water-Color Society," *Art Amateur* 4 (February 1881): 48.

60. "Fine Arts. The Water-Color Society. Fourteenth Annual Exhibition," *New York Daily Tribune*, 22 January 1881, 5.

61. "Among the Water-Colors," *New York Times*, 14 February 1881, 5, specifically pointed out this problem.

62. "Water-Colors at the Academy," *Art Interchange* 6 (3 February 1881): 25.

63. "Fine Arts. Fourteenth Annual Exhibition of the American Water Color Society–Private View Last Evening–First Notice of the Collection," *New York Herald*, 22 January 1881, 7; "Art Notes. The American Water-Color Society," *Art Journal* 7 (March 1881): 95; and "The American Water-Color Society," *New York Sun*, 23 January 1881, 3.

64. *New York Daily Tribune*, 22 January 1881, 5.

65. "Fine Arts. The American Water-Color Society. Fourteenth Exhibition," *New York Independent*, 3 February 1881, 8.

66. "The Water-Color Exhibition," *New York World*, 4 February 1881, 4.

67. "The Water Color Exhibition," *New York Evening Post*, 22 January 1881, 6. [William Crary Brownell], "Fine Arts. The Water-Color Exhibition," *Nation* 32 (3 February 1881): 80–81, noting that watercolor and oil should be used for different purposes, agreed. *Scribner's* stated an opposing position. It felt, once the technical challenges of watercolor had been overcome, the essential interests of the artist were the same as in oil. "Culture and Progress. Winter Picture Exhibitions," *Scribner's* 21 (April 1881): 955.

68. G.W.H. [George W. Hows], "Fine Arts. The Water-Color Exhibition. First Article," *New York Evening Express*, 25 January 1881, 3.

69. G.W.H. [George W. Hows], "Fine Arts. The Water-Color Exhibition. Third Article," *New York Evening Express*, 2 February 1881, 3.

70. See, for example, *New York World*, 4 February 1881, 4; "Water-Color Exhibition," *New York World*, 13 February 1881, 4; "The Water Color Exhibition," *New York Daily Graphic*, 26 January 1881, 637; and "Art Notes. The Great Success of the American Society of Water Colors," *New York Commercial Advertiser*, 24 January 1881, 1.

71. Homer's entries were: *Eastern Point Light* (fig. 138); *Gloucester, Mass.*; *Winding the Clock* (fig. 137); *Something Good about This!*; *Girl Reading*; *Clover*; *Girl*; *Sunset* (now known as *Sunset Fires*; fig. 127);

Coasters at Anchor; *July Morning*; *Gloucester Boys*; *A Lively Time*; *On the Housatonic River*; *Early Morning*; *Sunset* (now known as *Gloucester Sunset*; fig. 134); *Schooners at Anchor*; *Ozone*; *Field Point, Greenwich, Conn.*; *Three Boys*; *The Yacht Hope*; *Fishing Boats at Anchor*; and two simply called *Water Color*. Precise identification of many of these Gloucester watercolors is difficult due to their generic titles. On their placement, see, for example, *New York Sun*, 23 January 1881, 3, and "Fine Arts. Fourteenth Annual Exhibition of the American Water Color Society–Sixth and Concluding Notice," *New York Herald*, 21 February 1881, 6.

72. "Fine Arts. American Water-Color Society. Fourteenth Annual Exhibition. [Second Notice]," *New York Daily Tribune*, 29 January 1881, 5.

73. See, for example, *New York Sun*, 23 January 1881, 3, and "The Water-Color Society," *New York Times*, 6 February 1881, 5.

74. "Fine Arts. Fourteenth Annual Exhibition of the American Water Color Society–Third Notice," *New York Herald*, 31 January 1881, 6, and G.W.H. [George W. Hows], "Fine Arts. The Water-Color Exhibition. Fourth Article," *New York Evening Express*, 8 February 1881, 3.

75. Of the ones definitively identified today, we know that the sizes of the sheets varied from 8 x 12 inches to 13 x 19 inches. Foster, "Makers of the American Watercolor Movement," 66–67, outlined how the press encouraged artists to create watercolors that were modest in scale. "The Fine Arts. The Water-Color Exhibition. (Second Notice)," *Critic* 1 (12 February 1881): 39.

76. *New York Independent*, 3 February 1881, 8.

77. The presence of light effects and strong design elements of these sheets have been long noted by modern scholars, most recently in D. Scott Atkinson, "Winslow Homer in Gloucester 1880: An Artist Apart," in *Winslow Homer in Gloucester*, exh. cat. (Chicago: Terra Museum of American Art, 1990), 54, and Cikovsky and Kelly, *Winslow Homer*, 197–99.

78. Edward Hale to "Margaret," 2 December 1880, quoted in Cikovsky and Kelly, *Winslow Homer*, 197.

79. It is interesting to consider how Currier's watercolors shown in the winter of 1879 may have had a bearing on Homer's most radical sheets of 1880. I thank William H. Gerdts for his insight on this topic.

80. G.W.H. [George W. Hows], *New York Evening Express*, 25 January 1881, 3. *Art Interchange* had a dramatically opposite reaction, liking this sheet best for the "young girl's keen delight in the water, the clear air and summer sky." *Art Interchange*, 3 February 1881, 25.

81. G.W.H. [George W. Hows], "Fine Arts. The Water-Color Exhibition. Concluding Article," *New York Evening Express*, 12 February 1881, 3.

82. Ibid.

83. On Conkling, see "Roscoe Conkling," in Barbara A. Chernow and George A. Vallasi, eds., *The Columbia Encyclopedia*, fifth ed. (New York: Columbia University Press, 1993).

84. G.W.H., *New York Evening Express*, 12 February 1881, 3.

85. G.W.H., *New York Evening Express*, 2 February 1881, 3.

86. Ibid.

87. "Painters in Water-Color. The Exhibition at the Academy of Design," *New York Times*, 22 January 1881, 2.

88. "More Water Colors," *New York Evening Telegram*, 3 February 1881, 2.

89. "Pictures Here and There. Water Colors in the Corridor of the Academy of Fine Arts," *New York Evening Telegram*, 12 February 1881, 2.

90. Ibid.

91. S.G.W.B. [Samuel Greene Wheeler Benjamin], "The Exhibitions. V–Fourteenth Annual Exhibition of the American Water Color Society," *American Art Review* 2 (March 1881): 196.

92. *New York Sun*, 23 January 1881, 3.

93. Laffan reserved his highest praise for Robert Blum and Thomas Hovenden for their achievements of artistic completeness. Ibid.

94. Ibid.

95. "Fine Arts. The American Water-Color Society. Fourteenth Annual Exhibition. Third Notice," *New York Daily Tribune*, 14 February 1881, 5.

96. *New York Daily Tribune*, 29 January 1881, 5.

97. *New York Daily Tribune*, 22 January 1881, 5.

98. *New York Daily Tribune*, 29 January 1881, 6.

99. Ibid.

100. Ibid.

101. Ibid.

102. Mariana Griswold van Rensselaer, "The Water Color Exhibition, New York," *American Architect and Building News* 9 (19 March 1881): 135.

103. Ibid.

104. Within a few weeks of van Rensselaer's review in *American Architect and Building News*, she succinctly stated in *Lippincott's*: "Frank 'impressionism,' indeed is characteristic now of many of our cleverest men. Mr. Winslow Homer led the list this year, perhaps, and his rivals were Mr. Blum and Mr. Currier, who are both impressionists, though of very different kinds." M.G.v.R. [Mariana Griswold van Rensselaer], "Our Monthly Gossip. Art Matters. The New York Water-Color Exhibition," *Lippincott's* 27 (April 1881): 417–18.

105. van Rensselaer, *American Architect and Building News*, 19 March 1881, 135.

106. Ibid.

107. Mariana Griswold van Rensselaer, "The New York Art Season," *Atlantic* 48 (August 1881): 196.

108. M.G.v.R. [Mariana Griswold van Rensselaer], "An American Artist in England," *Century Magazine* 27 (November 1883): 15.

109. *New York Independent*, 3 February 1881, 8.

110. Ibid.

111. *Scribner's*, April 1881, 955.

112. Ibid., 955–56.

113. [Brownell], *Nation*, 3 February 1881, 80.

114. Ibid.

115. Ibid.

116. Ibid.

117. Ibid.

118. Ibid.

119. Ibid.

120. Strahan, *Art Amateur*, February 1881, 48.

121. Ibid.

122. Ibid.

123. Ibid.

124. Yount, "'Give the People What They Want.'"

125. See "A Rare Collection Rare Pictures," *New York Times*, 28 March 1880, 7; "English Art and Artists," *New York Times*, 24 May 1880, 5; "London's Art Galleries," *New York Times*, 31 May 1880, 5; "At the Royal Academy," *New York Times*, 3 June 1880, 5; "London Art Galleries," *New York Times*, 5 June 1880, 5; "New Publications," *New York Times*, 23 December 1880, 6; William C. Ward, "Fine Arts. Contemporary Art in England," *New York Independent*, 24 June 1880, 6–7; and William C. Ward, "Fine Arts. Contemporary Art in England," *New York Independent*, 29 July 1880, 9.

126. "The Art Gallery. American Pictures at Paris and London," *Art Amateur* 3 (July 1880): 26–27. It is worthwhile to note how a number of the American artists with English connections were men with whom Homer had artistic or personal ties. For example, Hennessey had been a good friend early in the decade and Brown was not only a fellow resident of the Tenth Street Studio Building, but a competitor in the field of figure painting.

127. Foster, "Makers of the American Watercolor Movement," 280, and Linda S. Ferber, "The Power of Patronage: William Trost Richards and the American Watercolor Movement," in Ferber and Gallati, *Masters of Light and Color*, 85. Abbey and Richards were two other artists with whom Homer's career had closely intersected over the last decade.

128. Ferber, "The Power of Patronage," in Ferber and Gallati, *Masters of Light and Color*, 86.

129. "Topics of the Time. Pettiness in Art," *Scribner's* 20 (May 1880): 146.

130. "Fine Arts. The Bridgman Reception," *New York Herald*, 13 March 1881, 16, and "Fine Arts," *New York Evening Post*, 16 March 1881, 4.

131. Homer departed for England eleven days before the reception for Bridgman, which was held March 24. "Reception to Mr. Bridgman," *New York Daily Tribune*, 25 March 1881, 5.

132. The *Mail* reported that twenty artists were sailing to Europe in June. "Studio Notes," *New York Evening Mail*, 31 May 1880, 1.

133. "Gossip About New York Artists," *New York Evening Post*, 3 June 1881, 4.

134. Mariana Griswold van Rensselaer, "An American Artist in England," *Century Magazine* 27 (November 1883): 13–21.

135. Homer's behavior again was recognized as comparable to that of many American artists of the last quarter of the nineteenth century. For example, such a viewpoint appears in Christian Brinton, "Winslow Homer," *Scribner's Magazine* 49 (January 1911): 18; J. Walker McSpadden, "Winslow Homer, The Painter of Seclusion," in *Famous Painters of America* (New York: Dodd, Mead & Co., 1916), 183; and Theodore Bolton, "The Art of Winslow Homer: An Estimate of 1932," *The Fine Arts* 18 (February 1932): 23–28.

Notes to Chapter 9

1. S.G.W. Benjamin, "The Exhibitions. VII–National Academy of Design. Fifty-Sixth Exhibition," *American Art Review* 2 (May 1881): 23.

2. *Art Journal* 2 (June 1876), 190.

3. Most recently, Nicolai Cikovsky has suggested lost love caused Homer an emotional crisis in "Reconstruction," in Cikovsky and Kelly, *Winslow Homer*, 103–4.

4. A. B. Adamson, "The Homer That I Knew," in Tony Knipe and John Boon, *Winslow Homer: All the Cullercoats Pictures*, exh. cat. (Sunderland, England: Northern Centre for Contemporary Art, 1988), 16.

Selected Bibliography

GENERAL

BOOKS AND CATALOGUES

Banner, Lois W. *American Beauty*. Chicago: The University of Chicago Press, 1983.

Banta, Martha. *Imaging American Women: Ideas and Ideals in Cultural History*. New York: Columbia University Press, 1987.

Beatty, Richmond Croom. *James Russell Lowell*. Nashville: Vanderbilt University Press, 1942.

Bender, Thomas. *New York Intellect: A History of Intellectual Life in New York City, from 1750 to the Beginnings of Our Own Time*. New York: Alfred Knopf, 1987.

Bercovitch, Sacvan, and Myra Jehlen, eds. *Ideology and American Literature*. New York: Cambridge University Press, 1986.

Brooks, Van Wyck. *New England Indian Summer, 1865–1915*. New York: Dutton, 1940.

Brown, Clarence Arthur. *The Achievement of American Criticism*. New York: Ronald Press, 1954.

Browne, Junius Henri. *The Great Metropolis: A Mirror of New York*. Hartford, Conn.: America Publishing Co., 1869.

Buck, Paul H. *The Road to Reunion, 1865–1900*. Boston: Little, Brown and Company, 1937.

Charvat, William. *The Origins of American Critical Thought 1810–35*. Philadelphia: University of Pennsylvania Press, 1936.

Davidson, Cathy N., ed. *Reading in America: Literature and Social History*. Baltimore: The Johns Hopkins University Press, 1989.

Degler, Carl N. *At Odds: Women and the Family in America from the Revolution to the Present*. New York: Oxford University Press, 1980.

Dicken-Garcia, Hazel. *Journalistic Standards in Nineteenth Century America*. Madison: University of Wisconsin Press, 1989.

Douglas, Ann. *The Feminization of American Culture*. 2d ed. New York: Doubleday, 1988.

Foner, Eric. *Reconstruction: America's Unfinished Revolution, 1863–77*. New York: Harper and Row, 1988.

Green, Harvey. *The Light of the House: An Intimate View of the Lives of Women in Victorian America*. New York: Pantheon Books, 1983.

Hall, Peter Dobkin. *The Organization of American Culture, 1700–1900: Private Institutions, Elites, and the Origins of American Nationality*. New York: New York University Press, 1982.

Halttunen, Karen. *Confidence Men and Painted Women: A Study of Middle-Class Culture in America, 1830–1870*. New Haven: Yale University Press, 1982.

Harris, Neil. *Cultural Excursions: Marketing Appetites and Cultural Tastes in Modern America*. Chicago: University of Chicago Press, 1990.

Heininger, Mary Lynn Stevens. *At Home with a Book: Reading in America, 1840–1940*. Rochester, N.Y.: Strong Museum, 1986.

——, et al. *A Century of Childhood*. Exh. cat. Rochester, N.Y.: Margaret Woodbury Strong Museum, 1984.

Higham, John. *Strangers in the Land: Patterns of American Nativism, 1860–1925*. New Brunswick, N.J.: Rutgers University Press, 1955.

Jackson, Kenneth T., ed. *The Encyclopedia of New York City*. New Haven, Conn.: Yale University Press, 1995.

Kasson, John F. *Rudeness and Civility: Manners in Nineteenth-Century Urban America*. New York: Hill and Wang, 1990.

Kirkland, Edward Chase. *Dream and Thought in the Business Community, 1860–1900*. Ithaca, N.Y.: Cornell University Press, 1956.

Lears, T. Jackson. *No Place of Grace: Antimodernism and the Transformation of American Culture 1880–1920*. New York: Pantheon Books, 1981.

Lenček, Lena, and Gideon Bosker. *The Beach: The History of Paradise on Earth*. New York: Viking, 1998.

McCabe, James D., Jr. *Light and Shadows of New York Life*. 1872. Reprint, New York: Farrar, Straus, and Giroux, 1970.

——. *New York By Gaslight: A Work Descriptive of the Great American Metropolis*. 1882. Reprint, New York: Greenwich House, 1984.

McKelvey, Blake. *The Urbanization of America 1860–1915*. New Brunswick, N.J.: Rutgers University Press, 1963.

Maass, John. *That Glorious Enterprise: The Centennial Exhibition of 1876 and H. J. Schwarzmann, Architect-in-Chief*. Watkins Glen, N.Y.: American Life Foundation, 1973.

Machor, James L., ed. *Readers in History: Nineteenth-Century American Literature*

and the Contexts of Response. Baltimore: The Johns Hopkins University Press, 1992.

Martin, Jay. Harvests of Change: American Literature, 1865–1914. Englewood Cliffs, N.J.: Prentice-Hall, 1967.

Morgan, H. Wayne. Victorian Culture in America, 1865–1914. Itaca, Ill.: F. E. Peacock, 1973.

Morris, Richard Brandon. Encyclopedia of American History. New York: Harper, 1953.

Mott, Frank Luther. American Journalism, A History: 1690–1960, 3d. ed. New York: MacMillan, 1962.

———. The History of American Magazines. 3 Vols. Cambridge, Mass.: Harvard University Press, 1967.

Mumford, Lewis. The Golden Day: A Study in American Literature and Culture. 3d ed. New York: Dover Publications, 1968.

Myerson, Joel, ed. The American Renaissance in New England. Detroit: Gale Research Co., 1978.

Nash, Roderick. Wilderness and the American Mind. Rev. ed. New Haven, Conn.: Yale University Press, 1978.

Nevins, Allan. The Emergence of Modern America, 1865–1878. New York: Macmillan, 1927.

Oleson, Alexandra, and John Voss, eds. The Organization of Knowledge in Modern America, 1860–1920. Baltimore: The Johns Hopkins University Press, 1979.

Parrington, Vernon Louis. Main Currents in American Thought: The Beginnings of Critical Realism in America, 1860–1920. Vol. 3. New York: Harcourt, Brace, 1930.

Pizer, Donald, and Earl N. Harbert. American Realists and Naturalists. Detroit: Gale Research Co., 1982.

Prichard, John Paul. Criticism in America. Norman: University of Oklahoma Press, 1956.

Raleigh, John Henry. Matthew Arnold and American Culture. Berkeley: University of California Press, 1957.

Rathbun, John, and Harry H. Clark. American Literary Criticism, 1860–1905. Boston: Twayne Publishers, 1979.

Rourke, Constance. American Humor. 1931. Reprint, New York: Harcourt Brace Jovanovich, 1959.

Schlereth, Thomas J. Victorian America: Transformations in Everyday Life, 1876–1915. New York: Harper Collins, 1991.

Smith, Henry Nash, ed. Popular Culture and Industrialism, 1865–1890. Garden City, N.Y.: Anchor Books, 1967.

Spencer, Benjamin T. The Quest for Nationality; An American Campaign. Syracuse, N.Y.: Syracuse University Press, 1957.

Summers, Mark W. The Gilded Age. Upper Saddle River, N.J.: Prentice Hall, 1997.

Sutherland, Daniel E. The Expansion of Everyday Life, 1860–1876. New York: Harper and Row, 1989.

Trachtenberg, Alan. The Incorporation of America: Culture and Society in the Gilded Age. New York: Hill and Wang, 1982.

ART

BOOKS AND CATALOGUES

Armstrong, David Maitland. Day Before Yesterday: Reminiscences of a Varied Life. New York: Charles Scribner's Sons, 1920.

Axelrod, Alex, ed. The Colonial Revival. New York: W. W. Norton, 1985.

Bermingham, Peter. American Art in the Barbizon Mood. Exh. cat. Washington, D.C.: Smithsonian Institution Press, 1975.

Boime, Albert. Thomas Couture and the Eclectic Vision. New Haven, Conn.: Yale University Press, 1980.

Bott, Katharina, and Gerhard Bott, eds. Vice Versa: Deutsche Maler in Amerika, Amerikanische Maler in Deutschland, 1813–1913. Exh. cat. Munich: Hirmer Verlag, 1996.

Burke, Doreen Bolger, et al. In Pursuit of Beauty: Americans and the Aesthetic Movement. Exh. cat. New York: Rizzoli, 1986.

Burnham, Patricia M., and Lucretia Hoover Giese, eds. Redefining American History Painting. New York: Cambridge University Press, 1995.

Burns, Sarah. Inventing the Modern Artist: Art and Culture in Gilded Age America. New Haven, Conn.: Yale University Press, 1996.

———. Pastoral Inventions: Rural Life in Nineteenth Century American Art and Culture.

Philadelphia: Temple University Press, 1989.

Campbell, Catherine, et al. The White Mountains: Place and Perceptions. Hanover, N.H.: University Presses of New England, 1980.

Carbone, Teresa A., and Patricia Hills. Eastman Johnson: Painting America. Exh. cat. Brooklyn: Brooklyn Museum of Art, 1999.

Casteras, Susan P. English Pre-Raphaelitism and Its Reception in America in the Nineteenth Century. Cranbury, N.J.: Associated University Presses, 1990.

Champney, Benjamin. Sixty Years' Memories of Art and Artists. Woburn, Mass.: Wallace & Andrews, 1900.

Clark, Eliot. History of the National Academy of Design, 1825–1953. New York: Columbia University Press, 1954.

Edwards, Lee. Domestic Bliss: Family Life in American Painting, 1840–1910. Exh. cat. Yonkers, N.Y.: Hudson River Museum, 1985.

Ferber, Linda, and Barbara Dayer Gallati. Masters of Color and Light: Homer, Sargent, and the American Watercolor Movement. Exh. cat. Washington, D.C.: Smithsonian Institution Press, 1998.

———, and William H. Gerdts. The New Path: Ruskin and the American Pre-Raphaelites. Exh. cat. Brooklyn: Brooklyn Museum of Art, 1985.

Fink, Lois Marie, and Joshua C. Taylor. Academy: The Academic Tradition in American Art. Exh. cat. Washington, D.C.: Smithsonian Institution Press, 1975.

Gallati, Barbara Dayer. William Merritt Chase. New York: Harry N. Abrams, Inc., 1995.

Gerdts, William H. American Impressionism. New York: Abbeville Press, 1984.

———, and James Yarnall, comps. Index to American Art Exhibition Catalogues. Boston: G. K. Hall, 1986.

Goetz, Thomas H. Taine and the Fine Arts. Madrid: Playor, 1973.

Harris, Neil. The Artist in American Society: 1790–1860. Chicago: University of Chicago Press, 1966.

Harvey, Eleanor Jones. The Painted Sketch: American Impressions from Nature, 1830–1880. Exh. cat. Dallas: Dallas Museum of Art, 1998.

Hills, Patricia. *The Genre Painting of Eastman Johnson: The Sources and Development of the Style and Themes.* New York: Garland, 1977.

——. *The Painter's America: Rural and Urban Life, 1810–1910.* New York: Praeger Publishers, 1974.

Hobbs, Susan. *American Art at the Centennial.* Exh. cat. Washington, D.C.: National Collection of Fine Arts, 1976.

Howat, John K., et al. *American Paradise: The World of the Hudson River School.* Exh. cat. New York: Metropolitan Museum of Art, 1987.

Huntington, David, and Kathleen Pyne. *Quest for Unity: American Art Between World's Fairs 1876–1893.* Exh. cat. Detroit: Detroit Institute of Arts, 1983.

Jacobs, Michael. *The Good and Simple Life: Artist Colonies in Europe and America.* Oxford: Phaidon Press, 1985.

Johns, Elizabeth. *American Genre Painting: The Politics of Everyday Life.* New Haven, Conn.: Yale University Press, 1991.

Kelly, Franklin, et al. *American Paintings of the Nineteenth Century.* Washington, D.C.: National Gallery of Art, 1996.

Kivy, Peter, ed. *Essays on the History of Aesthetics.* Rochester, N.Y.: University of Rochester Press, 1992.

Lancaster, Clay. *The Japanese Influence in America.* New York: Abbeville Press, 1993.

Lawall, David B. *Asher B. Durand: A Documentary Catalogue of the Narrative and Landscape Paintings.* New York: Garland Publishing, 1978.

Low, Will H. *A Chronicle of Friendships 1873–1900.* New York: Scribner's Sons, 1908.

Meixner, Laura L. *French Realist Painting and the Critique of American Society, 1865–1900.* New York: Cambridge University Press, 1995.

——. *An International Episode: Millet, Monet and Their North American Counterparts.* Exh. cat. Memphis: The Dixon Gallery and Gardens, 1982.

Morgan, H. Wayne. *New Muses: Art in American Culture, 1865–1920.* Norman: University of Oklahoma Press, 1978.

Mumford, Lewis. *The Brown Decades: A Study of the Arts in America.* 2d rev. ed. New York: Dover Books, 1955.

Murphy, Francis. *The Book of Nature: American Painters and the Natural Sublime.* Exh. cat. Yonkers, N.Y.: Hudson River Museum, 1983.

O'Leary, Elizabeth. *At Beck and Call: The Representation of Domestic Servants in Nineteenth-Century American Painting.* Washington, D.C.: Smithsonian Institution Press, 1996.

Pisano, Ronald G. *The Tile Club and the Aesthetic Movement in America.* New York: Harry N. Abrams, Inc., 1999.

Quick, Michael, and Eberhard Ruhmer. *Munich and American Realism in the Nineteenth Century.* Exh. cat. Sacramento: E. B. Crocker Art Gallery, 1978.

Rainey, Sue. *Creating "Picturesque America": Monument to the National and Cultural Landscapes.* Nashville, Tenn.: Vanderbilt University Press, 1994.

Robinson, Frank T. *Living New England Artists.* 1888. Reprint, New York: Garland, 1977.

Sill, Geoffrey M., and Roberta K. Tarbell, eds. *Walt Whitman and the Visual Arts.* New Brunswick, N.J.: Rutgers University Press, 1992.

Simpson, Marc, Sally Mills, and Patricia Hills. *Eastman Johnson: The Cranberry Harvest, Island of Nantucket.* Exh. cat. San Diego: Timken Art Gallery, 1990.

Sizer, Theodore, ed. *The Recollections of John Ferguson Weir.* New Haven, Conn.: Yale University Press, 1957.

Spassky, Natalie. *American Paintings in The Metropolitan Museum of Art.* Vol. 2. New York: The Metropolitan Museum of Art, 1980.

Stein, Roger. *John Ruskin and Aesthetic Thought in America, 1840–1900.* Cambridge, Mass.: Harvard University Press, 1967.

Stevens, Mary Anne, ed. *The Orientalists: Delacroix to Matisse: The Allure of North Africa and the Near East.* Exh. cat. New York: Thames and Hudson, 1984.

Strickler, Susan E., ed. *American Traditions in Watercolor: The Worcester Art Museum Collection.* New York: Abbeville Press, 1987.

Sturges, Hollister. *Jules Breton and the French Rural Tradition.* Exh. cat. Omaha: Josyln Art Museum, 1982.

Sullivan, Edward J. *Fortuny: 1838–1874.* Exh. cat. Barcelona: Fundació Caixa de Pensions, 1989.

Taylor, Joshua C. *The Fine Arts in America.* Chicago: University of Chicago Press, 1979.

Truettner, William H., and Roger B. Stein, eds. *Picturing Old New England: Image and Memory.* Exh. cat. Washington, D. C.: National Museum of American Art, 1999.

Tuckerman, Henry. *Book of the Artists.* 1867. Reprint, New York: J. F. Carr, 1966.

Weinberg, H. Barbara. *The Lure of Paris.* New York: Abbeville Press, 1991.

Weiss, Ila. *Poetic Landscape: The Art and Experience of Sanford R. Gifford.* Newark: University of Delaware Press, 1987.

White, Nelson. *The Life and Art of J. Frank Currier.* Cambridge, Mass.: Riverside Press, 1935.

Wilmerding, John, ed. *American Light: The Luminist Movement, 1850–75: Paintings, Drawings, Photographs.* Exh. cat. Washington D.C.: National Gallery of Art, 1980.

Winner, Viola Hopkins. *Henry James and the Visual Arts.* Charlottesville: University of Virginia Press, 1970.

DISSERTATIONS, THESES, AND PAPERS

Adams, Karen M. "Black Images in Nineteenth Century American Painting and Literature." Ph.D. diss., Emory University, 1977.

Baxter, Jean Taylor. "Burdens and Rewards: Some Issues for American Artists, 1865–76." Ph.D. diss., University of Maryland, 1988.

Bermingham, Peter. "Barbizon Art in America: A Study of the Role of the Barbizon School in the Development of American Painting, 1850–1895." Ph.D. diss., University of Michigan, 1972.

Bienenstock, Jennifer A. Martin. "The Formation and Early Years of the Society of American Artists: 1877–1884." Ph.D. diss., City University of New York, 1983.

Blaugrund, Annette. "The Tenth Street Studio Building (New York)," Ph.D. diss., Columbia University, 1987.

Bolas, Gerald D. "The Early Years of the American Art Association, 1879–1900." Ph.D. diss., City University of New York, 1998.

Burns, Sarah. "The Poetic Mode in American Painting: George Fuller and Thomas

Dewing." Ph.D. diss., University of Illinois, Urbana-Champaign, 1979.

Dinnerstein, Lois. "Opulence and Ocular Delight, Splendor and Squalor: Critical Writings in Art and Architecture by Mariana Griswold van Rensselaer." Ph.D. diss., City University of New York Graduate Center, 1979.

Docherty, Linda Jones. "A Search for Identity: American Art Criticism and the Concept of the 'Native School,' 1876–1893." Ph.D. diss., University of North Carolina, Chapel Hill, 1985.

Fink, Lois. "The Role of France in American Art, 1850–1870." Ph.D. diss., University of Chicago, 1970.

Fletcher, Frank. "The Critical Values of William Crary Brownell." Ph.D. diss., University of Michigan, 1951.

Foster, Kathleen Adair. "Makers of the American Watercolor Movement, 1860–90." Ph.D. diss., Yale University, 1982.

Laidlaw, Christine Wallace. "The American Reaction to Japanese Art, 1853–1876." Ph.D. diss., Rutgers University, 1996.

Meixner, Laura Lee. "Jean-François Millet: His American Students and Influence." Ph.D. diss., Ohio State University, 1979.

Myers, Julia Rowland. "The American Expatriate Painters of French Peasantry, 1863–1893." Ph.D. diss., University of Maryland, 1989.

Peters, Lisa N. "Charles DeKay: Art Critic for the People." Unpublished paper, 1985; courtesy William H. Gerdts American Art Library.

Roberts, Helene Emylou. "American Art Periodicals of the Nineteenth Century." Master's thesis, University of Washington, 1961.

Simon, Janice. "*The Crayon*, 1855–61: The Voice of Nature in Criticism, Poetry, and the Fine Arts." Ph.D. diss., University of Michigan, 1990.

Simoni, John P. "Art Critics and Criticism in Nineteenth Century America." Ph.D. diss., Ohio State University, 1952.

Skalet, Linda Henfield. "The Market for American Painting in New York, 1870–1915." Ph.D. diss., Johns Hopkins University, 1980.

Tolles, Thayer. "Helena deKay Gilder: Her Artistic and Institutional Achievements During the 1870s." Master's thesis, University of Delaware, 1990.

Van Hook, Leila Bailey. "The Ideal Woman in American Art, 1875–1910." Ph.D. diss., City University of New York, 1988.

Weiss, Jo Ann W. "Clarence Cook: The Critical Writings." Ph.D. diss., Johns Hopkins University, 1976.

Wright, Lesley Carol. "Men Making Meaning in Nineteenth Century American Genre Painting, 1860–1900." Ph.D. diss., Stanford University, 1993.

Yount, Sylvia L. "'Give the People What They Want': The American Aesthetic Movement, Art Worlds, and Consumer Culture, 1876–1890." Ph.D. diss., University of Pennsylvania, 1995.

Zalesch, Saul. "Ryder and Writers: Friendship and Patronage in the New York Art World, 1874–84." Ph.D. diss., University of Delaware, 1992.

ARTICLES

Blaugrund, Annette. "The Tenth Street Studio Building: A Roster, 1857–95." *American Art Journal* 14 (spring 1982): 64–71.

Burns, Sarah. "Barefoot Boys and Other Country Children: Sentiment and Ideology in Nineteenth-Century American Art." *American Art Journal* 20 (1988): 24–50.

——. "Yankee Romance: The Comic Courtship Scene in Nineteenth-Century American Art." *American Art Journal* 18 (1986): 53–75.

Commager, Henry Steele. "The Artist in American History." *The Corcoran Gallery of Art Bulletin* 4 (June 1951): 2–13.

Curti, Merle. "America at the World's Fairs, 1851–1893." *American Historical Review* 55 (July 1950): 833–56.

Davis, John. "Children in the Parlor: Eastman Johnson's *Brown Family* and the Post-Civil War Luxury Interior." *American Art* 10 (summer 1996): 61–65.

Fidell-Beaufort, Madeline, and Jeanne K. Welcher. "Some Views of Art Buying in New York in the 1870s and 1880s." *Oxford Art Journal* 5 (1982): 48–55.

Fink, Lois M. "American Artists in France, 1850–1870." *American Art Journal* 5 (November 1973): 49.

——. "French Art in the United States, 1850–1870: Three Dealers and Collectors." *Gazette des Beaux-Arts* 92 (September 1978): 87–100.

Gallatin, A. E. "Notes on Some Masters of the Water Color." *Arts and Decoration* 4 (April 1916): 278–79.

Gerdts, William H. "The American 'Discourses': A Survey of Lectures and Writings on American Art, 1770–1858." *American Art Journal* 15 (summer 1983): 61–79.

——. "American Landscape Painting; Critical Judgments, 1730–1845." *American Art Journal* 17 (winter 1985): 28–59.

Goodrich, Lloyd. "The Study of Nineteenth-Century Art." *Art in America* 33 (October 1945): 220–40.

——. "What is American in American Art?" *Art in America* 4 (1963): 24–39.

Harris, Neil. "Realism, Photography and Journalistic Objectivity in Nineteenth Century America." *Studies in the Anthropology of Visual Communication* 4 (winter 1977): 86–98.

Johnston, W. R. "Fortuny and His Circle." *Walters Art Gallery Bulletin Supplement* 2 (April 1970): n.p.

——. "W. H. Stewart, The American Patron of Mariano Fortuny." *Gazette des Beaux-Arts* 77 (March 1971): 183–88.

Matthews, Mildred B. "The Painters of the Hudson River School in the Philadelphia Centennial Exhibition of 1876." *Art in America* 34 (July 1946): 143–60.

Meixner, Laura Lee. "Popular Criticism of Jean-Francois Millet in Nineteenth Century America." *Art Bulletin* 65 (March 1983): 94–105.

Meservey, Ann Farmer. "The Role of Art in American Life: Critics' Views on Native Art and Literature, 1830–65." *American Art Journal* 10 (May 1978): 73–89.

Miller, Lillian B. "Painting, Sculpture and the National Character, 1815–60." *Journal of American History* 53 (March 1967): 696–707.

O'Doherty, Barbara Novak. "Some American Words: Basic Aesthetic Guidelines, 1825–1870." *American Art Journal* 1 (spring 1969): 78–91.

Troyen, Carol. "Innocents Abroad: American Painters at the 1867 Exposition Universelle, Paris." *American Art Journal* 16 (autumn 1984): 3–29.

Walsh, J. C., and S. E. Strickler. "Technique in American Watercolors from the Worcester Art Museum, Mass." *Antiques* 131 (February 1987): 412–25.

"Walter Shirlaw." *Bulletin of the Brooklyn Institute of Arts and Sciences* 5 (October 15, 1910): n.p.

Weinberg, H. Barbara. "Thomas B. Clark: Foremost Patron of American Art from 1872–1899." *American Art Journal* 8 (1976): 60–75.

Young, Mahonri Sharp. "The Tile Club Revisited." *American Art Journal* 2 (fall 1970): 81–91.

Zalesch, Saul E. "Competition and Conflict in the New York Art World, 1874–79." *Winterthur Portfolio* 29 (summer/autumn 1994): 103–20.

WINSLOW HOMER

BOOKS AND CATALOGUES

Atkinson, D. Scott. *Winslow Homer in Gloucester*. Exh. cat. Chicago: Terra Museum of American Art, 1990.

Beam, Philip C. *Winslow Homer's Magazine Engravings*. New York: Harper and Row, 1979.

Cikovsky, Nicolai, Jr., ed. *Winslow Homer, A Symposium*. Washington, D.C.: National Gallery of Art, 1990.

——, and Franklin Kelly. *Winslow Homer*. Washington, D.C.: National Gallery of Art, 1995.

Cooper, Helen A. *Winslow Homer Watercolors*. Exh. cat. Washington, D.C.: National Gallery of Art, 1986.

Cox, Kenyon. *Winslow Homer*. New York: (privately printed), 1914.

Curry, David Park. *Winslow Homer: The Croquet Game*. New Haven, Conn.: Yale University Art Gallery, 1984.

Downes, William Howe. *The Life and Works of Winslow Homer*. Boston: Houghton Mifflin, 1911.

Gardner, Albert Ten Eyck. *Winslow Homer, American Artist: His World and His Work*. New York: Clarkson Potter, 1961.

Goodrich, Lloyd. *The Graphic Art of Winslow Homer*. Exh. cat. New York: The Museum of Graphic Art, 1968.

——. *Winslow Homer*. New York: Macmillan, 1944.

——. *Winslow Homer*. New York: The Whitney Museum of American Art, 1973.

——, and Abigail Booth Gerdts. *Winslow Homer in Monochrome*. New York: Knoedler & Co., 1986.

Green, Samuel M. *The Harold Trowbridge Pulsifer Collection of Winslow Homer Paintings and Drawings at Colby College*. Waterville, Maine: Colby College Press, 1949.

Hendricks, Gordon. *The Life and Work of Winslow Homer*. New York: Harry N. Abrams, Inc., 1979.

Knipe, Tony, and John Boon. *Winslow Homer: All the Cullercoats Pictures*. Exh. cat. Sunderland, England: Northern Centre for Contemporary Art, 1988.

Murphy, Alexandra R. *Winslow Homer in the Clark Collection*. Williamstown, Mass.: The Sterling and Francine Clark Art Institute, 1986.

Pousette-Dart, Nathaniel. *Winslow Homer*. New York: Frederick A. Stokes, 1923.

Simpson, Marc, et al. *Winslow Homer: Paintings of the Civil War*. Exh. cat. San Francisco: Fine Arts Museums of San Francisco, 1985.

Tatham, David. *Winslow Homer and the Illustrated Book*. Syracuse, N.Y.: Syracuse University Press, 1992.

——. *Winslow Homer in the Adirondacks*. Syracuse, N.Y.: Syracuse University Press, 1996.

Watson, Forbes. *Winslow Homer*. New York: Crown, 1942.

Wilmerding, John. *Winslow Homer*. New York: Praeger, 1972.

——, and Linda Ayres. *Winslow Homer in the 1870s*. Exh. cat. Princeton, N.J.: Princeton University Press, 1990.

——, and Elaine Evans Dee. *Winslow Homer, 1836–1910: A Selection from the Cooper-Hewitt Collection, Smithsonian Institution*. Washington, D.C.: Smithsonian Institution Press, 1972.

——, ed. *Essays in Honor of Paul Mellon*. Washington, D.C.: National Gallery of Art, 1986.

Winslow Homer Memorial Exhibition. Exh. cat. New York: The Metropolitan Museum of Art, 1911.

Wood, Peter H., and Karen C. C. Dalton. *Winslow Homer's Images of Blacks: The Civil War and Reconstruction Years*. Exh. cat. Austin: University of Texas Press, 1988.

DISSERTATIONS, THESES, AND PAPERS

Carren, Rachel Ann. "From Reality to Symbol: Images of Children in the Art of Winslow Homer." Ph.D. diss., University of Maryland, College Park, 1990.

Colacino, Jana Therese. "Winslow Homer Watercolors and the Color Theory of M. E. Chevreul." Master's thesis, Syracuse University, 1994.

Conrads, Margaret C. "Winslow Homer and His Critics in the 1870s." Ph.D. diss., City University of New York, 1999.

Giese, Lucretia Hoover. "Winslow Homer: Painter of the Civil War." Ph.D. diss., Harvard University, 1985.

The Graduate School and University Center of the City University of New York/The Lloyd Goodrich and Edith Havens Goodrich/Whitney Museum of American Art/Record of Works by Winslow Homer.

Provost, Paul Raymond. "Winslow Homer's Drawings in Black-and-White, c. 1875–1885." Ph.D. diss., Princeton University, 1993.

Tatham, David. "Winslow Homer in Boston: 1854–1859." Ph.D. diss., Syracuse University, 1970.

ARTICLES

Adams, Henry. "The Identity of Winslow Homer's Mystery Women." *Burlington Magazine* 132 (April 1990): 244–52.

——. "Winslow Homer's 'Impressionism' and Its Relation to His Trip to France." *Studies in the History of Art* 26 (1990): 61–89.

——. "Winslow Homer's Mystery Woman." *Art and Antiques* 7 (November 1984): 38–45.

Baldinger, Wallace S. "The Art of Eakins, Homer and Ryder: A Social Re-evaluation." *Art Quarterly* 9 (summer 1946): 212–33.

Benson, E. M. "Nineteenth Century Americans: Winslow Homer and Homer D. Martin." *American Magazine of Art* 29 (October 1936): 184–85.

Boime, Albert. "Blacks in Shark-infested Waters: Visual Encodings of Racism in Copley and Homer." *Smithsonian Studies in American Art* 3 (winter 1989): 19–48.

Bolton, Theodore H. "The Art of Winslow Homer: An Estimate in 1932." *The Fine Arts* 18 (February 1932): 23–28, 52–55.

Brinton, Christian. "Winslow Homer." *Scribner's Magazine* 49 (January 1911): 9–23.

Buch, John H. "Winslow Homer's Paintings." *Metropolitan Museum of Art Bulletin* 6 (February 1911): 43–44.

Buchanan, Charles L. "Inness and Winslow Homer." *The Bookman* 47 (July 1918): 487–97.

Burns, Sarah. "Modernizing Winslow Homer." *American Quarterly* 49 (September 1997): 615–39.

Caffin, Charles H. "A Note on the Art of Winslow Homer." *Bulletin of the Metropolitan Museum of Art* 6 (March 1911): 50, 52.

Calo, Mary Ann. "Winslow Homer's Visits to Virginia During Reconstruction." *American Art Journal* 12 (winter 1980): 4–27.

Chase, J. E. "Recollections of Homer." *Harper's Weekly* 54 (October 22, 1910): 13.

Cikovsky, Nicolai, Jr. "Winslow Homer's *Prisoners from the Front*." *Metropolitan Museum of Art Journal* 12 (1977): 155–72.

——. "Winslow Homer's (So-called) Morning Bell." *American Art Journal* 29 (1998): 5–17.

——. "Winslow Homer's Unfinished Business." *Studies in the History of Art* 37 (1990): 92–117.

Cooke, Herewald Lester. "The Development of Winslow Homer's Watercolor Technique." *Art Quarterly* 24 (summer 1961): 169–94.

Cox, Kenyon. "Three Pictures by Winslow Homer in the Metropolitan Museum." *Burlington Magazine* 12 (November 1907): 121–24.

——. "The Watercolors of Winslow Homer." *Art in America* 2 (October 1914): 404–15.

——. "Winslow Homer." *Nation* 100 (February 18, 1915): 206–7.

Docherty, Linda J. "A Problem of Perspective: Winslow Homer, John H. Sherwood, and *Weaning the Calf*." *North Carolina Museum of Art Bulletin* 16 (1993): 32–48.

Downes, William Howe. "Life and Works of Winslow Homer." *Nation* 94 (January 4, 1912): 19–20.

E., H. W. "Winslow Homer: Early Criticisms." *Bulletin of the Metropolitan Museum of Art* 5 (December 1960): 268–69.

Foster, Allen Evarts, comp. "A Check List of Illustrations by Winslow Homer in *Harper's Weekly* and Other Periodicals." *Bulletin of the New York Public Library* 40 (October 1936): 842–51.

——, comp. "A Check List of Illustrations by Winslow Homer Appearing in Various Periodicals: A Supplement to the Check List Published in the Bulletin of the New York Public Library." *Bulletin of the New York Public Library* 44 (July 1940): 537–39.

Fowler, Frank. "An Exponent of Design in Painting." *Scribner's Magazine* 33 (May 1903): 638–40.

Gerdts, William H. "Winslow Homer in Cullercoats." *Yale University Art Gallery Bulletin* 36 (spring 1977): 18–35.

Gibson, Eric. "Homer and Sargent: Yankee Honesty vs. Cosmopolitan Flair." *New Criterion* 5 (February 1987): 58–65.

Goodrich, Lloyd. "Realism and Romanticism in Homer, Eakins, and Ryder." *Art Quarterly* 12 (winter 1949): 17–29.

——. "Winslow Homer." *The Arts* 6 (October 1924): 185–209.

——. "Winslow Homer." *Perspectives* no. 14 (1956): 44–45.

Hoeber, Arthur. "Art and Artists." *New York Globe and Commercial Advertiser*, 7 (February 1911): 8.

——. "Painter of the Sea." *World's Work* 21 (February 1911): 17.

Hurley, Patricia M. "Forum: Winslow Homer's Children Playing on a Fence." *Drawing* 8 (September/October 1986): 58.

Ingalls, Hunter. "Elements in the Development of Winslow Homer." *Art Journal* 34 (fall 1964): 18–22.

Kaplan, Sidney. "The Negro in the Art of Homer and Eakins." *Massachusetts Review* 7 (winter 1966): 105–20.

Katz, Leslie. "The Modernity of Winslow Homer." *Arts* 33 (February 1959): 24–27.

Knauff, Christopher W. "Certain Exemplars of Art in America: IV. Elliott Dangerfield–Winslow Homer." *The Churchman* 78 (July 23, 1898): 123–25, 128.

La Farge, Henry A. "Early Winslow Homer." *ArtNews* 52 (November 1953): 41.

Mather, Frank Jewett, Jr. "Art of Winslow Homer." *Nation* 92 (March 2, 1911): 225–27.

——. "Winslow Homer as a Book Illustrator with a Descriptive Checklist." *Princeton University Library Chronicle* 1 (November 1939): 15–52.

Morton, Frederick W. "The Art of Winslow Homer." *Brush and Pencil* 10 (April 1902): 40–54.

Nettles, Gail. "Winslow Homer and the Women in His Works." *Winslow Homer: An Annual* 6 (1991): 3–62.

Newlin, Alice. "Winslow Homer and Arthur Boyd Houghton." *Metropolitan Museum of Art Bulletin* 22 (March 1936): 56–59.

Porter, Fairfield. "Homer, American vs. Artist: A Problem in Identities." *ArtNews* 57 (December 1958): 24–27, 54, 56.

Provost, P. R. "Drawn Toward Europe: Winslow Homer's Work in Black and White." *Master Drawings* 31 (spring 1993): 35–46.

Prown, Jules D. "Winslow Homer in His Art." *Smithsonian Studies in American Art* 1 (spring 1987): 31–46.

Quick, Michael. "Homer in Virginia." *Los Angeles County Museum of Art Bulletin* 24 (1978): 60–81.

Richardson, E. P. "Three Early Works by Winslow Homer." *Bulletin of the Detroit Institute of Arts* 31 (1951–52): 6–9.

Saint-Gaudens, Homer. "Winslow Homer." *Carnegie Magazine* (February 1937): 259–68.

Sherman, Frederic Fairchild. "The Early Oil Paintings of Winslow Homer." *Art in America* 6 (June 1918): 201–8.

Shurtleff, R. H. "Correspondence. Shurtleff Recalls Homer." *American ArtNews* 3 (October 29, 1910): 4.

Spassky, Natalie. "Winslow Homer at The Metropolitan Museum of Art." *Metropolitan Museum of Art Bulletin* 39 (spring 1982): 4–48.

Stein, Roger B. "Winslow Homer in Context." *American Quarterly* 42 (1990): 74–92.

Tatham, David. "Trapper, Hunter, and Woodsman: Winslow Homer's Adirondack Figures." *American Art Journal* 22 (1990): 40–67.

——. "*Two Guides*: Winslow Homer at Keene Valley, Adirondacks." *American Art Journal* 20 (1988): 21–34.

——. "Winslow Homer and the New England Poets." *Proceedings of the American Antiquarian Society Annual Meeting* 89 (October 1979): 241–60.

——. "Winslow Homer in the Mountains." *Appalachia* 36 (June 15, 1966): 73.

——. "Winslow Homer's Library." *The American Art Journal* 9 (May 1977): 92–98.

Walsh, Judith. "The Language of Flowers and Other Floral Symbolism Used by Winslow Homer." *Antiques* 156 (November 1999): 708–17.

Watson, Forbes. "Ryder, Eakins, Homer." *The Arts* 17 (May 1930): 630–34.

W[ehle], H. B. "Early Paintings By Homer." *Bulletin of The Museum of Modern Art* 18 (February 1923): 38–41.

Weitenkampf, Frank. "The Intimate Homer: Winslow Homer's Sketches." *Art Quarterly* 6 (autumn 1943): 306–21.

Wilmerding, J. "Winslow Homer's Creative Process." *Antiques* 108 (November 1975): 965–71.

——. "Winslow Homer's *Right and Left.*" *Studies in the History of Art* 9 (1980): 59–85.

Wilson, Christopher Kent. "A Contemporary Source for Winslow Homer's *Prisoners from the Front.*" *Source* 4 (summer 1985): 37–40.

Wright, W. H. "Modern American Painters and Winslow Homer." *Forum* 54 (December 1915): 670–72.

Young, J. W. "The Art of Winslow Homer: America's First Great Outdoor Painter." *Fine Arts Journal* 19 (February 1908): 57–63.

Photography Credits

Index